DAVID SMITH
Sculpture and Drawings

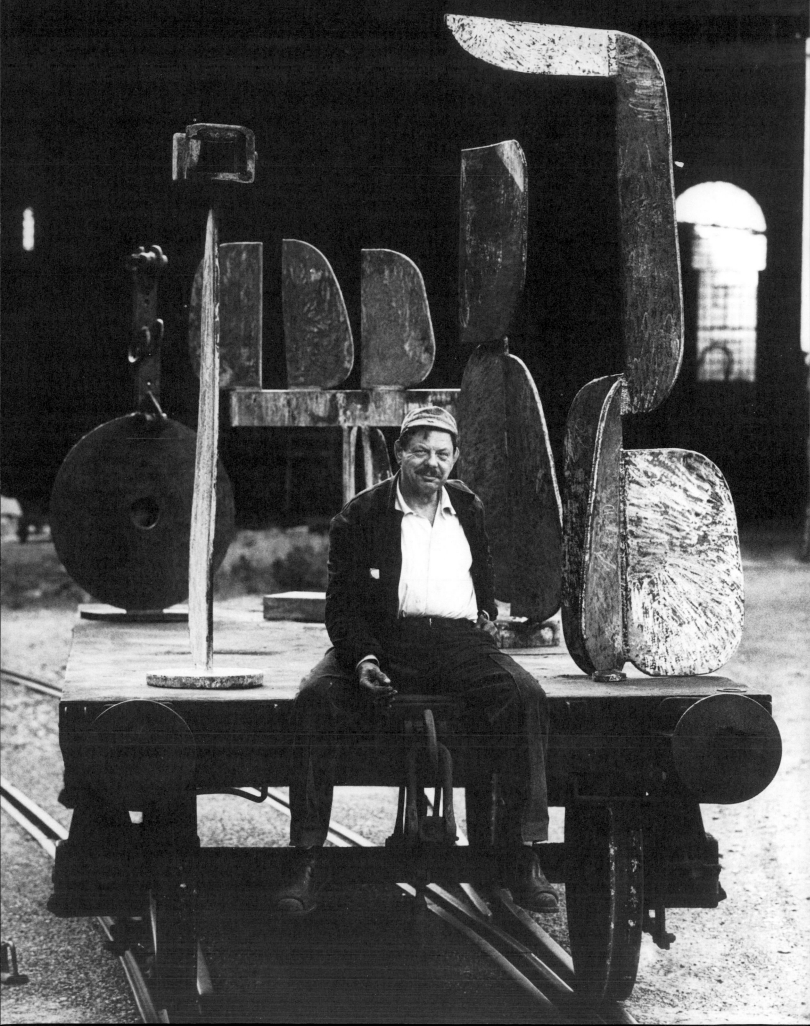

DAVID SMITH

Sculpture and Drawings

Edited by
Jörn Merkert

With contributions by
Hannelore Kersting, Rachel Kirby
and Jörn Merkert

and selected writings by
David Smith

Prestel-Verlag · Munich

This catalogue has been published in conjunction with the exhibition
'David Smith: Sculpture and Drawings' held at the Kunstsammlung Nordrhein-Westfalen,
Düsseldorf (4 March – 27 April 1986), the Städtische Galerie im Städelschen Kunst-
institut, Frankfurt am Main (19 June – 28 September 1986) and Whitechapel Art Gallery,
London (7 November 1986 – 4 January 1987).

Translation of the essays by Jörn Merkert and Hannelore Kersting: Lesley Bernstein
Editorial & Translation Services, London

Front cover: *Zig II,* 1961 (cat. 35)
Back cover: *Cubi XV* and *Cubi XIX* (cat. 45)
Frontispiece: David Smith in Voltri, 1962

The exhibition 'David Smith: Sculpture and Drawings' has been organized jointly by the
Kunstsammlung Nordrhein-Westfalen, Düsseldorf, the Städtische Galerie im
Städelschen Kunstinstitut, Frankfurt am Main, and Whitechapel Art Gallery, London.
Conception: Jörn Merkert, Hannelore Kersting, Nicholas Serota

Typesetting: Typoservice Urban GmbH, Munich, using 'Akzidenz-Grotesk' by
Berthold AG, Berlin (TPS/DMS System)
Lithography: Brend'Amour, Simhart GmbH & Co., Munich
Printing and binding: Passavia GmbH, Passau
Printed in Germany

ISBN 3 7913 0793 2

Contents

Foreword

"Sculpture is the poetic statement of form"
David Smith, *Notebooks,* c.1950

David Smith was an eloquent poet. Twenty years after his death the whole career is beginning to come into focus and we can appreciate the continuity of his approach, the consistency of his vision, as well as those developments in technique which so influenced a generation of sculptors.

In Britain Smith has been known more through the work and teaching of an artist like Anthony Caro than through his own sculpture. There have been few opportunities to see a body of work, other than the Museum of Modern Art memorial exhibition which was shown at the Tate in 1966 and the Whitney Museum drawings exhibition seen at the Serpentine in 1980. On the Continent, where Smith is often regarded as a purely 'American' phenomenon, less than a handful of works are owned by public or private collections, in sharp contrast to the reverence paid to almost exact contemporaries like Rothko or de Kooning. This exhibition, which has been organized by three European institutions, is therefore intended to redress the balance and to show the full stature of Smith's endeavour in both sculpture and drawing.

Where Smith is known, it is largely for the welded steel sculptures made from found metal parts during the late fifties and the magisterial stainless steel *Cubis* completed in the two years before his death in 1965. Surprisingly little attention has been paid to his work from the late forties and early fifties. We have therefore been fortunate in being able to bring together a particularly strong group of sculpture from this period. Smith's exploration of interior and exterior structures, his use of symbolic images and his search for a rendering of landscape in three dimensions resulted in a series of remarkable, potent sculptures. They are the sculptural equivalent of the nascent Abstract Expressionist language found in paintings like Pollock's *The She-Wolf* (1943), Rothko's *Primeval Landscape* (1945) and Gorky's *The Betrothal II* (1947). It is precisely these metaphorical works by Smith which today seem to have a particular resonance in relation to the works of younger sculptors who are developing a language based on similar organic and natural forms.

The exhibition, which has been selected by Jörn Merkert, Hannelore Kersting and myself, and shown previously in Düsseldorf and Frankfurt, has had the support of the artist's daughters Candida and Rebecca, and of Peter Stevens, who assists on the administration of the Estate. We are most grateful to them for their generosity in making work available and for their assistance at all stages in the preparations for the exhibition. Laurence Rubin of M. Knoedler and Co. Inc. has helped trace works and has been equally generous in his support of our endeavour. Amongst others who assisted at certain moments I should like particularly to thank David McKee for his long interest in our wish to realize an exhibition and for his insights into David Smith's work. On behalf of the Whitechapel I should also like to thank Jörn Merkert and the Kunstsammlung Nordrhein-Westfalen in Düsseldorf for shouldering the main burden of organizing and coordinating this complex project. Finally, may I thank the owners of works for their generosity in lending sculptures and drawings for an extended tour. Their understanding and support has made it possible for us to do justice to the achievement of David Smith.

Nicholas Serota
Whitechapel Art Gallery

Biography

David Smith was born on 9 March 1906 in the mid-Western town of Decatur, Indiana. A sister, Catherine, was born in 1911. Smith's ancestry and upbringing were puritan; his great-grandfather, a blacksmith at one time, was one of the first settlers in the town and family tradition credited him with a hand in its founding. Smith's mother was a school teacher and a strict Methodist, and his father a telephone engineer. "Some of the first things I played with were telephones. I took them apart and used the magnets. My father was an inventor – he invented electrical things… When I was a kid everyone in town was an inventor."[1]

The young Smith was fascinated by the railway: "I had a pretty profound regard for railroads… We used to play on trains and around factories. I played there just like I played in nature, on hills and creeks… I've always had a high regard for machinery. It's never been an alien element; it's been in my nature."[2]

Contact with any kind of visual art was virtually non-existent: "I don't think I had seen a museum out in Indiana or Ohio other than some very, very dark picture with sheep in it in the public library."[3] Yet a desire to become a painter began to form while he was still young. During Smith's teenage years, towns all around the mid-West were being transformed by metal-working companies, as machines replaced older methods of working in industry and agriculture.

1921 – 24

In 1921 the family moved to Paulding, Ohio, where the father became manager of the Telephone Company and Smith went to High School. Though he did not distinguish himself particularly, he found his skill at cartoons admired, and enrolled in 1923 in a correspondence course in drawing at Cleveland Art School, Ohio.

On graduating in 1924, he spent a year at Ohio University, where he gave most of his attention to art, though frustrated at the type of teaching practised there: "I wish somebody had taught me to draw in proportion to my own size, to draw as freely and as easily, with the same movements that I dressed myself with, or that I ate with, or worked with in the factory. Instead, I was required to use a little brush, a little pencil, to work a little area, which put me into a position of knitting – not exactly my forte."[4]

1925

In the summer of this, the most important of the sculptor's early years, Smith worked in the Steel Frame Assembly Department of the Studebaker Automative plant in South Bend, Indiana. He practised riveting, soldering, welding and working a lathe, and though he took the job "strictly for money – more than I ever earned in my life", and moved on to white-collar work as soon as the opportunity arose, he liked the identity it gave him as a 'working man', and the fact that "before knowing what art was and before going to art school, as a factory worker I was acquainted with steel and the machines used in forging it."[5]

While still in South Bend, he matriculated at Notre Dame University, but dropped out after a fortnight on finding there was no provision for studying art.

1926 – 27

In 1926 he was employed by the co-operative Morris Plan Bank, first in Washington, D.C. (while attending evening classes in poetry at Georgetown University), and finally, at the end of the year, in New York. No sooner had he arrived than he met, in his own rooming-house, a young painter called Dorothy Dehner, who was studying at the Art Students League. She later recalled: "We started talking before dinner time and the conversation lasted until early morning. We talked about art and artists, religion, families, friends, pets, travel in foreign parts, poetry and a thousand other things." At the first opportunity Smith, too, enrolled at the League. According to Dehner, he was working at that time "for a finance company, writing very high-toned letters to credit bureaux and the like. For this work he wore spats (in winter), wing collars and often carried a cane. His outfit for Richard Lahey's night class was considerably more informal."[6]

In 1927 Smith became a full-time student, attending painting classes during the day and making prints at night and on Saturdays. Much of his time and ideas were shared with Dorothy, and on Christmas Eve they were married.

1928 – 29

Throughout the year, Smith studied with the Czech abstract painter Jan Matulka, a former pupil of Hans Hoffman, who had newly arrived at the League.

"It was from him in 1928 that for the first time I learned of cubism and constructivism. Then the world kind of opened for me. I also learned a lot at the time from just looking at reproductions, mostly in European magazines. I first saw Picasso – then his iron constructions in *Cahiers d'Art* and I realized that I too knew how to handle this material. At about the same time I saw reproductions of the Russian constructivists in some German magazines. I couldn't read the texts in either the

David Smith at Bolton Landing in about 1939

French or the German magazines, so my acquaintance-ship was purely visual... Matulka was the most notable influence on my work."[7]

1929 – 30

In the summer of 1929 Smith and Dorothy spent a holi-day at Bolton Landing, in upstate New York, as guests of Thomas Furlong, Secretary of the League. The Smiths were greatly impressed with the place, high in the Adi-rondack mountains above Lake George, and for $1000 bought a dilapidated colonial cottage – a former fox farm – in eighty-five acres of land. For the next eleven years, they spent the summer and autumn of each year there, working and enjoying a spartan but sociable life-style amongst a circle of like-minded people. One such new friend was John Graham, Russian emigré, intellectual and artist, who had lived in Paris and whose contacts with a wide cross-section of avant-garde European artists brought Smith an informed understanding of the major modernist art styles. Smith's own work at this time was in an abstract Surrealist style; he was experimenting with painting, collage and reliefs, and was becoming increasingly interested in the combination of construc-tion and painting.

It was in Graham's house that Smith came across the reproductions of Julio González's sculptures in welded metal, a medium which the Spanish artist had pioneered five years before. Though he had not yet made the deci-sion to become a sculptor rather than a painter, these had an immediate impact on him. It was also through John Graham that the Smiths met Milton Avery, Stuart Davis, Jean Xceron, Arshile Gorky and Willem de Kooning – artists who, like the Smiths (though some-what older), were hungry for news and ideas coming out of Europe.

According to Sidney Geist, "In the thirties artists in America and especially in New York had become the best educated artists in the world. Not only Cézanne, Picasso, Miró, Léger, the Mexicans, the museum and the primitive, but Kandinsky, Klee, Matisse and Mondrian were studied and emulated with an application that had no counterpart anywhere else."[8] David Smith was in the vanguard of that generation.

1930 – 31

In October the Smiths set off for St.Thomas in the Virgin Islands and for eight months lived "like Gauguin". With pieces of wood and coral he collected, Smith put together small constructions with wire. He also carved a negro head in white coral and painted it "purplish brown".

1932 – 33

Back in Bolton Landing, Smith made further construc-tions from wood, soldered metal and 'found' materials (some of which he brought back with him). Then, with welding equipment belonging to a local garageman he welded his first free-standing metal sculptures (*Saw Head, Agricola Head;* cat. 2, 3).

Even in these earliest works in metal, Smith had grasped the potential of the medium. Here was a tech-nique which was quintessentially modern, with which he was familiar and which lent itself naturally to combina-tion with forms based on the principles of modernist painting, yet not committed to any one movement, nor to the convention of the closed sculptural volume. Smith went on producing works on canvas, and especially drawings, all his life and always argued the close links between painting and sculpture. But from the mid-thirties onwards, he accepted that "I paint and draw as a sculptor".

1934

Buying a forge from a defunct blacksmith shop, Smith set up a studio in a woodshed at Bolton Landing and at the same time moved into a machine-shop on the Brook-lyn waterfront, "a long rambling junky-looking shack

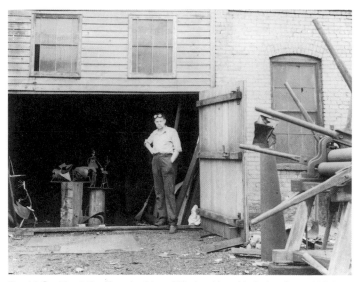

David Smith at the Terminal Iron Works, New York, in about 1934

called Terminal Iron Works". He worked there, very happily, until 1940, and always maintained a great respect and affection for the people he met there: "Any method I needed, I could learn it... and often got donated materials besides. These were the depression days. My sculpture *Blackburn* was made afterwards in homage."⁹

That year Graham made Smith the precious gift of a sculpture by González, entitled *Head*.

1935 – 36

From October 1935, the Smiths spent nine months travelling in Europe. In Paris he saw "the newest Picasso hot off the easel", and later said that the introductions from John Graham "made my world there". In Greece over the winter he tried his hand at bronze-casting and took samples of colour from antique sculptures. In Moscow he saw the magnificent collection at the Museum of Modern Western Art, and in London he studied Egyptian and Sumerian coins and seals. Wherever he went, he soaked himself in European art and artefacts, antique, historic and modern alike. On his return, however, he recognized "that no matter how inhospitable New York was to my work, my life and destiny and materials were here". "I certainly gave up any idea of ever being an expatriate, so I laid into my work very hard."

1937 – 40

In 1937 Smith embarked on a series of fifteen bronze medallions which he called *Medals for Dishonour* (cat. 59–61). Made with dentists' and jewellers' tools, these combined images drawn from art history (Bosch, Brueghel, etc.), Picasso's *Guernica,* newspaper cuttings

and medical books in a subjective surrealist idiom. From a formal point of view he was "interested in the idea of intaglio – as a reverse process. The theory is that you're on the opposite side pushing the walls out." From the point of view of content, they represent Smith's most forthright expression in sculpture of idealist Pacifist views.

The medallions provided the iconography for many of the anthropomorphic images of the forties – the spectres, sinister birds, preying insects and numerous symbols of sexual aggression *(Maiden's Dream, Portrait of the Eagle's Keeper, Atrocity, False Peace Spectre)*. More important to his later work, though, were the free-standing pieces he created alongside the medallions in an ambitious range of styles, as he sought a three-dimensional language of forms drawn primarily from two-dimensional traditions *(Aerial Construction, Interior for Exterior, Head as a Still Life* [cat. 9], *Billiard Player Construction* [cat. 4]).

In January/February 1938 Smith was given his first one-man show by Marian Willard in New York, who became his dealer for many years. It comprised seventeen welded-iron sculptures and a number of drawings. As an opportunity to exhibit, the commercial show was an isolated one. Smith's experience of working in the thirties differed little from that of other radical artists in New York: "One did not feel disowned – only ignored and much alone, with a vague pressure from authority that art couldn't be made here."

Later in 1938 he experimented with arc (electric) as opposed to oxyacetylene (torch) welding *(Structure of Arches;* cat. 8).

In February 1939 Smith was assigned to the Sculpture division of the Works Project Administration, a federal project set up to help artists and to encourage the making of works for public places.

In the Spring of 1940 he and Dorothy moved permanently to Bolton Landing, taking with them the name Terminal Iron Works for his studio.

1940 – 41

In February 1940 Smith spoke at a forum of the United American Artists group in favour of abstract art as against the then fashionable Social Realism: "The tradition of our art is international, as are American people, customs and science. There is no true American art and there is no true American mind. Our art tradition is that of the Western world, which originally had its tradition in the East. Art cannot be divorced from time, place or science... The literal message from the painter has seen its day. [Abstraction] is the language of our time."¹⁰

In November a further exhibition at the Willard Gallery showed the medals, completed in 1940, accompanied by a catalogue for which Smith wrote didactic individual commentaries.

1941 saw him included in the Whitney Annual and two Museum of Modern Art circulating exhibitions. The scarcity of metal, though, and the demands of the war effort, virtually halted the rapid development of Smith's sculpture for the next few years. During 1941, he worked as a machinist at Glens Falls, New York.

1942 – 44

From 1942–44 he worked on night shift for the American Locomotive Company in Schenectady, assembling tanks. In his spare time he made small bronzes on themes of violence and destruction, some pieces in marble and a great number of drawings. He also completed building a new studio at Bolton Landing which he set up in the manner of a machine shop.

At the factories he was considered a first-rate welder, and received valuable experience in arc-welding, but he was restless at the time spent away from his art. In a letter to Moholy-Nagy in reply to an offer of teaching, he wrote: "I feel that the locomotive business has taken more than two years out of me. I've learned much from it, but life is short, my ideas many and I hope for the rest of my life to do only my own work."[11]

In 1943 Clement Greenberg noticed and began to write about his work in *The Nation,* and the Museum of Modern Art bought *Head* (1938).

1945 – 48

The years immediately after the war were a highly productive period for Smith. With the art seen a decade before fully assimilated, the sculptures of these years represent a new assurance and inventiveness. They bring together the elements of fantasy and abstraction, hitherto explored separately, in an idiom which is increasingly lyrical, but charged with a powerful symbolic content (*Reliquary House, Pillar of Sunday* [cat. 11], *Home of the Welder* [cat. 10], *Steel Drawing I* [cat. 12]).

In January 1946 the Willard and Buchholz galleries held a retrospective of fifty-four sculptures from the years 1936–45, including thirty completed in 1944 and 1945. In 1947 a further, touring retrospective was organized by the American Association of University Women. That August, at the first Woodstock Art Conference, Smith spoke on 'The Sculptor's Relationship to the Museum, Dealer and Public': "I don't believe the artist has any professional duty to the public: the reverse is the case. It is

the artist who possessed the concept. It is the public's duty to understand… The artist's creative vision cannot go so far beyond the rest of the world that he is not understandable. He is limited by his time. He is dependent upon the past, but he is a contributing factor to the character of his time. His effort is to contribute a unity that has not existed before."[12]

1948 – 50

From 1948 to 1950 Smith taught at Sarah Lawrence College, Bronxville. In 1948 he completed building a new house, with minimum outside help, on the site of the old farmhouse at Bolton Landing, but in 1950 he and Dorothy separated, and Smith stayed on alone at their new home. (They were divorced in 1952.)

1950 – 52

During the course of 1950 Smith met Helen Frankenthaler, who bought *Portrait of the Eagle's Keeper,* and Robert Motherwell, who at Smith's request wrote a catalogue introduction to a Willard Gallery exhibition: "When I saw that David places his work against the mountains and sky, the impulse was plain, an ineffable desire to see his humanness related to exterior reality, to nature at least if not to man, for the marvel of the felt scale that exists between a true work and the immovable world, the relation that makes both human."[13]

The same year, a Fine Arts Fellowship from the Guggenheim Foundation, renewed for a second year,

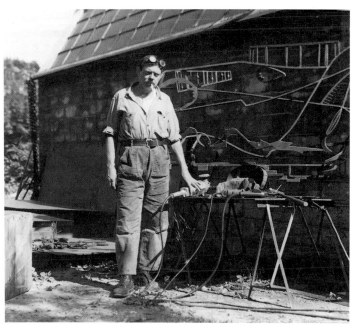

David Smith with *Hudson River Landscape* in 1951

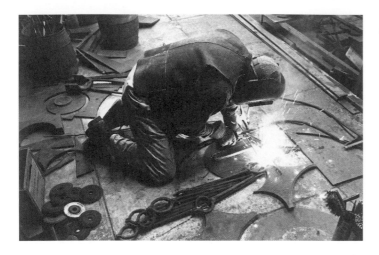

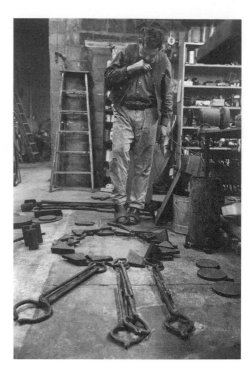

David Smith
welding at Bolton
Landing in 1962

David Smith
working on *Voltri
Bolton X* in 1962

temporarily freed Smith from teaching and other jobs. His first action was to buy in the biggest stock of quality materials he could afford. The scale of his sculpture increased dramatically, and he produced many of his greatest works: *The Cathedral* (cat. 18), *The Banquet, Star Cage* (cat. 20), *Australia* (cat. 21), *Blackburn – Song of an Irish Blacksmith* (ill., p. 34), and *Hudson River Landscape* (cat. 23). During 1950 *Cello Player* (1946) was exhibited in an International Open-Air Exhibition at Middelheim Park, Antwerp.

Smith's working method underwent a major change around this time. While he had always practised several styles concurrently, he now began to commit himself to doing extended series in a regular way, a method he continued for the rest of his life. The first series was the *Agricolas* (cat. 24, 25), begun in 1951, based on 'found' machine and farm equipment parts: "The Agricola series are like new unities whose parts are related to past tools of agriculture. Forms in function are often not appreciated in their context except for their mechanical performance. With time and the passing of their function, and a separation of their past, metaphoric changes can take place permitting a new unity, one that is strictly visual."[14]

Next came the *Tanktotems* (cat. 27, 31), made from tank or boiler plates, but manufactured according to the artist's specifications. They were started in 1952, but a decade later Smith stated: "I'm still working on them and don't rule them out until the day I die – that is, as long as concave and convex are still a mystery."

1953 – 55

In 1953, while teaching at the University of Arkansas, Smith married Jean Freas, by whom he had two daughters: Rebecca, born in 1954, and Candida, born the following year. In 1954 and 1955 he did further spells of teaching, at other universities.

Beginning in 1953, the Museum of Modern Art circulated an exhibition entitled 'Twelve Modern American Painters and Sculptors' in France, Switzerland, Germany, Sweden, Finland and Norway, which included six sculptures by Smith. In 1954 *Hudson River Landscape* (cat. 23) was shown at the XXVII Venice Biennale, the year Smith was a delegate to UNESCO's first International Congress of Plastic Arts there.

It was in this period that Smith began to place his sculptures permanently in the fields around his house and studio, the brick-red *Agricola I*, whose installation was filmed in 1954, probably being the first. Here he could see them silhouetted against the forest, mountains and sky of different seasons and in the dammed-up stream he called his "reflecting pool".

"When [a sculpture] is finished there is always that time when I am not sure – it is not that I am not sure of my work, but I have to keep it around for months to become acquainted with it and sometimes it is as if I've never seen it before and as I work on other pieces and look at it all the kinship returns, the battle of arriving, its relationship to the preceding work and its relationship to the new piece I am working on."[15]

1956 – 57

In February 1956 Smith wrote 'González: First Master of the Torch', a tribute to the sculptor published in *Art News* to coincide with his retrospective at the Museum of Modern Art.

The same year he began the *Sentinels* series, tall vertical structures in which he used industrial I-beams extensively and even added wheels.

In 1957 Smith was given long-awaited public recognition with a full-scale retrospective at the Museum of Modern Art, covering the work of twenty-five years. From then on, solo exhibitions of his work were held regularly in the States, and his sculpture was well received (and his lectures well respected) by critics and a growing public alike. He still sold little, though (almost all the major pieces in the MOMA exhibition were still in his ownership), and his life-style and manner of working continued unchanged.

1958 – 60

In June 1958 Smith represented the United States at the XXIX Venice Biennale. During the summer, the exhibition 'Contemporary American Sculpture' in Brussels showed *Royal Bird* (cat.16). In September 1959 he was awarded a prize at the V Bienal de São Paulo and was included in Documenta II, Kassel.

During 1959, while staying in the United States, Anthony Caro visited him at Bolton Landing, an event which was indirectly to have a tremendous influence on post-war British sculpture. That year he began his *Albany* series, smaller sculptures in steel painted black, followed in 1960 by the *Zigs* (short for 'ziggurats'), in which huge simple geometric forms were used in conjunction with a surface of multi-coloured paint patterns (cat. 34, 35).

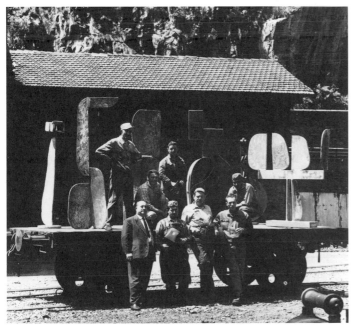

On the factory site at Voltri in 1962

This was the time of Smith's last great technical innovation: unpainted but burnished stainless steel. He used the medium for the later *Sentinels* (finished in 1961) but only fully explored its possibilities in his final series, the *Cubis,* monumental combinations of cubic forms between ten and twenty feet in height and designed to be placed outdoors: "I like outdoor sculpture and the most practical thing for outdoor sculpture is stainless steel, and I made them and I polished them in such a way that on a dull day, they take on the dull blue, or the color of the sky in the late afternoon sun... Some are down by the water and some are by the mountain. They reflect the colours. They are designed for outdoors."[16] On another occasion he said of the *Cubis*, "They are conceived for bright light, preferably the sun, to develop the illusion of surface and depth... stainless steel seems dead without light – and with too much it becomes car chrome."[17]

1961

In 1961 he and Jean were divorced, and from then on Smith lived alone, except for occasional visits from his daughters and from friends. His daughters were always very important to Smith, and many of his sculptures of the last ten years were named after them or dedicated to them. His pattern of friends, though, changed. An estrangement had taken place in the late fifties with earlier intimates, including Marian Willard, and he built a new circle, among whom were Herman Cherry, Clement Greenberg, Helen Frankenthaler, Robert Motherwell and Kenneth Noland.

At the Carnegie Institute 'Pittsburgh International' exhibition, Smith refused third prize, suggesting that the prize money of $1000 be used to purchase a work of art for the Museum.

1962

In 1962 Smith was invited by the Italian Government to spend a month working in Italy, making a sculpture for the fourth 'Festival of Two Worlds' in Spoleto. On arrival, he discovered to his delight that he had free access to five disused welding factories, Italsider, the owners, having moved to an automated plant near Genoa. Smith moved into the Voltri factory. Later, in his own report on the visit, he described "the beauties of the forge shop, parts dropped partly forged, cooled now but stopped in progress – as if the human factor had dissolved and the great dust settled – the found tombs of the twentieth century..."[18]

Though he went to Italy with clear ideas as to the work he would do, these plans were soon abandoned

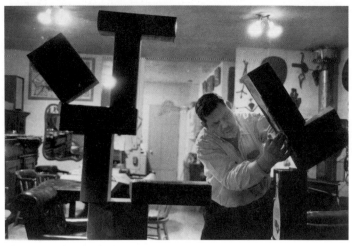

Maquettes for the *Voltri*. 1962

tion completely by surprise, had to be exhibited separately – but to great effect – in the Spoleto amphitheatre (cat. 36, 37). They included two wagons, made to fulfil an old dream (ultimately unrealized) of building a sculpture on the scale of a locomotive.

1963 – 65

Soon after returning to Bolton Landing in 1964, he had a one-man show at the Marlborough-Gerson Gallery in New York, and was presented with Brandeis University's Creative Arts Award. In February 1965 he was appointed by President Johnson to the National Council on the Arts. Recognition was giving way to respectability.

Meanwhile, Smith worked with unstinting energy on the *Voltron* and *Voltri-Bolton* series (cat. 38, 39), with materials brought back from Italy in large quantities, simultaneously continuing his earlier concerns in the *Cubis, Circles* and *Wagons* (cat. 41, 45–47).

On 23 May 1965, though, when driving to Bennington, Vermont to give a lecture, his truck overturned. He died that night.

because of the "wholly new world" of forms and ideas that presented itself at Voltri. In a burst of creativity he made twenty-six sculptures in thirty days, an achievement in quality and quantity which has since become legendary. The sculptures, taking the organizers of the exhibi-

Notes

1 Thomas B. Hess, "The Secret Letter", in *David Smith,* exhibition catalogue (Marlborough-Gerson Gallery, New York, 1964); reprinted on pp. 163–67 of the present volume.
2 Ibid.
3 David Sylvester, "David Smith", *Living Artists,* I/3 (April 1964); reprinted on pp. 160–63 of the present volume.
4 David Smith, "Memories to Myself", address given to the 18th conference of the National Committee on Art Education at the Museum of Modern Art, New York, on 5 May 1960.
5 David Smith, address given during the symposium "The New Sculpture" at the Museum of Modern Art, New York, on 12 May 1952.
6 Dorothy Dehner, "First Meetings", *Art in America,* L/1 (Jan. – Feb. 1966).
7 Katherine Kuh, "David Smith", in *The Artist's Voice: Talks with Seventeen Artists* (New York, 1962).
8 Hilton Kramer, "David Smith: Stencils for Sculpture", *Art in America,* L/4 (Winter 1962).

9 David Smith, "Letter to Emanuel Navaretta" (Nov. 1959), in Garnett McCoy (ed.), *David Smith* (New York, 1973), p. 208.
10 David Smith, "On Abstract Art", ibid., p. 37.
11 David Smith, "Letter to Lázló Moholy-Nagy" (1 April 1944), ibid., p. 195.
12 David Smith, "The Sculptor's Relationship to the Museum, Dealer, and Public", ibid., p. 52; reprinted on pp. 155–56 of the present volume.
13 Robert Motherwell, "For David Smith", in *David Smith,* exhibition catalogue (Willard Gallery, New York, 1950).
14 Cleve Gray (ed.), "David Smith (1906–1965): A Tribute", *Art in America,* LIV/1 (Jan. – Feb. 1966).
15 Ibid.
16 Hess, op. cit. (n. 1).
17 David Smith, "Notes on my Work", *Arts Magazine,* XXXIV/5 (Feb. 1960).
18 David Smith, "Report on Voltri", in McCoy, op. cit. (n. 9), p. 156.

Cubi XXVII 1965
New York, The Solomon
R. Guggenheim Museum
(not in the exhibition)

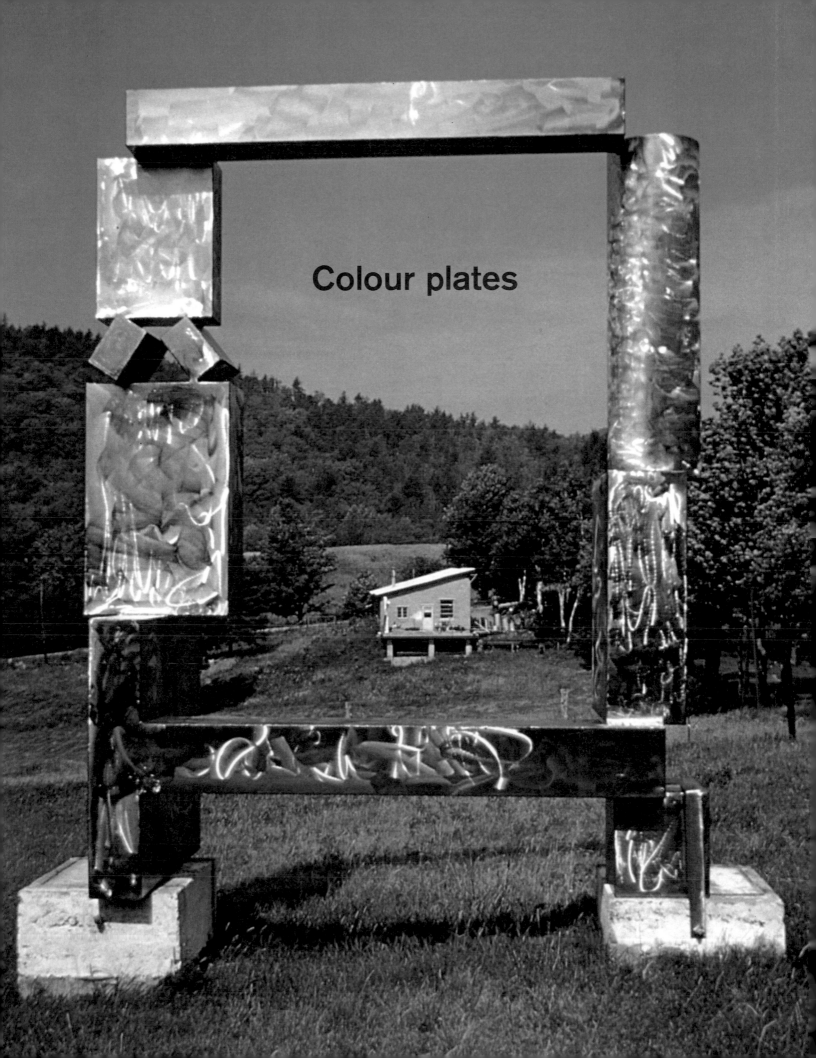

Colour plates

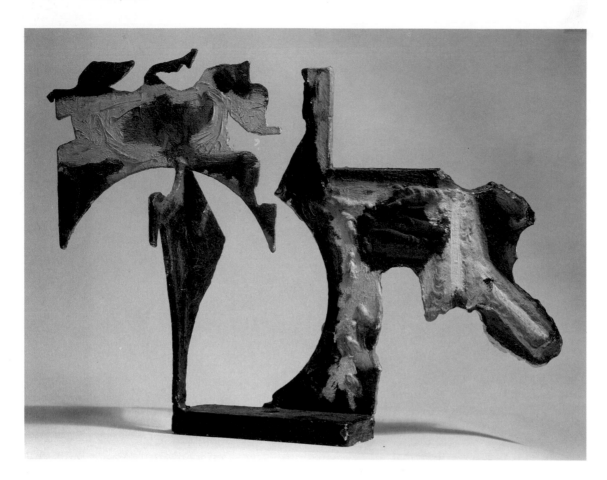

Untitled 1937
(cat. 7)

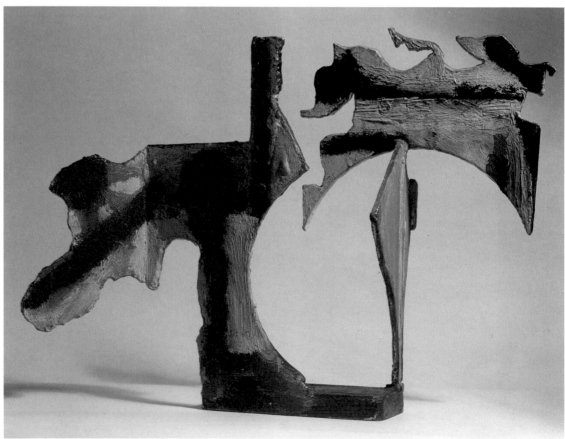

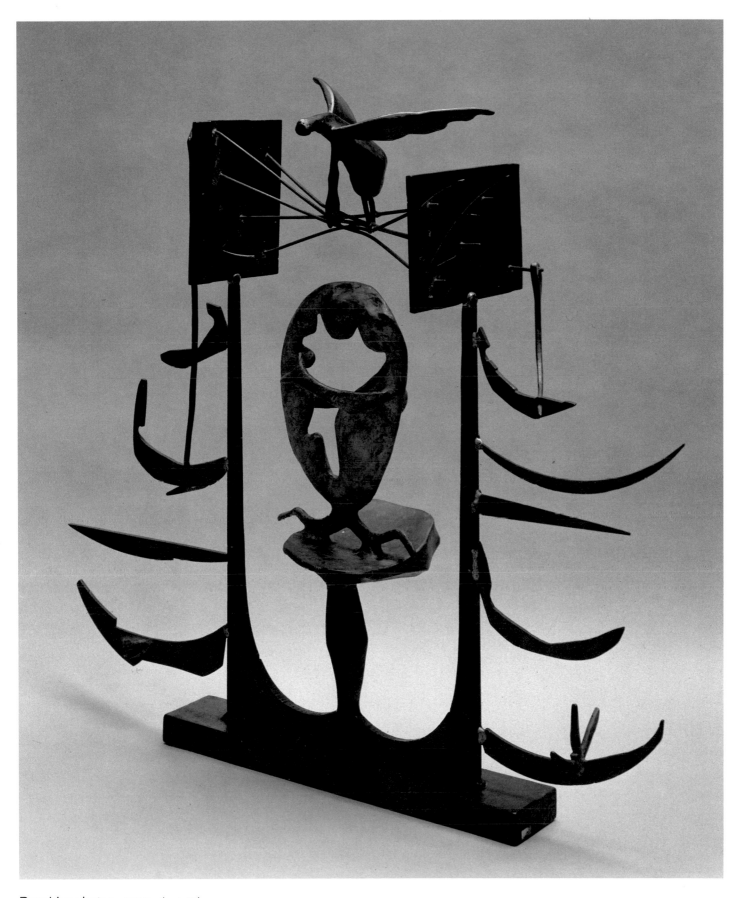

Royal Incubator 1950 (cat.19)

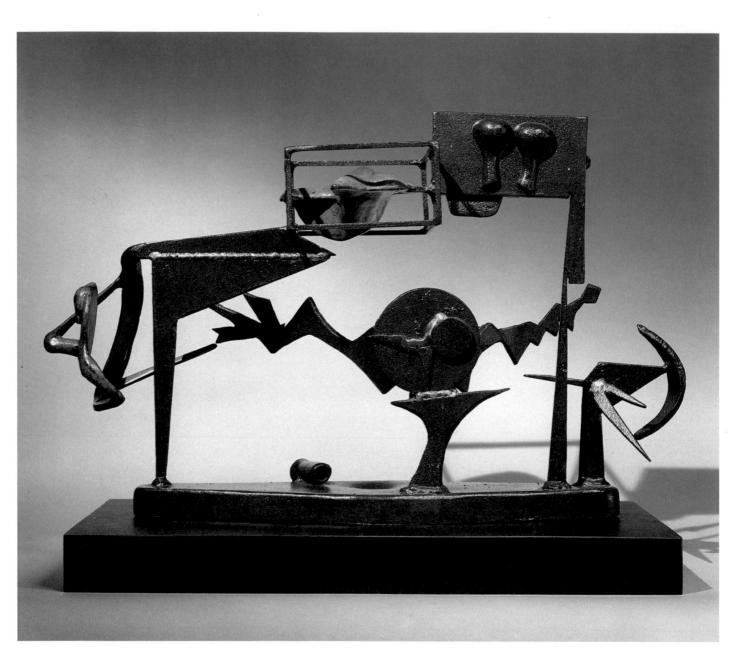

The Garden (Landscape) 1949 (cat.17)

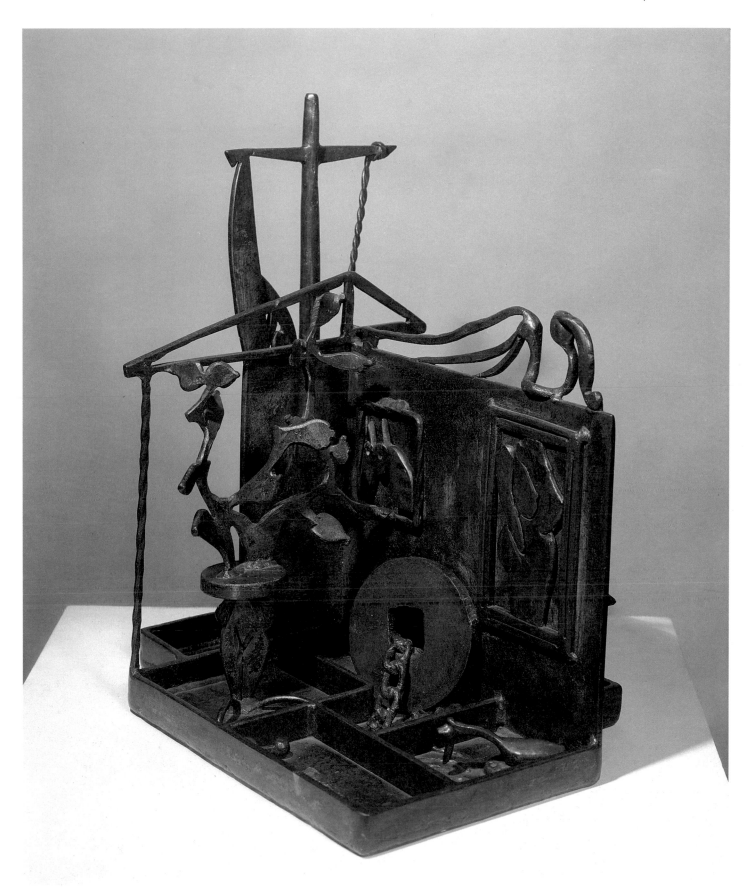

Home of the Welder 1945 (cat.10)

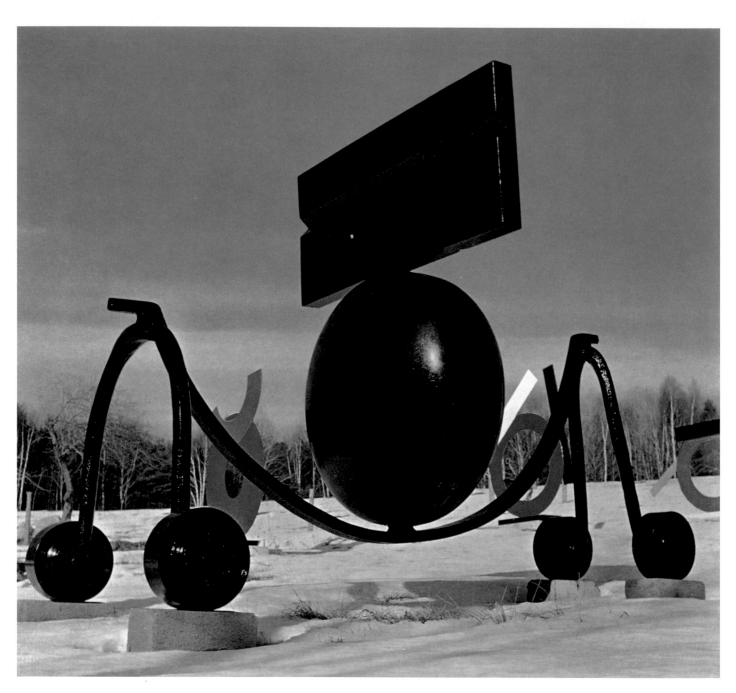

Wagon I 1964 Ottawa, National Gallery of Art (not in the exhibition)

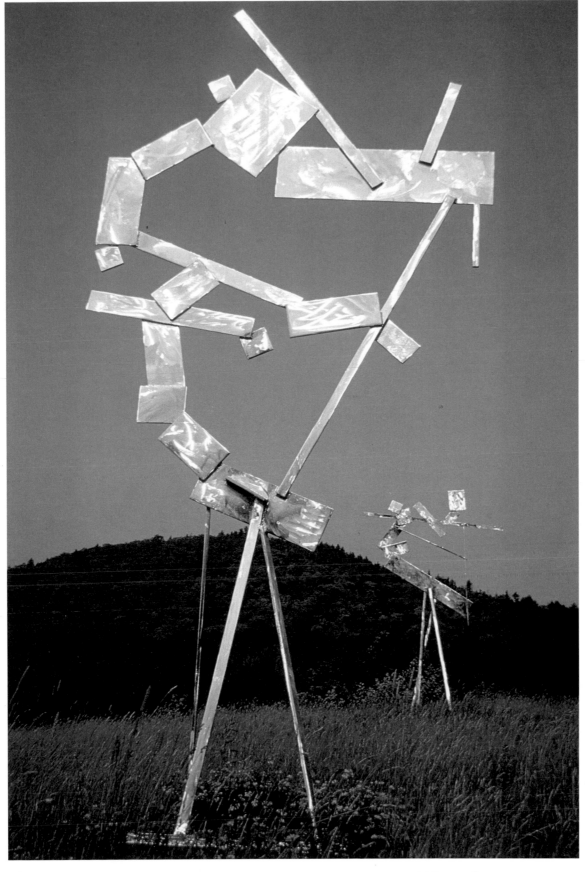

Twenty five Planes 1958
(not in the exhibition)

Eight Planes Seven Bars 1958
(not in the exhibition)

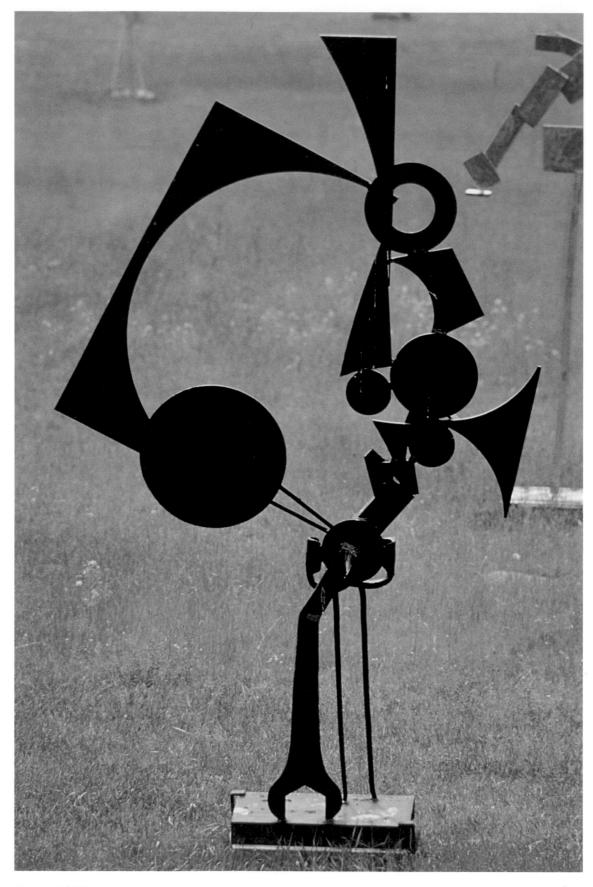

Voltron XVIII 1963 Albany, Institute of History and Art (not in the exhibition)

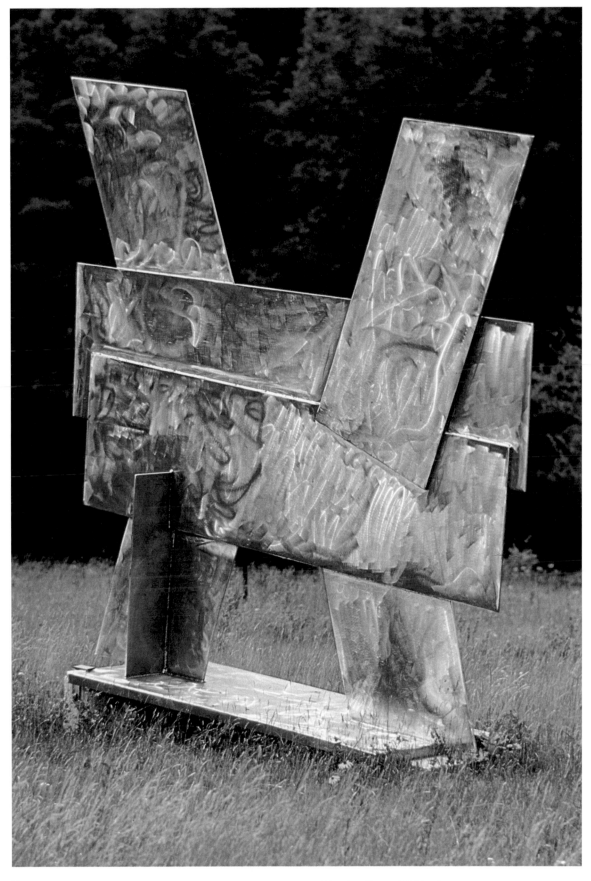

Becca 1965 New York, The Metropolitan Museum of Art (not in the exhibition)

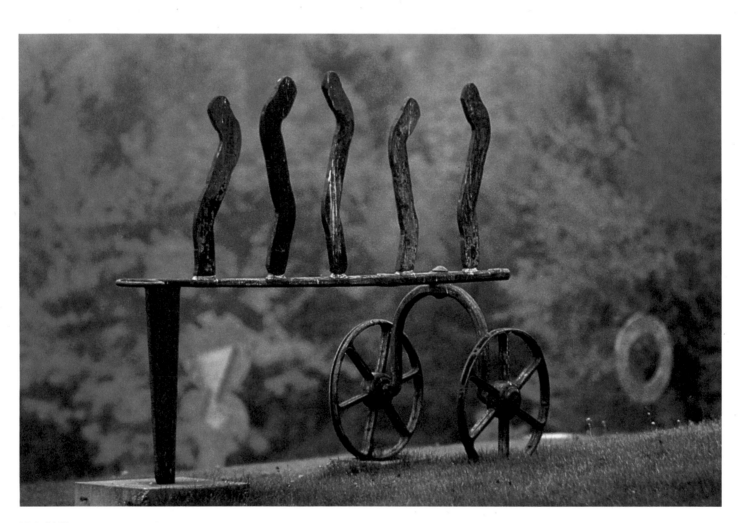

Voltri VII 1962 (cat. 37)

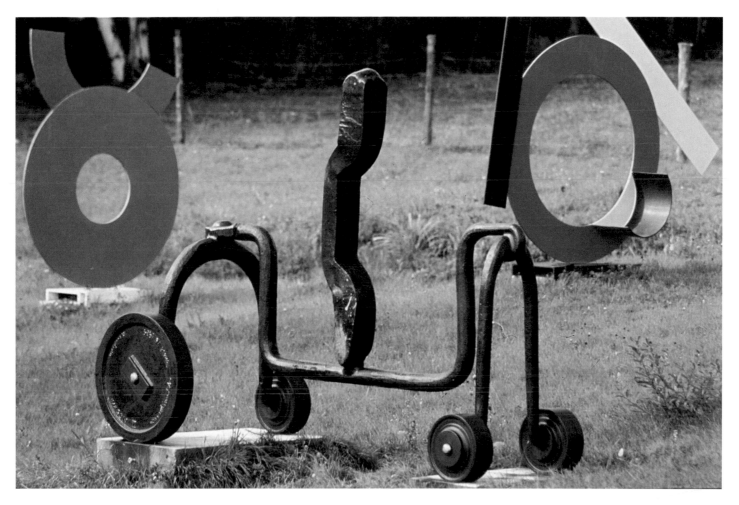

Wagon II 1964 (cat. 41)

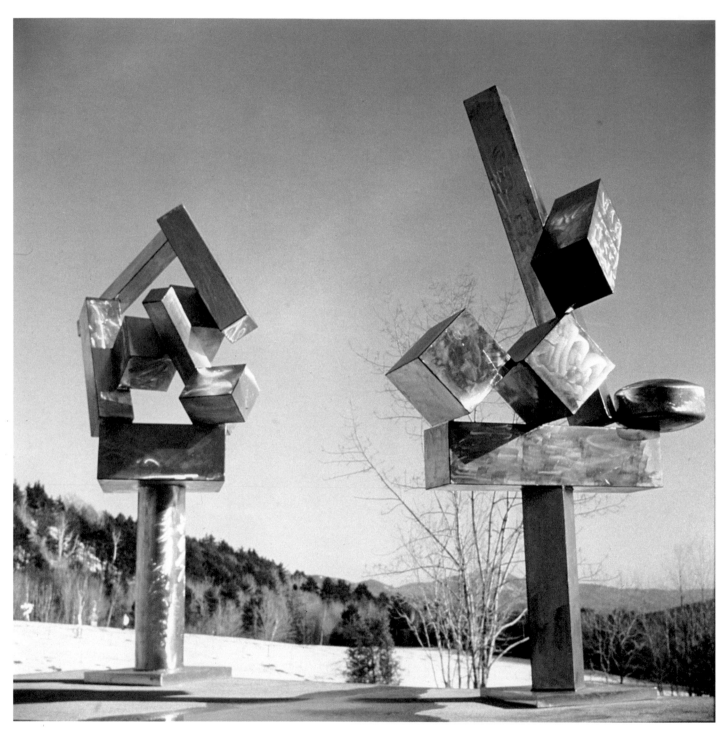

Cubi XV 1963
Dallas, Museum of Fine Arts
(not in the exhibition)

Cubi XIX 1964 (cat. 45)

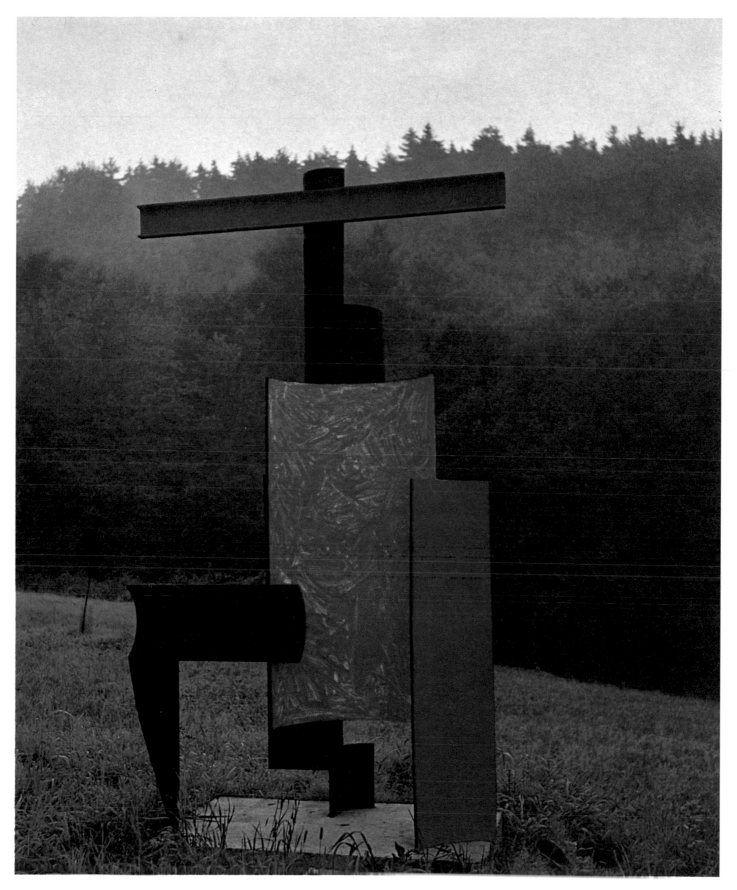

Zig II 1961 (cat. 35)

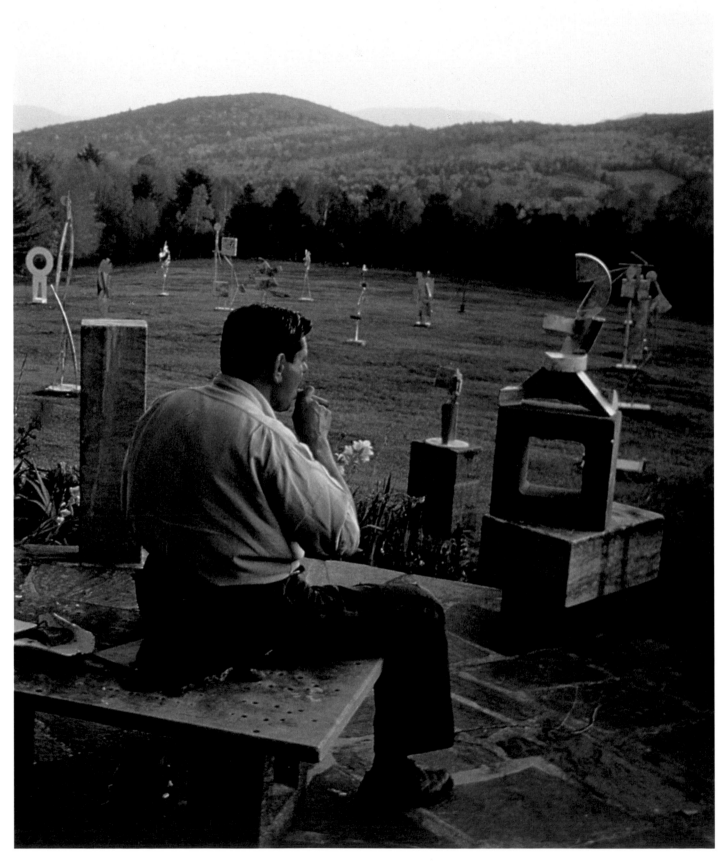

David Smith on the terrace overlooking the northern sculpture park at Bolton Landing

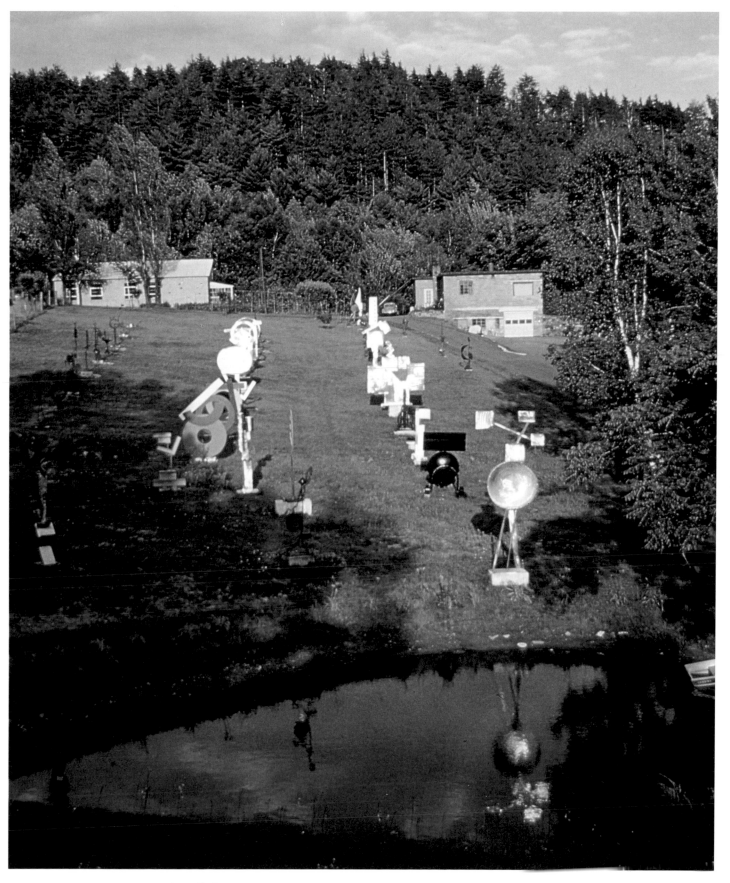

The southern sculpture park at Bolton Landing

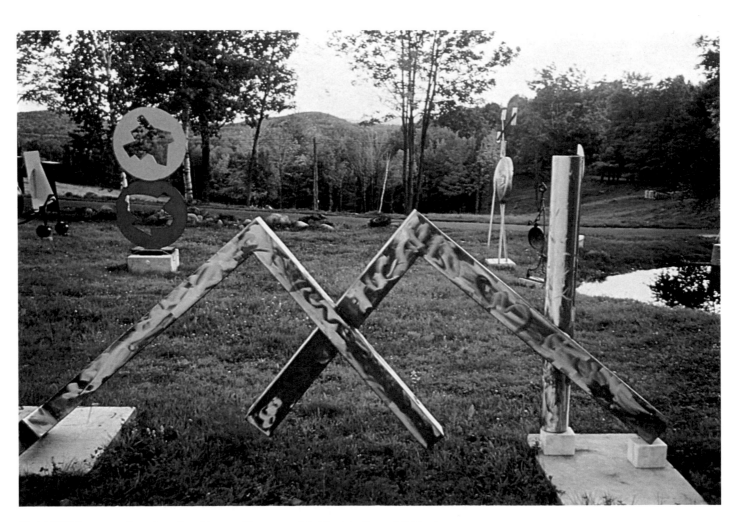

Cubi XXIII 1964 Los Angeles, County Museum of Art (not in the exhibition)

Jörn Merkert

"There are no rules in sculpture"

The Sculpture of David Smith

Opposites and Contradictions

David Smith is one of the fathers of twentieth-century American art and the pioneer of a specifically American kind of sculpture. In the United States he ranks as one of the greatest proponents of the art, yet until quite recently knowledge of him in Europe has, surprisingly, been confined to a small section of the art world.

European collections contain very few works by him and his sculpture has been the subject of only one notable retrospective exhibition, which toured several European cities twenty years ago but met with little response. In spite of this, David Smith has been held in great esteem by his fellow artists and has exerted a strong, if as yet unexamined, influence on the development of European sculpture. That accounts for his being hailed as an "impressive rediscovery" when the present exhibition was shown in Germany.[1]

When viewed from the distance of the twenty years that have passed since his death, and across the many stylistic developments that have taken place during the last half-century, David Smith's sculpture is seen to occupy a very special position. 'Classicism' might be the word that springs to mind, but patient analysis of the many changes of style in his work, rarely following current artistic movements and trends, reveals its close spiritual ties with the time he lived in. Today, when sculpture has emerged into the limelight of the art world,[2] Smith's many-sided work may be appreciated by a younger generation capable of seeing it with the greater clarity made possible by its removal in time. It is worth remembering that, had he lived, David Smith would have celebrated his eightieth birthday on 9 March this year.

Smith became involved in art by chance. Born in 1906, his childhood and adolescence were rooted in the pious, narrow-minded environment of a small provincial town, Decatur in Indiana. But he was also influenced by the adventurous pioneering spirit of the first immigrants; Smith's own great-grandfather had been an immigrant blacksmith. Then there was the struggle for survival in dire financial straits and the near-idyllic surroundings of the countryside. Finally, he was affected by the optimistic, forward-looking and yet destructive power of the indus-

trial era which, with its technology, telephones, trains, cars, ships, aeroplanes and machines, ended cloistered ways of life and created lines of communication that soon stretched across the world, breaking down barriers and opening up vast new vistas. He grew up in a disjointed world, in which the First World War had a powerful effect even on small-town America. If time sometimes seemed to stand still, it did so to the accompaniment of noise from the new factories. A job was a job, whether in a bank or a factory. The uncertainty and insecurity of the time also meant freedom of choice, freedom to seek out and experiment, freedom to embrace life's adventure. Art – in Smith's case drawing and, earlier, writing – may have represented a means of establishing a position in life, a road towards discovering his own identity.

David Smith the sculptor originally wanted to be a painter, and a painter he remained all his life. He was one of the first sculptors to paint the surfaces of his works. Yet his sculpture never became painterly, never lost its essential plasticity. Colour was just one way of transcending traditional notions of three-dimensional art in order to arrive at a completely new conception of sculpture. Conversely, colouring sculptures allowed paint to be used in unprecedented ways. Sometimes painting played no part at all in Smith's solution of sculptural problems. Nevertheless, he continued all his life to make intensive use of paint in conjunction with the media normally associated with it: in pictures on canvas and in those large-scale works on paper which he mostly called "drawings" and in which he experimented with every possible material and technique.

In the early thirties, reproductions in the French magazine *Cahiers d'Art* of sculptures by Picasso and Julio González provided David Smith with one of his formative experiences: for the first time, he saw iron sculptures welded together from individual sections. Before this, he had been impressed, to begin with, by the Cubist paintings of Picasso and by Mondrian's Constructivism, and then by the Surrealism of Giacometti and Miró. Finally, on a lengthy trip in the mid-thirties he encountered the culture of Europe in all its manifestations, from classical Greece to avant-garde Paris. In addition, he absorbed influences from the remote cul-

tures of Egypt and Mesopotamia as well as from the art of the Sumerians and Indians, all of which he saw on his many visits to museums. Above all, it was the panoply of Western cultural history and the art of his European contemporaries that helped Smith to form his own, very personal artistic attitudes and, eventually, to revolutionize conceptions of art in his native America. This in turn influenced artists in Europe.

Smith's basic materials were iron and steel. Experiments with stone, wood and coral, with metals such as bronze, zinc and steel wire, and with the painting of individual sections of a single sculpture, date almost exclusively from his early period, up to about 1950. For Smith, the association of iron with brutality, violence and destruction, with the machinery of war and death, was augmented in the first quarter of this century by a more peaceful aspect: the resilient strength it displayed both in the building of bridges and other constructions and in the unleashing of power from machines. Part of a new

optimism about the future, iron seemed to guarantee the realization of man's most audacious dreams.

As he looked at reproductions of iron sculptures by Picasso and González, David Smith realized that this material, familiar to him from many temporary jobs in industry, could also be transformed into art. He was struck by the possibility that, through the craft of forging (almost an art in itself), industrial techniques could be introduced into sculpture. Welding; setting up one's workshop in a factory; employing machinery and assistants; making use of scrap metal, worn-out tools and cast-offs from the iron foundry – all this could be put at the service of revealing the poetic qualities of a wholly unconventional medium. Later, colour too would acquire a meaning totally different from that which it possessed in his early work.

And then there was the dream of size, of making *big* sculptures, none of them monuments in the traditional sense, but nevertheless, in spirit and technique, a metaphor for the new age. The human dimension was not to be forgotten – neither man's existential fears nor his hopes, neither his confidence about the future nor his often despairing feeling of leading a lonely existence at the mercy of harsh reality. Recalling his own origins, and viewing himself in a historical perspective, man would discover the need to locate himself somewhere within the centuries-long continuum of human history and its artistic expression. This was David Smith's understanding of himself as a craftsman. Yet to produce works which reflected the new age, the artist had to use both the materials and the techniques of that age.

In the course of almost fifteen years spent in New York from 1926 to 1940, David Smith became very much a creature of the big city. This helps to explain some of the fascination technology, industrial craftsmanship and factory production held for him. It was hardly accidental that, in 1934, after a long search, he seized upon the Terminal Iron Works in Brooklyn Harbour as the ideal workshop. Here, his frequent and close contact with the factory workers, who were never stinting with their advice, gave his work a vital connection with the everyday world. Despite the strange appearance of his art, he won the workers' deep respect because their lives, too, revolved around practical, functional dealings with iron and steel and the techniques associated with them.[3] During 1949 and 1950, Smith created the sculpture *Blackburn – Song of an Irish Blacksmith* (fig. 1) in honour of a factory foreman who had helped him a great deal.

Smith's big-city attitudes were also reflected in the fact that he was a night worker, a man who thrived on lengthy discussion in the bars of Brooklyn and downtown Manhattan – discussion with fellow artists, with

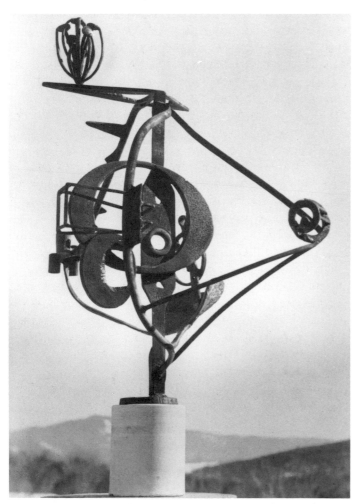

Fig. 1 David Smith, *Blackburn – Song of an Irish Blacksmith.* 1949–50. Duisburg, Wilhelm-Lehmbruck-Museum

night-birds who happened to drop by or with dockhands working the early shift. This belonged to that urban alienation which forces people in on themselves and which was another feature of the spirit of the age. And the feeling of being understood by only a few souls led to an aggressive need to defend oneself and one's position. This heavily-built, reflective man, whose robust physique corresponded exactly to the image of a confident, hard-working sculptor, was nevertheless a deeply sensitive person, easily hurt, but with an endlessly lyrical sensibility and tact. This is quite apparent even in a photograph taken much later. It shows David Smith in his studio at Bolton Landing, pushing the pieces of an as yet unfinished sculpture into the desired positions on the floor with his toe: he does it carefully, tenderly, almost like a dancer (ill., p.14). It is evident, too, in Robert Motherwell's touching recollections, in which he describes the contradictory impressions Smith made on him: loneliness and vigorous lust for life, lone-wolf machismo and the need for warmth, melancholy and an almost explosive strength. Motherwell called this his "Ernest Hemingway side...that was so adumbrated in New York City, and which...was a safety valve."[4]

Financial problems after the years of the Great Depression were the outward cause of David Smith's move, in 1940, from the big city of New York to the isolation of Bolton Landing, a tiny eyrie above Lake George in northern upstate New York. Ten years before, he had bought an abandoned fox farm cheaply, with large areas of hilly woodland around it, and since then had spent the summer months there. Life here was much less expensive and he was able to provide some of his food himself; but the main advantage was independence and distance from the hectic rush of the city. This fulfilled his need for direct contact with nature, for withdrawal and for a chance to work undisturbed, but, despite Bolton Landing's remoteness from anything resembling civilization, it had little to do with any idealistic, romantic 'Back to Nature' philosophy.[5] In contrast to the Great Outdoors he had found, he called this collection of wooden huts Terminal Iron Works in memory of the good working conditions he had enjoyed at the New York factory. Gradually he built studios which allowed him to draw, paint and read away from the dirt and dust of the sculptor's workshop. Nominally a factory owner, he received a discount on scrap metal and tools.

Sculpture

When one considers the toll sculpture takes in terms of expensive material, time and physical strength, the size

of David Smith's oeuvre is remarkable. The catalogue by Rosalind Krauss[6] lists 676 works, including a large number of very heavy and imposing pieces. For years, he had suffered because of his inability to afford all the material he needed, and this did not start to change until 1950, when he received two consecutive annual grants from the Guggenheim Foundation. This allowed him not only to work with vastly increased energy, but also to build up a sizeable stock of materials. It was shortly before this that his main period of creativity began, with more than two-thirds of all his work being produced during the last twenty years or so of his life.

There was a more deep-seated reason for this huge output, which lay in Smith's conception of sculpture and in the methods which can be classified under the general heading of the 'collage principle'. The process of welded – instead of pasted – collage gave him the advantage of speed over traditional techniques of sculpture, though it could still be painstaking, protracted work. It enabled him to pursue an idea at once and, if desired, to explore its various possibilities in a number of different sculptures. This was something especially favoured by Smith. He did not always refine his ideas until he arrived at a final solution, but instead gave them a fresh form. That was perfectly in keeping with the character of his work, which was determined less by the individual *shaping* of details than by the *combining* of various elements. The same piece of metal could be aesthetically unsatisfying in one context and the key formal component in another.

This is one of the contradictions in David Smith's work. He produced his works in series, almost mechanically, in modes of artistic expression that could be both very similar to one another and very different within a particular series. They are united, not by a common style, but by the fact that their large number of diverse elements belong to a single 'family' with common origins. On the other hand, this basic principle of collage is also responsible for the large, bewildering array of groups of sculptures in Smith's oeuvre: he sometimes worked on several groups simultaneously, each of them of a different character, and often took a considerable time to complete a series, interrupting work on it for long periods. The far-reaching influence of collage, of the assembling of different elements, is thus reflected in the development of his oeuvre as a whole, with a number of contrasting sculptural possibilities being explored at one and the same time.

Of course, this sometimes confusing complexity also bears witness to stylistic uncertainty; but perhaps it is this very 'lack of style' in David Smith's work that lends it unity. "I do not work with a conscious and specific con-

viction about a piece of sculpture. It is always open to change and new association. It should be a celebration, one of surprise, not one rehearsed. The sculpture is a statement of my identity. It is part of my work stream, related to my past works, the 3 or 4 in process, and the work yet to come. In a sense it is never finished. Only the essence is stated, the key presented to the beholder for further travel."[7]

Sculpture, art as a versatile means of self-discovery and the forging of one's own identity, no longer conforms to traditional rules, which only hinder it; therefore, it must necessarily 'lack style'. It opens itself up to all life's experiences, moods, events and insights, displaying and reflecting them in constantly changing styles. The absence of a single style thus signifies freedom from convention and tradition.

This was a view held by many American artists of Smith's generation.[8] That it represented a radical challenge to the artists themselves is apparent from Smith's saying that "there are no rules in sculpture."[9] This assertion underlies his entire oeuvre: a constant reminder not to become tired and complacent, but to explore and expand the new territories opened up by each individual work. Is this personal philosophy not also a startling recurrence of the old pioneering spirit of America, the unceasing need to discover an unknown continent that was also one's own identity? "My problem is to be able to work every day and to press my limitations beyond their endurance."[10]

David Smith's method of working remained flexible over long periods of his life. He would often develop in wholly new, unplanned directions that surprised even him, yet he stayed open to deflections from these new paths. A sculpture could not, and must not, be drawn up in advance, for it arose from the materials and techniques employed. This can also be seen in his drawings; it is rare to find detailed designs for any of his sculptures, and designs also exist for works that were never made. Smith placed drawing at the service of a kind of sculpture which appears almost exclusively in his early work; when this was abandoned, the works on paper acquired a very free, spiritual relationship with the sculptures, which will be examined later. Certainly there are no scale models for David Smith's sculptures. Neither waste of materials, nor the need to ensure the approval of a potential buyer would have been sufficient reason for him to construct maquettes – let alone the idea that they might constitute a stock of works to be produced at will. Only once, in his late *Cubi* series (cat. 45–47; colour pl., pp. 17, 25, 28, 32), did Smith use maquettes, assembled hastily from cardboard bottle containers and no longer preserved in their entirety, to try out some of the endless

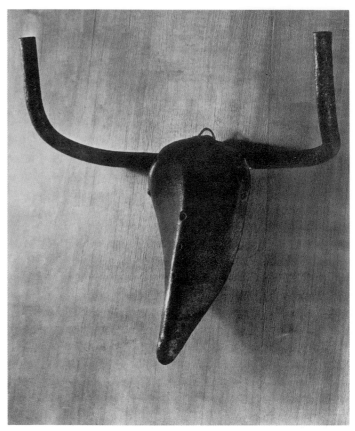

Fig. 2 Pablo Picasso, *Head of a Bull*. 1942. Paris, Musée Picasso

possibilities involved (ill., p. 16). This one exception was possible and necessary because during this stage of his work he was assembling sculptures from prefabricated, standardized solids such as cubes, parallelipipeds and roughly spherical shapes. Even here, it was only for a small part of one group, consisting of a very delicate balance of sculptural elements, that he made any preliminary studies. For only slightly more complex groups this became impossible.

Object and Abstraction

To this very direct use of materials belongs another basic characteristic of David Smith's work. The often strikingly powerful effect of his sculptures is due partly to the authenticity of each of its parts, however much they may have been altered by working and shaping or have been rendered unrecognizable by their new context. The starting point for any sculpture, and the basis for deciding to place a particular part within the context of the whole, was the visual fascination exercised by the part in its own right, be it an unusually shaped piece of scrap metal, an old-fashioned iron tool, the remains of an I-beam or some discarded object. The artist's eye was

stimulated by the qualities of form that make a piece of scrap important to the work as a whole or even give rise to an idea in the first place.

Particularly in the early sculptures, we thus find a reverse process of abstraction at work. On the one hand, the scrap of metal which has no practical use *per se* is recognized as having the same expressive qualities as an object which does; on the other hand, the artist ceases to see the object he has found in its functional, objective reality and sees it instead in aesthetic terms. It becomes an abstract object whose very realness gives it a completely new individuality. In this way, a rusted circular saw blade becomes the basis of a *Saw Head* (cat. 2) and the three turns of a steel spring become a skull (cat. 3). The nameless pieces of detritus become abstract human forms which are easily intelligible as such. Smith did not, therefore, begin with a recognizable object and then abstract and translate it into a language of form with its own rules.

This way of taking objects from reality and combining them unexpectedly to form a self-sufficient work of art is familiar from Surrealism. One of the best-known exam-

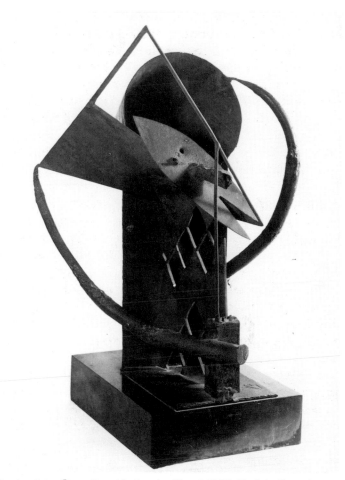

Fig. 4 Julio González, *Harlequin.* About 1930. Zurich, Kunsthaus

ples is Picasso's *Head of a Bull* from 1942, made out of the saddle and handlebars of a bicycle (fig. 2). These everyday *objets trouvés* are wittily combined to create a new, startling image. A similar thing happens in Picasso's *Head of a Woman* (1929–30; fig. 3), where the difference between Picasso and Smith is particularly apparent. Smith's work is much closer to that of Julio González (see fig. 4). In the Spanish sculptor's work, the everyday objects used as parts for a sculpture almost completely lose their individual, functional meaning and instead, whether reworked and or left as they are, go to make up a completely new level of reality where they are virtually unrecognizable. It takes a highly analytical eye to trace them back to their original identity. Here the complete autonomy of the work of art is apparent precisely because of the materials used in it, and the very direct way in which their function has changed. It is also due to the fact that the sculpture is not formed from a single block, but consists of a spatial, and thus not necessarily solid, collection of elements which the viewer perceives in a constant state of change as he moves round it. Surfaces which occupy one's field of vision when

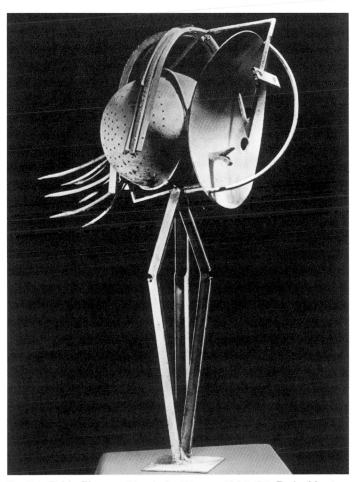

Fig. 3 Pablo Picasso, *Head of a Woman.* 1929–30. Paris, Musée Picasso

viewed from the front become lines which cut through the whole space when viewed from the side, whilst curved convex surfaces enclose spaces like plastic solids. Although the result of this is a high degree of abstraction, the sculptor's use of real objects gives the works an extraordinary degree of 'realism'.

This interplay of concrete and abstract realities underlies all of David Smith's work with varying degrees of intensity. Even though an ever-increasing degree of abstraction becomes apparent over the years, it is also clear that throughout this artistic development, and despite the reduced geometricality of the elements making up his work, he was constantly occupied with the theme of the human form. The work of David Smith becomes 'more abstract' as the decades pass, but in a very different way.

The sculptures of the 1940s often possess an almost hallucinatory magic and have something literary or theatrical about them. *Home of the Welder* (cat. 10; colour pl., p. 21) and *Pillar of Sunday* (cat. 11), both dated 1945, or *Cathedral* (cat. 18) and *Royal Incubator* from 1950 (cat. 19; colour pl., p. 19) tell secret, almost unfathomably personal stories in which nothing actually 'happens'. The individual elements of the work have a symbolic function and it is their diverse erotic allusions that give them their quality of intimate secrecy. They are like the scenery and actors in an unknown play.

Here there is a close parallel with Giacometti's *Palace at 4 a.m.,* of 1932–33 (fig. 5), which likewise resembles not so much a sculpture as a miniature set design for a play. But with David Smith it may be assumed that he actually created a kind of secret code in these works,

with which he gave expression to very intimate and personal experiences without their being capable of clear understanding or interpretation. Attempts to analyse the strange and apparently illogical confrontation of figuratively concrete and abstractly anthropomorphic symbols on a deep psychological level, with all its contradictions, imperfections and ambiguities, hardly succeed in revealing the secrets behind these works.[11] Some pages in a 1945 sketchbook (fig. 6) show his intense preoccupation with particular motifs, such as those in *Home of the Welder,* but these simply point to a few of the sources, such as graffiti, or to the formal connection with the models of Egyptian houses he saw in the Metropolitan Museum. No real clues are given to help solve the puzzle, although Smith's subject matter often makes undisguised reference to his personal situation. It is this firm refusal to disclose anything that gives *Home of the Welder* its great fascination. The viewer is compelled to construct his own private mythology from the assemblage of objects before him.

The artist's intentions, rooted in Surrealism, are thus revealed here in an abstract, but still identifiably concrete way, not in a puzzle produced by taking an object out of its everyday context and placing it in a new and unfamiliar one. Representational forms are transferred in a descriptive manner to a reality which exists only within the work of art itself. This unreal, and apparently arbitrary, combination of images is another result of the collage principle. In addition, the works cited here show how often, and with what means, David Smith used art to discover the most personal, private and even unconscious aspects of his inner world. In the 1950s, he gradually began to abandon this psychological and literary aspect of his work in favour of human forms which resemble idols or totems in their reduction to the most basic elements. This represents another process of abstraction, relating to the thematic content of the sculptures and leading in a completely different direction.

As already demonstrated, one work by David Smith may contain many disparate formal, thematic and spiritual elements which can also occur separately in different sculptures of the same time. It is not, therefore, surprising if sculptures with a strong narrative content appear side by side with highly abstract ones. *Helmholtzian Landscape* and *Landscape with Strata,* both completed in 1946, and *The Garden* from 1949 (cat. 13, 14, 17; colour pl., p. 20) show, partly in colour, a group of plant-like and geometric elements enclosed in a kind of miniature stage. They hang freely in space and unfold their plasticity within the central area. Bearing in mind the references to the natural world in the titles of these pieces, one perceives a reversal of objective reality: earth

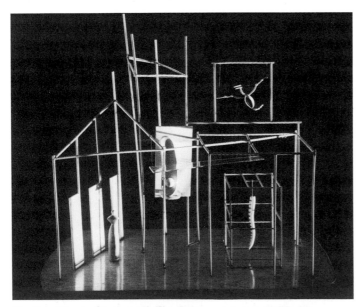

Fig. 5 Alberto Giacometti, *The Palace at 4. a. m.* 1932–33. New York, The Museum of Modern Art

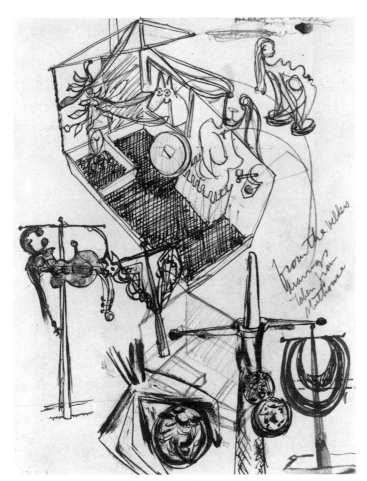

Fig. 6 David Smith, Sketches for *Home of the Welder*. 1945.
Cambridge (Mass.), Fogg Art Museum

and sky are portrayed by animated 'silhouettes' of open
space, whilst the actual events take place on and above
an imaginary horizon. The 'frame' of each work recalls
pictures, an association strengthened by the almost
planar arrangement of the elements in depth. The col-
ours – broken yet clear, and often flowing into one an-
other – grant painting an equal share in the expressive
force of these sculptures. In *Helmholtzian Landscape*
(cat. 13), whose title refers to the German physicist who
worked on the theory of three-colour vision,[12] colour is
employed to emphasize the spatial relationships of the
individual, flatly arranged sculptural elements. The highly
abstract organization of this structure, increased by the
use of colour, suggests subjects such as constellations,
cloud formations, trees and bushes. Thus, at this rela-
tively early stage in David Smith's career one already
encounters the second central theme of his work: land-
scape and nature in general. Both this theme and that of
the human form stand in marked opposition to the in-
organic materials and the mechanical means of produc-
ing them.

The Series, I: Agricolas – Tanktotems – Sentinels

Although it was not until 1951 that Smith began giving
names to his groups of sculptures, his earlier work can
also be classified in broad formal or thematic categories:
Heads, surreally theatrical *Rooms* and painted *Land-
scapes.* Like subsequent series, they were produced in
an interwoven sequence. Smith later placed great impor-
tance on seeing his work in terms of groups of sculp-
tures. Most of these are on plinths together with his
signature, the title and number of the series, and are
often dated by day, month and year. Smith betrayed a
relatively lax attitude to dating his works and grouping
them within a series, for individual works were frequently
made in a different order to that suggested by the
numbering system.[13] It is worth recalling the way Smith
went about his work; he often worked on several sculp-
tures simultaneously, was in the habit of breaking off
work for long periods at a time while he worked on other
pieces, and had such a clear conception of some sculp-
tures that he could continually postpone the actual
process of building them. This would suggest that many
of his sculptures were never carried out because he
found it more important to turn his attention to the more
problematic ones, of which he had a less clear idea in
his mind.

"When it [the sculpture] is finished there is always
that time when I am not sure – it is not that I am not sure
of my work, but I have to keep it around for months to
become acquainted with it and sometimes it is as if I've
never seen it before and as I work on other pieces and
look at it all the kinship returns, the battle of arriving, its
relationship to the preceding work and its relationship to
the new piece I am working on. Now comes the time
when I feel very sure of it, that it is as it must be and I
am ready to show it to others and be proud I made it."[14]
"There's no one way, and if I found myself resorting to a
repeated approach, I'd change it... That's just the way I
live. The trouble is, every time I make one sculpture, it
breeds ten more, and the time is too short to make them
all. And don't forget, there's a lot of damn labor in
making a sculpture."[15]

The various series are too numerous and too complex
to be described in detail here or shown in even the most
comprehensive exhibition. Furthermore, there are also
large numbers and a great variety of pieces which do not
form part of any series.[16] Only a few of the series, also
represented in the present volume, will be examined
here, in order to demonstrate the significance of such
groupings for Smith.

'Agricola' is the Latin word for farmer. As the title
implies, the sculptures making up the series of this

name (cat. 24, 25) are mostly welded together from pieces of agricultural machinery, like ploughshares and springs, but also include tools such as screwdrivers, hoes and pliers of all kinds. The series is made up of seventeen works, mostly from 1951–52; later on, Smith incorporated the *Heads* from the early 1930s into this group, because they also contain farm implements. *Agricola XXII* did not appear until 1959, when Smith had been working on other series for a long period.[17]

The group consists mainly of medium-sized sculptures, with occasional life-size ones. All of them include a human form, sometimes very abstract or obscure, and all of them possess an almost magical fascination arising from the strangeness that concrete, everyday objects acquire when juxtaposed. The title of the series is reflected not only in the craftsman's aesthetic which the sculptures embody and which grants the welding process an expressive function, but also in the majestic image of a human existence in which, despite a frequent playfulness of mood, agriculture is raised to the status of an ancient, fundamental condition of life. The sculptures reach out into space, mostly in lines, and have little or no

Fig. 7 David Smith, *Agricola I.* 1951–52. Washington, Hirshhorn Museum and Sculpture Garden

corporeal substance. Empty space plays an important part in these ethereal works, which, with their bars proceeding in different directions and overlapping one another, are like drawings moving in space.

This idea of sculpture as a many-faceted image penetrated by space is found in an early work, *Construction,* of 1932 (cat. 1), and later, immediately prior to the *Agricola* series, it led to the first impressive peak in Smith's oeuvre in pieces such as *Royal Bird* (1948), *Star Cage* (1950), and *Australia* and *Hudson River Landscape,* both from 1951 (cat. 16, 20, 21, 23). In these works, he achieved a synthesis of the surreal approach to 'figurative' themes and his 'abstract' coloured landscapes. These two aspects were brought together with the aid of free construction in space inspired by Cubism. From the very beginning, the element of drawing played an important part in the genesis of these sculptures, whether in the form of sketches of the prehistoric birds he had seen in the Natural History Museum, or of the many fleeting impressions of landscape which he recorded in a manner reminiscent of Surrealism's *écriture automatique* and which were finally absorbed into *Hudson River Landscape* (cat. 23). This sculpture "came in part from drawings made on a train between Albany and Poughkeepsie. A synthesis of drawings from ten trips over a seventy-five mile stretch ... [Everything] flashed past too fast to tabulate but elements ... are in the sculpture. Is *Hudson River Landscape* the Hudson River or is it the travel, the vision; or does it matter? The sculpture exists on its own, it is an entity."[18] Whilst Smith had forged the forms he wanted in these works, the *Agricola* series was dominated by the surreal idea of the object as fetish, expressed by combinations of just a few *objets trouvés* which appeared in the sculptures almost as he found them.

E. A. Carmean, in his extensive analysis of David Smith's oeuvre, examined another of its major features, the recourse to works from an earlier history of art. Although there is no documentary evidence that it was deliberate, there are striking similarities between *Agricola I* and Adriaen de Vries's *Mercury* in the National Gallery in Washington, which Smith would certainly have seen (figs. 7, 8).[19] It is more than likely that Smith is here attempting to show his own sculpture as an integral part of the historical continuum of art. The animated pose, certain movements in space and even such formal details as the winged feet and the herald's staff entwined with vines recur within the abstract organization of Smith's sculpture.

This use of earlier masterpieces as an inspiration for contemporary art is a frequent and legitimate practice, and no different in kind from the influence Picasso, Gon-

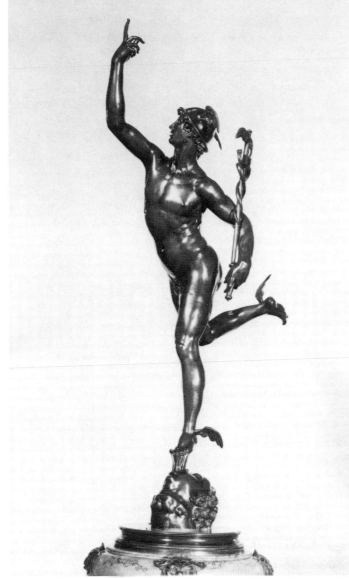

Fig. 8 Attributed to Adriaen de Vries, *Mercury.* 1603–13. Washington, National Gallery of Art

zález and Giacometti exerted on Smith's work. *Home of the Welder* has been related to the art of ancient Egypt, while Smith himself explained how the huge carved stone wheels of the chariots in Indian temples inspired him in his *Wagon* sculptures (cat. 41; colour pl., pp. 22, 27).[20]

Over and above his view of himself as a sculptor in iron, Smith always saw himself within the context of the history of artistic endeavour, and often looked for parallels with the art of classical antiquity. This can be seen even in minor details like the Latin title of the *Agricola* series, in his signature, which he usually wrote in Greek, in the many visits to museums and in his constant reading of books on art. Furthermore, as a teacher, Smith continually insisted, albeit in an unconventional

way, on a view of art which went beyond the aspect of craftsmanship.

Comparison of *Agricola I* with Adriaen de Vries's *Mercury* provides a most convincing demonstration of how, whatever the degree of abstraction Smith's work attains, it can still be seen in essence as 'concrete' or 'figurative'. As we have seen, and as Smith himself said, the only rules he adhered to were those independent, abstract rules which he himself discovered in his sculpture. This is not the imaginative re-working of the human figure into a deliberately expressive but abstract image. Instead, it was the requirements of the materials and techniques he used, and the totally new sculptural opportunities which they offered him – and which he first had to explore – that ultimately led to these abstract, autonomous constructions in space. They preserve the human image in a strangely unfamiliar form, without actually representing it.

This is particularly evident in the subsequent series of *Tanktotems,* 1952–60, and *Sentinels,* begun in 1956 (cat. 27, 29, 31, 33). "A totem is a 'yes'. And a taboo is a 'no'. A totem is a yes-statement of a commonly recurring denominator."[21] No irony was intended when Smith repeated this idea again and again, or when he introduced the formal element of reworked walls of water-tanks into the title of the *Tanktotem* series. In the first place, this is merely a reminder that each piece forms part of a larger group. In addition, Smith probably intended it as a profanation of the totem as a divine image.

Even though Smith refused to see this particular group of sculptures as "ritual objects for a new religion" or as treating "basic social relationships... between the work of art and the spectator"[22], they nevertheless contain a "constantly recurring denominator" in the shape of mankind, including both 'primitive' peoples and the original inhabitants of the United States. This perhaps somewhat romantic aspect should not lead one to forget that these images of humans were made using a highly technical production process appropriate to the age in which they originated. Craftsmanship, whose key position in Greek mythology was undoubtedly an important factor in Smith's view of himself as an artist, had an equal share in them. Large-scale thinking, the surprising combination of spiritual and historical themes from the most diverse sources, is always at work in Smith's sculpture. *Tanktotem III* (cat. 27), for example, evokes images of primitive creatures, half bird, half insect, making halting progress across the earth. The same applies to *Royal Bird* (cat. 16), which is indeed a direct, if somewhat free rendition of prehistoric birds from the Natural History Museum.

In the *Sentinel* series (cat. 29, 33), Smith reduces the corporeality of his figures in even more radical fashion,

making use of some features of the *Agricola* series, in which the sculptures had become a network of lines and spaces and were full of animated movement in space. In the *Sentinels* this expansive movement is replaced by a more static relationship of lines and surfaces to each other. Rather than swinging upwards, curves are used to support other forms, while flat surfaces occupy stable positions, instead of creating an impression of fluttering movement. Everything is focused on the tall, immaterial centre of the sculptures, whilst the pieces of metal, deliberately simple and geometric, carry no references to their earlier function. Right down to the smallest detail, these works reveal a strictness of conception which excludes all playful elements. This preserves the cool materiality of the machine parts used in some of the sculptures, lending them a very tranquil, almost majestically poetical quality. The title *Sentinel* is appropriate to the watchful tension of these sculptures, even if they contain no hint as to what is being watched over. As can be seen in some of the photographs of the fields around Bolton Landing, Smith positioned the works in accordance with their character: in high-up places, where they could keep guard over the surrounding country.

These sculptures, too, have a parallel in a history of art still earlier: the caryatids and *kouroi* of early classical Greece. In total contrast to the almost completely bodiless *Sentinels,* the marble caryatids are rooted in their central axes with a compact, monolithic severity. Characterized, as are Smith's sculptures, by a still inwardness, and articulated by gentle, flowing lines, they acquire a hint of movement from their slight contrapposto and an aura of restrained gaiety from their faint smiles.

This parallel is even more interesting with regard to *Lectern Sentinel* (1961; cat. 33), which is made from specially cut stainless-steel plates, set in vertical positions and placed on top of one another. Their varying sizes, their overlappings and their positioning at different angles create a gently vibrant rhythm which leads the eye upwards. A few steel plates placed at angles to each other thus give rise to an almost monumental figure which, although it remains strictly frontal, quite clearly incorporates the classical motif of contrapposto, with a resting and a supporting 'leg'. This is continued in the slanted 'hips' of the figure, while the staggered arrangement of smaller plates above this point gives expression to the curving of the 'spine' caused by the position of the legs and to the twist of the 'body'. Finally, the contrapposto motif reaches its traditional conclusion in a tilted 'head', here indicated by the ring balancing on the end of a long angle-iron.

These two examples alone show clearly that in some respects it is difficult to see these sculptures as a series.

They do not share a similarity of approach to plastic expression, nor do they speak a common language of form; they are not even made from the same material. More than any other series in the work of David Smith, they are full of disparities: they range from works where space is an important part of the whole to ones made up of flat iron plates and, while some of them are constructed from shapes carefully cut out by the artist, others are made from machine parts placed in an abstract context. The great artistic inventiveness of this group can also be recognized in their brief exploration of sculptural possibilities which were not to be fully exploited until later series. For example, *Lectern Sentinel,* with its simple geometricality of squares and rectangles, and its polished, reflective surface, contains the germ of an idea which was followed up in all its ramifications in the *Cubi* series (cat. 44–47; colour pl., pp. 17, 25, 28, 32). Likewise, Smith placed some of the sculptures in the *Sentinel* series on wheels in order to make them easier to move around. Later, in the chariot-like vehicles of the *Voltri* group (cat. 37; colour pl., p. 26) and, finally, in the *Wagon* series (cat. 41; colour pl., pp. 22, 27) this motif was to acquire an almost monumental character.

Apart from their Sentinel theme, there are three features shared by all the sculptures in this series, despite the variety of materials and sculptural solutions they employ. The first is a rigorous severity of expression, which masks a quiet, inner animation; the second is their often larger than life size, which emphasizes their inherent monumentality; and the third is that they are no longer mounted on bases – a development which, forming a counterpoint to their grandeur of expression, had been heralded in *Agricola I* and carried out in more detail in the *Tanktotems*. Abstract, and yet firmly rooted in the forms of classical antiquity, the simplified figures making up the *Sentinel* series have a human dimension in spite of their imposing size: sculpture and viewer are placed on the same level.

Tiptoeing around

The increase in the size of David Smith's sculpture was due in part to his improved financial situation after receiving a grant from the Guggenheim Foundation in 1950. His first one-man show at the Museum of Modern Art in New York in 1957 made his art known to a wider public. Smith was now 51. For years he had been harbouring a wish to work on a larger scale, and this wish was now fulfilled. How important this monumental scale was to him can be inferred from the fact that, from the earliest days up until the fifties, he often photographed

his sculpture from a very low viewpoint against the background of the landscape of Bolton Landing or Lake George, in order to suggest that they were far bigger than was actually the case. The monumental nature of many of his sculptures, at first revealed only by photographic means, at last achieved concrete realization during the years of the *Tanktotems* and *Sentinels.* This need on the part of the sculptor should also be seen as an attempt to assert his artistic personality over the wide open spaces of the American landscape – a need also felt by the painters of his generation, who considered this to be an important condition of the genuinely American art they were striving to create.[23] As his sculptures grew in size, major changes took place in the way he produced them; an old artistic principle assumed an increasing importance in his work and led to a break with the traditional rules of sculpture. Since, in Smith's words, "there are no rules in sculpture", a work need not necessarily reach out into space in a way which changed continually as the viewer moved round it, but could also consist of a series of flat surfaces offering separate views.

This unusual limitation of sculpture's three-dimensionality to clearly-defined front, rear and side, views was due in the first place to Smith's use of larger, much heavier parts. Before this, each part could be moved around relatively easily, tried out in the upright position and finally placed wherever Smith felt was most suitable. To preserve this spontaneity and freedom Smith tried out his ideas by placing the individual pieces of a potential sculpture on the ground and moving them about in a long process of experimentation. The heavy materials proved surprisingly easy to manoeuvre in this way. Smith could survey all he saw in regal fashion and, with his hands in his pockets, push the pieces around with his foot. He called this process "toeing in"[24] (fig., p. 14). Its light-footed technique stands in strong contrast to the normal physical demands of sculptures in metal or other heavy materials. One is tempted to call this a process of de-materialization. This is also apparent in the fact that the artistic medium of drawing was freed from its close relationship with the process of creating a sculpture, since designing – 'drawing' – was carried out directly with the materials being used in the sculpture. Yet there was a connection of another kind with drawing, because Smith often placed the parts on sheets of metal, a 'background' he painted white so as to be able to see the shapes evolving (fig. 9). Smith made use of the new opportunities this technique afforded in various ways. Sometimes he would draw a shape he needed, but which was not immediately available, directly on the white plate, next to the existing parts. Alternatively, he

Fig. 9 David Smith's garage at Bolton Landing with sculptures in progress. 1959

could record the outlines of a particular grouping, number the pieces and pack them away in order, particularly if he was not satisfied with the original design but did not wish to pursue it for the time being. At a later date, he could then continue the work exactly where he had left off, without having a large, half-finished sculpture taking up space in his workshop. In this way, he could work on several sculptures at the same time.

It is not just the act of drawing to which the development of the sculpture on a two-dimensional surface, and the resultant planar structure, bear close similarities. The continual arrangement and re-arrangement of the individual parts is a process exactly similar to that of collage, a method central to all aspects of David Smith's thought and work. How crucial it was on every level becomes clear from the contradictions and opposites in the life and attitudes of this man. Both peasant and city-dweller, a craftsman and factory worker full of the consciousness of his relationship with tradition and history, this philosophizing, self-educating creature of nature was himself a collage. The principle of collage thus governed his innermost being and this provides a further indication that, for Smith, art was a means of finding his own identity in a nexus of opposing ideas, experiences, attitudes and opinions.

Since life is a stream of overlapping events acting upon one another, we can intervene decisively in the ceaseless movement only if we change ourselves and take on its endless variety. We can see David Smith doing this in the bewildering number of opposing ideas, often pursued simultaneously in different works, which constituted his answer to the confusion of life. Not an easy answer, it is characterized by non-conformity and

by severity towards oneself and others. This may be seen to contradict the openness and flexibility we have just noted as essential attitudes in Smith's life. His inherent loneliness must often have been accompanied by despair.

We now recognize more clearly what Robert Motherwell meant by the "Ernest Hemingway side" of David Smith. There are quite similar attitudes to be found among the New York painters of his generation; not only in Motherwell himself, but also in Willem de Kooning and Jackson Pollock, both of whom were friends of Smith. The work of all of them was inspired by the two great European sources of modern art: Cubism and Surrealism.

Cubism laid claim to a different, unfamiliar reality embodied in an autonomous work of art which originated according to its own rules, collage enabling extracts from everyday reality to be integrated directly into the work. Surrealism went beyond the magical, unsettling combination of displaced objects to discover the creative force of the unconscious, which did not conform to any formal artistic rules. One of its methods – known as *écriture automatique* – consisted of recording psychological states in abstract fantasies produced by spontaneous, unplanned and uncontrolled drawing. 'Automatic' creation recurs in the highly unconventional working methods developed by David Smith to expand the scope of sculptural possibilities.

The Series, II: Zigs – Voltris – Cubis

For the *Zig* sculptures, Smith once again chose an unusual word, and one never abbreviated, as the title of the series. It, too, refers to ancient history ('Zig' is short for 'Ziggurat', the stepped pyramid-shaped tower found in Babylonian temple complexes) and describes the structure of the sculptures in this group (cat. 34, 35; colour pl., p. 29). "Zig – just an affectionate term for Ziggurat – Ziggurat is too big a word and – I don't know – it seems more intimate, and it doesn't have to be as high as the towers of Babylon; but it is a vertical structure of more than one level."[25] This layered structure is the lowest common denominator between Smith's *Zigs* and their very different 'models': the impartial observer would hardly be likely to see them as pieces of architecture inspired by the buildings of Babylonia. Yet the sculptures, in their combinations of large, curved sections, are quite emphatically *built*. They consist of segments of pipe of various lengths, cut through vertically, whose curving surfaces embrace the surrounding space. The interlocking parts go to produce tall, rhythmical structures which, despite their diagrammatic, abstract nature, take on the character of monuments, of heroic human images.

In this series, David Smith employed colour as a means of plastic emphasis more frequently and consistently than anywhere else. Sometimes he would paint the whole structure in one colour (cat. 42), unifying the various parts of the construction and reducing the hardness and massiveness of the iron. At other times, he would break up the uniformity created by this even surface through a gestural application of the final coat, allowing the priming to show through in places. *Zig II,* from 1961 (cat. 35; colour pl., p. 29), represents a third possibility which Smith made use of in a number of sculptures in this and subsequent series. If markedly gestural painting of identical or similar parts may, on the one hand, emphasize both their unity and their contrasting structures when different or complementary colours are used, then, on the other, it may also endow an element curving in space with the wholly different spacial illusionism inherent in colour. Just as colours placed side by side in a painting are experienced optically as in front of or behind each other, so colour in David Smith's sculpture – and this is another part of Cubism's heritage – gives rise to tensions and oppositions.

A shape may achieve plasticity in a non-material fashion, while from another viewpoint a curve enclosing an empty space may appear as a flat surface intersecting space. And likewise, the three-dimensional interrelation of the parts can be articulated by giving them different colours, which make their interaction even more evident.

Initially, David Smith had doubts as to whether, or how, a sculpture should be painted. Just as the formal composition of a sculpture could be changed during work on it, so repeated paintings allowed its colour to be altered in a very simple, spontaneous way. "I have to paint them wrong and look at them and sometimes change all the various old formalities, or even change the colors – it takes a little time, and it is funny where you draw the line. Sometimes you have to change the whole thing and sometimes it is kind of raw."[26]

By introducing colour into the foreign medium of sculpture, and by allowing it to interact with the latter's purely abstract construction of three-dimensional forms, Smith permitted it to become the very means of dissolving the boundaries between the two media, with their apparently conflicting rules. Transcending traditional barriers opened up a whole new world of possibilities for both media. This can have an unsettling effect on the viewer, as he is confronted with something which is neither pure painting nor pure sculpture. The definition of space through three-dimensional shapes is extended

by applying colour to their surfaces; at the same time, the purely optical spatial qualities of colour can now also be experienced as physical reality. The sculptural techniques evolved in order to cope with the weight and size of the individual pieces had led to 'flat' works which, in contradiction to traditional notions of sculpture as constructions in space to be viewed from any angle, offered a series of separate views. In an extraordinary way, colour was now being used to increase both the spatial dimension of the sculptures and the planar character of decidedly three-dimensional works. Often, both aspects appear in one and the same sculpture.

1962 was the year in which David Smith, to his own surprise, realized a number of wholly new sculptural ideas in a burst of most intense activity. He took stock of all his previous work and developed earlier approaches in unexpected directions, entering new realms of artistic endeavour in the process. In the summer of that year, he was invited to spend a month in Spoleto and take part in an exhibition entitled 'Sculpture in the City', to which numerous sculptors had been asked to work on-site for the Festival of Two Worlds.[27] At this point, Smith had already started work on the polished refined-steel *Cubi,* and went to Spoleto intending to produce one or two of these sculptures there. He declined an invitation to work in the new Italsider steel factory near Genoa, on the grounds that its production methods were too highly automated.[28] But he was enthusiastic when offered the chance to work in five old abandoned factory buildings in Voltri, using the machinery, tools and scrap that had

been left behind. "The beauties of the forge shop, parts dropped partly forged, cooled now but stopped in progress – as if the human factor had dissolved and the great dust settled – the found tombs of early twentieth century."[29] In thirty days, and with help from the factory workers, he produced the incredible number of twenty-six sculptures, some of them huge in scale. Six of these were displayed around the town, and the remaining twenty were shown in a spectacular exhibition specially arranged in the ancient amphitheatre of Spoleto.

Harking back somewhat to the *Agricola* series, the *Voltris* and the subsequent *Voltri-Boltons* (cat. 35–39; colour pl., pp. 24, 26) did not simply show the iron they were made from in all its massive simplicity. Forging, welding, cutting, rolling and other processes were left deliberately visible, and surfaces remained for the most part untreated in order to reveal the full beauty of the metal and its many-hued, natural rust patina. Tools, machine components and 'found' objects, such as heavy iron wheels and scraps from sheets of steel that had been rolled and cut, form an integral part of the sculptures. Together with these unchanged items, Smith also made use of others specially prepared by himself. This group therefore combines highly simplified, 'flat' works, rising up like strange signs, with innovations which were to remain without sequel in his oeuvre.

Although Smith had employed the wheel motif on many occasions, originally in the form of a ring, circle or disc (cat. 29), and later (particularly in the *Zigs*) to create sculptures he could move around easily (cat. 32), it now

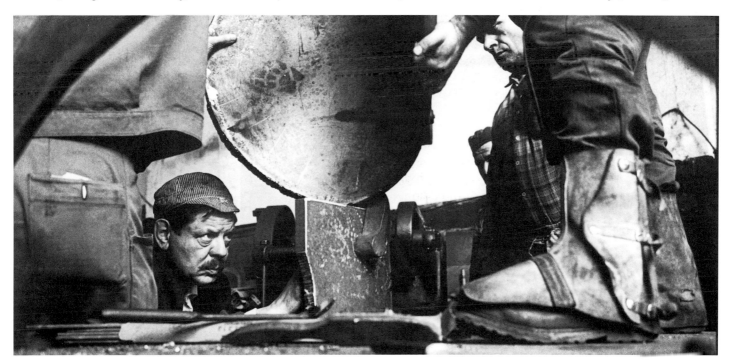

Fig. 10 David Smith at work in Voltri in 1962

acquired a whole new dimension – in *Voltri VII,* for example (cat. 37; colour pl., p. 26). This is not the only sculpture in the series to use the wheel as the main, dominant theme and create a vehicle which is not a wagon as such. With their two wheels and long shafts, they look more like ancient chariots or carriages, having been reduced to basic, skeletal structures which 'leave out' the passenger compartment. In unparalleled formal condensation the wheels, the curved axle, and the long shaft protruding forwards and propped up at the front, combine to create an antiquated contraption that exists in a state of fragile equilibrium. Along the axis a number of surfaces, rising in alternate directions, stand next to one another in a series of gentle, opposing curves. From a distance they remind one of veiled human figures, though David Smith denied this: "They are not personages – they are forgings."[30] However, they are connected with a group of sculptures dating from 1955 and entitled *Forgings.* The extent to which these simple metal rods, squashed, stretched and slightly bent with the forge hammer, resemble human figures despite their minimal figuration and almost total abstraction may be seen from drawings done in 1953 as preliminary sketches for the *Forgings* (cat. 81–83).

The *Voltris,* named after the place where they were made, show a particularly large number of parallels with ancient art, one of which – the two-wheeled 'chariot' – has already been noted. During his stay in Italy, Smith delved again into the history of the Old World, nearly thirty years after his first and only European visit of any length in 1935–36. In addition to the inspiration afforded by the works of art, spanning many centuries, which he found everywhere in and around Spoleto, he enjoyed unlimited opportunities for work under unique conditions. Carmean has shown how aspects of Greek and Roman sculpture and vase-painting form part of these sculptures[31], and how Smith managed to incorporate this rich tradition into his work in an unpretentious, discreet manner, free of all historicism. When looking at these works, such parallels are of secondary significance, and direct comparisons with possible 'models' may produce too narrow a view of Smith's achievement. Even without them, one can appreciate that the radical simplification of formal vocabulary, the subtle, restrained rhythm in the relation of the parts to one another and the unexpectedly ancient feel of the material are permeated with the spirit of classical antiquity and its ideals of beauty.

After these busy few weeks, Smith had to ship the numbered pieces of unfinished works, together with large quantities of material, scrap, tools and bits of machinery, back to America. In his next series, the *Voltri-Boltons* (cat. 38, 39), he continued the experiences and discoveries he made in Italy in nineteen further works, created at Bolton Landing out of the material he had brought back from Italy. The more modest equipment of his Terminal Iron Works led to quite different solutions. In this series, he returned to a human figure which often acquired a distinctly surreal character through the ambiguous, malleable nature of its component parts, just as had been the case in the *Agricola* series.

The *Wagons,* all made in 1964 (cat. 41; colour pl., pp. 22, 27), show how he was preoccupied with ancient myths and the world views of other cultures over and above his particular experiences in Voltri. In his interview with Thomas Hess, Smith says: "As far as I know, I got the wheel idea from Hindu temples…They cut them out of stone on the temples to represent the processions where they carry copies of temples down the streets on wagons. Carved stone wheels. It's a fascinating idea. I went to the Museum of Science and Industry where they have square wheels."[32]

In single works (cat. 32), as well as in the *Sentinels* and especially the *Zigs,* David Smith had put his sculptures on wheels and thereby made the base part of the sculpture itself. The wagons in the *Voltri* group form part of a structure with two large wheels and, while in no way illustrative, resemble horseless chariots or carriages. But these vehicles do not 'work': the image of an object combines in a unique way with the wholly different function and form of a work of art. This enables the 'driver' or 'passenger', apparently from another world, to be incorporated in the sculpture as an abstract formal abbreviation. The wagons have inner movement, yet cannot move: they stand finely balanced on their shafts.

In the *Wagons* of 1964, the sculptures themselves no longer have wheels, but the car with its four wheels is the main theme. A lengthy, bowed longitudinal axis hangs downwards from two lateral axles bent into a vertical position. On top of this sits a huge figure, which appears to weigh the car down and bring it to a standstill. In *Wagon I* (colour pl., p. 22) this figure is a massive, robot-like creature with a flattened sphere for its body and a wide, girder-like head on top, while in *Wagon II* (cat. 41; colour pl., p. 27) it consists of a curved abstract form which, like those in *Voltri VII* (cat. 37; colourpl., p. 26), is reminiscent of a mourning human figure lost in grief. In the latter, small, flat pieces of metal were arranged in a row, so that from a distance they might be taken as representing a train of mourners, whereas the quite similar shape in *Wagon II* has acquired such massive, commanding proportions as to make the whole seem like a solemn hearse from a bygone age of iron.

The mythical, archaic dimension of these sculptures cannot conceal the fact that they embody a very modern,

artistically unconventional and quite personal dream of their sculptor, one rooted in the near-ideal working conditions he found at Voltri. This was the dream of building a huge, mobile sculpture with a flat goods wagon as its base: many sculptures and many wagons, a whole train of them – an 'art train' which could have travelled across the country, just as in the Hindu reliefs he saw replicas of temples were carried on the backs of wagons in processions. "I could have made a car with the nude bodies of machines, undressed of their details and teeth – I could have made a flatcar with a hundred anvils of varying sizes and character which I found at forge stations. I could have made a flatcar with painted skeletal wooden patterns. In a year I could have made a train."[33] So the photograph by Ugo Mulas, showing David Smith on a goods wagon among his sculptures from Voltri, represents a happy foreshadowing of this dream (frontispiece ill., p. 2). Just before his death, Smith bought a number of tractors and combine harvesters to "make them into sculptures – I am going to make the sculptures on top of them, so that I can drive the tractors."[34]

One is tempted to see the *Cubis* as a culmination of David Smith's work, in which his concept of sculpture takes another wholly unexpected turn as a result of radically simplified means (cat. 44–47; colour pl., pp. 17, 25, 28, 32). For Smith, this group, which he had been tentatively trying out in single works made of polished steel since 1956, became the centre of his activity in 1963.[35] The group comprised twenty-eight sculptures in all, exploring, but by no means exhausting, the artistic possibilities they opened up. Smith's dream of mobile sculptural 'environments' shows that other ideas were occupying him alongside the *Voltri-Boltons, Wagons* and *Cubis.* Nonetheless, after his both dramatic and thoroughly prosaic fatal accident on 23 May 1965, the *Cubis* became his artistic last will and testament, the monumental conclusion of a richly varied oeuvre.

Unusually, the various works in the *Cubi* series can be divided into sub-groups, such as the balanced type, in which the individual shapes are arranged like a still life on a crossbeam (cat. 45; colour pl., p. 28). They might also be seen as the abstract representation, in a concentrated three-dimensional form, of a tree with a prominent crown of leaves. Then there are the *Gates* (cat. 46; colour pl., p. 17) which, despite their title, offer not open structures one can walk through, but powerful, wide frames. Erected in the hilly fields around Bolton Landing, they enclose views of the countryside. And finally, the group includes free arrangements in space which, although free of any illustrative character, bear a resemblance to the human figure (cat. 47; colour pl., p. 32). In the *Cubis*, David Smith takes a fresh look at themes which run through his entire oeuvre. The motif of framed views was encountered both in the abstract *Landscapes* (cat. 13, 14, 17; colour pl., p. 20) and in *The Head as Still Life* from 1940 (cat. 9). Similarities also exist between *Cubi XXVI* (cat. 47) and *Structure of Arches* of 1939 (cat. 8).

Present as in all Smith's works, the collage principle is particularly striking here when one bears in mind that he had previously assembled some of the sculptures from this series by sticking together cardboard bottle containers. The difference from earlier works lies in the fact that the *Cubis* were no longer constructed from pieces of partly-worked scrap metal, but from large quantities of standardized, mass-produced parts made specially for Smith. As a result, they are in themselves anonymous, lifeless, inexpressive objects. At first sight, the *Cubis* appear almost uninteresting, because they radiate none of the power that comes from unusual formal invention, but Smith uses the simplest methods to create a quietly expressive balance of parts which is full of internal movement. The few points of contact between the elements, their support in precarious positions, their boldly outstretched arms and axial movement all contribute to a rich canon of poetic content.

Another major trait of the *Cubis* is their totem-like character, which connects them with the series of that name from the 1950s. In addition, one of the early influences on David Smith's work, Cubism, takes on a wholly new and unexpected aspect through the use of constructivist means raised almost to the level of an absolute. In this, Smith broke the bounds of his stylistic and generational ties with the Abstract Expressionism of, say, Pollock and pointed to an artistic movement apparently diametrically opposed to it: Minimal Art.

In every way, the *Cubis* are strict examples of a newly formulated conception of sculpture. And yet here, as elsewhere, David Smith the painter incorporated colour and the gestures of painting into his work. The steel surfaces were ground in circular movements in order to reduce their shine. Light was thus reflected in all directions, the various tones of the silvery surface capturing every change in natural light. The hermetically severe forms were broken up in a subtle, almost impressionistic fashion, so that their ethereal appearance in the light provided a natural counterpart to the delicate equilibrium of their solid bodies.

Bolton Landing

In 1929, David Smith had bought the secluded old farm amidst the woods high in the mountains above Lake

George as an inexpensive summer retreat. His decision to leave New York in 1940 and move to the tranquility of Bolton Landing was dictated in the first place by financial considerations, but was also connected with the wish to realize his dream of ideal working conditions. If this could not be fulfilled in New York, then the inspiring and technically unlimited possibilities of the Terminal Iron Works in Brooklyn Harbour had at least shown him some important prerequisites.

David Smith, for whom life, art and work were one and the same thing, needed to work undisturbed, even if that meant loneliness. Not many people can bear a life in which they see no-one for days on end, in which conversation – let alone on art – is often impossible. Two marriages did not survive this life on the land and Smith's reaction to it. He himself often suffered terrible despair in this loneliness. "And so this being the happiest – is disappointing, the heights come seldom – the times of true height are so rare some seemingly high spots being suspected later as illusion – such being those contacts with people wherein elation comes related to or in dependence with others – the worth of existence is doubtful but if stuck with it – seems no other way but to proceed – the future – the factory or the classroom both undesirable yet possible at present but in 20 years neither will be open – and, my cause may be no better – can I change my pursuit – not, and have even this much all of which I should be happy with – and nothing has been as great or as wonderful as I envisioned. I have confidence in my ability to create beyond what I have done, and always at the time beyond what I do – in what do I lack balance ... it would be nice to not be so lonesome sometimes."[36]

With the enlarged studios, the gradual improvement in his working conditions as he became able to buy more material and better tools, and with the steadily growing recognition of his work, life at Bolton Landing must certainly have become easier. But within him, the foundation of his existence remained unaltered. The development of David Smith's sculpture is therefore a visible reflection of the course of his life. Working on any piece of sculpture was an exercise in self-discovery. Since he permitted no retreat or suppression in his art, his oeuvre could – indeed, had to – give expression to all the contradictions of existence. The close connection between the work and the person lends an additional, not purely aesthetic authenticity and credibility to the means of artistic expression which Smith chose, discovered and developed. The ever-present method of the collage was also the underlying principle of his life. Using collage, he could defy the risks and perils involved in treading new artistic ground and, in doing so, gain a new freedom.

This lack of attention to traditional artistic rules should not be mistaken for carelessness, least of all from this man who was so full of respect for history and nature, for man as a product of nature and culture. He had realized that everyone has to explore his own life and map out his territory in pioneer fashion. This was why David Smith was able to assert, and carry through the assertion in his life's work, that "there are no rules in sculpture".

Notes

1 Rolf Lauter, "David Smith – eine eindrucksvolle Wiederentdeckung", *Artis,* XXXVIII/9 (September 1986), pp. 16–20. The first retrospective of David Smith's sculpture in Europe was organized by the Museum of Modern Art in New York and toured to Otterlo (Netherlands), London, Basle, Nuremberg and Duisburg in 1966–67. It was accompanied by various small catalogues. With forty-eight major works, the exhibition provided an impressive documentation of all important phases in Smith's oeuvre. This book first appeared in German in conjunction with the retrospective exhibition 'David Smith – Skulpturen, Zeichnungen', with which the Kunstsammlung Nordrhein-Westfalen, Düsseldorf, inaugurated its new building in March 1986. It is the first substantial monograph on David Smith to be published in Europe.
Public collections in Europe contain only six sculptures by Smith: one each in the Tate Gallery, London, the Wilhelm Lehmbruck Museum, Duisburg, the Rijksmuseum Kröller-Müller, Otterlo, the Städtische Kunsthalle, Mannheim; and two in the Museum Ludwig, Cologne. A further sculpture is on loan from a German private collection to the Folkwang Museum in Essen. For details of David Smith's representation in group exhibitions see pp. 179–184 of the present volume.

2 In recent years, many large-scale exhibitions in Europe have surveyed twentieth-century sculpture. They include: *Eisen- und Stahlplastik 1930–70,* Württembergischer Kunstverein, Stuttgart (1970); *Skulptur,* Westfälisches Landesmuseum, Münster (1977); *Skulptur im 20. Jahrhundert,* Wenkenpark, Riehen/Basle (1980); *Sculpture du XX^e siècle, 1900–45,* Fondation Maeght, St. Paul de Vence (1981); *Skulptur im 20. Jahrhundert,* Merian-Park, Basle (1984).

3 "The welders allowed Smith to work there, helped him to improve his welding technique, and sometimes even gave him material to work with. It was a happy association ... He often spoke of his affection for the men at 'Terminal Iron Works' and their uncritical acceptance of his work. He described *Blackburn – Song of an Irish Blacksmith* (1949–50)

as an homage to one of the welders and said he intended to do another, dedicated to Blackburn's colleague Buckhorn" (Karen Wilkin, *David Smith* [New York, 1984]).

4 Robert Motherwell, "Recollections of David Smith", pp. 168–69 of the present volume.

5 In 1930–31, Smith had turned his back on civilization for some time when he went with his wife Dorothy Dehner to St. Thomas, one of the Virgin Islands, and lived "like Gauguin" for eight months. Perhaps his taking refuge in Bolton Landing may be seen as a somewhat more comfortable exile; that would mean he had no real interest in dropping out of civilization completely. One of the reasons why Smith moved to Bolton Landing for good was that in 1940 the farm finally acquired mains electricity – essential for his welding.

6 Rosalind E. Krauss, *The Sculpture of David Smith – a catalogue raisonné* (New York/London, 1977).

7 *David Smith by David Smith,* ed. Cleve Gray (New York, 1972), p. 164.

8 For this aspect of American painting, see Jörn Merkert, "Stillosigkeit als Prinzip – Zur Malerei von Willem de Kooning", in *Willem de Kooning – Retrospektive,* ed. Paul Cummings (Munich, 1984), p. 123 f.

9 Gray, op. cit. (n. 7), p. 68.

10 Katharine Kuh, *The Artist's Voice,* interview with David Smith, New York, 1962, quoted in *David Smith – A Retrospective Exhibition* (Fogg Art Museum, Cambridge, Mass., 1966), p. 106.

11 In his detailed description of *Home of the Welder,* Edward Fry says: "The significance of these transposed images, however, is again ambiguous, aside from a secret and probably subconscious implication of a sado-masochistic syndrome of love and hate, accompanied by a fear of castration, as is indicated also by the dumbbells. However, the possibly castrated phallic welding torch, and the image of the sculptor's work springing and blooming from woman as its base, provide a further and contradictory implication of awareness, on at least a subconscious level, of an interlocking psychic mechanism of compensation: that the very conditions which threaten the artist's manhood and happiness nevertheless also give rise to his art, through which he obtains redress and personal ascendence; and which is, unlike the dog but like a child, the fruit of his relation to woman.

Such an interpretation is admittedly hypothetical but is supported by a similar complexity of secret references in such works as RELIQUARY HOUSE; and HOME OF THE WELDER in particular should be considered as one of the greatest examples of auto-psychoanalysis in the history of modern art." (Edward F. Fry, *David Smith,* exhibition catalogue [The Solomon R. Guggenheim Museum, New York, 1969], p. 40 ff.).

12 The German physician and natural historian Hermann Ludwig Ferdinand von Helmholtz (1821–94) elaborated on the 'three-colour theory' developed in the eighteenth century by Thomas Young, who had explained Newton's doctrines on colour using light waves.

13 E. A. Carmean Jnr. has researched and described this feature of the *Cubi* series: E. A. Carmean Jnr., *David Smith,* exhibition catalogue (National Gallery of Art, Washington, 1982), p. 50 ff.

14 Gray, op. cit. (n. 7), p. 57.

15 Kuh, op. cit. (n. 10), p. 107.

16 Among the series recorded by Rosalind E. Krauss, op. cit. (n. 6) are: *Constructions* (Summer 1932), *Heads* (1933), *Carved Wood Series* (1933), *Reclining Figures* (1935–c. 1955), *Medals for Dishonour* (1936–40), *Spectres* (1940s and 50s), *Agricola* (1951–52), *Tanktotems* (1951–52), *Forgings* (1955), *Ravens* (c. 1956–60), *Sentinels* (1956–c. 1961), *Albany* (1959–c. 1962), *Zigs* (1961–64), *Circles* (1962–63), *Primo Piano* (1962), *Voltris* (1962), *Voltri-Bolton Landing* (1962–63), *Menands* (1963) and *Cubis* (1959–65).

17 The *Agricola* series of 1951–52 comprises seventeen works; together with the early *Heads,* which Smith subsequently added to the group, and the sculptures created years later but given the same title, Smith's Roman numbering of the series reaches XXII.

18 Smith, "The Language is Image", *Art and Architecture,* LXIX (February 1952); reprinted on pp. 151–52 of the present volume.

19 Carmean, op. cit. (n. 13), p. 73 ff.

20 Smith, "The Secret Letter", interview with Thomas B. Hess, New York, October 1964; reprinted on pp. 163–67 of the present volume.

21 Smith, ibid.

22 Hess, ibid.

23 See the remarks by Smith in his interview with David Sylvester (*Living Arts,* April 1964), reprinted on pp. 160–63 of the present volume.

24 Smith, in Dan Budnik, *The Terminal Iron Works,* exhibition catalogue (American Federation of Arts, Albany, 1974), p. 4.

25 Gene Baro, "Some Late Words from David Smith", *Art International,* IX/7 (October 1965), p. 49.

26 Ibid., p. 49.

27 The other artists invited were Calder, Chadwick, Consagra, Pomodoro, Lipton, Rosati, Chillida, Richier, Moore, Manzù, Franchina and Marini; see E. A. Carmean Jnr., "David Smith: the Voltri Sculpture", in *The Subjects of the Artist – American Art at Mid-Century,* exhibition catalogue (National Gallery of Art, Washington, 1978), p. 217.

28 Ibid.

29 David Smith, "Report on Voltri", in Garnett McCoy (ed.), *David Smith* (New York/Washington, 1973), p. 158.

30 Ibid., p. 162.

31 Carmean, op. cit. (n. 27), p. 223 ff.

32 Smith in his interview with Hess, op. cit. (n. 20).

33 Smith, op. cit. (n. 29), p. 161.

34 Baro, op. cit. (n. 25), p. 49.

35 The sculpture *Five Units Equal* of 1956 (not in the exhibition) is painted, but, with its cube shapes repeated on top of one another, anticipates in a more rigid form the idea of the *Cubis.*

36 Gray, op. cit. (n. 7), p. 170.

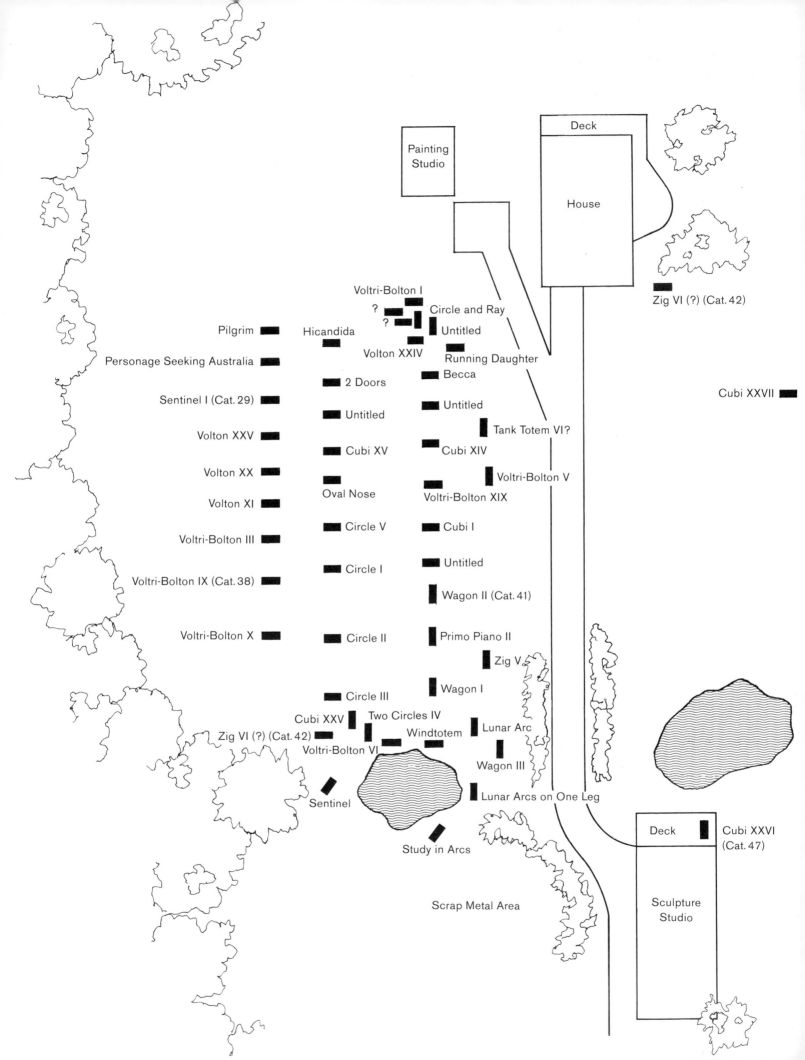

Painting
Studio

Deck

House

Zig VI (?) (Cat. 42)

Voltri-Bolton I

? Circle and Ray

? Untitled

Pilgrim Hicandida Volton XXIV Running Daughter

Personage Seeking Australia Becca

Sentinel I (Cat. 29) 2 Doors Untitled

Volton XXV Untitled Tank Totem VI?

Volton XX Cubi XV Cubi XIV

Volton XI Voltri-Bolton V

Voltri-Bolton III Oval Nose Voltri-Bolton XIX

Voltri-Bolton IX (Cat. 38) Circle V Cubi I

Circle I Untitled

Wagon II (Cat. 41)

Voltri-Bolton X Circle II Primo Piano II

Zig V

Wagon I

Circle III

Cubi XXV Two Circles IV Lunar Arc

Zig VI (?) (Cat. 42) Windtotem

Voltri-Bolton VI Wagon III

Sentinel Lunar Arcs on One Leg

Cubi XXVII

Deck Cubi XXVI
(Cat. 47)

Study in Arcs

Scrap Metal Area

Sculpture
Studio

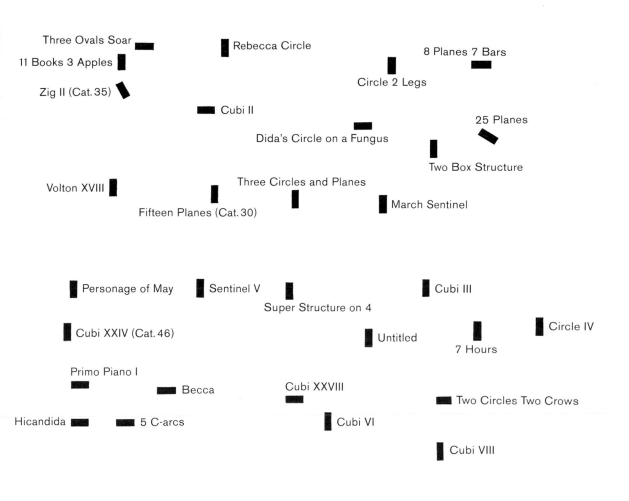

Three Ovals Soar

11 Books 3 Apples

Zig II (Cat. 35)

Rebecca Circle

8 Planes 7 Bars

Circle 2 Legs

Cubi II

Dida's Circle on a Fungus

25 Planes

Two Box Structure

Volton XVIII

Three Circles and Planes

Fifteen Planes (Cat. 30)

March Sentinel

Personage of May

Sentinel V

Super Structure on 4

Cubi III

Cubi XXIV (Cat. 46)

Untitled

7 Hours

Circle IV

Primo Piano I

Becca

Cubi XXVIII

Two Circles Two Crows

Hicandida

5 C-arcs

Cubi VI

Cubi VIII

Plan showing the arrangement of the sculptures
at Bolton Landing after David Smith's death in 1965

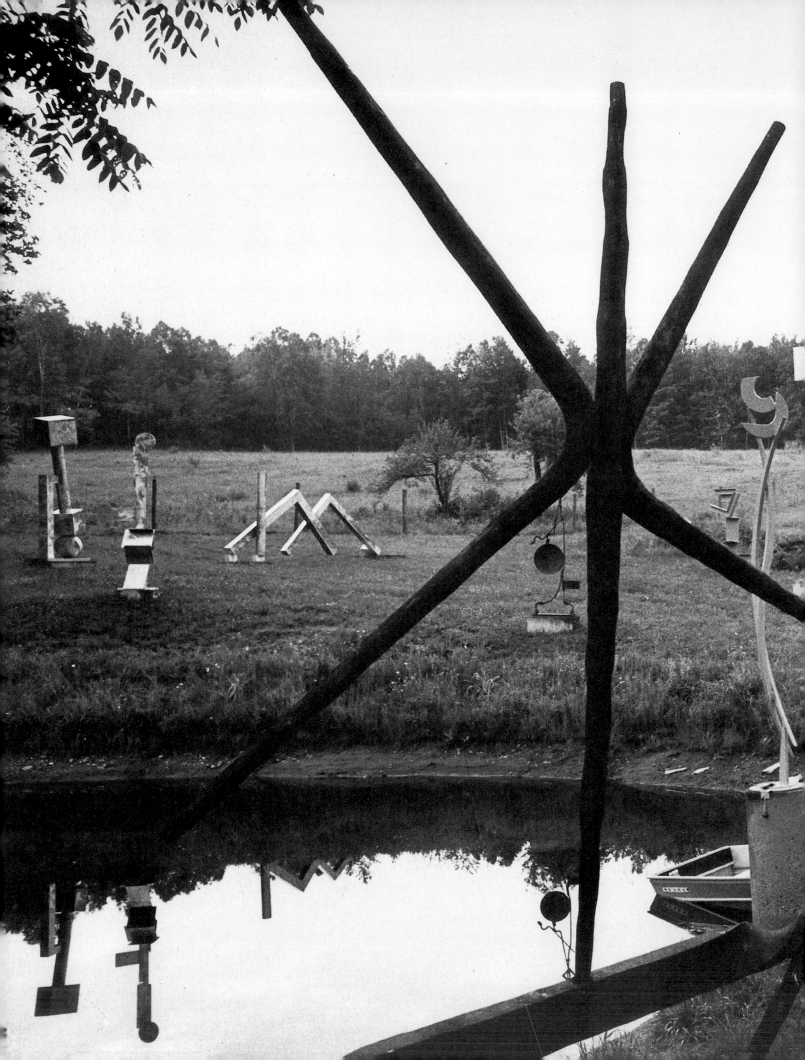

Sculpture

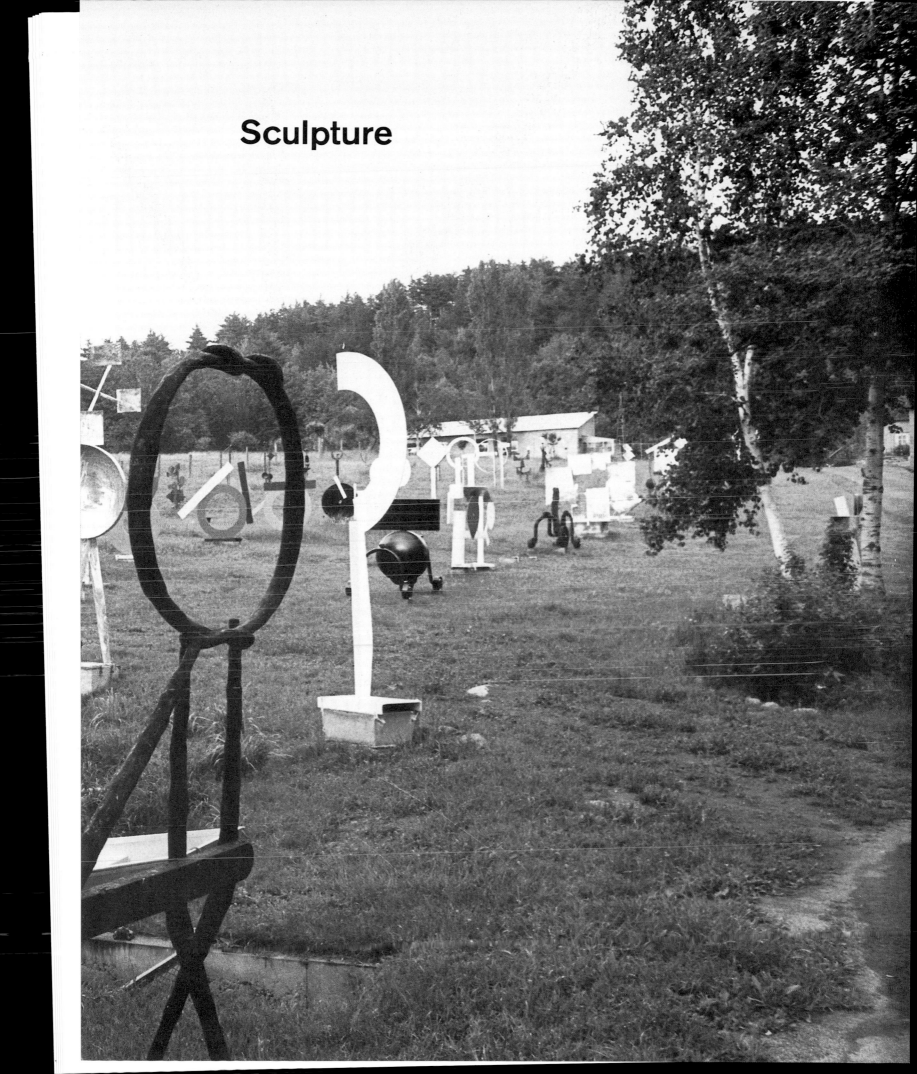

12 Steel Drawing I 1945
 Steel 56.5 x 66 x 15 cm
 Hirshhorn Museum and Sculpture Garden, Washington

13 Helmholtzian Landscape 1946
Steel, painted blue, red, yellow and green
40 x 48.5 x 19.5 cm
Collection of Mr. and Mrs. David Lloyd Kreeger

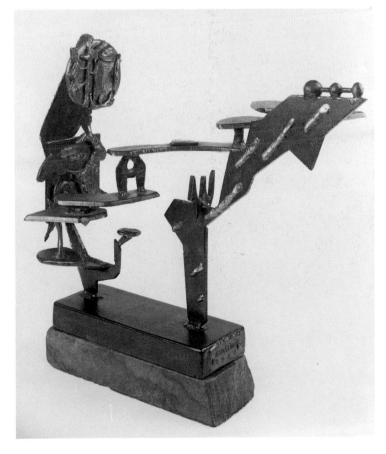

14
Landscape with Strata 1946
Steel, bronze and stainless steel
42.5 x 55 x 25 cm
Collection of Dr. and Mrs. Arthur E. Kahn

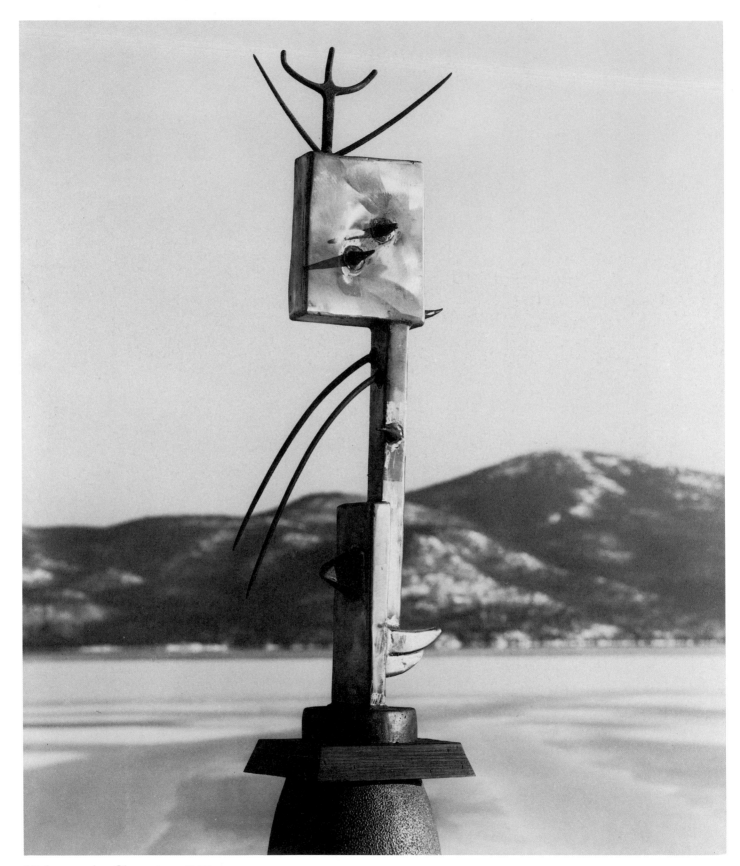

15 Aggressive Character 1947
 Stainless steel and wrought iron 82.5 x 10 x 19 cm
 Collection of Candida and Rebecca Smith (by courtesy of M. Knoedler & Co., Inc., New York)

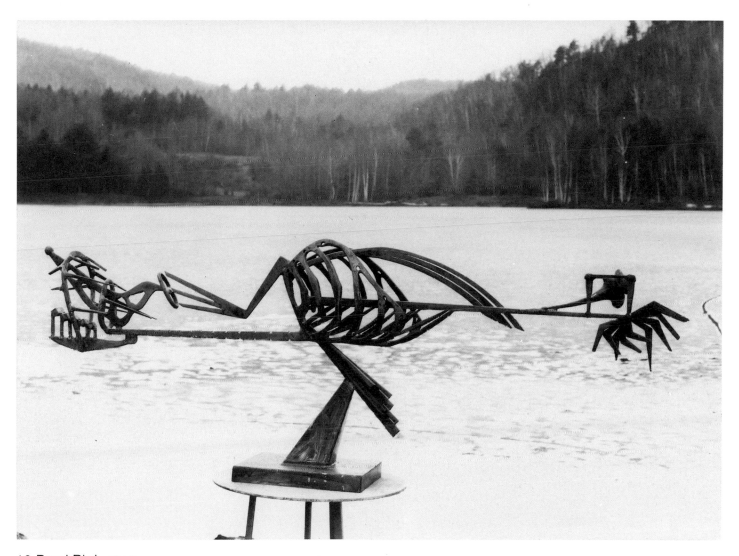

16 Royal Bird 1948
Steel and bronze 52.5 x 151 x 23 cm
Walker Art Center, Minneapolis, Minnesota (Gift of the T. B. Walker Foundation)

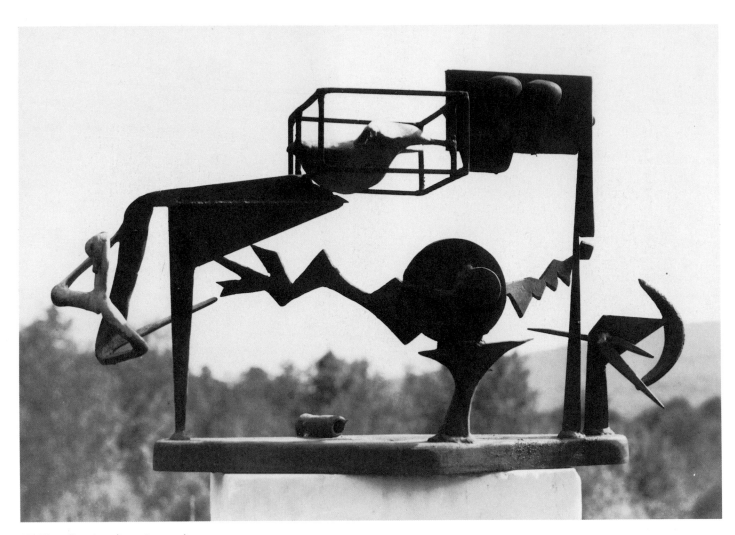

17 The Garden (Landscape) 1949
 Steel and bronze, painted green and brown
 39.5 x 60.5 x 19 cm
 Collection of Stefan T. Edlis

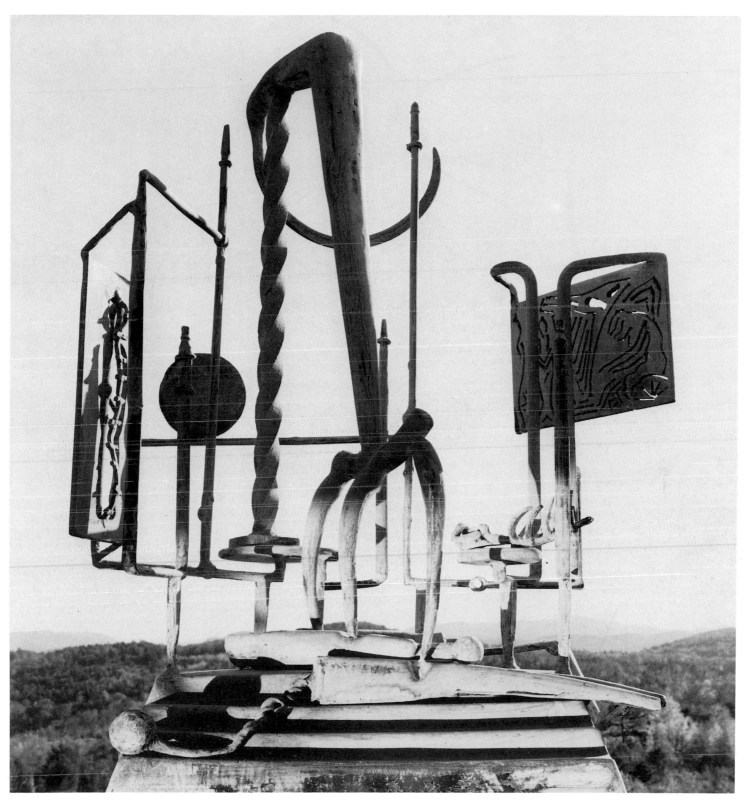

18 Cathedral 1950
 Steel, painted brown 86.5 x 62 x 43.5 cm
 Private collection, New York (by courtesy of the David McKee Gallery, New York)

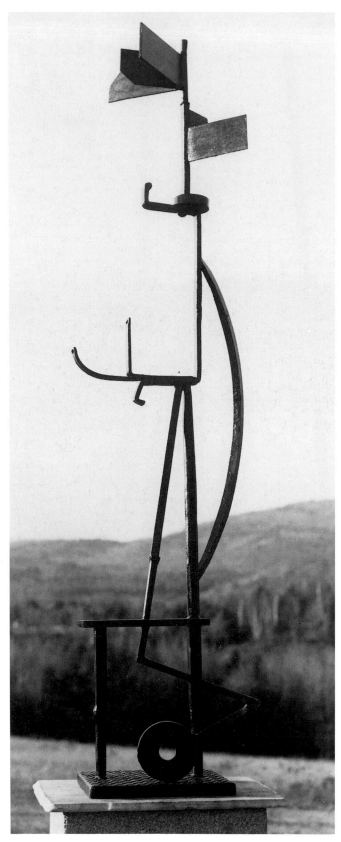

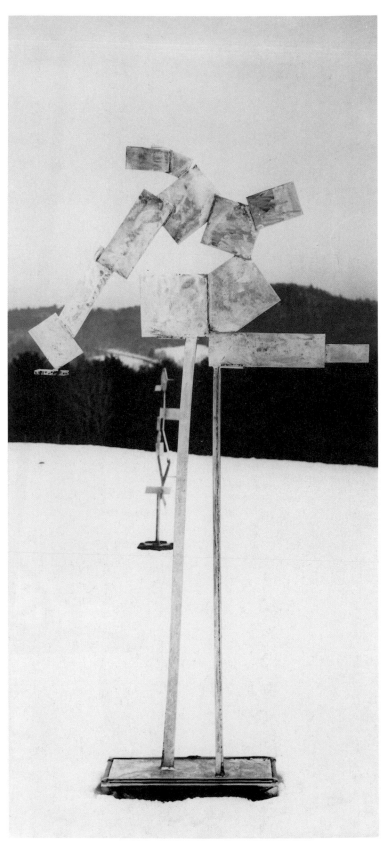

29 Sentinel 1 1956
 Steel 227.5 x 43 x 57.5 cm
 National Gallery of Art, Washington
 (Gift of the Collectors' Committee, 1979)

30 Fifteen Planes 1958
 Stainless steel 289 x 151 x 41.5 cm
 Seattle Art Museum, Washington
 (Gift of the Virginia Wright Fund)

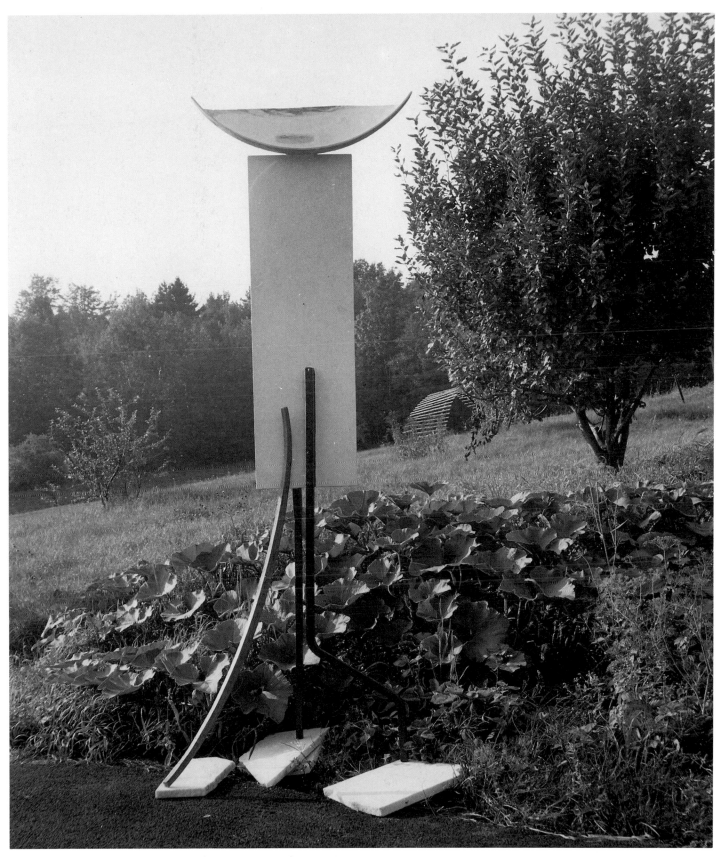

31 Tanktotem IX 1960
 Steel, painted blue, black and white 228.5 x 84 x 61.5 cm
 Collection of Candida and Rebecca Smith (by courtesy of M. Knoedler & Co., Inc., New York)

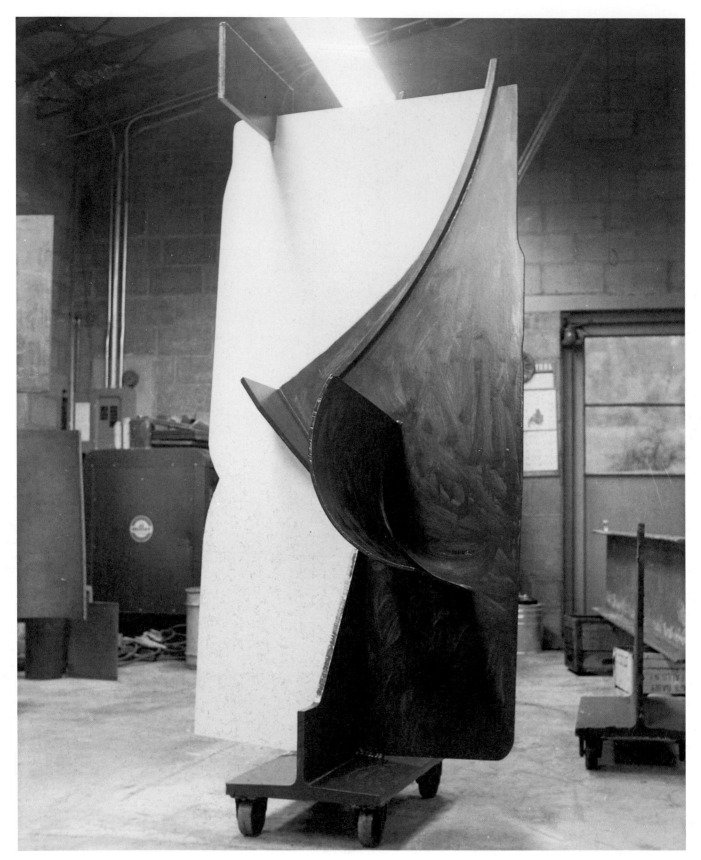

32 Black White Forward 1961
 Steel, painted black, white and brown 224 x 122 x 96.5 cm
 Collection of Candida and Rebecca Smith (by courtesy of M. Knoedler & Co., Inc., New York)

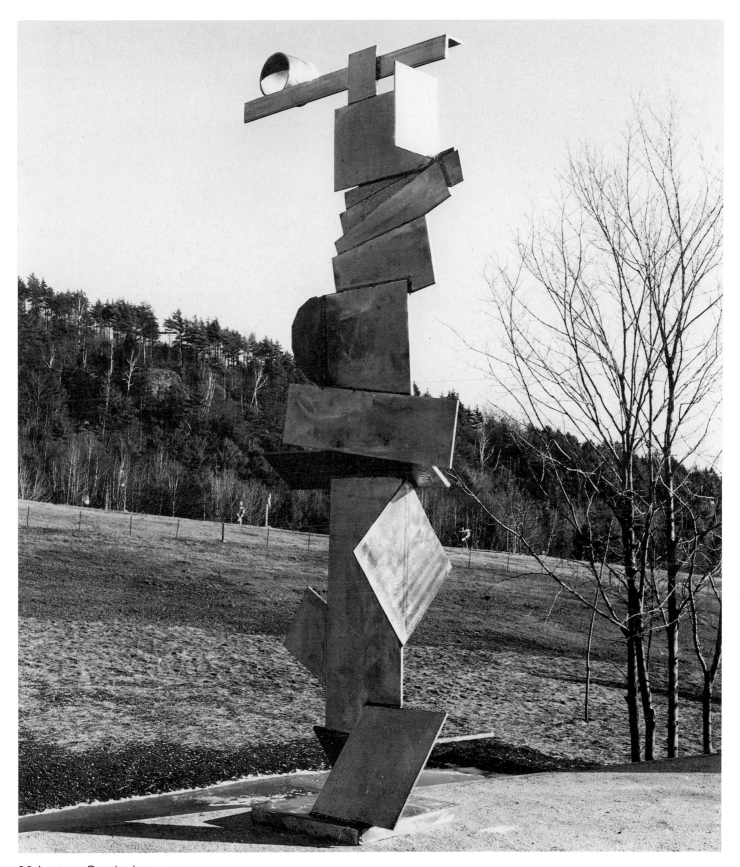

33 Lectern Sentinel 1961
 Stainless steel 258.5 x 84 x 52 cm
 Whitney Museum of American Art (Gift of the Friends of the Whitney Museum, and purchase)

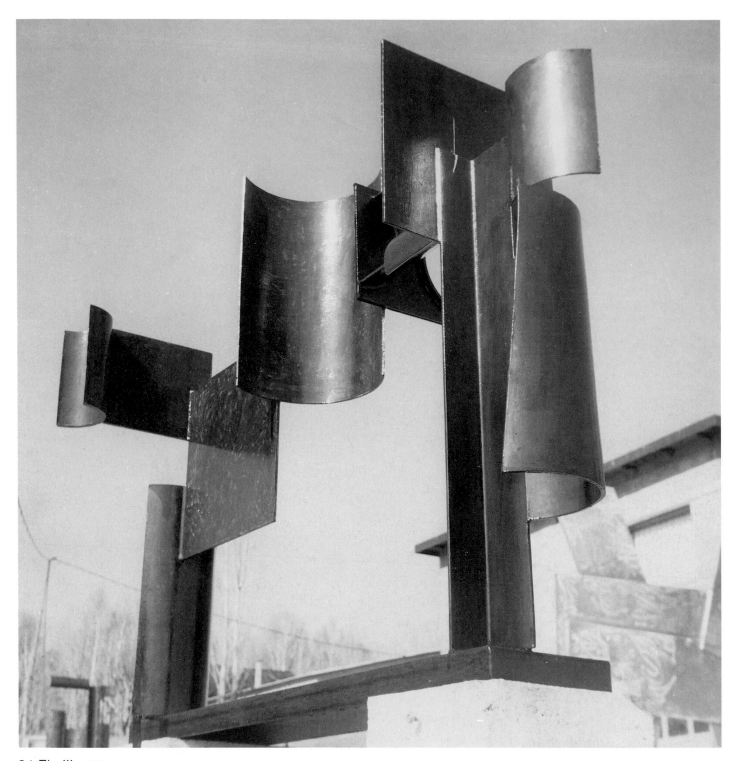

34 Zig III 1961
Steel, painted black 235.5 x 282 x 152.5 cm
Collection of Candida and Rebecca Smith (by courtesy of M. Knoedler & Co., Inc., New York)

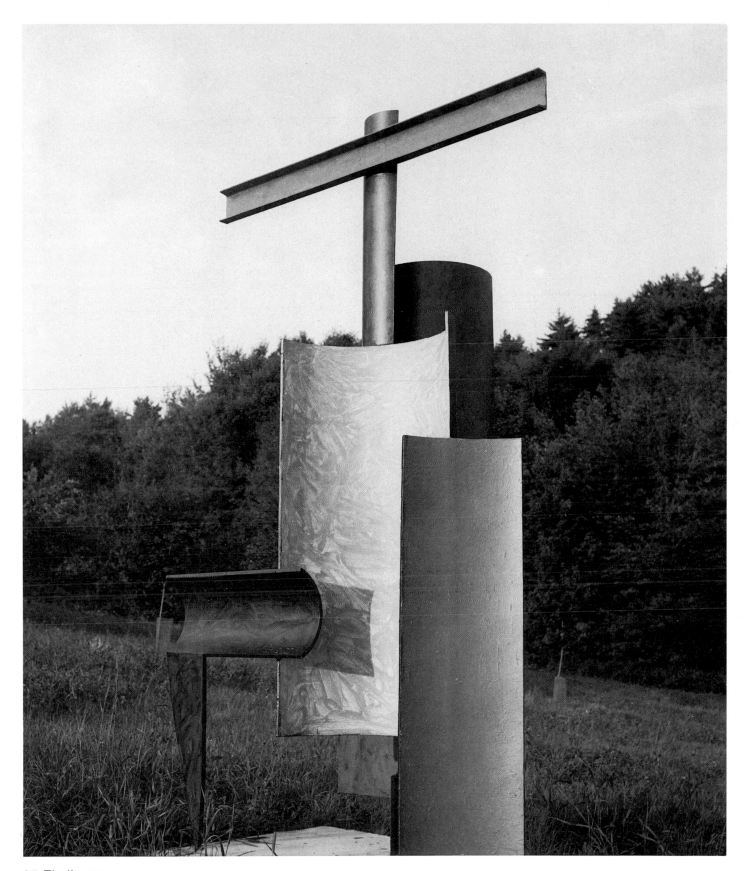

35 Zig II 1961
Steel, painted black, red and orange 255.5 x 150.5 x 95 cm
Des Moines Art Center, Iowa (Gift of the Gardner Cowles Foundation in memory of Mrs. Florence Call Cowles, 1972)

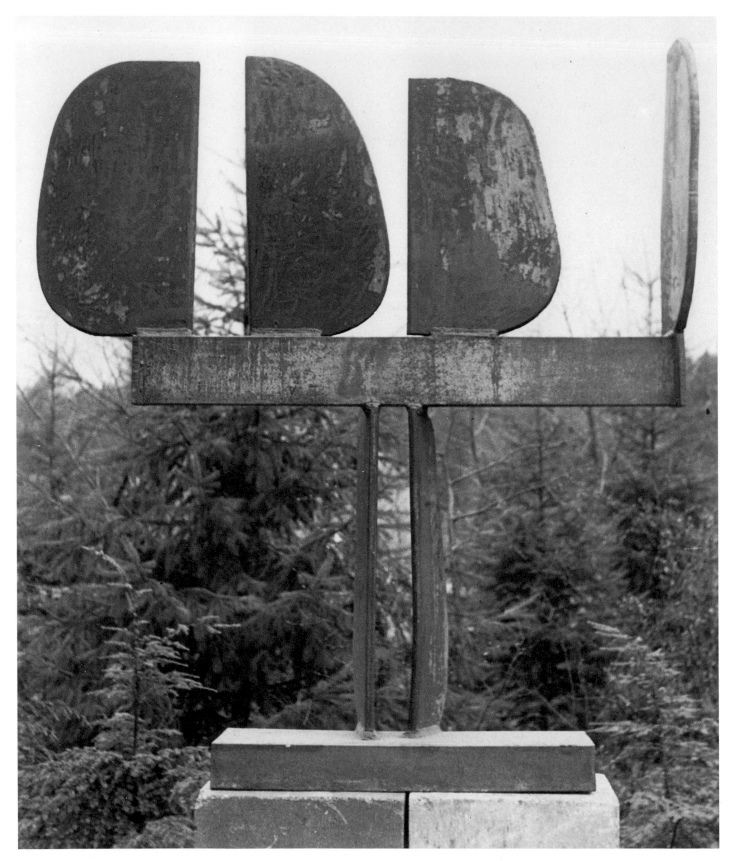

36 Voltri IV 1962
 Steel 174 x 152 x 37 cm
 Rijksmuseum Kröller-Müller, Otterlo, Netherlands

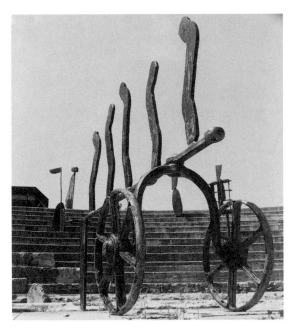

37
Voltri VII 1962
Iron
216 x 312 x 110.5 cm
National Gallery of Art, Washington
(Ailsa Mellon Bruce Fund, 1977)

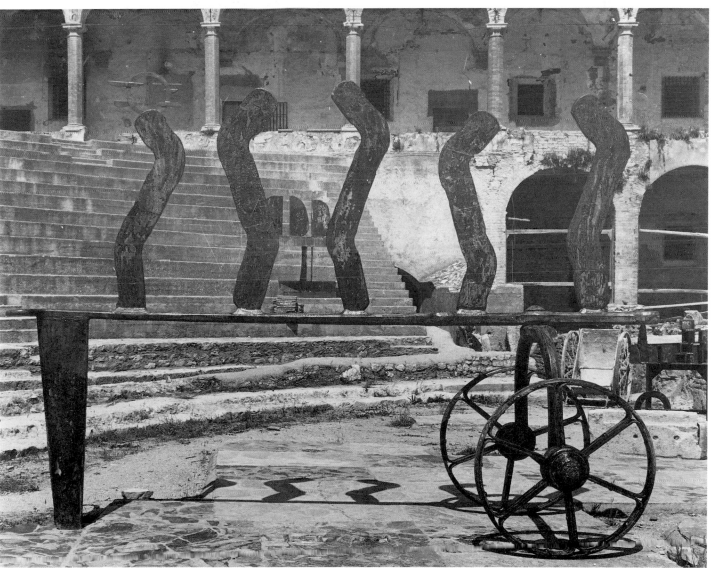

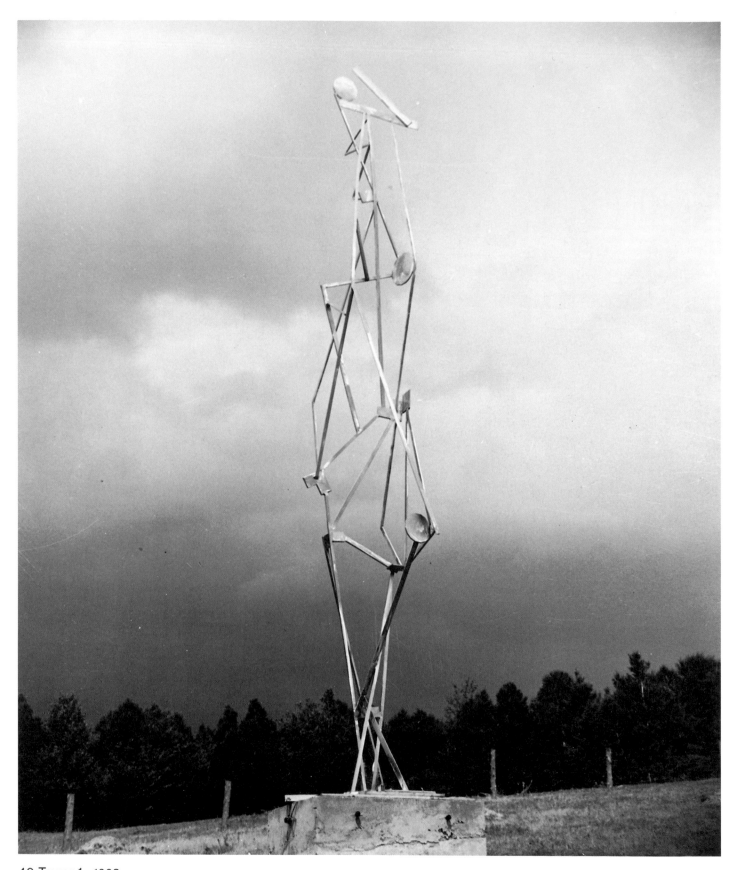

40 Tower 1 1963
 Stainless steel 640 x 86.5 x 91.5 cm
 Collection of Candida and Rebecca Smith (by courtesy of M. Knoedler & Co., Inc., New York)

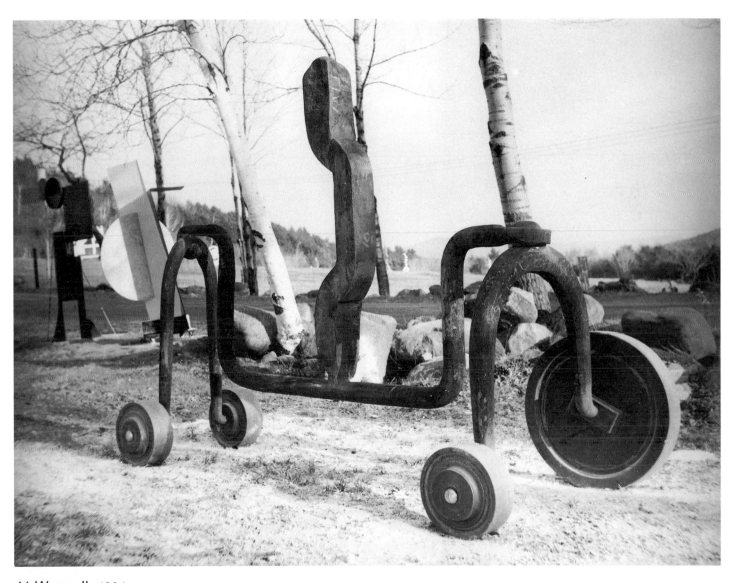

41 Wagon II 1964
 Steel 273 x 282.5 x 112 cm
 Collection of Candida and Rebecca Smith (by courtesy of the National Gallery of Art, Washington)

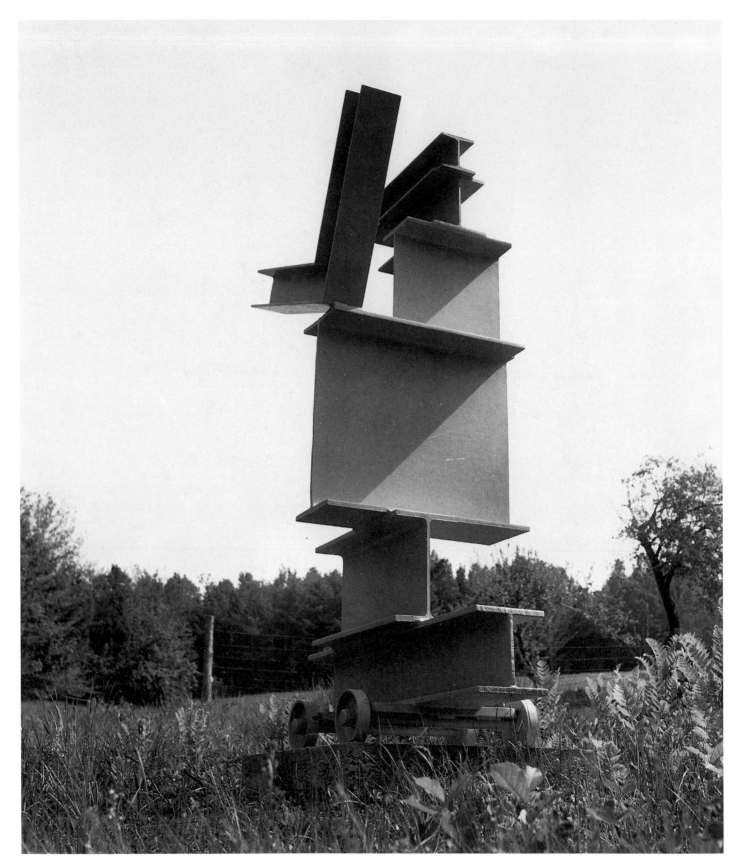

42 Untitled (Zig VI) 1964
Steel girders, painted yellow ochre 200 x 112.5 x 73.5 cm
Collection of Candida and Rebecca Smith (by courtesy of M. Knoedler & Co., Inc., New York)

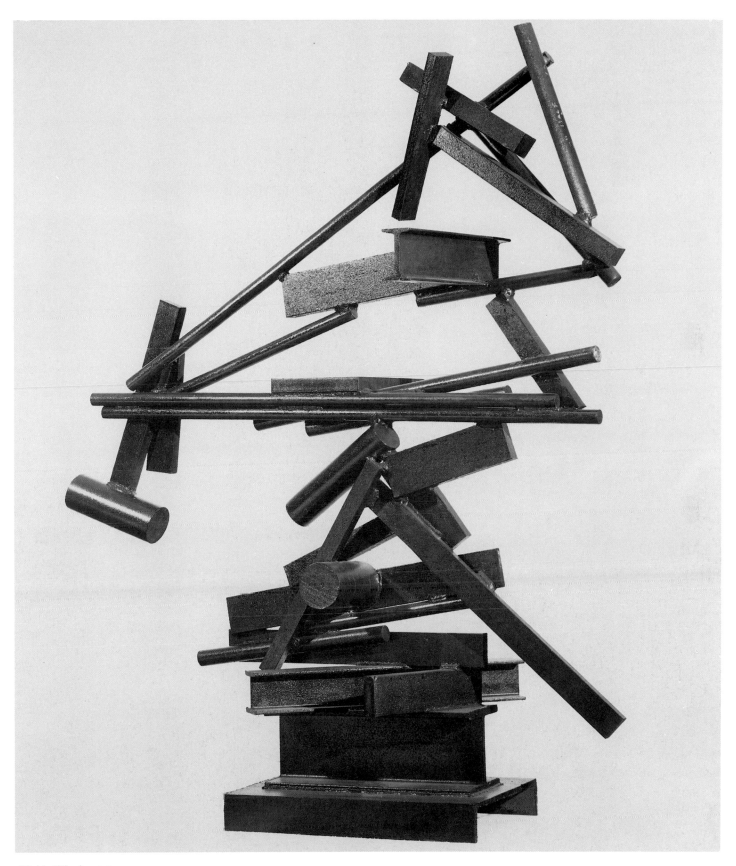

43 Untitled 1964
 Steel 210 x 170 x 75 cm
 Collection of Candida and Rebecca Smith (by courtesy of M. Knoedler & Co., Inc., New York)

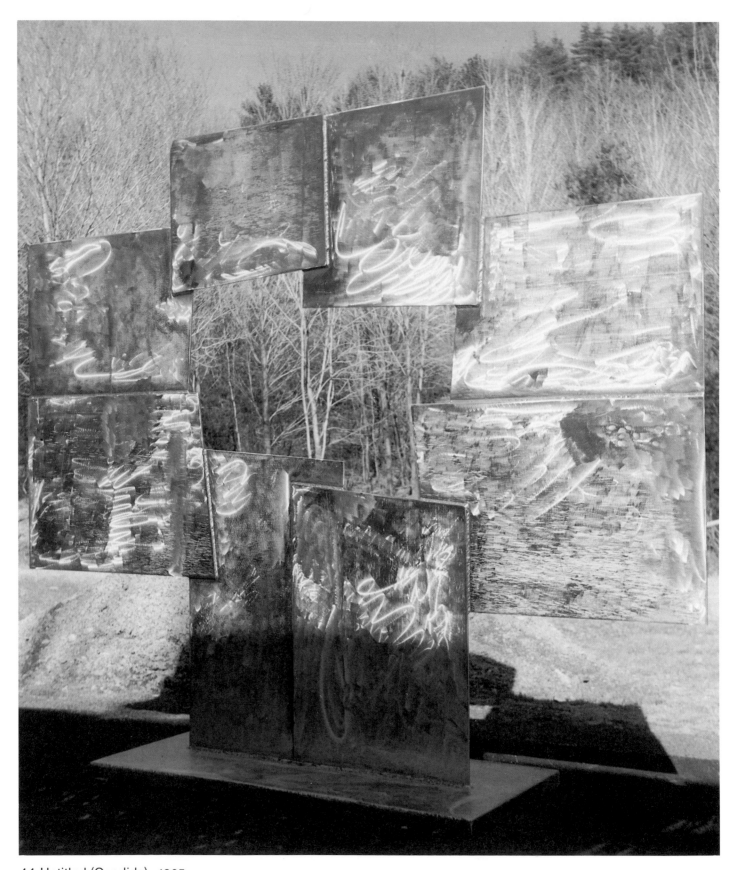

44 Untitled (Candida) 1965
 Stainless steel 256.5 x 304 x 78 cm
 Collection of Candida and Rebecca Smith (by courtesy of M. Knoedler & Co., Inc., New York)

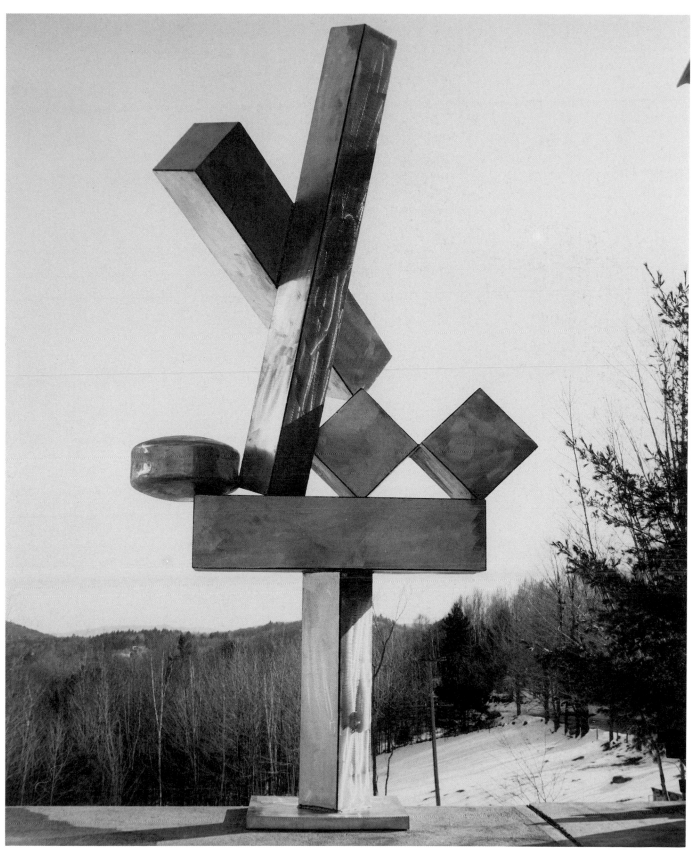

45 Cubi XIX 1964
Stainless steel 287.5 x 55 x 52.5 cm
The Trustees of the Tate Gallery, London

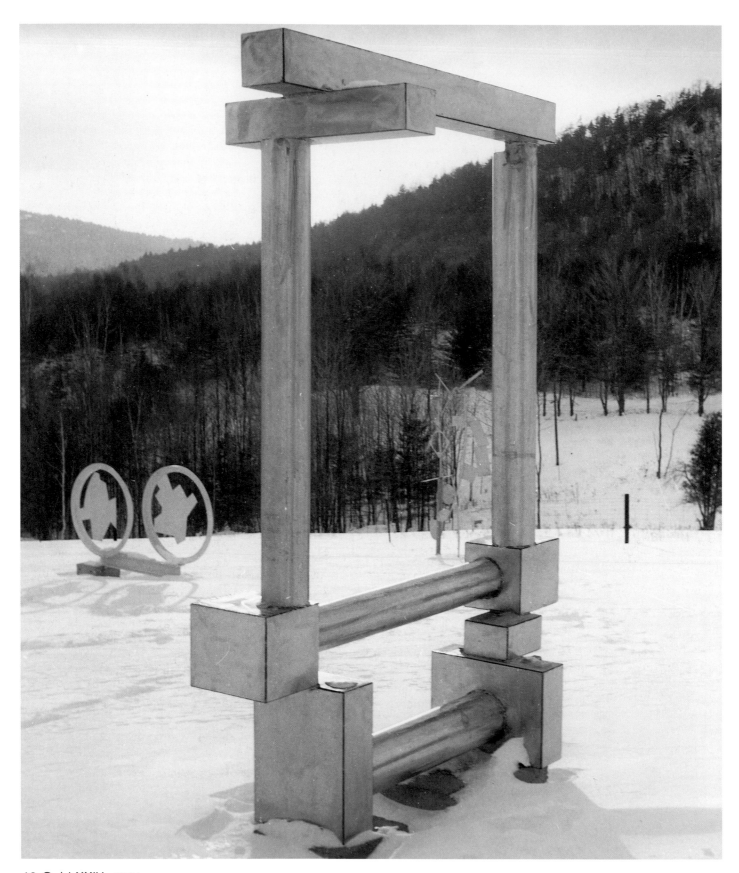

46 Cubi XXIV 1964
 Stainless steel 291 x 214 x 72.5 cm
 Museum of Art, Carnegie Institute, Pittsburgh (Howard Heinz Endowment Purchase Fund, 1967)

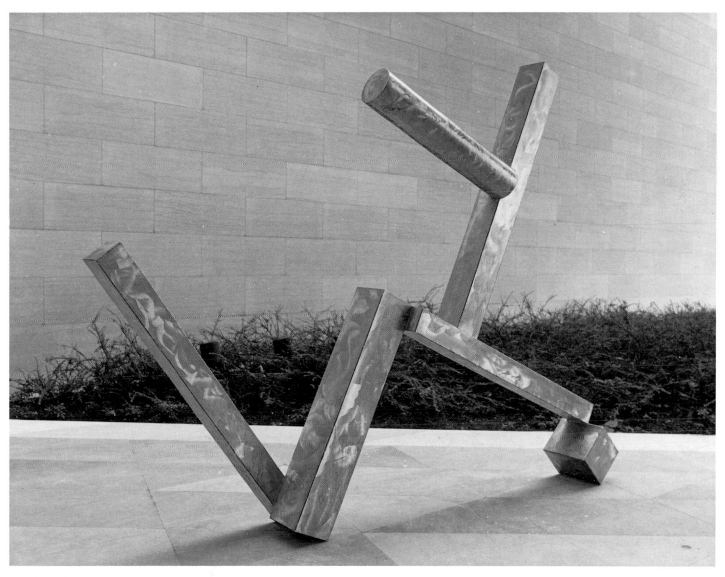

47 Cubi XXVI 1965
Stainless steel 303.5 x 383.5 x 65.6 cm
National Gallery of Art, Washington (Ailsa Mellon Bruce Fund, 1978)

Hannelore Kersting

David Smith: The Drawings and Paintings

"To the serious students I would not teach the analysis of art or art history – I would first teach drawing; teach the student to become so fluent that drawing becomes the language to replace words. Art is made without words. It doesn't need words to explain it or encourage its making."[1] David Smith's lack of confidence in any intellectual theory of art, which can provide only unsatisfactory answers to the insoluble dilemma of sensory perception and the impossibility of putting it into words, is as clear in this statement as his unshakeable belief in the elemental power of graphic art. He held this positive view throughout his life, to the extent that despite his large output of sculpture he still considered himself first and foremost a painter and a draughtsman.

His passionate desire to be able to employ the medium of drawing (which he never distinguished in principle from painting) with freedom and confidence is shown when he looks back wistfully: "I wish somebody had taught me to draw in proportion to my own size, to draw as freely and as easily, with the same movements that I dressed myself with, or that I ate with, or worked with in the factory."[2] Smith was not referring to drawing in its function as a preparatory aid in planning sculptures (in any case rendered largely superfluous by his additive method of producing three-dimensional works), but rather to drawing as an autonomous means of expression. Smith used its special qualities as a means of self-realization, for the immediacy of drawing allows the artist to make a spontaneous statement without loss of energy or expressive content: "Like the written line, it is a quickly recognized key to personality... Drawing is the most direct, closest to the true self, the most natural liberation of man."[3] Drawing preserves the creative impulse in all its intensity, an intensity which is reduced during the long and arduous process of translation into sculpture. Using drawing, Smith was able not only to realize his artistic intentions in a modified form while still creating sculptures, but also to compensate for the self-imposed disciplining of his restless temperament when working in three dimensions. This was why he could assert that "I am content to leave hundreds of sculptures in drawings which time, cost and conceptual change have passed by"[4] The result is an extensive body of

drawings, notable for an impressive and bewildering variety arising from the juxtaposition of apparently irreconcilable, contradictory polarities. A deliberate rejection of classification in terms of a 'logical' development, this variety characterizes the entire oeuvre of this distinctive artistic personality.

Surrealistic Beginnings

Like de Kooning, Smith works through the self-imposed formal themes of his work in groups of variations (some of which will be discussed here without regard to their chronology). Smith also shares with de Kooning a continual return to the main subjects of his early work, in particular landscape and the female figure (figs. 1, 2). Narrative content appears only during a single short phase in the late thirties and early forties, when Smith wished to bring the horrors of war into the public eye. In these relatively meticulous, surrealistic drawings (cat. 63–65), whose attention to detail and painstaking draughtsmanship stand in stark contrast to the raw brutality of the scenes portrayed, Smith depicts the perversities of fascist rule, personified in the swastika and the image of Hitler (cat. 63). As a metaphor for violent conquest and powerlessness he frequently uses the image – almost a cliché – of sexually threatened, mostly defenceless women, variations of which appear in separate scenes on a single sheet. The form and, above all, the content of these works are closely linked to the *Medals for Dishonour* and the preparatory drawings for them (cat. 59–61). In an interview Smith commented on the overt moralistic content of these works, which remained an exception in his oeuvre: "I have strong social feelings. I do now. And about the only time I was ever able to express them in my work was when I made a series of medallions which were against the perils or evils of war, against inhuman things... It was about the only thing I have ever done which contributed to social protest. I don't feel that I have to protest with my work. Whatever society I belong to must take me for my ability; my effort is to drive to the fullest extent those few talents that were given me, and propaganda is not necessarily my forte."[5]

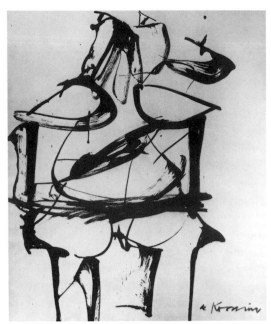

Fig. 1 Willem de Kooning, *Abstract Landscape,* 1949.
Oil on paper mounted on cardboard, 48.2 x 64.8 cm. New York,
Whitney Museum of American Art

Fig. 2 Willem de Kooning, *Woman.* About 1959.
Pen and ink on paper. 58.4 x 46.4 cm. American
private collection

Drawing and Sculpture:
Differentiating between the Media

In fact, Smith's forte is expansive, abstract drawings with expressive, supple lines and bold colours, which he handles with as much confidence as he does various forms of black. Depite their considerable differences, David Smith's drawings have one formal feature in common – their decentralized arrangement. This reflects his democratic philosophy: the drawings refuse to arrange themselves in hierarchical fashion around a dominating centre and instead display a rhythmic structure with a number of focuses in different areas of the paper. Herein lie affinities with Abstract Expressionism (fig. 3) and Jackson Pollock's 'all-over' technique (figs. 4, 5)[6]. Smith's preference for oblong formats encourages this tendency, since they abolish the dominance of the central perpendicular, a main factor in the organization of an upright composition. In this respect the drawings differ from the sculptures, almost all of which focus around the central axis and base and for this reason alone often invite comparison with the human figure.

Of course, the differences between the drawings and sculptures are in part founded in those between the two media themselves, which Smith characterized as follows: "A sculpture is a thing, an object. A painting is an illusion. There is a difference in degree in actual space and the absolute difference in gravity."[7] And elsewhere he states: "Gravitation is the only *logical* factor a sculptor

has to contend with. The parts can't float, as in painting, but must be tied together. Because these parts are necessarily more controlled by gravitation than by esthetic factors, I draw a lot. I want to be free from this logic when I can."[8]

In bringing the two media closer together, Smith always managed to find ways and means of circumventing these limiting factors. His sculpture *Steel Drawing I* (cat. 12), for example, consists of large planes resembling panel paintings, with the 'drawing' cut out of the metal.

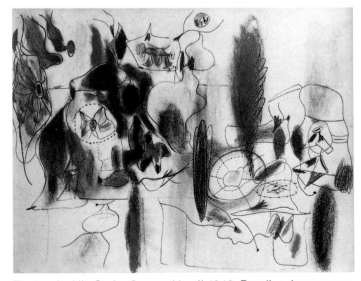

Fig. 3 Arshile Gorky, *Composition II.* 1943. Pencil and wax crayon on paper, 57.8 x 73.6 cm. Collection of Barbara and Donald Jonas

The work thus differs from a conventional drawing only in the optical inclusion of the surrounding space.

Conversely, there are drawings by Smith in which the arrangement is similar in principle to that of a sculpture, with silhouette-type forms rising from a plinth (cat. 87) or a base line (cat. 68).[9] Unlike the preparatory drawings for sculptures, in which the illusionistic means of perspective foreshortening are used to produce a relatively realistic image (cat. 62), the autonomous drawings only hint at a three-dimensional reality – a hint immediately contradicted by the irrational relationship between the abstract shapes and the drawing surface. A suggestion of gravity is required in order to make clear that its denial is the real theme of the drawings. This lack of concern for constructions based on the laws of physical reality often gives rise to an additive, discontinuous system consisting of large numbers of individual elements. Even though separated in space, these elements can be placed in a directional relationship to each other or in one produced by formal analogies. Those parts of the composition which are left blank thus play an important part in the whole and give particular weight to the individual brushstrokes.

The Functions of Line

This applies particularly to those almost calligraphic works in ink which Smith painted with a broad brush. In this especially sensitive medium the brush reacts like a seismograph to the slightest change in the direction or pressure of the hand. In his drawings Smith also employed the spray and 'dripping' techniques, the latter more often associated with Jackson Pollock. The use of

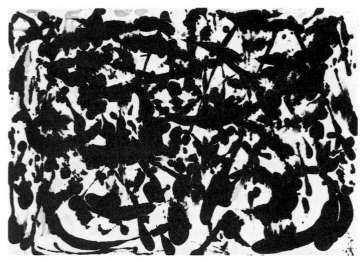

Fig. 5 Jackson Pollock, *Untitled.* About 1951. Pen and ink on paper, 61.9 x 87 cm. New York, The Museum of Modern Art

these media was no doubt dictated, at least in part, by the wish to reduce to a minimum the physical contact with intractable materials involved in the creation of sculptures. The brush drawings bear eloquent testimony to the artist's expressive handwriting, whether in the swelling and skrinking of organic forms or in the structure of the brushstrokes themselves. The strokes of individual hairs of the brush are often visible and there exists a give-and-take between broken layers of translucent colour and the light ground. In addition, the 'hieroglyphic' brushstrokes may be read as the only visible traces of a larger flow of movement, whose energy they intensity by their very incompleteness. Smith himself linked this with Asian art: "Certain Japanese formalities seem close to me, such as the beginning of a stroke outside the paper continuing through the drawing space to project beyond, so that the included part possesses both the power of origin and projection."[10]

In Smith's sculptures, line serves a number of different functions. It can be independent of the other elements of the sculpture and move around freely. It can form the contour of an enclosed form, bound to the latter's surface and its edges, and, if the form is solid and if the space it encloses is not open, can give it texture in the shape of brushwork, engraving or polishing. In drawing or painting the possibilities are more varied because, for example, the boundaries between line and area are not as hard and fast as in the clear-cut medium of sculpture. This means that lines can be drawn which are so broad that their edges may be interpreted as the contours of flat figures – as in Smith's numerous 'matchstick figures', which are related to certain of his welded sculptures (cat. 81–83). Here, the broad lines appear more dynamic than the areas, owing to their directional thrust.

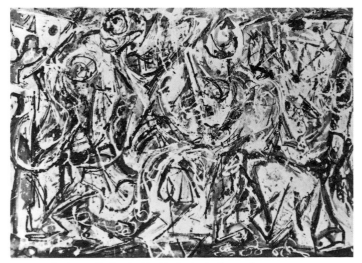

Fig. 4 Jackson Pollock, *Untitled.* 1946. Gouache on paper, 56.5 x 82.6 cm. Lugano, Collection of H. H. Thyssen-Bornemisza

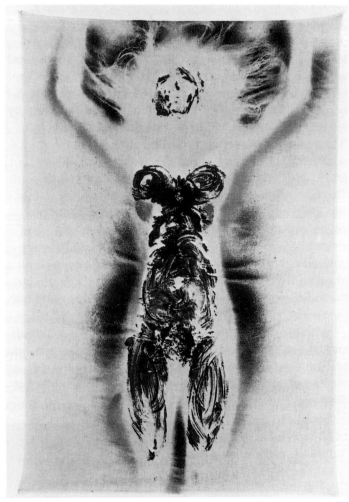

Fig. 10 Yves Klein, *Vampire*. About 1960. Paint on synthetic resin mounted on canvas, 142.5 x 94 cm. Private collection

intention of stressing the similarities between these two media rather than the differences. "The difference in technical pursuit does not change the mind's reaction to form. Accent on any aesthetic difference is the prerogative of the layman. In my own case I don't know whether I make some pieces as painted sculpture or paintings in form."[12] Later, in 1961, he was to say: "I never conceived of myself as anything other than a painter because my work came right through the raised surface, and color and objects applied to the surface."[13] Smith's early collages (cat. 47, 50), which included found objects and scraps of various materials, paved the way for this move into sculpture. If three-dimensionality and the law of gravity separate sculpture from drawing, colour is the element which draws them closer together. Smith is preoccupied with colour to the extent that it dominates a large part of his oeuvre as a whole. As he himself says, this is partly due to the need to protect his outdoor sculptures from the weather. But given the great importance of colour to the impact of his sculptures, and the passion with which he devoted himself to the problem of colour, this cannot fully account for its importance in his work. Of course, paint protected the surfaces of his sculptures from corrosion, but it also rendered them more sensitive, since a thin coating of paint is more easily damaged than is bare metal. As in painting, colour gives the work an element of untouchability and denies the viewer a tactile experience of even the most robust materials. Smith's use of colour for its distancing effect accentuates, not the tangible, physical properties of the material, but solely the visual qualities of a comparatively unapproachable work of art.

Colour also has a modifying function, and to the same degree in both painted sculpture and drawing. It is able to order the various elements optically and establish connections between them. Here too, it can be employed in opposite ways. Larger surfaces can be broken up by the further addition of colour. The underlying self-contained shape may thereby sacrifice some of its clarity in favour of the painterly impressions produced by the blurring of its outlines. But more often, several elements, perhaps each consisting of a single brushstroke, are united optically by being given the same colour. Colour thus reaches beyond individual components to create a dynamic, ambivalent tension between the self-contained form of a detail and its chromatic relationship to the whole. In this way, colour both articulates and coordinates two systems of relationship.

The ability of colour to accentuate and to establish order is seen even in Smith's own signature, over which he takes great care. A key to his evaluation of himself as an artist, it is worthy of particular attention. Apart from

dimensionality of the latter. This procedure is not unlike his practice of laying out the individual parts of a sculpture on an area of his workshop floor painted white, and then trying out various combinations until he reached a satisfactory solution and the pieces could be welded together to form the sculpture (fig., p. 44). The white area here performs the same function as paper or canvas in a two-dimensional work, enabling individual parts to be related to a whole. Smith, who declines to use the traditional sculptural technique of working from a monolithic block of material, thus uses a technique from painting during the genesis of a sculpture. In his final years, when the large-scale *Cubis* were created, the spray-paintings indirectly take over this function.

The Modifying Function of Colour

Smith's methods, involving the combining of techniques from two-dimensional art and sculpture, reflect his

the somewhat alien monogram of Greek letters, in his later works Smith develops the novel technique of emphasizing his name by writing it within a field of contrasting colour. Sometimes this colour stands in such obvious, and irritating, contrast to the black and white of a drawing that the signature becomes a separate constituent element of the whole. Likewise, Smith attaches plaques to his sculptures which are obviously made of a material different from that of the work itself. In this way, Smith draws attention to his confidence as creator of the work: on the one hand, he has chosen the materials and established a relationship between them, and, on the other, has exercised his freedom to change this relationship in order set himself apart from the work. The viewer is thus left in no doubt as to the dominance of the artistic personality, one with a deep sense of responsibility to, and an aloofness from, his creations.

Not the least of the things Smith gives expression to in his work is this very demand for an unconditional recognition of the subjectivity of individual artistic personality. It makes applying an analytical approach to his work difficult − and that would certainly have pleased him.

Notes

1 David Smith, "What I Believe About the Teaching of Sculpture", address given at the Midwestern University Art Conference, Louisville, Kentucky, on 27 October 1950. Quoted in Garnett McCoy (ed.), *David Smith* (Documentary Monographs in Modern Art) (New York, 1973), p. 63 and reprinted on pp. 157–58 of the present volume.

2 David Smith, "Memories of Myself", paper given at the 18th Conference of the National Committee on Art Education at the Museum of Modern Art, New York, on 5 May 1960. Quoted in G. McCoy, ibid., p. 149.

3 David Smith, "Drawing", Lecture delivered at Sophie Newcombe College, Tulane University, on 21 March 1955. Quoted in G. McCoy, ibid., p. 119 f., and reprinted on pp. 154–55 of the present volume.

4 David Smith, "The New Sculpture", manuscript for a symposium of the same name held at the Museum of Modern Art, New York, on 21 February 1952. Quoted in G. McCoy, ibid., p. 83.

5 David Sylvester, Interview with David Smith in New York on 16 June 1961. Quoted in G. McCoy, ibid., p. 170 f., and reprinted on pp. 160–63 of the present volume.

6 See Walter Kambartel, *Jackson Pollock, Number 32, 1950* (Stuttgart, 1970).

7 Smith, op. cit. (n. 4), p. 82.

8 S. Rodman, *Conversations with Artists* (New York, 1957), p. 129 f.

9 See G. Inboden, "Zeichnung und Plastik bei David Smith", in exhibition catalogue, *David Smith: Zeichnungen* (Stuttgart, 1976), p. 16.

10 Smith, op. cit. (n. 4), p. 83.

11 Thomas B. Hess, "The Secret Letter", interview with David Smith, June 1964. Quoted in G. McCoy, op. cit. (n. 1), p. 183, and reprinted on pp. 163–67 of the present volume.

12 David Smith, op. cit. (n. 1), p. 64, and p. 157 of the present volume.

13 D. Sylvester, op. cit. (n. 5), p. 174.

Drawings

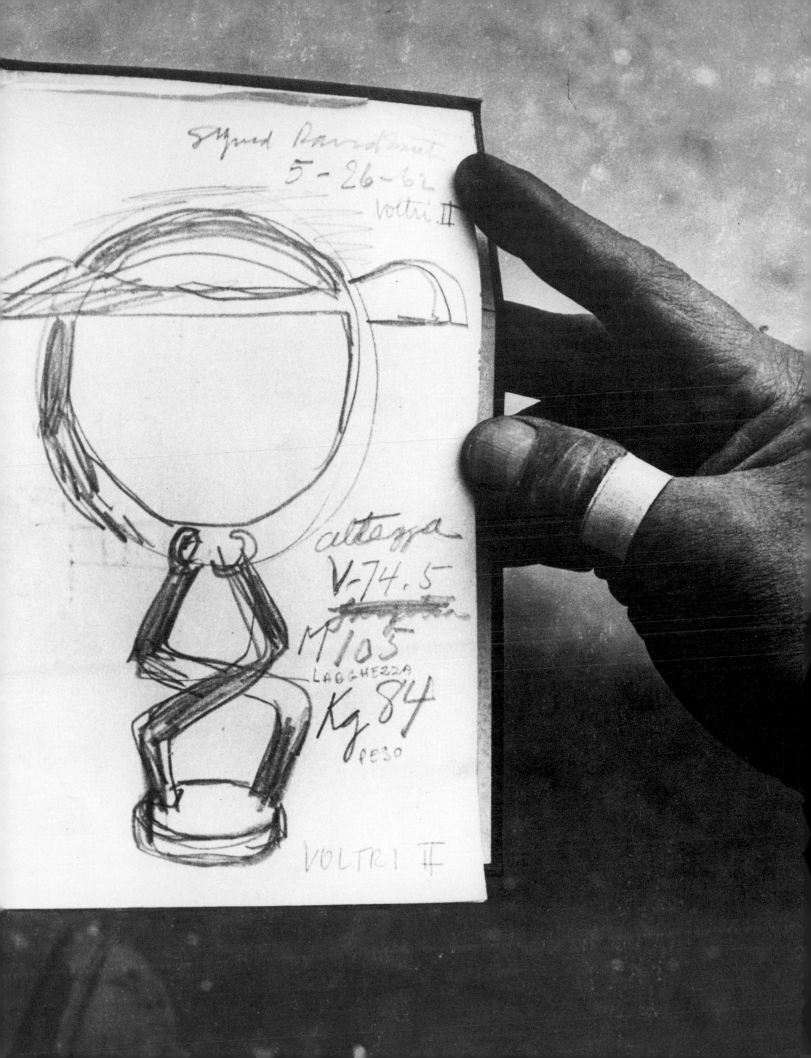

The four early oil paintings and the relief shown in the exhibition have been included here under 'drawings'. For his works on paper David Smith used the most diverse media, transcending traditional concepts of drawing and sometimes crossing the boundary into painting. David Smith himself did not make a distinction between 'drawing' and 'painting' when referring to these works.

48 Untitled 1930
 Oil on canvas 30.5 x 40.6 cm
 David Smith Estate (by courtesy of Washburn Gallery, New York)

49 Untitled 1930–47
 Oil on canvas 26.7 x 39.4 cm
 Collection of Candida and Rebecca Smith (by courtesy of M. Knoedler & Co., Inc., New York)

50
Untitled (Relief Painting) 1932
Oil on wooden board and
wooden relief elements, painted
blue, green and black
47 x 55.9 cm (wooden frame)
David Smith Estate
(by courtesy of Washburn Gallery,
New York)

51 Untitled 1936 Oil on canvas 35.6 x 48.3 cm
Collection of Candida and Rebecca Smith (by courtesy of M. Knoedler & Co., Inc., New York)

52 Untitled (Billiard Players) 1936
 Oil on canvas 119.4 x 132,1 cm
 Collection of Mr. & Mrs. Barney A. Ebsworth

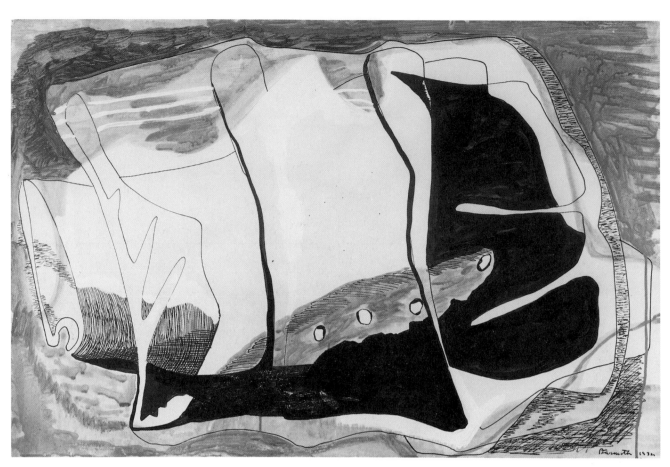

53 Untitled (St.Thomas Theme) 1932
 Pen and ink with wash on cardboard 50.8 x 76.2 cm
 Collection of Candida and Rebecca Smith (by courtesy of M. Knoedler & Co., Inc., New York)

54
Abstract Nautical Scene 1933
Cut-outs in blue, ochre, white
and green tempera on lined
paper mounted on canvas
45.7 x 61 cm
Collection of Candida and
Rebecca Smith (by courtesy of
M. Knoedler & Co., Inc., New York)

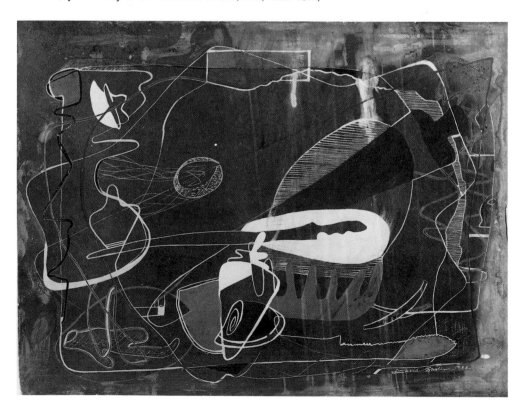

55
Abstraction 1933
Red, grey and black forms in tempera on blueprint
43.2 x 35.6 cm
Collection of Candida and Rebecca Smith
(by courtesy of M. Knoedler & Co., Inc., New York)

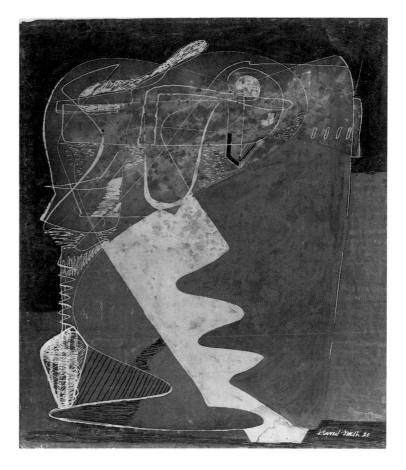

56
Untitled 1936–37
Brush and ink with wash
43.2 x 55.9 cm
Collection of Candida and Rebecca Smith
(by courtesy of M. Knoedler & Co., Inc., New York)

57
Suspended Abstraction 1937
Pen and ink with tempera
24.8 x 29.8 cm
Collection of Candida and Rebecca Smith
(by courtesy of M. Knoedler & Co., Inc., New York)

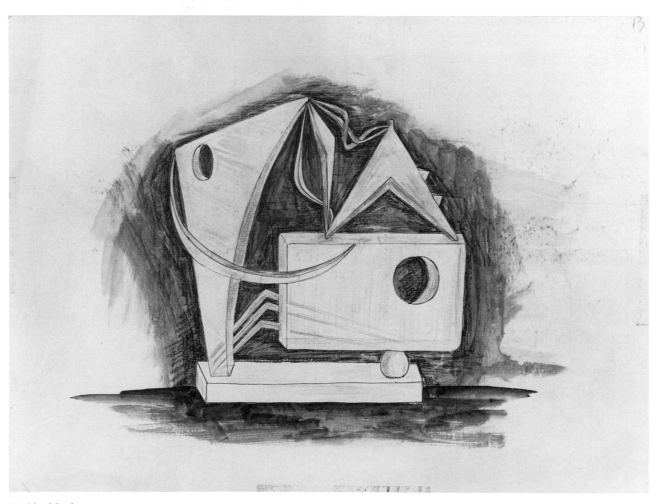

58 Untitled 1937–38
 Pen and ink and pastel, with wash 43.2 x 55.9 cm
 Whitney Museum of American Art, New York (Gift of Joel and Anne Ehrenkranz)

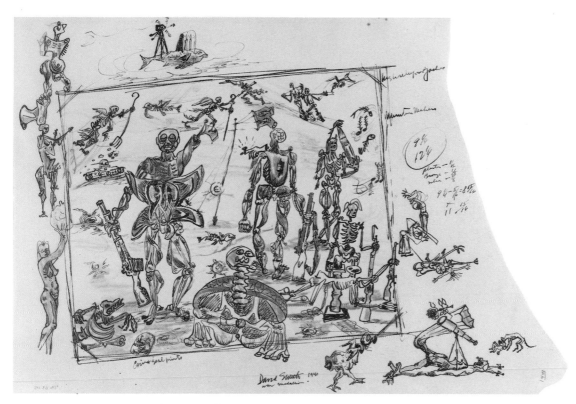

59 Medals for Dishonor (War med) 1938–39
 Pen and ink 33.7 x 40.6 cm
 Collection of Candida and Rebecca Smith
 (by courtesy of M. Knoedler & Co., Inc., New York)

61 Medals for Dishonor 1938–39
 Pen and ink 33.7 x 41.9 cm
 Collection of Candida and Rebecca Smith
 (by courtesy of M. Knoedler & Co., Inc., New York)

60 Medals for Dishonor 1938–39
 Pen and ink 33.7 x 41.9 cm
 Collection of Candida and Rebecca Smith
 (by courtesy of M. Knoedler & Co., Inc., New York)

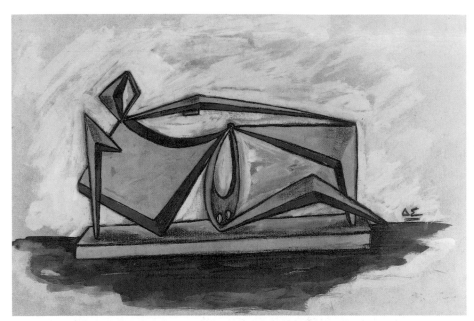

62
Reclining Figure 1939–40
Tempera
30.5 x 45.7 cm
Collection of Candida and Rebecca Smith
(by courtesy of M. Knoedler & Co.,
Inc., New York)

63
Arian Fold Type 1 1943
Pen and ink
49.9 x 63.5 cm
David Smith Estate
(by courtesy of M. Knoedler & Co.,
Inc., New York)

64
Fascist Royalty 1943
Pen and ink
49.5 x 63.5 cm
Collection of Candida
and Rebecca Smith (by
courtesy of M. Knoedler
& Co., Inc., New York)

65
Untitled 1942–43
Pen and ink
50.8 x 62.9 cm
David Smith Estate (by
courtesy of M. Knoedler
& Co., Inc., New York)

70
Untitled 1951
Pen and black and blue ink with
tempera and orange wash
46.4 x 57.8 cm
Collection of Candida and Rebecca Smith
(by courtesy of M. Knoedler & Co., Inc., New York)

71
Untitled 1952
Grey and white tempera
75.3 x 107.3 cm
Collection of Candida and
Rebecca Smith (by courtesy of
M. Knoedler & Co., Inc., New York)

72
Untitled 1952
Brush and grey and purple ink
39.4 x 52.1 cm
Collection of Candida and
Rebecca Smith (by courtesy of
M. Knoedler & Co., Inc., New York)

73 Untitled 1952
Brush and black and dark-green ink with tempera 45.7 x 59.1 cm
Collection of Candida and Rebecca Smith (by courtesy of M. Knoedler & Co., Inc., New York)

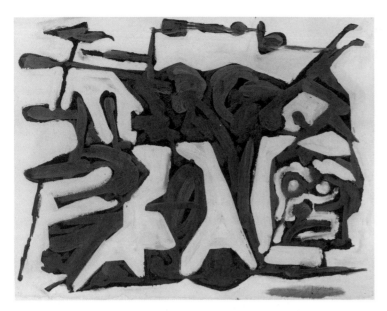

74
Untitled 1952
Brush and ink with tempera
45.7 x 59.7 cm
Collection of Candida and Rebecca Smith
(by courtesy of M. Knoedler & Co., Inc., New York)

75
Untitled 1952
Brush and ink
39.4 x 52.1 cm
Collection of Candida and
Rebecca Smith (by courtesy of
M. Knoedler & Co., Inc., New York)

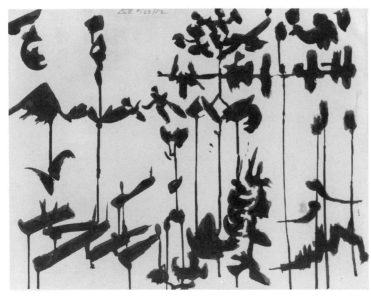

76
Untitled 1952
Brush and ink with white tempera
45.7 x 59.1 cm
Collection of Candida and Rebecca Smith
(by courtesy of M. Knoedler & Co., Inc., New York)

77
Untitled 1953
Brush and ink
75.6 x 108.6 cm
Collection of Candida
and Rebecca Smith
(by courtesy of
M. Knoedler & Co.,
Inc., New York)

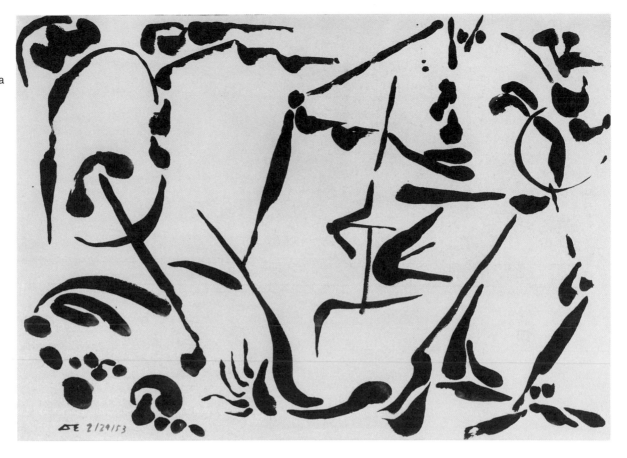

78
Untitled 1953
Brush and violet ink
76.2 x 107.5 cm
Wilhelm-Lehmbruck-
Museum der Stadt
Duisburg

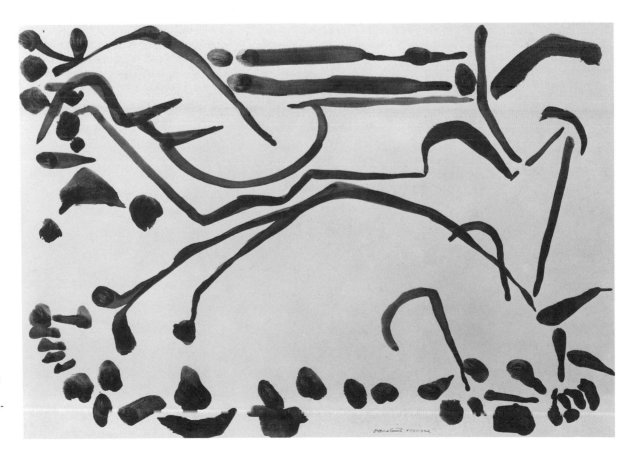

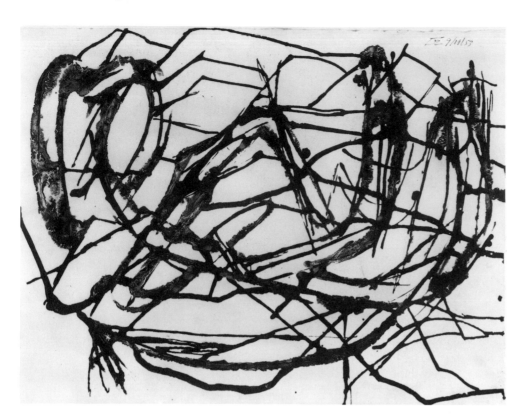

79 Untitled 1953
Brush and blue-black ink
39.4 x 52.1 cm
Collection of Candida and
Rebecca Smith (by courtesy
of M. Knoedler & Co., Inc.,
New York)

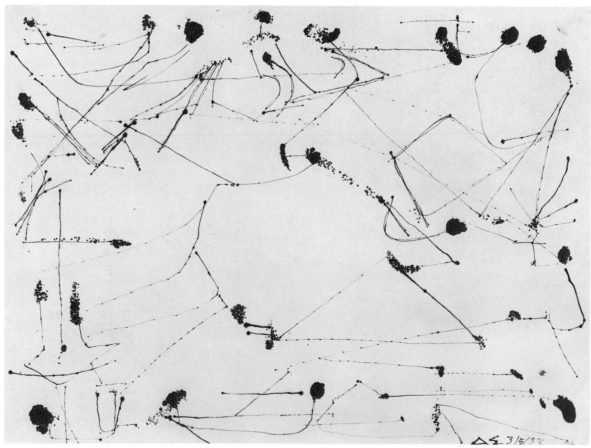

80 Untitled 1953
Brush and ink 45.7 x 61 cm
Collection of Candida and Rebecca Smith (by courtesy of M. Knoedler & Co., Inc., New York)

81
Untitled 1953
Brush and dark-red ink
39.4 x 51.4 cm
Collection of Candida and Rebecca Smith
(by courtesy of M. Knoedler & Co., Inc., New York)

82
Untitled 1953
Brush and dark-red ink
39.4 x 51.4 cm
Collection of Candida and Rebecca Smith
(by courtesy of M. Knoedler & Co., Inc., New York)

83
Untitled 1953
Brush and ink
45.7 x 61 cm
Collection of Candida and Rebecca Smith
(by courtesy of M. Knoedler & Co., Inc., New York)

84 Untitled 1953
Pen and black and green ink 45.7 x 61 cm
Collection of Candida and Rebecca Smith (by courtesy of M. Knoedler & Co., Inc., New York)

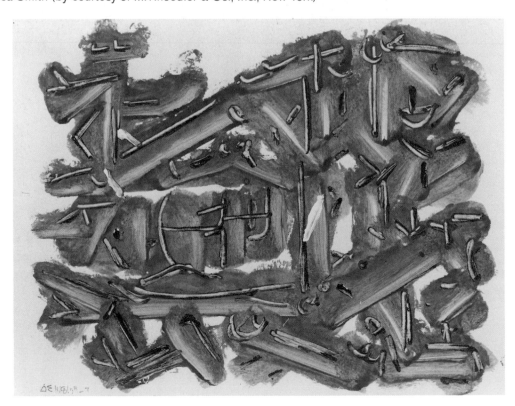

85
Untitled 1954
Brush and salmon-coloured
ink with red tempera
40 x 51.4 cm
Private collection

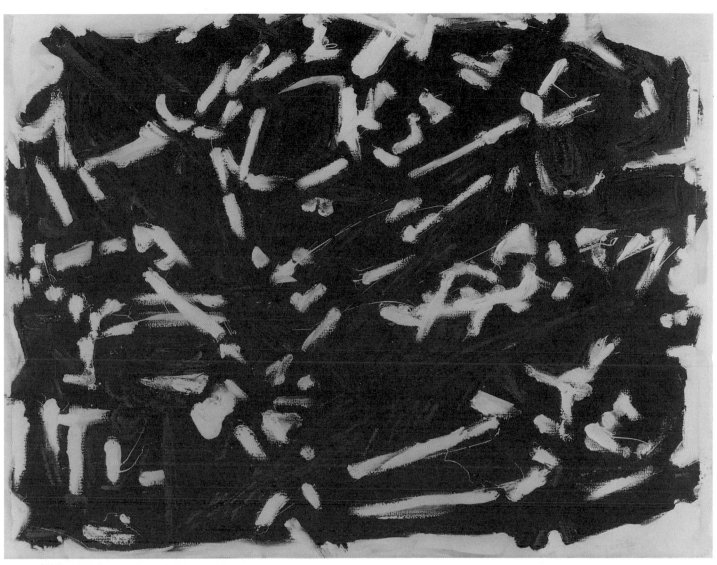

86 Untitled 1954
 Brush and ink with white and red oil colour
 50.8 x 66 cm
 Collection of Candida and Rebecca Smith
 (by courtesy of M. Knoedler & Co., Inc., New York)

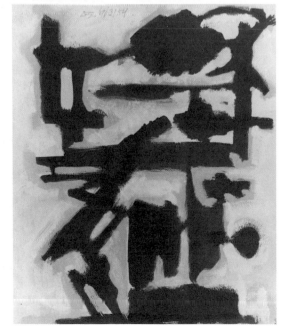

87
Untitled 1954
Mixed media in grey,
white and black
25.4 x 20.3 cm
Private collection

88
Untitled 1955
Brush and ink
43.2 x 53.3 cm
Collection of Candida
and Rebecca Smith (by
courtesy of M. Knoedler
& Co., Inc., New York)

89
Untitled 1955
Brush and ink
42.6 x 53.3 cm
Collection of Candida
and Rebecca Smith (by
courtesy of M. Knoedler
& Co., Inc., New York)

90
Untitled 1956
Brush and black, white and salmon-coloured ink
with tempera and grey oil colour
51.4 x 39.7 cm
Collection of Candida and Rebecca Smith
(by courtesy of M. Knoedler & Co., Inc., New York)

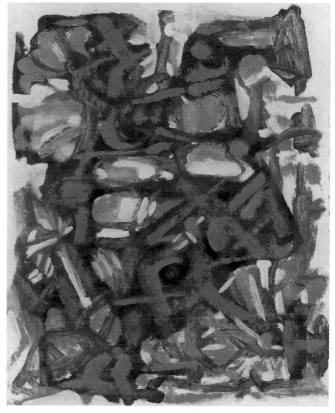

91
Untitled 1957
Black, blue and red oil colour
58.4 x 89.5 cm
Collection of Candida and Rebecca Smith
(by courtesy of M. Knoedler & Co., Inc., New York)

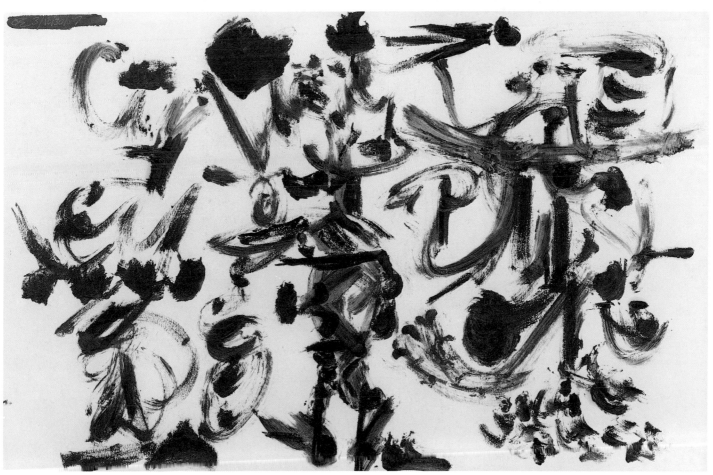

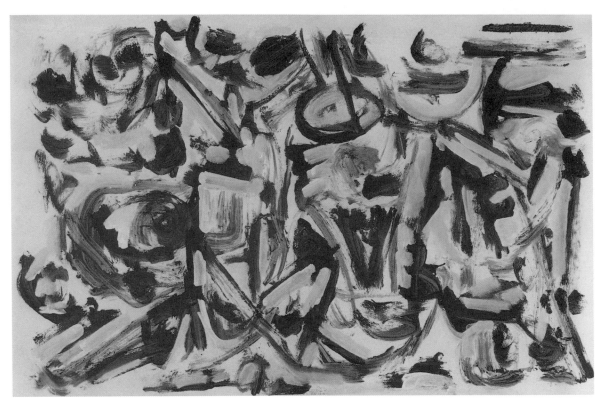

92 Untitled 1957
 Yellow, blue, red and white oil colour 58.4 x 89.5 cm
 Collection of Candida and Rebecca Smith (by courtesy of M. Knoedler & Co., Inc., New York)

93 Untitled 1957
 Yellow, blue, red and black oil colour 58.4 x 89.5 cm
 Collection of Candida and Rebecca Smith (by courtesy of M. Knoedler & Co., Inc., New York)

94 Untitled 1957
 Brush and ink 68 x 101.6 cm
 Collection of Candida and Rebecca Smith (by courtesy of M. Knoedler & Co., Inc., New York)

95 Untitled 1957
 Brush and ink 68 x 101.3 cm
 Collection of Candida and Rebecca Smith (by courtesy of M. Knoedler & Co., Inc., New York)

96
Untitled 1957
Mixed media in black and white
69 x 101.5 cm
Wilhelm-Lehmbruck-Museum
der Stadt Duisburg

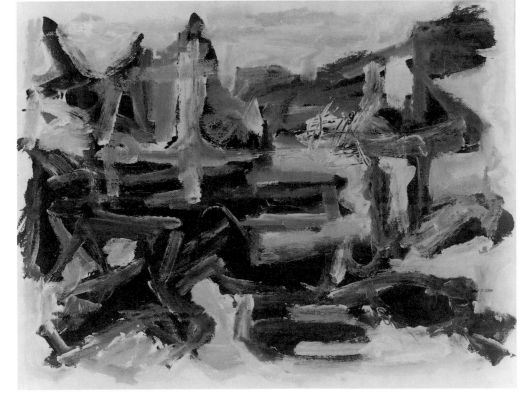

97
Untitled 1957
Brush and ink, red and white
oil colour and tempera
40 x 51.8 cm
Collection of Candida and Rebecca
Smith (by courtesy of M. Knoedler
& Co., Inc., New York)

98
Untitled 1957
Brush and ink on Japanese paper
44.5 x 57.2 cm
Collection of Candida and Rebecca Smith
(by courtesy of M. Knoedler & Co., Inc., New York)

99
Untitled 1957
Brush and ink on Japanese paper
44.5 x 57.2 cm
Collection of Candida and Rebecca Smith
(by courtesy of M. Knoedler & Co., Inc., New York)

100
Untitled 1957
Brush and purple ink on Japanese paper
44.5 x 57.2 cm
Collection of Candida and Rebecca Smith
(by courtesy of M. Knoedler & Co., Inc., New York)

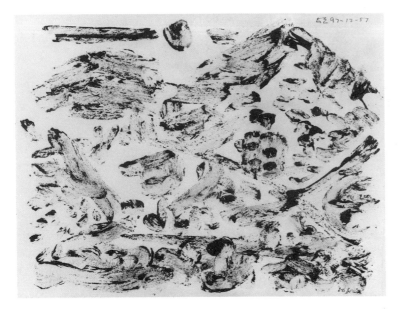

101
Untitled 1957
Brush and ink on Japanese paper
44.5 x 57.2 cm
Collection of Candida and Rebecca Smith
(by courtesy of M. Knoedler & Co., Inc., New York)

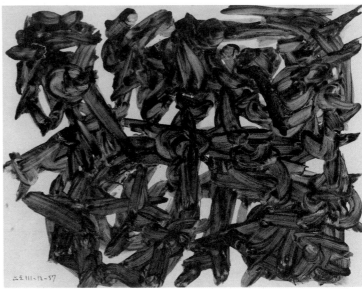

102
Untitled 1957
Brush and ink on Japanese paper
44.5 x 57.2 cm
Collection of Candida and
Rebecca Smith (by courtesy of
M. Knoedler & Co., Inc., New York)

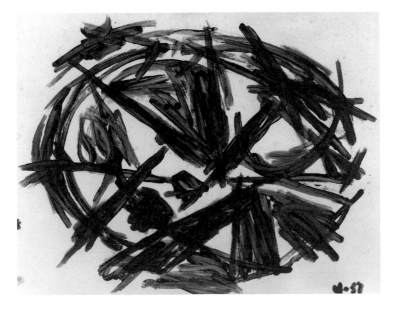

103
Timeless Clock 1957
Brush and ink
51.4 x 66.7 cm
Collection of Candida and Rebecca Smith
(by courtesy of M. Knoedler & Co., Inc., New York)

104 Untitled 1958
Brush and red and green ink with tempera 67.3 x 101 cm
Collection of Candida and Rebecca Smith (by courtesy of M. Knoedler & Co., Inc., New York)

105 Untitled 1958
Brush and ink 68 x 101 cm
Collection of Candida and Rebecca Smith (by courtesy of M. Knoedler & Co., Inc., New York)

106
Untitled 1958
Spray drawing
44.5 x 28.9 cm
Collection of Candida and Rebecca Smith
(by courtesy of M. Knoedler & Co., Inc., New York)

107
Untitled 1959
Brush and violet ink
51.6 x 66 cm
Gabriele Henkel, Düsseldorf

108 Untitled 1959
 Brush and ink
 45.7 x 57.2 cm
 Collection of Candida and
 Rebecca Smith (by courtesy
 of M. Knoedler & Co., Inc.,
 New York)

109
Untitled 1959
Brush and ink with grey
tempera 45.7 x 57.2 cm
Collection of Candida and
Rebecca Smith (by courtesy
of M. Knoedler & Co., Inc.,
New York)

110 Untitled 1959
 Brush and ink 67.3 x 101.6 cm
 Collection of Candida and Rebecca Smith (by courtesy of M. Knoedler & Co., Inc., New York)

111 Untitled 1959
 Brush and ink 67.3 x 101.6 cm
 Collection of Candida and Rebecca Smith (by courtesy of M. Knoedler & Co., Inc., New York)

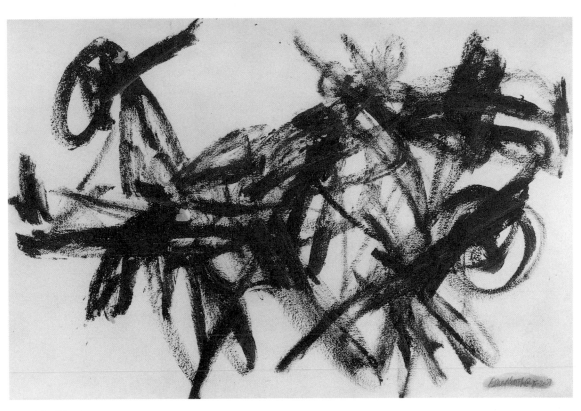

112 Untitled 1959
 Brush and ink with tempera 67.3 x 101.6 cm
 Collection of Candida and Rebecca Smith (by courtesy of M. Knoedler & Co., Inc., New York)

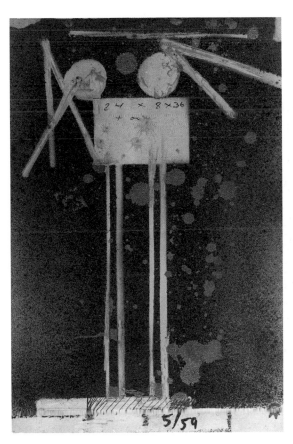

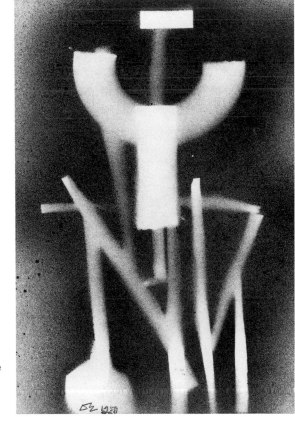

113
Untitled 1959
Spray drawing
44.5 x 29.2 cm
Collection of Candida
and Rebecca Smith (by
courtesy of M. Knoedler
& Co., Inc., New York)

114
Untitled 1959
Spray drawing
44.5 x 29.2 cm
David Smith Estate
(by courtesy of
Anthony d'Offay,
London)

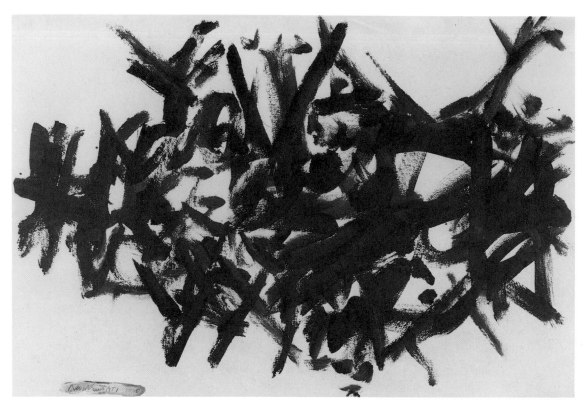

115 Untitled 1960
 Brush and ink 68 x 101 cm
 Collection of Candida and Rebecca Smith (by courtesy of M. Knoedler & Co., Inc., New York)

116 Untitled 1960
 Brush and ink 68 x 101 cm
 Collection of Candida and Rebecca Smith (by courtesy of M. Knoedler & Co., Inc., New York)

117 Untitled 1960
Mixed media in brown, green, red and blue 66.5 x 104.3 cm
Collection of Henkel KGaA, Düsseldorf

118 Untitled 1960
Mixed media in black and white 76 x 102 cm
Collection of Henkel KGaA, Düsseldorf

119
Untitled 1960
Brush and brown ink
39.4 x 52.1 cm
Collection of Candida and Rebecca Smith
(by courtesy of M. Knoedler & Co., Inc.,
New York)

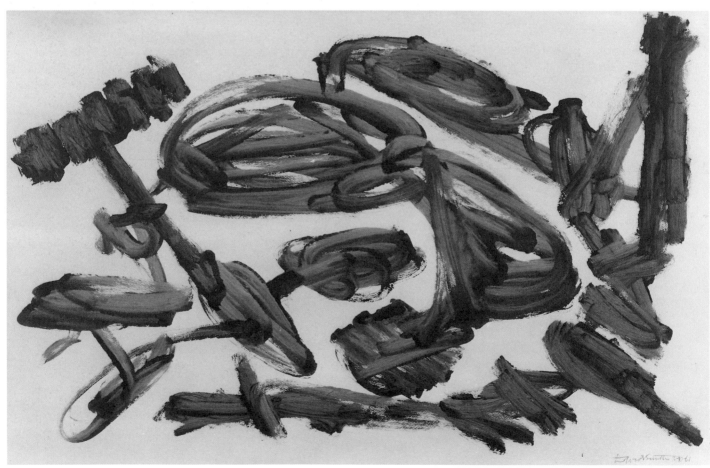

120 Untitled 1961
 Brush and ink 55.9 x 75.9 cm
 Collection of Candida and Rebecca Smith (by courtesy of M. Knoedler & Co., Inc., New York)

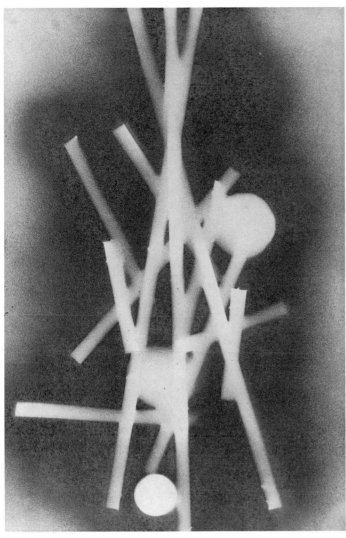

121 Untitled 1961
 Spray drawing 43.2 x 29.2 cm
 David Smith Estate (by courtesy of M. Knoedler & Co., Inc.,
 New York)

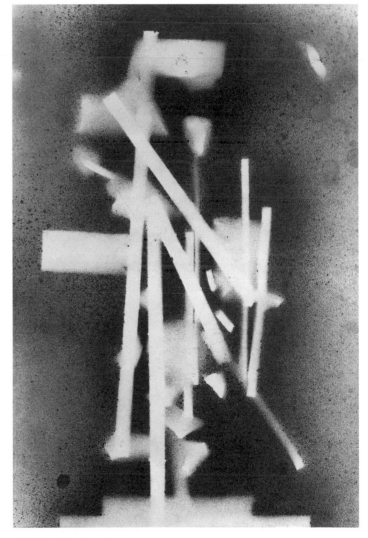

122 Untitled 1961
 Spray drawing 44.5 x 29.2 cm
 David Smith Estate (by courtesy of the Anthony d'Offay
 Gallery, London)

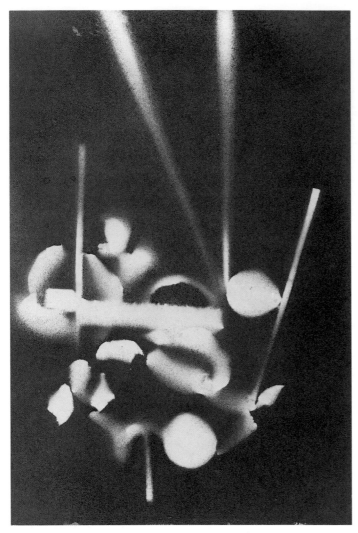

123 Untitled 1962
 Spray drawing 44.5 x 29.2 cm
 Collection of Candida and Rebecca Smith
 (by courtesy of M. Knoedler & Co., Inc., New York)

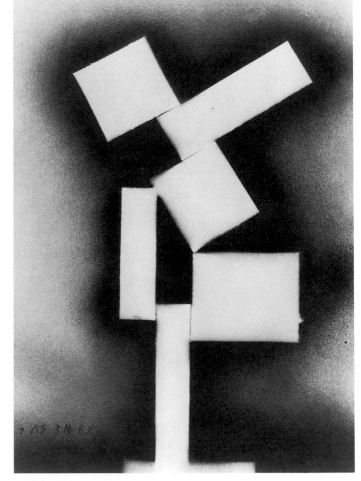

124 Untitled 1963
 Spray drawing 41.3 x 29.2 cm
 Collection of Candida and Rebecca Smith
 (by courtesy of M. Knoedler & Co., Inc., New York)

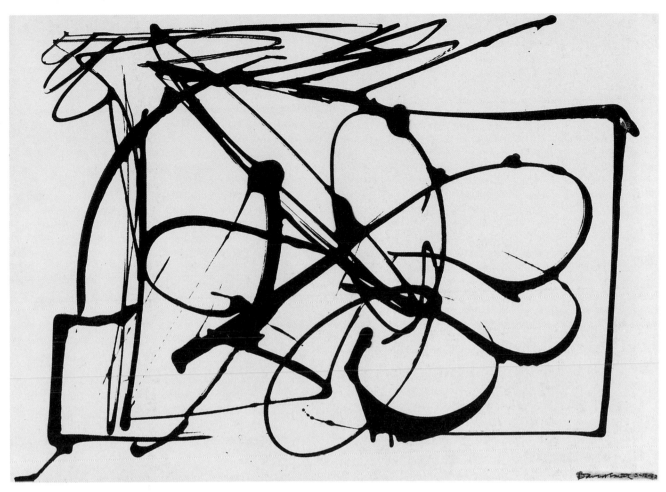

125
Untitled 1963
Black varnishing paint
48.2 x 66.3 cm
Private collection

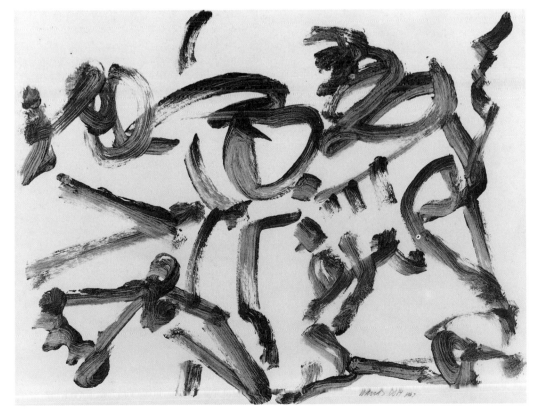

126
Untitled 1963
Brush and brown ink
on Japanese paper
44.5 x 57.2 cm
Collection of Candida and
Rebecca Smith (by courtesy of
M. Knoedler & Co., Inc.,
New York)

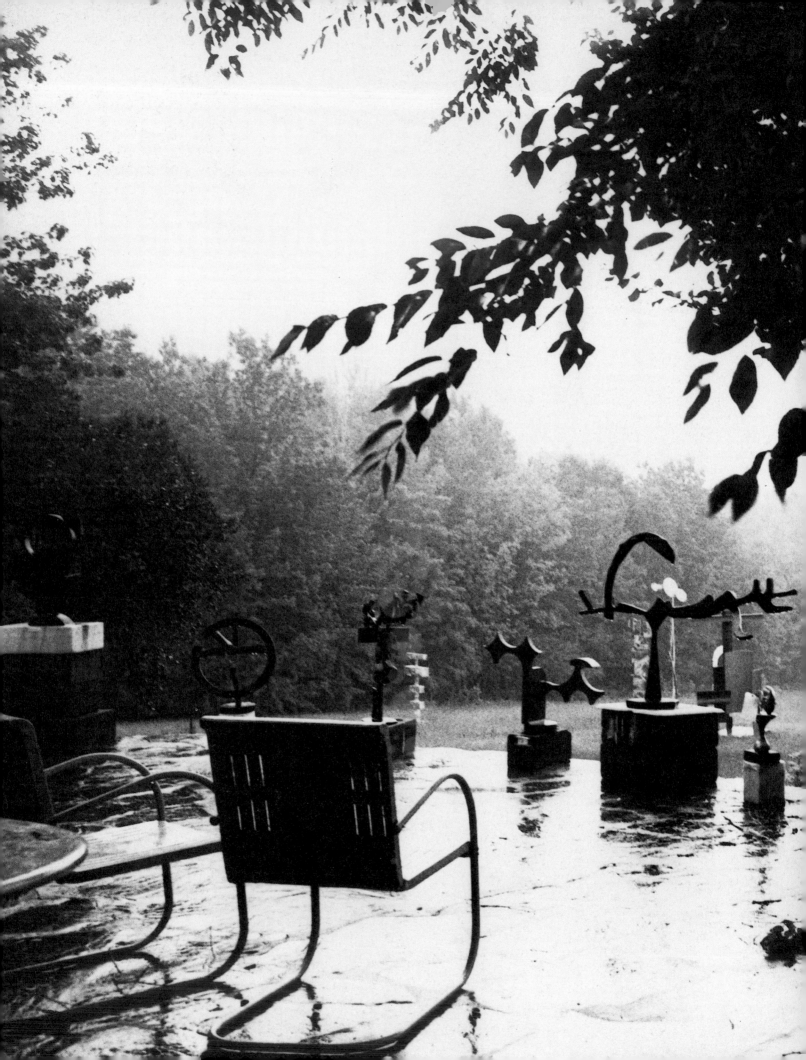

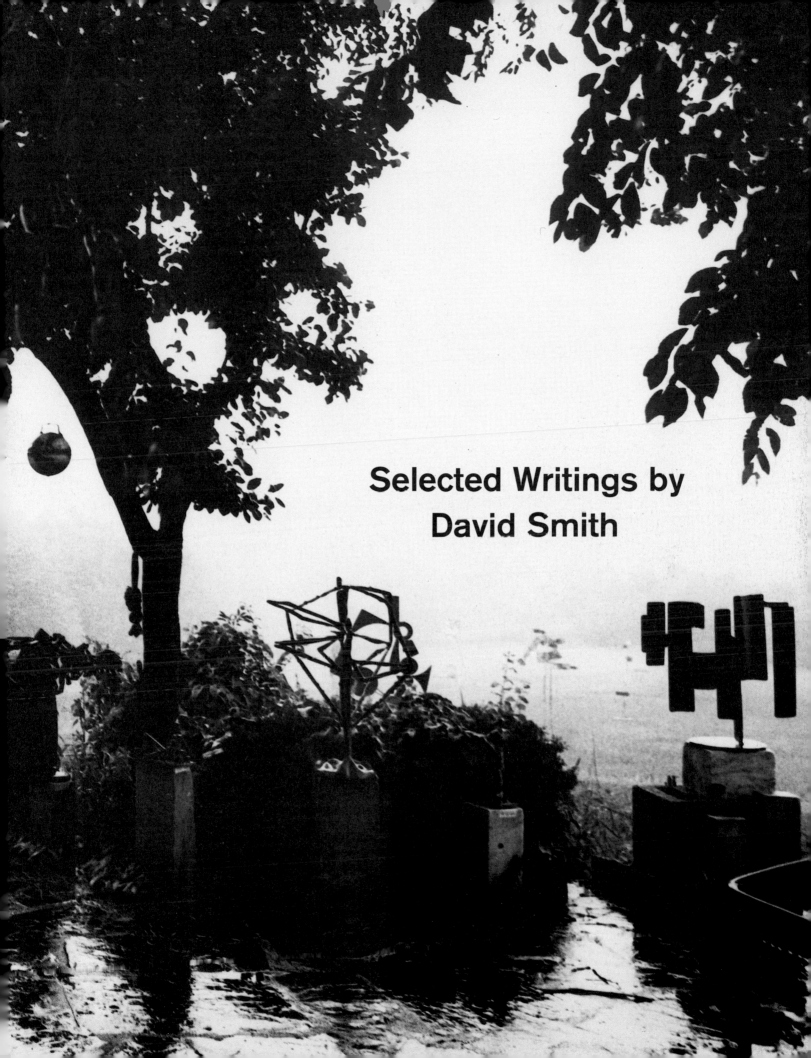

Selected Writings by
David Smith

Notes for "David Smith Makes a Sculpture"

David Smith wrote these notes for Elaine de Kooning for her article on his work published in Art News, *September 1951. They were printed intact in* Art News, *January 1969.*

I follow no set procedure in starting a sculpture. Some works start out as chalk drawings on the cement floor, with cut steel forms working into the drawings. When the structure can become united, it is welded into position upright. Then the added dimension requires different considerations over the more or less profile form of the floor drawing assembly.

Sometimes I make a lot of drawings using possibly one relationship on each drawing which will add up in the final work. Sometimes sculptures just start with no drawing at all. This was the case of *The Fish,* which is some six feet high and about five feet long. My drawings are made either in work books or on large sheets of linen rag. I stock bundles of several types, forgetting the cost so I can be free with it. The cost problem I have to forget on everything, because it is always more than I can afford – more than I get back from sales – most years, more than I earn. My shop is somewhat like the Federal Government, always running with greater expenditures than income and winding up with loans.

For instance, 100 troy ounces of silver solder cost over $100, phoscopper costs $4 a pound, nickel and stainless steel electrodes cost $1.65 to $2 a pound, a sheet of stainless steel ⅛ inch thick, four feet by eight feet costs $83, etc. When I'm involved aesthetically I cannot consider cost, I work by the need of what each material can do. Usually the costly materials do not even show, as their use has been functional.

The traditions for steel do not exist that govern bronze finishes, patinas, or casting limits. There are no preconceived limits established as there are for marble, the aesthetics of grain and surface or the physical limits of mass to strength. Direction by natural grain, hand rubbing, monolithic structure, or the controls of wood do not apply physically or traditionally to steel.

Steel has the greatest tensile strength, the most facile working ability, as long as its nature relates to the aesthetic demand. It can join with its parent metal or other metals varying in colors, or act as a base for metal deposition, paint, or its own natural oxide, [the molecule of] which is only one oxygen atom less than the artistic range of iron oxides.

I have two studios. One clean, one dirty, one warm, one cold. The house studio contains drawing tables, etching press, cabinets for work records, photos, and drawing paper stock. The shop is a cinderblock structure, transite roofed, and has a full row of north window skylights set at a 30 degree angle. With heat in each end it is usable to zero weather.

I do not resent the cost of the best material or the finest tools and equipment. Every labor-saving machine, every safety device I can afford I consider necessary. Stocks of bolts, nuts, taps, dies, paints, solvents, acids, protective coatings, oils, grinding wheels, polishing discs, dry pigments, waxes, chemicals, spare machine parts, are kept stacked on steel shelving, more or less patterned after a factory stockroom.

Stainless steel, bronze, copper, aluminum are stocked in ⅛ inch by 4 foot by 8 foot sheets for fabricating. Cold and hot rolled 4 foot by 8 foot sheets are stacked outside the shop in thicknesses from ⅛ inch to ⅞ inch. Lengths of strips, shapes, and bar stock are racked in the basement of the house or interlaced in the joists of the roof. Maybe I brag a bit about my

stock, but it is larger since I've been on a Guggenheim Fellowship than it ever has been before. I mention this not because it has anything to do with art, but it indicates how important it is to have material on hand, that the aesthetic vision is not limited by material need, which has been the case too much of my life.

By the amount of work I produce it must be evident that the most functional tools must be used. I've no aesthetic interest in tool marks; my aim in material function is the same as in locomotive building, to arrive at a given functional form in the most efficient manner. The locomotive method bows to no accepted theory in fabrication. It stands upon the merit of the finished product. The locomotive function incorporates castings, forgings, rivets, welding, brazing, bolts, screws, shrink fits, all used because of their respective efficiency in arriving at a functioning object. Each method imparts its function to varying materials. I use the same method in organizing the visual aesthetic end. I make no claim for my work method over other mediums. I do not use it to the exclusion of other mediums. A certain feeling for form will develop with technical skill, but imaginative form (viz. aesthetic vision) is not a guarantee for high technique.

I handle my machines and materials with ease – their physical resistance and the noise they make in use do not interfere with my thinking and aesthetic flow. The change of one machine or tool to the other means no more than changing brushes to a painter or chisels to a carver.

I do not accept the monolithic limit in the tradition of sculpture. Sculpture is as free as the mind, as complex as life, its statement as full as the other visual mediums combined. I identify form in relationship to man. The front view of a person is ofttimes complete in statement. Sculpture to me may be 1-2-3-4 sides and top view since the bottom by law is the base. Projection of indicated form, continuance of an uncompleted side I

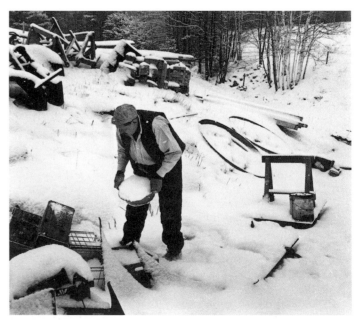

David Smith sorting out materials at Bolton Landing in 1962

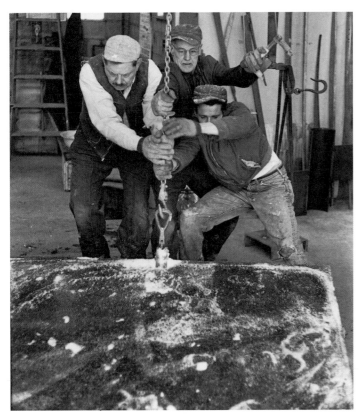

David Smith with Leon Pratt (centre) at Bolton Landing in 1962

leave to the viewer or the suggestion of a solid by lines, or the vision of the forms revolving at given or varying speeds. All such possibilities I consider and expect the viewer to contemplate.

When such incompletions are evident, usually there are directives which can enable the viewer to complete the concept with the given form. The art form should not be platitudinous, predigested, with no intellectual or emotional demands on the consumer.

When I make sculpture all the speeds, projections, gyrations, light changes are involved in my vision, as such things I know in movement associate with all the possibilities possible in other relationships. Possibly steel is so beautiful because of all the movement associated with it, its strength and function. Yet it is also brutal, the rapist, the murderer, and death-dealing giants are also its offspring. But in my Spectre series, I speak of these things and it seems most functional in its method of statement.

Since 1936 I have modeled wax for single bronze castings. I have carved marble and wood, but the major number of works have been steel, which is my most fluent medium and which I control from start to completed work without interruption. There is gratification of being both conceiver and executor without intrusion. A sculpture is not quickly produced; it takes time, during which time the conviction must be deep and lasting. Michelangelo spoke about noise and marble dust in our profession, but I finish the day more like a greaseball than a miller. But my concepts still would not permit me to trade it for cleaner pursuits.

Distance within the work is not an illusion, it relates to the known measure known as inches in most of our considerations. Inches are rather big, monotonous chunks related to big flat

feet. The only even inch relationship will be found in the sculpture base wherein the units 4-6-8-12, etc., are used in mechanical support. Rarely will an even inch be involved in visual space, and when it is approached it will occur plus or minus in variants of odd thousandths, odd 64ths, 32nds, and 16ths. This is not planned consciously. It is not important, but is my natural reaction to symbolic life. Unit relationships within a work usually involve the number 7 or a division of its parts. I wasn't conscious of this until I looked back, but the natural selection seems influenced by art mythology.

My work day begins at 10 or 11 a.m. after a leisurely breakfast and an hour of reading. The shop is 800 feet from the house. I carry my 2 p.m. lunch and return to the house at 7 for dinner. The work day ends from 1 to 2 a.m. with time out for coffee at 11:30. My shop here is called the Terminal Iron Works, since it closer defines my beginning and my method than to call it 'studio'.

At 11.30 when I have evening coffee and listen to WQXR on AM, I never fail to think of the Terminal Iron Works at 1 Atlantic Avenue, Brooklyn, and the coffeepot nearby where I went, same time, same station. The iron works in Brooklyn was surrounded by all-night activity – ships loading, barges refueling, ferries tied up at the dock. It was awake 24 hours a day, harbor activity in front, truck transports on Furman Street behind. In contrast the mountains are quiet except for occasional animal noises. Sometimes Streevers's hounds run foxes all night and I can hear them baying as I close up shop. Rarely does a car pass at night. There is no habitation between our road and the Schroon River four miles cross country. I enjoy the phenomenon of nature, the sounds, the Northern Lights, stars, animal calls, as I did the harbor lights, tugboat whistles, buoy clanks, the yelling of men on barges around the T.I.W. in Brooklyn. I sit up here and dream of the city as I used to dream of the mountains when I sat on the dock in Brooklyn.

I like my solitude, black coffee, and daydreams. I like the changes of nature; no two days or nights are the same. In Brooklyn what was nature was all manmade and mechanical, but I like both. I like the companionship of music, I sometimes can get WNYC but always WQXR, Montreal, Vancouver, or Toronto. I use the music as company in the manual labor part of

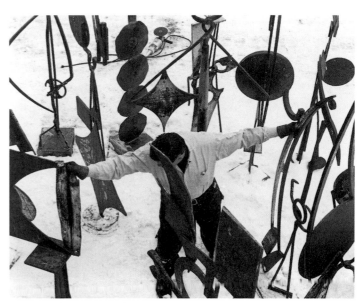

David Smith at Bolton Landing in 1962

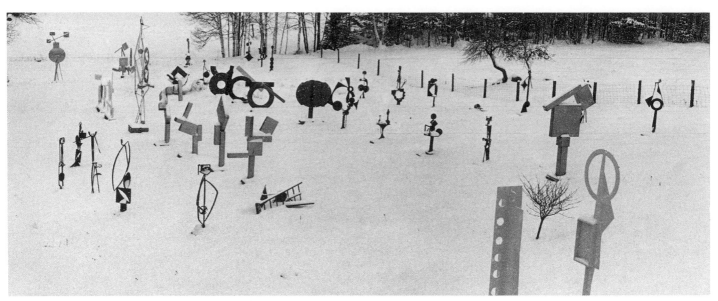

The northern sculpture park at Bolton Landing (from the north-west) in 1965

sculpture, of which there is much. The work flow of energy demanded by sculpture wherein mental exhaustion is accompanied by physical exhaustion provides the only balance I've ever found, and as far as I know is the only way of life.

Of course I get rides on. When I'm working I get so wound up with work that sleep doesn't come and I work through to 3-4-5 in the morning. This I did back in Brooklyn. All my life the work day has been any part of the 24, on oil tankers, driving hacks, going to school, all three shifts in factories. I once worked in a bank, but cannot stand the routine life. Any two-thirds of the 24 hours are wonderful as long as I can choose.

After 1 a.m. certain routine work has to be done, clearing up, repairing machines, oiling, painting, etc. I tune in WOR and listen to Nick's, Café Society, Eddie Condon's, whoever is on. After several months of good work, when I feel I deserve a reward, I go to New York, concerts at YMHA, gallery shows, museums, eat seafood, Chinese, go to Eddie's, Nick's, Sixth Avenue Cafeteria, Artists Club, Cedar Tavern, run into up-late artists, bum around chewing the fat, talk shop, finish up eating breakfast on Eighth Street, and ride it as hard and as long as I can for a few days, then back to the hills.

Sculpture is a problem. Both to me and to my dealer, the Willard Gallery. Aside from sales, the problem of transport and storage is immense. The intrinsic cost ofttimes is half its price,

and never less than one-third. Only a few serious dealers handle it; some museums and a few collectors buy it. As dwelling space contracts, the size and concept of sculpture increases. I foresee no particular use, other than aesthetic, in society, least of all architecture. But demand was never the thing that made art in our period of civilization.

Sometimes I work on two and possibly four pieces at one time, conceptually involved on one, conceptually in abeyance on another waiting for relationships to complete; and on one or two others finished but for a casting to come from the foundry or grinding, finishing and a few hours of manual labor waiting to be done. Sometimes it's only a matter of mounting, weighing, measuring, and naming. Such detail work fits in schedule when the muse has gone. I maintain my identity by regular work, there is always labor when inspiration has fled, but inspiration returns quicker when identity and the work stream are maintained. Actually time overtakes much of my projects. I get only half of my vision into material form. The rest remains as drawings, which, after a certain time growth, I cannot return to because the pressing demand is the future. I have no organized procedure in creating. *The Fish* went through from start to finish with a small drawing in my work book, during its middle stage. *The Cathedral* matured from start to finish with no drawings. Usually there are drawings, anything from sketches in pocket notebooks to dozens of big sheet paintings.

Perception and Reality

This speech, given at Williams College, Williamstown (Massachusetts), on 17 December 1951, is one of several variations on the same theme presented by Smith during the early 1950s.

I wish to remind you of the hypocritical world that art enters. One Pulitzer Prize poet stated that "vitamins and profits alone are not worth dying for… The republic was founded and preserved by men and women who frankly acknowledged themselves dependent on God." I find poet [Robert] Hillyer a dreamer. I find such noble concepts to be the pretense of our

people with their practice nowhere near the pretense, as in the case of most stated American glories: freedom, equality, the ten commandments, the bill of rights. Belief is belied by compromise and contradiction in behavior.

The bastardization which materialistic enterprise has inflicted upon both culture and spiritual response by its control

of communication media is all too evident. Truth, as it relates to the republic and its democratically elected officials, is a *qualified theorem* in the eyes of the average man. The poetic use of words has been ruined by commercials. *That one hour* in a hundred on the radio when classical music is presented is cut and graded for the purpose of softening the audience preparatory to the commercial, a mollifying delivery of quarter truths. The type of classical music played is important here; it must be familiar, and, as Virgil Thomson has pointed out, one of a standard repertoire of fifty symphonies. A contemporary classic such as a Schönberg composition is not a safe or suitable introduction to a soothing commercial. Hence the value and necessity of universally accepted symphony music to the world of sponsors, whose choice ultimately sets the limits to what is called in the trade, our listening pleasure.

It is no wonder that when the artist speaks with what he calls truth, the audience, accustomed to censored digests and synthetic catharsis, views it as a foreign language. Art divorced from commercial persuasion, having little dollars-and-cents value, is regarded with suspicion.

People wanting to be told something, *given the last word*, will not find it in art. Art is not didactic. It is not final; it is always waiting for the projection of the viewer's perceptive powers. Even from the creator's position, the work represents a segment of his life, based on the history of his previous works, awaiting the continuity of the works to follow. In a sense a work of art is never finished.

My concept as an artist is a revolt against the well-worn beauties in the form of a statue. Rather I would prefer my assemblages to be the savage idols of basic patterns, the veiled directives, subconscious associations, *the image recall* of orders more true than the object itself, resulting in vision, in aura, rather than object reality.

No two people see the same work of art because no two people are each other. No two people see the same apple or pear, because a pear is not a pear except in theory. When seen, a pear is an image. It is red, green, hard, soft, juicy, rotten, falling, rolling, segmented, sweet, sour, sensuously felt. A pear is a violin, a pear is a woman's hips. Pear and violin have strings, woman has hair. Pear and woman have seeds, violin has notes, soft violin, hard woman, sour notes – associations can go on indefinitely only to show that a fruit can only exist as an eidetic image because it cannot exist in reality without associations.

If a painter paints a pear, the beholder's mind can select and experience the desired action in a flash. The depth of association, hence the completeness of the image in this recognition flash, is dependent upon the will of the beholder. The response to pear varies greatly, depending upon what comes through after censoring, and so it is with the response to art. Neither perception of pear nor perception of a painting requires faculties beyond those of an average man. Perception through vision is a highly accelerated response, so fast, so complex, so free that it cannot be pinned down by the very recent limited science of word communication. To understand a work of art, it must be seen and perceived, not worded. Words can be used to place art historically, to set it in social context, to describe the movements, to relate it to other works, to state individual preferences, and to set the scene all around it. But the actual understanding of a work of art only comes through the process by which it was created – and that was by perception.

The Language is Image

From Arts and Architecture, *February 1952*

The words I use in talking about art do not bear close relationship to making art, nor are they necessary directives or useful explanations. They may represent views that govern some choice in sublimation – censored exchange or as opposites. When I work the train of thought has no words, it is simply all in the visual world, the language is image. If I write it is not at the expense of my work, it is done during travel and nonwork pursuit. Probably I resent the word world (Joyce, etc., excepted) because it has become the tool of pragmatists, has shown limited change, has rejected creative extension. It seems that the pragmatists have turned words against their creators when dealing with perception. Most of the words on art have been an actual hindrance to the understanding of art perception. This anti-art verbiage starts in elementary grades and is constant throughout the majority of educational institutions, both state and sectarian.

Judging from cuneiform, Chinese and other ancient texts, the object symbols formed identities upon which letters and words were later developed. Their business and exploitation use has become dominant over their poetic-communicative use, which explains one facet of their inadequacy.

Thirty or forty thousand years ago primitive man did not have the word picture, nor this demand for limited vision. His relationship to the object was with all its parts and function, by selection, or the eidetic image.

Since recorded origins true perception in art has had various official safeguards and mono-interpretations, such limits in making art or receiving art being more or less law and answering to one interpretation, usually literary or confined to an official symbol language for religio-commercial use.

The cave man from Altamira to Rhodesia had produced true reality by the eidetic image. This image even today defies word explanation as does any art, since it is simply to be received by a totally different physical sense.

The true reality of an apple is not any one naturalistic image. The eye of man is not a camera eye, it is a cerebral eye. It is not a two-dimensional photograph, nor any one view. The reality is actually all apples in all actions. Apples are red, yellow, green, round, halved, quartered, sweet, sour, rotten, sensuously felt, hanging, crushed to juice, and all the associations two years would take to tabulate, yet when stimulated the mind can select and experience the desired action in a flash; 'apple' is meaningless without memory.

Perception through vision is a highly accelerated response, so fast, so complex, so free that these qualities are unattainable by the very recent limited science of word communication.

In perceiving, all men are potentially equal. The mind records everything the senses experience. No man has sensed anything another has not, or lacks the components and power to assemble. The word version of art represents both censoring

View out onto the southern sculpture park at Bolton Landing in 1962

and prejudice. Yet it is the version educational institutions advocate and is the general public's basic response. Yet perception open to any man, in any status, ignores the language barrier.

My realities giving impetus to a work which is a train of hooked visions arise from very ordinary locales – the arrangement of things under an old board; stress patterns; fissures; the structure pattern of growth; stains; tracks of men, animals, machines; the accidental or unknown order of forces; accidental evidences such as spilled paint, patched sidewalks, broken parts, structural faults; the force lines in rock or marble laid by glacial sedimentation. Realistic all, made by ancient pattern or unknown force to be recorded, repeated, varied, transformed in analogy or as keys to contemporary celebrations. Some works are the celebration of wonders. After several of these a specter. In my life, joy, peace are always menaced. Survival, not only from commercial destruction but the threat of daily existence, the battle of money for material – and welfare during.

I date my aesthetic heritage from Impressionism. Since Impressionism, the realities from which art has come have all been the properties of ordinary man; the still life has been from the working man's household; the characters, environment, landscape have been of common nature. The bourgeois or

upper-class reality and grandeur pretension have not been the realities which the artist's eyes have transformed. The controls of my art are not outside the daily vision of common man. The vision and organization are very personal and, I hope, my own.

The hostile demand for reality usually is the stopped image, which to me has no place in art, being a totally different value from perception and one related more to photography than art. Hostility to art often exists as a fear of a misunderstood intellectualism.

Primitive man attained the eidetic image. This must have been attained by great desire and affection. At least it was not hostility based on historic standards or censored by self-consciousness.

Limits and lack may exist in the artist's sense-presentation. Some artists produce for greater sense-perception. Perception is a quality which all men exercise, there being a difference in degree. The creation of known forms or symbols, related or associated into a new image not existing before, does not exclude it from understanding; since it comes from common subconscious registry, nothing is secret or mystical.

For instance, the sculpture called *Hudson River Landscape* came in part from drawings made on a train between Albany and Poughkeepsie. A synthesis of drawings from ten trips over a seventy-five mile stretch; yet later when I shook a quart bottle of India ink it flew over my hand, it looked like my landscape. I placed my hand on paper – from the image left I traveled with the landscape to other landscapes and their objects – with additions, deductions, directives which flashed past too fast to tabulate but elements of which are in the sculpture. Is *Hudson River Landscape* the Hudson River or is it the travel, the vision; or does it matter? The sculpture exists on its own, it is an entity. The name is an affectionate designation of the point prior to the travel. My object was not these words or the Hudson River but the existence of the sculpture. Your response may not travel down the Hudson River, but it may travel on any river or on a higher level, travel through form-response by choice known better by your own recall. I have intensified only part of the related clues; the sculpture possesses nothing unknown to you. I want you to travel, by perception, the path I traveled in creating it.

You can reject it, like it, pretend to like it, or almost like it, but its understanding will never come with words, which had no part in its making, nor can they truly explain the wonders of the human sensorium.

The Artist and Nature

Address given at the University of Mississippi on 8 March 1955

To talk about nature as the artist's subject has been more the preoccupation of those who do not like to look at art but need easily recognizable objects to talk about. Nature has especially been the harangue of professional critics who lack the courage to oppose openly certain advanced schools of art.

The demand for nature usually boils down to the fact that what is wanted are echoes instead of invention. At times artists talk about nature and state dependence upon it. Some echo the demand made by critical expectancy. Some use the word in their own particular terms with their own meaning. After all, everything that happens in art must happen in nature.

An attitude critical of nature comes from those outside of art making and usually represents a limited vision. Artists learn more from art than from nature. Works of art are more the artist's identity than nature-object identity. But with the change of time, and the change in environment, different artists choose different aspects of nature. Nature, after all, is everything and everybody. It is impossible for any artist not to be of nature or to deal with problems other than those of nature. On the whole, we are more compassionate than to view nature critically. Being a part of nature we do not question it. We accept it and as one of its elements called creative man, we function.

Reality better represents the artist's term for his position and that, like his own term for nature, includes man the artist along with his imagination. Reality includes the visual memory of all art, and the working reality of his particular art family. The heritage to which he is born is something he knows and accepts as his identity, as one knows and feels his own personal family. His interest in reality is not its prosaic representation but the poetic transposition of it.

Like primitive man, the artist often imagines reality better than he can understand or explain it. In fact, the whole creative process in art flows by vision, without questioning it, without words or even the thought of explanation.

The eidetic image, the after-image, is more important than the object. The associations and their visual patterns are often more important than the object. Ambivalences in visual terms may be more expressive. White is more white when it is dominantly black. Visual metaphoric exchange is perceived daily in many ways. When it is verbalized its poetic value is lost. The mind's eye and not the mirror eye contributes to the perceptual realization of art-making more than the reporting view or the idea way.

From the most recent contemporary view the only reality the artist need recognize is that he is the artist. Within this realization he identifies himself as the maker of art, independently, personally, wholly devoted. The maker of art is his nature and his reality. In effect he becomes his own subject matter.

He has not arrived at this position suddenly and alone. It has been a family heritage, especially his art-family of the twentieth century. Impressionism, Post-Impressionism, Fauvism, Cubism, Constructivism, De Stijl, and Surrealism are all in his kinship.

The United States aesthetic at the turn of the century was dependent upon the European. Most of our artists studied in Paris, the art center of Europe, encountered, followed, or contributed to the various new and revolutionary ways art was forming. Beginning in 1909, Stieglitz's gallery in New York exhibited some returning painters essentially influenced by Post-Impressionism, namely Weber, Hartley, Maurer, [Bernard] Karfiol, and [Samuel] Halpert. This was the beginning of our change. After the Armory Show in 1913 early Cubism introduced another vision to accompany Post-Impressionism. For a short time these two movements stimulated United States artists to a semi-abstract position. The sculptors Archipenko, Laurent, and Lachaise became United States residents, bodily moving their work and views into the academy conservatism of the United States sculpture scene. There was no unifying stimulus and little public support. The conviction of the new view for most of the artists was not deep enough to last long. The concept of Cubism was still fluid, and not well defined – some of our painters got waylaid with Italian Futurism, its speed and machines which, in a way, was more definite due to the manifestos, writings, and organized effort. Most of our painters worked with a realist concept, applying a Futurist or Cubist rendering. Until 1940, the abstract painters or sculptors in our country could be counted in single numbers.

After 1946, the abstract painters and sculptors blossomed by thousands. With 1950, a new movement, yet unnamed for certain, but most often referred to as 'Abstract Expressionism', developed without manifesto or organization, indigenous and independent, the United States's first native art movement. The history of this is in process, the situation is still fluid. Claims are made that France had a simultaneous movement, but I believe history will show our lead. Some of the French critics have given this credit to us.

This movement in the United States was much like Cubism in France. Cubism was not an organized movement, but those who participated in it agree that its collective result came from each man's individual poetic vision and wholly within his own nature. Cubism did not include all the great artists and innovators in Europe at its peak of 1910–14 any more than Abstract Expressionism includes all the truly creative work in the United States up to 1955. The reference to schools by either name is most general.

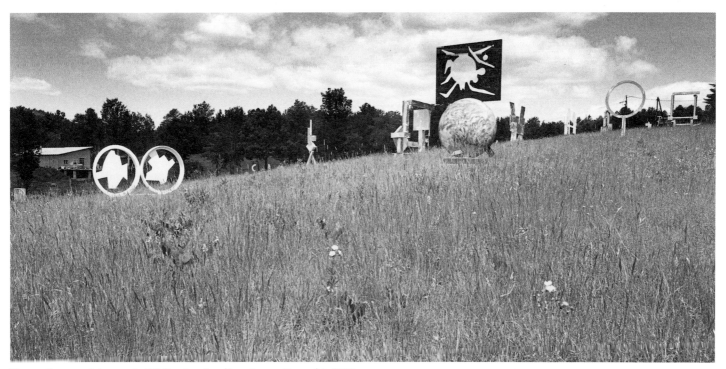

The southern sculpture park at Bolton Landing (from the south-west) in 1962

It doesn't matter particularly whether the French or United States artists were first. We have come of age, and intuitively create with an autonomous conviction. I couldn't begin to name these new-order painters and sculptors. There are thousands. Their number increases steadily in all parts of the country.

The masters, Picasso, Matisse, Bonnard, Rouault, Brancusi, Braque, etc., have stayed the masters. We are their inheritors as much as their own countrymen or the countries in which they have chosen to live.

Many Europeans have come to our country either as guests or refugees – Chagall, Léger, Miró, Masson, Klee, Moore, Brancusi, and many others. Even as visitors, they have fortified our art. Others like Lipchitz, Mondrian, Gabo, Duchamp have become United States residents, bringing part of the international heritage to our country. Nothing in particular, but in general many things have made our environment.

I suppose historians will be able to find reasons to suit their needs why we have happened, but I hope we are eclipsed as the relative beginning of a greater movement.

As we stand, we have no dependence upon the outsiders who say what art is, was, or should be. We realize that the aestheticians only can speak after the act of art. We are always ahead, and further separated from them by the fact that the heritage of our art is always visual and not verbal. The theory-laden historians truth-beauty calculations of past ages have no connection with us.

We work with our own convictions. We will stand or fall with the confidence that art is what we make.

Painting carried the creative banner at the turn of the century. Brancusi, our greatest living sculptor, was the only exception. Cubism, essentially a sculptural concept originated by painters, did more for sculpture than any other influence. Besides, some of the greatest departures in sculpture were made by painters. Both Picasso and Matisse contributed works with origins quite outside the sculptor's concept. Picasso made the first Cubist head in 1909. It was Picasso, working with another Spaniard, González, in 1929, who made the iron constructions utilizing 'found' or collected objects.

Cubism freed sculpture from monolithic and volumetric form as Impressionism freed painting from chiaroscuro. The poetic vision in sculpture is fully as free as in painting. Like a painting, sculpture now deals in the illusion of form as well as its own particular property of form itself. Both new vision and new material have contributed importances and new paths. But certainly what is most important on our scene is the identity the artist has attained.

Drawing

This lecture on drawing was developed from class notes and delivered at a forum conducted by George Rickey at Sophie Newcomb College, Tulane University of Louisiana, New Orleans (Louisiana), on 21 March 1955.

Many students think of drawing as something hasty and preparatory before painting or making sculpture. A sort of purgatory between amateurism and accomplishment. As a preliminary before the great act, because everybody can draw some, and children are uninhibited about it and do it so easily, and writing

The painting studio at Bolton Landing in 1962

itself is a style of drawing, and it is common on sidewalks, board fences, phone booths, etc.

But actually only a very experienced artist may appreciate the challenge, because it is so common an expression. It is also the most revealing, having no high expectancy to maintain, not even the authenticating quality of gold frames to artificially price or lend grandeur to its atmosphere. And, by its very conditioning, it comes much closer to the actual bareness of the soul and the nature of free expressionism.

It is not expected to carry the flourish, the professionalism of oil painting, nor the accuracy and mannered clarity in the formal brushing of the watercolorist.

If it is pompous, artificial, pretentious, insincere, mannered, it is so evident, so quick to be detected, and like the written line, it is a quickly recognized key to personality. If it is timid, weak, overbold or blustering, it is revealed much as one perceives it in the letter or a signature. There is not the demand or tradition for technique and conformity. The pureness of statement, the honesty of expression, is laid bare in a black-and-white answer of who that mark-maker is, what he stands for, how strong his conviction, or how weak. Often his true personality is revealed before repetitions or safer symbols can come to his defense. More his truth than other media with technique and tradition, more his truth than words can express, more free from thinking in words than polished techniques, drawing is more shaped like he is shaped, because the pressure of performance has not made him something he isn't.

The drawing that comes from the serious hand can be unwieldy, uneducated, unstyled and still be great simply by the superextension of whatever conviction the artist's hand projects and being so strong that it eclipses the standard qualities criti-

cally expected. The need, the drive to express can be so strong
that the drawing makes its own reason for being.

Drawing is the most direct, closest to the true self, the most
natural liberation of man – and if I may guess back to the
action of very early man, it may have been the first celebration
of man with his secret self – even before song.

But its need doesn't stand on primitive reconstruction –
anyone knows, everyone feels the need to draw. I truly believe
that anything anyone has seen he can draw, and that everyone
here has now seen everything he ever will see, and that all that
stands between his drawing anything in the world is his own
inhibition. What that is we don't know. Each must dig himself
out of his own mind and liberate the act of drawing to the
vision of memory. It is not so much that this correlation is
impossible – but more the mental block that keeps him from
trying that which he deems impossible.

We are blocked from creative ways of expressing by ways
we feel about things and by ways we think we ought to feel, by
word pictures that cancel out creative vision, and intimidations
that limit creative expression.

If drawing could come now as easily as when a man was six,
he would not doubt or think, he would do. But since he
approaches it more consciously and not with the child's free-
dom, he must admit to himself that he is making a drawing –
and he approaches mark-making humbly, self-consciously, or
timidly. Here he finds pressure and intimidation and inhibition.
But the first mark of drawing is made. Sometimes it takes cour-
age to make this one statement. This stroke is as good as he
can make, now. The next and those to come lead toward crea-
tive freedom. He must try to be himself in the stroke. He domi-
nates the line related to image and does not permit the image
to dominate him and the line. Not a line the way others think the
line should be – not how history says it once was; nor what
multitudes say they cannot do with a straight line. For a line so
drawn with conviction is straighter in context than the ruler.

The deviations outside mechanical realism, which, usually
with a bit of hostility, represent the average expectancy, are the
nature of human line – the inaccuracies, so-called, are often
other images trying to assert themselves in association. And
the truth of image is not single, it is many – the image in
memory is many actions and many things – often trying to
express its subtle overlapping in only one line or shape.

Simply stated, the line is a personal-choice line. The first
stroke demands another in complement, the second may
demand the third in opposition, and the approach continues,
each stroke more free because confidence is built by effort. If
the interest in this line gesture making is sustained, and the

Life drawing at Bolton Landing

freedom of the act developed, realization to almost any answer
can be attained. Soon confidence is developed and one of the
secrets of drawing felt, and marks come so easily and move so
fast that no time is left to think.

Even the drawing made before the performance is often
greater, more truthful, more sincere than the formal production
later made from it. Such a statement will find more agreement
with artists than from connoisseurs. Drawings usually are not
pompous enough to be called works of art. They are often too
truthful. Their appreciation neglected, drawings remain the life
force of the artist.

Especially is this true for the sculptor, who, of necessity,
works in media slow to take realization. And where the original
creative impetus must be maintained during labor, drawing is
the fast-moving search which keeps physical labor in balance.

The Sculptor's Relationship to the Museum, Dealer and Public

Address given at the First Woodstock Conference of Artists in Woodstock, New York State, on 29 August 1947.

I was a member of a steelworkers' union that fights for you and
watches over your welfare. An artists' organization is an entirely
different thing in the sense that its problems are different, but
nevertheless there are certain grounds that everybody has in
the straight battle. There are economic factors that benefit all of
us, in any equity organization or brotherhood. The artist's pro-
duct varies according to his individual ability. His concept and

concept-battle is pretty much of an individual affair. The eco-
nomic battle is much the same for all creative artists.

Exhibiting with museums and societies offers little economic
salvation. In most societies and some museums an exhibition
fee is levied, which when added to the expense of packing,
shipping, and insuring makes the artist pay dearly to show his
child. The salvation appears to be in the business contact

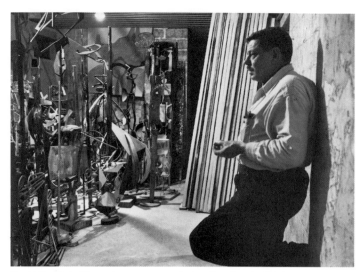

David Smith in his sculpture store at Bolton Landing in 1962

known as the dealer. But there are not enough dealers to represent the large number of exhibiting artists. The number of dealers is proportioned to the number of people who buy art, not to the number of artists who need dealers.

Some dealers act as patrons. They carry nonsalable artists in whom they have faith. But because they derive no income except from sales, there is a limit to the length of time and the number of nonselling artists a dealer can carry. Some actually encourage the artist to new heights in his own direction. Others encourage the artist to meet some fancied or real public demand, and/or provide contracts for converting so-called fine art into advertising. Due to the odds, artists usually solicit dealers. Artists can submit works to museums, but they cannot successfully solicit purchases from either collectors or museums.

Most dealers work on a 33⅓ per cent commission plan. This means that after the dealer advertises, publishes the catalogue, mails the announcements, pays the gallery help, rent, and utilities for three weeks or more, the exhibit sales must come near $ 3,000 to even the score. It usually costs the artist one-third or more of his sale price to produce the work. Herein sculpture differs materially in that the cost of production nears 50 per cent of the selling price. Then, too, few dealers have space or preference for it.

The artist's labor, or wage, is from 16⅔ per cent to 33⅓ per cent of the sales price. This is not a standard used in determining art prices, but an average based upon questions to both painters and sculptors. The wage per hour for art work is usually below that of organized labor. There are exceptions that exceed these figures, but these are a fair average. Even the much sought-for security of university teaching pays less than skilled union labor.

With these figures in mind, is it any wonder that artists are galled by the museum practice of deducting 10 to 15 per cent of the sale price of a work? This divine right is usually backed by some logical reason relating to the budget or what the museum does for the artist. We artists live on sales to museums. The museum has just as much need for the artist as the artist has for the museum. This cut-rate policy can be elimi-

nated by concerted action on the part of artists. Museums usually buy through dealers – so add up the dealer's third, the one-third or more cost of productions, the museum's 10 to 15 per cent deduction, and you have a possible 1⅔ minimum to 23⅓ maximum per cent of margin for your labor and creation.

Private collectors usually acquire work before museums. They account for the earliest and greatest number of acquisitions in the contemporary field, probably not because of greater appreciation or astuteness but because one mind instead of ten decides. Museums usually have well-informed and appreciative curators, but purchases must be approved by trustees who are quite often more concerned with money values than art values.

Whatever hope we have economically lies with state sponsorship or with private collectors, especially the younger collectors who, for the most part, are professional people. Certain economic assistance can be gained from sculptural and mural commissions, but it is doubtful that any great art or revolutionary concepts will be developed in their execution. Such work approaches commercial standards – preconceptions of it having been made by minds of less vision than those of the artists.

I don't believe in competitions, unless remuneration is made for submission of entries. Exhibition prize money smells of royal condescension. Prize money should be equally divided among the creators of the works exhibited. I don't believe in exhibiting in any museum that levies exhibition fees and handling charges. I don't believe in artists' donations to museums. I don't believe the artist has any professional duty to the public; the reverse is the case. It is the artist who possessed the concept. It is the public's duty to understand.

Art is always an expression of revolt and struggle. Progressive man and progressive art are identified with the struggle, intellectually and anthropologically. That is our history as artists. That is man's history as a primate. The terms 'active beauty' and 'imagination' are interchangeable. They are part of the creative concept, a basis of fine art, a state forever disturbing to the philistine mind constantly at rest.

The artist's creative vision cannot go so far beyond the rest of the world that he is not understandable. He is limited by his time. He is dependent upon the past, but he is a contributing factor to the character of his time. His effort is to contribute a unity that has not existed before. The receptor must to some degree be able to put himself in the artist's place. This participation can be unconscious, and free, and pleasurable. If the participation is conscious during the transportation, the participant becomes a critic, in the fine sense.

Ernst Kris states that no art has a homogeneous audience. The audience is always stratified in degrees of understanding. There are those who come close, those who remain on the fringe, and those who pretend.

Franz Boas, in summing up the art of primitive people, wrote as follows: "I believe we may safely say that in the narrow field that is characteristic of each people, the enjoyment of beauty is quite the same as among ourselves, intense among the few, slight among the mass."

Fine art is unrelated to our finance-capital-culture. The instincts of aggression and self-destruction are more dominant than beauty and imagination. The creative artist's life has always been a battle. That is progress and the continuing state of evolution.

What I Believe About the Teaching of Sculpture

The following address was given at a panel on the Teaching of Sculpture, held at the Midwestern University Art Conference in Louisville, Kentucky, on 27 October 1950.

The concept of art can be known only by following the path of the creator who conceives it, not by the analysis of the critic or the words of art history.

To the serious students I would not teach the analysis of art or art history – I would first teach drawing; teach the student to become so fluent that drawing becomes the language to replace words. Art is made without words. It doesn't need words to explain it or encourage its making.

Period art is related to the writing, music, and the social scene and demands a living emotional understanding by individual experience. Most of the critic-historians use word conclusions not based on the creative artist's directives. The accent on conclusions is too much stressed in our study.

I would stress anthropology such as Boas's study of the creative art in the history of man, psychology as it depicts the function of the creative mind. In writing I would include the study of Joyce's work, such as *Finnegans Wake,* wherein the use of words and relationships function much as in the process of the creative artist's mind. Music must be included. It transmits aural relationships that are akin to the artist's creative form directives. I could cite Schönberg in this instance.

The myth of man is covered by the joint fields of anthropology and psychology. Not only does the myth of man control many things in the creative art field, but within the art stream exists the artist's myth as well. The whole language of art, the history of art, is not spoken in words but represented visually.

The way I would teach art demands more freedom than the average academic institution permits. It would demand a great change in the present archaic educational routine. It would be based more on individual need and less on mass production, the repetition of curriculum setup. It would require the latitude of full days.

I would first start the teaching of art by doing, developing fluency in expression. I would teach contemporary art, contemporary concepts – because that is the world the student lives in – before any accent was made on the history of art.

The history of art is an important but subservient aspect in the making of art. I would require that it be by visual response, based on the understanding of doing as the true way. The present bone-dry art history is fractious and individually prejudiced, lacking social and psychological interpretation, even subject to change by the most recent excavations or excavations to come. Most of the conclusions and clichés belong too much to the pragmatists who wrote them.

I make no separate provision for the cause of sculpture apart from painting. The preference governing actual material is personal. The concept in either art comes from the expression of emotion and thought. The difference in technical pursuit does not change the mind's reaction to form. Accent on any aesthetic difference is the prerogative of the layman. In my own case I don't know whether I make some pieces as painted sculpture or paintings in form.

After the fluency of drawing is attained, and the will to produce an aesthetic result, certain technical activities must be introduced. For the feeling of form develops with technical skill. The means for fulfillment must be provided strictly on the individual's need. Imaginative form will not develop with the acqui-

sition of skill or high technique. But at a point in student development one piece in bronze is worth more than all books and all teachers. The filing, finishing, patination of a rough bronze to completion is a maturing point. There is probably not a college city in America where decent casting cannot be obtained if the problem is planned.

I do not demand that all students be artists, but I would insist that they study that way. I would emphasize the artist's position in society, the influences and traditions, and the world in which the student must fight for survival. I would direct him to literature, music, anthropology, wherein these fields presented aesthetic stimulation to complement his own work.

I would tell him the limits of his audience and that his world is no different from the world for any man of ideas, nor for that matter relatively no more different from the artist's world for the past hundred years.

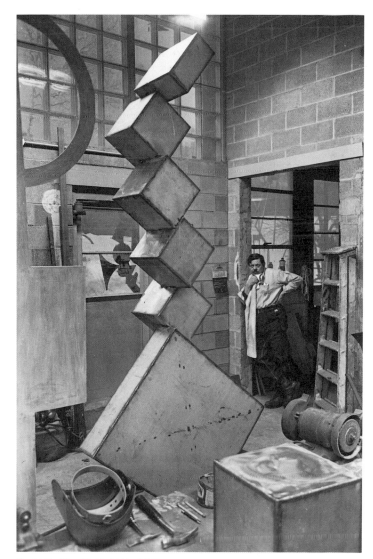

David Smith with *Cubi I* in 1962

But to point out the need let me quote [Franz] Boas: "No people known to us, however hard their lives, may spend all their time and energies in the acquisition of food and shelter – nor do those who live under more favorable conditions, and who are free to devote to other pursuits the time not needed for securing their sustenance, occupy themselves with purely industrial work or idle away the days in indolence. Even the poorest tribes have produced work that gives them aesthetic pleasure – and those whom a bountiful nature or greater wealth of invention has granted freedom from care, devote much of their energy to the creation of works of beauty."

There is a need for art. As well as ego satisfaction, the artist has a social obligation to produce to the fullest extent of his ability. It is society's duty to make the effort to understand before it takes an active prejudice. At present he is confronted with a limited audience and a hostile majority, especially with all the excuses found to be anti-intellectualist amid social upheaval and perpetual war.

To the majority there is no need for art on the basis that creative art is produced. We live in a hypocritical world. Our ideologies are only pretensions. We are afraid to be serious, introspective or contemplative. Everything must jump, joke, quickly change scene. Our words in the hands of advertisers have lost their meaning. Books must be digested.

There is still an innate natural sense of beauty in all people. Aesthetic pleasure is released by natural forms, the song of a bird, the flow of a landscape, the formation of clouds, the roll of water; various natural phenomena all possess aesthetic value, but they are not art nor is the imitation thereof, in diminution or enlargement, art. Television and technicolor may even supplant this natural sense of beauty.

But the artist will still state his truth. The artist reprojects the vision in his mind; he possesses it. The vision represents the sum total of his experience. It is part myth, part dream, part reality. It shows the state of inspiration which Plato termed "productive madness". Every swipe of the brush, every stroke of the chisel, every segment applied in construction, is a revisualization, a finality, a simplification of reordered reality, raised to a symbolic level.

Ernst Kris states that productive madness is a specific state of ego control in which unconscious material is freely accessible and, in Freud's own words, "rises to a preconscious level". The subjective experience is that of a flow of thoughts or images driving towards expression in word or shape. We may sense the irrational creative force and attempt to describe it, but we will not necessarily understand it. Certain canons of beauty or imagination, which work on the same fundamental principle, are absolute, having common denominators in our associations, but we are ignorant of the laws which determine the number and variety of the more complex combinations...

The student of art comes with a calling. The underlying directive may be from various motives. He may be directed to art by the opportunities to express sublimations, gratifications, substitutions, constructions or destructions. His impulses do not differ from those of other productive men who follow the same general principle. He is like the clergyman, the prize-fighter, the poet, the scholar – the odds are terrific against financial respectability, yet since the ego is greater than the promise of riches, these brothers, men with the call, will always be with us. Despite the retrogressive society, art, artists, and particularly the avant-garde are increasing. Apathy has bred an extremely hardy lot in America.

Clement Greenberg states: "Painting was freed from sculpture by impressionism. Sculpture was freed from the monolith by cubism." The freedom of man's mind to celebrate his own feeling by a work of art parallels his social revolt from bondage. The time now is the greatest time in the history of man to make art. It is the only world I know, it is the only one I can live in.

Questions to Students

The following series of questions appears in an undated typescript among the David Smith Papers. Probably written about 1953–54, it accurately reflects Smith's view of the way an artist should approach his work.

1. Do you make art your life, that which always comes first and occupies every moment, the last problem before sleep and the first awaking vision?
2. Do all the things you like or do amplify and enjoin the progress of art vision and art making?
3. Are you a balanced person with many interests and diversions?
4. Do you seek the culture of many aspects, with the middle-class aspiration of being well-rounded and informed?
5. How do you spend your time? More talking about art than making it? How do you spend your money? On art materials first – or do you start to pinch here?
6. How much of the work day or the work week do you devote to your profession – that which will be your identity for life?
7. Will you be an amateur – a professional – or is it the total life?
8. Do you think the artist has an obligation to anyone but himself?
9. Do you think his contemporary position is unique or traditional?
10. Do you think art can be something it was before? Can you challenge the ancients?
11. Have you examined the echoes of childhood and first learning, which may have once given you the solutions? Are any of these expectancies still operating on your choices?
12. Do you hold with these, or have you recognized them? Have you contradicted them or have you made metaphoric transposition?
13. Do you examine and weigh the art statements of fellow artists, teachers, authorities before they become involved in your own working tenets?
14. Or do the useful ideas place themselves in a working niche of your consciousness and the others go off unheard?
15. Do you think you owe your teachers anything, or Picasso or Matisse or Brancusi or Mondrian or Kandinsky?
16. Do you think your work should be aggressive? Do you think this an attribute? Can it be developed?
17. Do you think your work should hold within tradition?
18. Do you think that your own time *and now* is the greatest in the history of art, or do you excuse your own lack of full devo-

tion with the half belief that some other time would have been better for you to make art?

19. Do you recognize any points of attainment? Do they change? Is there a final goal?

20. In the secret dreams of attainment have you faced each dream for its value on your own basis, or do you harbor inherited aspirations of the bourgeoisie or those of false history or those of critics?

21. Why do you hesitate – can you not draw objects as freely as you can write their names and speak words about them?

22. What has caused this mental block? If you can name, dream, recall vision and auras why can't you draw them? In the conscious act of drawing, who is acting in your unconscious as censor?

23. In the conceptual direction, are you aiming for the successful work? (To define success I mean the culminating point of many efforts.)

24. Do you aim for a style with a recognizable visual vocabulary?

25. Do you polish up the work beyond its bare aesthetic elements?

26. Do you add ingratiating elements beyond the raw aesthetic basis?

27. If you add ingratiating elements, where is the line which keeps the work from being your own?

28. Are you afraid of rawness, for rawness and harshness are basic forms of U.S. nature, and origins are both raw and vulgar at their time of creation?

29. Will you understand and accept yourself as the subject for creative work, or will your effort go toward adapting your expression to verbal philosophies by non-artists?

30. If you could, would you throw over the present values of harmony and tradition?

31. Do you trust your first response, or do you go back and equivocate consciously? Do you believe that the freshness of first response can be developed and sustained as a working habit?

32. Are you saddled with nature propaganda?

33. Are you afraid to exercise vigor, seek surprise?

34. When you accept the identification of artist do you acknowledge that you are issuing a world challenge in your own time?

35. Are you afraid to work from your own experience without leaning on the crutches of subject and the rational?

36. Or do you think that you are unworthy or that your life has not been dramatic enough or your understanding not classic enough, or do you think that art comes from Mount Parnassus or France or from an elite level beyond you?

37. Do you assert yourself and work in sizes comparable to your physical size or your aesthetic challenge or imagination?

38. Is that size easel-size or table-size or room-size or a challenge to nature?

39. Do you think museums are your friend and do you think they will be interested in your work?

40. Do you think you will ever make a living from museums?

41. Do you think commercial art, architectural art, religious art offer any solution in the maturing of your concepts?

42. How long will you work before you work with the confidence which says, "What I do is art"?

David Smith in 1957

43. Do you ever feel that you don't know where to go in your work, that the challenge is beyond immediate solution?

44. Do you think acclaim can help you? Can you trust it, for you know in your secret self how far short of attainment you always are? Can you trust any acclaim any farther than adverse criticism? Should either have any effect upon you as an artist?

In particular, to the painter:

Is there as much art in a drawing as in a watercolor – or as in an oil painting?
Do you think drawing is a complete and valid approach to art vision, or a preliminary only toward a more noble product?

In particular, to the sculptor:

If a drawing is traced, even with the greatest precision, from another drawing, you will perceive that the one is a copy. Although the differences may deviate less than half a hair, recognizable only by perceptual sensitivity, unanimously we rule the work of the intruder's hand as non-art.
But where is the line of true art – when the sculptor's process often introduces the hands of a plaster caster, the mold maker, the grinder and the polisher, and the patina applier, all these processes and foreign hands intruding deviations upon what was once the original work?

Interview with David Sylvester

The following tape-recorded discussion with David Smith took place in New York on 16 June 1961, and was conducted by David Sylvester of the British Broadcasting Corporation. It was published in Living Arts *in April 1964.*

SMITH: There is no collaboration nor is there any affinity between [architects and artists]. Architects have had the opinion that they are the fathers of all the arts, that their buildings are sculptures, and that the use of painting and sculpture ofttimes defiles their purities. There are no affinities between us, especially with me. I do not solicit architects. I have seen that man works better when he is working within his own spirit than when he is working with the domination or the collaboration of the architect. Now we're not working for money. We're working to make greater art out of ourselves. We're working to extend our own potential. I don't think any of us really wish to revert and repeat a point of arrival that we've arrived at before to make a repeat for the sake of money. I don't know where this idea of collaboration would be. Mostly architects look down upon us, and mostly architects are big businessmen here and we're just one of their small clients in the building. They choose to put the marble in the men's room and they put the bronze in the fixtures and they really don't need sculpture at all.

SYLVESTER: If you knew an architect whom you found sympathetic, would you like to see some of your sculpture placed in an architectural setting outside buildings? Inside the large entries of buildings?

SMITH: I would like to see it, certainly, but I'm working in quite a large size, you know. My work is running from nine to fifteen feet high. Right now I have a very modest acceptance and rather small amount of sales, and I am surviving without architects. And if they choose to use my work as it stands I would be delighted to sell it to them and have them use it, but I do not think that I will change my point of view to meet theirs. I have no natural affinity with modern architecture. I can't afford to live in any of these buildings. It's no part of my world. My sculpture is part of my world; it's part of my everyday living; it reflects my studio, my house, my trees, the nature of the world I live in. And the nature of the world that painters and sculptors live in is walkup places with cracks; you look out the windows and see chimney tops, and I don't think any of us can make the old-fashioned royal bow to suit their needs. Liberty, or freedom of our position, is the greatest thing we've got.

SYLVESTER: There's a picture in London of the American artist of your generation, you and the action painters, of being rather a group. Has there been a sort of collaboration of ideas between you? And did you find knowing Pollock, being a close friend of Pollock and people like that, fruitful for your work?

SMITH: No. We talked about other things usually. But we did spring from the same roots and we had so much in common and our parentage was so much the same that, like brothers, we didn't need to.

SYLVESTER: The parentage, I suppose, of course, was the whole Cubist thing. But why do you think it suddenly exploded in this way into this terrific growth that began in the late forties of American art?

SMITH: Well, Pollock, de Kooning, and practically everybody I can think of who is forty to fifty now and sort of 'arrived' artists, in a sense – they all came from a depression time. We all came from the bond of the WPA, which we affectionately call it; it was the Works Progress Administration and it was a government employment of artists for...

SYLVESTER: The New Deal thing?

SMITH: Yes, it was definitely the New Deal thing, and somewhat of a defensive thing. We made very little more by working than people drew for not working for unemployed relief. We drew maybe five or six dollars a week more for working...

SYLVESTER: Yes.

SMITH: ... which was very nice because for the first time, collectively, we belonged somewhere.

SYLVESTER: And this gave you a stimulus?

SMITH: Well, we belonged to society that way. It gave us unity, it gave us friendship, and it gave us a collective defensiveness.

SYLVESTER: You mean belonging to society at large or merely belonging to your own group?

SMITH: In a sense we belonged to society at large. It was the first time we ever belonged or had recognition from our own government that we existed.

SYLVESTER: Do you still feel that you belong in that way or has that now been lost?

SMITH: Well, the government doesn't belong – we don't belong to the government any more; I mean times have changed.

SYLVESTER: Do you still get any patronage?

SMITH: No patronage, not that I know of. A few of our more traditional men have had monument patronages or they design a coin or something like that, but there is no patronage generally speaking, and not even recognition.

SYLVESTER: So the postwar thing owed absolutely nothing to any help from officialdom?

SMITH: We owe nothing to the federal government for recognition, no. Not now.

SYLVESTER: There wasn't a lot of help at first from American collectors, was there – the private collectors?

SMITH: Private collectors were quite few and far between. But there was another thing the WPA did. It stimulated the interest in art; you see, while some artists were employed, don't forget there were a lot of teachers, and there were critics and all people related to the arts. There were many public classes, adult painting classes, adult sculpture classes, WPA exhibitions that traveled throughout the country; they went to union halls and schools and places like that where art had never been shown before. And there was an interest stimulated there by people, and the response to it, and also other people to do it. You know, amateur response is sort of groundwork for professional collectors. Most collectors can paint or draw to a degree, and so therefore they seem to recognize the artists who are full-time artists quicker.

SYLVESTER: So really, government help in the thirties had a lot to do with creating the climate which produced this postwar thing, although there hasn't been subsequent help?

SMITH: Yes – reasons are very hard to find, and reasons are never one thing, they are a hundred things – I can't think of one thing that stimulated the response of the public better than the WPA educational projects did. Nor do I know anything that kept so many artists alive during the thirties than the WPA. There was nothing else.

SYLVESTER: A lot of the work that was being done in the thirties by the present abstract painters was sort of figurative work,

some form of social realism, wasn't it? Some connection with Diego Rivera and so on?

SMITH: The great body of work at that time was called social realism which did relate to Rivera and using figures.

SYLVESTER: But not in your own case?

SMITH: Not in our own case. Many of those men who were what were called nonobjectivists went right through the thirties firmly convinced of their own stand; there were many of us – not too many – who came from fathers or grandfathers who were Cubists. We came not very directly, you see; we came through the French magazine *Transition* and through *Cahiers d'Art*. We came through both of those magazines, and we came through men like Stuart Davis, and Jean Xceron, and John Graham, and men like that who more or less went back and forth between Paris and here and told us what was going on in Europe.

SYLVESTER: You yourself were working abstract before a lot of the painters, weren't you?

SMITH: I have been essentially an abstract sculptor.

SYLVESTER: But weren't you in Europe yourself for some time in the late thirties?

SMITH: In 1935 and '36. Most of us tried to go to Europe if we could; most of us did. Of course, de Kooning had come from Europe...

SYLVESTER: Quite.

SMITH: And Gorky had come from Europe. Graham was a Russian, and he had come from Europe. Stuart Davis had gone to Europe earlier.

SYLVESTER: How do you feel it affected your development – going there at that moment?

SMITH: It was very important. Most of all, it was one of the greatest points of my own liberation mentally. You see, before – in the early part of the thirties – we all were working for a kind of utopian position, or at least a position where somebody liked our work. In the early thirties none of us – like Pollock or Gorky or de Kooning – could really, none of us could show our work any place, nobody wanted to show it, and it seemed that the solution was to be expatriates. Most of the men a little older than we were had seen the solution in expatriatism all the way from Mallorca to Paris itself. And the one thing that I learned in 1935 and '36 – I was in England and Russia and Greece and France and places like that – and the one thing when I came back that I realized was that I belonged here; my materials were here, my thoughts were here, my birth was here, and whatever I could do had to be done here. I thoroughly gave up any idea of ever being an expatriate. So I laid into work very hard. That must have been in the minds of other men. Otherwise, there wouldn't be so many of us here now.

SYLVESTER: It's often said that one of the reasons why American art built up after the war was that it was stimulated by European artists who came here from Paris in 1940 and stayed here during the war. Do you think there is anything in that?

SMITH: That is part of the scene and it is important. It has been very rewarding to us to have men like Lipchitz, and Mondrian, and Gabo become Americans and live here with us; that is good and it's been very nice. We have met them and we have found that they were humans like we were and they were not gods and they were fine artists. And so we know more about the world now.

SYLVESTER: In the thirties, of course, a lot of the more or less social realist work that was being done then was involved in social commitment. I believe you were exceptional in having a strong left-wing commitment but working abstract.

SMITH: I have strong social feelings. I do now. And about the only time I was ever able to express them in my work was when I made a series of medallions which were against the perils or evils of war, against inhuman things. They were called *Medals for Dishonor*. When I was in the British Museum in London in 1936 I bought a series of postcards which were made during the First World War, and they were war medallions of the Germans. And that, and Sumerian cylinder seals that I had been studying in Greece, and intaglio carving, and so forth, impelled me to do that series of medallions which took me three years. I first had to learn how to carve in reverse in order to make these. It was about the only thing I have ever done which contributed to a social protest. I don't feel that I have to protest with my work. Whatever society I belong to must take me for my ability; my effort is to drive to the fullest extent those few talents that were given me, and propaganda is not necessarily my forte.

SYLVESTER: I talk about your being abstract, but it isn't fair; a lot of your forms seem to me to be referential to nature. I see a lot of your big stainless steel things as personage. Are they at all this for you?

SMITH: They don't start that way. But how can a man live off of his planet? How on earth can he know anything that he hasn't seen or doesn't exist in his own world? Even his visions have to be made up of what he knows, of the forms and the world that he knows. He can't go off his planet with visions no matter how they're put together. And he naturally uses his proportion and his sort of objectivity. He can't get away from it. There is no such thing as *truly* abstract. Man always has to work from his life.

SYLVESTER: You have no preconceptions about which way the thing is going to go?

SMITH: I try not to have. I try to approach each thing without following the pattern that I made with the other one. They can begin with any idea. They can begin with a found object, they can begin with no object. They can begin sometimes even when I'm sweeping the floor and I stumble and kick a few parts and happen to throw them into an alignment that sets me off thinking and sets off a vision of how it would finish if it all had that kind of accidental beauty to it. I want to be like a poet, in a sense. I don't want to seek the same orders. Of course, I'm a human being, I have limited ability, and there's always an order there. People recognize my work even if I think that I've really been far out in this work. I strive very hard to move a little bit but you can't move very far. Picasso moves far. He's a great man who moves very far. But I still recognize Picasso's work no matter how far he's moved from one phase or one new picture or one new sculpture; I always recognize his work.

SYLVESTER: How would you analyze the difference between your work and its intentions and the Cubist constructions – you know, González, Picasso – of which it's a continuation?

SMITH: Well, living here in America at that time, going to school at the time that I went to school, I didn't read French, so when I had a *Cahiers d'Art* I didn't know what it was about. I learned from the pictures just the same as if I were a child, in a certain sense. I learned the world from seeing before I ever learned the world from words. So my world was the Dutch movement De Stijl; it was Russian Constructivism; it was Cubism; it was even Surrealism. Or even German Expressionism. Or even Monet. All these things I did not know had divisions in them. They all fitted in to me. They were all so new and so wonderful and they all came to me at one time, practically. The historians hadn't drawn the lines yet as to which and where

at which particular time, and my heritage was all those things simultaneously. So I am all those things, I hope, with a very strong kind of intellectual regard for Cubism and an admiration for it because it was great at a particular time. It was both painting and sculpture.

SYLVESTER: Taking Cubism, Surrealism, Expressionism, not worrying about the thing – I wonder whether the vitality of post-war American art has something to do with this sort of absolute freedom of attitude which you've talked about in yourself. I wonder whether this also applies to people like de Kooning and Pollock, and whether this has helped them not to worry but to take what they could and what they wanted to take quite freely from earlier modern art.

SMITH: I think it has. Gorky didn't read French. And I don't think Bill [de Kooning] read French either. We were all together at a particular time in the early days, and we were sort of expatriates. We drank coffee together in cafeterias, and when I say we drank coffee it was usually one cup because few of us could afford more than one five-cent cup of coffee in those days, plus a cookie maybe. And all we did was walk around and talk sometimes. But mostly we worked. And we each sort of took according to what we wanted. You must remember I had come from Indiana and I had only seen a sculpture a couple of years before that, or a painting. Gorky came into Providence and de Kooning came into New York. I think they all had a little bit more, knowing of museums and art, than I did before, and they both were European in a sense, and I think all Europeans know more about art than people from Indiana do. I don't think I had seen a museum out in Indiana or Ohio other than some very, very dark picture with sheep in it in the public library. But I didn't know anything about art until I came to New York.

SYLVESTER: But you'd wanted to produce art before? Or this happened when you came?

SMITH: I wanted to be a painter when I came.

SYLVESTER: And you did paint for some years?

SMITH: I painted for some years. I've never given it up. I always – even if I'm having trouble with a sculpture – I always paint my troubles out.

SYLVESTER: What was it that made you turn from painting to sculpture suddenly?

SMITH: I think it was seeing Picasso's iron sculpture in a *Cahiers d'Art* about 1928 or 1929. Seeing iron and factory materials used in producing art was quite a revelation, and since I had worked in factories and I have known iron and metal and metalworking since I have been very young, it came to me that it should be. After my first year in college I worked on the assembly line in the Studebaker plant in South Bend, Indiana. I had seen ironwork in the Russian Constructivists – Rodchenko and Malevich and – I don't know – Tatlin. I'd seen reproductions of their work sometimes in German magazines. So it was a revelation in a way. Later on I learned that González had done the welding for Picasso on those 1928–29 works that went into 1930, but I didn't know it at the time, and if it had said so in the article it was in French and I wouldn't have known it anyhow.

SYLVESTER: This seems to be important, incidentally – going back to what we were talking about before – the fact that you and the others were seeing the works in reproduction and you weren't reading the texts and maybe this was why you were able to use them so freely.

SMITH: Yes. And I also liked the idea that we have no history, that we have no art history, and we pay no attention to art historians. We all were pretty raw I think.

SYLVESTER: You weren't at all – in your use of sheet metal and so on – you weren't at all influenced by Calder?

SMITH: No. I knew metalworking before I knew Calder. And Calder is one of our great men, and he is earlier by a few years than any of the rest of us. Calder had worked in Paris quite a bit in the early days, though he did go to school here in New York at the Art Students League, I have been told.

SYLVESTER: Have you ever had any temptation to work in traditional materials, carving or modeling?

SMITH: I do both. I model in wax and make bronzes that way, and I carve sometimes; some of my early work was carved. I don't choose to close out any method, approach, or material. Oh, I draw. I draw figures and things like that at times.

SYLVESTER: Do you ever do it from a model? Do you ever do it from nature?

SMITH: Sure. As a matter of study and a matter of balance. I draw a great deal, because sculpture is such hard work and if I put in ten hours or eleven hours a day or more at hard labor, you know, the sort of dirty work of my profession, I like to take a bath and change my clothes and spend the rest of the day drawing.

SYLVESTER: You do it all yourself, don't you? I mean you could now afford studio assistants.

SMITH: I can't use studio assistants any more than Mondrian could have used assistants to paint in solid areas or any more than de Kooning or any of my friends can use somebody else to put the backgrounds in, even though they might just be pure white. They don't want the marks of another hand on their own work. Now that is twentieth century, too.

It is defensive in a certain way because it's contradictory to the progression of this age. We are among the few people left who are making the object from start to finish.

SYLVESTER: You never feel it will be conceivable for you to make a model and have an assistant make it on a big scale?

SMITH: No. I don't even make copies. If I make a cast sculpture I make *one* and all the marks are mine. I don't approve of copies, and I don't make and produce copies for the sake of making more money.

SYLVESTER: And this, of course, connects you very closely to the painters of your generation, doesn't it? I mean this to-and-fro between the artist and the material, this special emphasis on it now. This makes you very closely linked with Pollock and de Kooning.

SMITH: Well, we were all friends and I talked with painters and I belong with painters, in a sense, and all my early friends were painters because we all studied together. And I never conceived of myself as anything other than a painter because my work came right through the raised surface, and color and objects applied to the surface. Some of the greatest contributions of sculpture to the twentieth century are by painters. Had it not been for painters, sculpture would be in a very sorry position.

Some of the greatest departures in the concept of sculpture have been made by Picasso and Matisse. There was a series of heads that Matisse made called *Jeannette*. In there are some of the very brilliant departures in the concept of sculpture. Painting and sculpture aren't very far apart.

SYLVESTER: This is one of the great twentieth-century discoveries, isn't it?

SMITH: I hope it is.

SYLVESTER: Now that a lot of you have become extremely successful and are getting big prices now, is this going to make a difference? Is this going to make the thing more difficult?

SMITH: Absolutely not! It hasn't hurt one of our men. Oh, maybe we drink a bottle more per week or month than we ever did, but even a lot of our men do not sell when they don't feel like selling, and if they've sold enough they say, "Well, that's enough for this year, I'll sell next year." When they do get a little sum of money it goes into a better studio, more paint, maybe a new suit of clothes, maybe a party for other artists. A few of us have cars. I still stick with a truck which I've always had. A lot of the artists have no cars. But it certainly goes into more paint and bigger canvases. Five different men that I know have made a little better livelihood recently, have been more successful,

and they have gotten out of a cold-water flat and gone into a nice big, long studio. Some of them are painting pictures twenty-six feet long, ten feet high. Well, that's a wonderful point of liberation. If they had any mercenary reasons for such a thing, they would lose it there because they never in the world can sell a picture twenty-six feet long and ten feet high. It doesn't fit any place; it has absolutely no functional need any place. But it's their desire to do it and it's a statement of freedom against having painted little pictures for so long in a little studio with canvas that was small, and it's a statement of liberty.

"The Secret Letter": Interview with Thomas B. Hess

The following interview by Thomas B. Hess, Editor of Art News, *was held in June 1964. It was published in the catalogue of the Marlborough-Gerson Gallery exhibition of David Smith's work in October 1964 under the title "The Secret Letter"*

HESS: You've used 'found objects', tools and other things picked up around the countryside – plowpoints and old trace chains – in your sculptures.

SMITH: Of course. The sculptures I made in 1933 were all found objects.

HESS: What's the idea behind the found object as far as you're concerned? For the Surrealists, it made a metaphysical jump between the reality of the object and the idea of a work of art.

SMITH: Tom, I don't know what *A Work of Art* is. It changes in my life and it changes in my regard. I have no respect for it particularly. First of all, these things have a basic geometric form that's already 'found'. In a recent work I made one wheel, and the other three wheels I bought by ordering them from Bethlehem Steel Co. They weigh 275 pounds apiece. They are blank forgings made by Bethlehem for 100-ton overhead trolleys. You might say they are 'found' objects. I found them in a catalogue and chose them because they fitted a particular need. Are triangles, circles, and spheres 'found'? They have always been there. Painters don't 'come upon' subjects for a still life; the Impressionists didn't come upon their subjects. They found their trees; they chose their apples; those are all 'found objects' – flowers, fruit, everything.

I find many things, but I only choose certain ones that fit a niche in my mind, fit into a relationship I need, and that relationship is somewhat of a geometric nature. They aren't meant to relate to the art. But there is a certain romantic relationship in my mind to the old handmade objects that have ceased to function.

HESS: Actually you've always chosen things that once were useful, old discarded implements; never useless things.

SMITH: I don't know what useless things are.

HESS: Well, there's a lot of ornamental stamped iron in the scrap heaps.

SMITH: I couldn't use what was ornament.

HESS: I mean everything I've seen you use has either been a discarded tool or a functional object which has passed its period of usefulness. But it retains a kind of beauty in terms of its lost function – like a bone.

SMITH: Lots of bones. Sure.

HESS: Then there is a geometry of nostalgia?

SMITH: I don't know; I don't like that word. Maybe I'm not beyond nostalgia or sentiment or any of the lower things, but

Tom, don't forget, when one chooses a couple of old iron rings from a hub of a wagon, they are circles, they are suns; they all have the same radius; they all perform the same Euclidean relationship. They also have the romance of past function and new use. They have sentiment and they also have the geometry. There is no simple answer...

HESS: You think nostalgia implies sentimentality?

SMITH: Of course; I'm full of it. I was born a Calvinist. Do you think a Calvinist ever comes on without being sentimental?

HESS: By nostalgia, I mean when you pick up the casting of the thorax of an old discarded piano and put it in your work, you always respect its integrity as a thing. As against Marcel Duchamp, for example, who mocked his urinal or hat rack. You look at your found objects with respect.

SMITH: Well, let's remember my heritage. When I was a kid, I had a pretty profound regard for railroads. I used to sit down on the edge of town and watch trains go through. I used to hop trains, ride on the tops of boxcars. We used to play on trains and around factories. I played there just like I played in nature, on hills and creeks. I remember when I first sat in my father's lap and steered a car. In fact, I've always had a high regard for machinery. It's never been an alien element; it's been in my nature.

HESS: The main image in American folk poetry is the railroad; it comes and takes people away from the small town; its noises...

SMITH: And don't forget I've worked in locomotive plants. I've sat on those goddamned engines, welding them up, hoping I could someday make sculptures as big. And I will someday. I think.

HESS: And there's the surface of some of your sculpture – oxidized iron, rust.

SMITH: I kind of like rust.

HESS: The nostalgia of rust...

SMITH: Well, it's memory.

HESS: What was your father?

SMITH: He was the manager of a telephone company – independent telephone. I was born into that. Some of the first things I played with were telephones. I took them apart and used the magnets. My father was an inventor and he invented electric things – coinboxes that you couldn't fill with slugs and things like that. He invented an electric victrola before they were ever on the market.

When I was a kid, everyone in town was an inventor. There must have been fifteen makes of automobiles in Decatur, Indiana; two blocks from where I lived there were guys building automobiles in an old barn. Invention was the fertile thing then... I remember airplanes flying over Decatur when I was a kid. There was a plane that's now in the Smithsonian called the Vin Fizz. Vin Fizz was a grape drink they advertised with the plane flying over town.

HESS: The danger with the American-type inventor, though, is of becoming a hick, provincial, Edison.

SMITH: But one of the ideas an artist has, even though he is sophisticated and knows the whole history of art, is a kind of gnawing sense of innocence. He has to work with everything he's got. He has to focus everything, all his energies, in one direction, with the innocence that art never existed before he existed.

HESS: With an innocence that presumes a tremendous amount of sophistication and insight?

SMITH: It's also arrogance. You know you don't have the innocence of a child. But with your age and culture and history, you also have that attitude. I grant each artist the right to believe that he is the only artist in the world, and the greatest.

HESS: You have to assume that every artist is also a highly cultured man. You're interested in German sixteenth- and seventeenth-century medallists and..

SMITH: ... in Greek and Sumerian seals and in Cubism, the Baroque and...

HESS: And you want a library of art books.

SMITH: Sure. I love to read art books. I want to know everything that has ever been known by any man.

HESS: So you are not in the least provincial about art.

SMITH: No artist I know is provincial...

HESS: What is your place in avant-garde art? I think you did have an idea about it in the 1930s and 1940s. I don't know if you still do. But there was a certain air of enthusiasm?

SMITH: Well, I think that's true, Tom. We had no group identity in the 1930s. In the 1940s it developed when Pollock and Motherwell and Rothko were showing and seemed to become a kind of group for us, which we didn't have in the 1930s. Then it was just Stuart [Davis] and Gorky and Bill [de Kooning] and Edgar Levy and a few others. We were all individuals, sort of expatriates in the United States and in New York. The dominant style was social realism and we were always voted down. You rarely saw our work in shows, but we marched in May Day parades and we supported all the humane causes; we were all on the Loyalists' side in Spain. It was only in the 1940s, when Motherwell and those men started to develop, that there seemed to be a group of abstract artists.

HESS: The avant-garde idea, which seemed exhilarating then, now seems pretty repulsive. Of course, in those days, no one was in it for a buck.

SMITH: The chance then wasn't a sale; the chance was only the privilege to exhibit. That was the point of attainment. Nobody I knew in the 1930s and 1940s made a living from sales. Artists showed their work to other artists...

HESS: 'Totem' is a recurring word in your titles. Do you have an idea about tribal sculpture – as against folklore?

SMITH: A totem is a 'yes'. And a taboo is a 'no'. A totem is a yes-statement of a commonly recurring denominator.

HESS: You mean I could ask, "Mr. Smith, are you making ritual objects for a new religion?"

SMITH: No. I don't believe in anybody's religion. The bug is all those social implications in your words. I mean, everything considered, primitive society has totems and taboos, and there are totems and taboos in our society – your behavior at a Museum of Modern Art opening, or your behavior at dinner.

HESS: In your sculpture, do you have an idea of a content which concerns basic social relationships – between the work of art and the spectator, perhaps? Let's assume that the artist today works for other artists and a few friends. But is there a possibility of working for a huge imaginary audience? Could your sculpture be totems for an ideal society?

SMITH: Romantically, I wish it could. But I don't see its being accepted in present capitalist society, nor in a contemporary socialist society. The only rewards that I get in the way of compliments are from other artists.

HESS: But you do enormous sculptures, many of them too big to be exhibited – except in your own backyard.

SMITH: That's part of my work. I'm going to make them so big that they can't even be moved.

HESS: A lot of American artists work like that. Adolph Gottlieb was telling me that he's doing fourteen-foot-high paintings, and his gallery has ten-foot ceilings...

SMITH: It's a defiant position. If you can make a living selling your work, you are not going to bow to the sales angle. You are going to make things of your own nature. I would say that Adolph has a natural, built-in desire to paint them big. I know Adolph; the only times we ever showed someplace in the 1930s, we had to be able to carry our work on the subway; deliver it ourselves and pick it up. And we were just showing. We weren't selling.

HESS: Actually, you don't work for other artists; you work for yourself.

SMITH: That's true, but your audience is other artists. There are always a few (very few) critics.

HESS: But isn't your work unique in that it seems to consider a wide, even if nonexistent, social role?

SMITH: I think I'm an idealist.

HESS: What's the ideal? Are your totems for...

SMITH: ... a true socialist society, but I don't know any ideology that meets my theoretical ideal. That goes for religions or any social ideals. In other words, there is nobody I belong to or belong with.

HESS: There was a certain social setup when you were a kid in Indiana, and you had certain ideas about machinery and materials. And on your farm you've set up those huge 'useless' sculptures which, to me, have a certain symbolic effect – like a book in a secret language.

SMITH: The secret language, Tom, is very simple: I'm building the biggest, the best goddamned sculptures I can make within my present limits, conceptually and financially. If I could have built sculpture within my conception several years ago, they would have been twenty-five to thirty feet high...

The greatest part of American art in the 1930s and 1940s and even the 1950s was never built because the artists didn't have enough money to make them bigger and greater. That's where the best part of American art lies, because of our financial inability to buy what it took just to make it. Maybe it's the same for young artists today. Maybe the same for all artists, of all times.

I don't believe in the concept of anything. I believe in the conviction of the artist. The artist's conviction shows. The strength of a work is more dependent on the conviction of the artist than on a concept.

HESS: Do you remember the article Elaine de Kooning wrote about one of your sculptures in *Art News* in 1951? I think the sculpture was called *The Cathedral*.

SMITH: That's right, *The Cathedral*.

HESS: I remember she described one form as an altar-shape and on that was a figure-shape which was pierced by a prong coming down...

SMITH: ... an ecclesiastical prong.

HESS: ... and you added some molten silver to the figure and she quoted you as saying that the silver represented Purity. No one could possibly see this detail without help, or read it from the title.

SMITH: Yes. Every once in a while, when I make a big rusty iron thing, I bore a hole in it and add some gold; just for the hell of it. I don't think anybody ever sees it. That tickles me a little.

HESS: The details in your work are important and you invest them with all sorts of possible meanings, private meanings, which are thrown away...

SMITH: It's public when I show it and private when I make it. All good art that I know about is pretty private when it's made. I look for private meanings in Renaissance artists. I look for private meanings first.

HESS: Do you still work over details like that?

SMITH: In some sculptures, yes; and some, no. Some sculptures are to be seen five hundred feet away and some are small and intimate, and have very intimate details.

Take last night. When I went to sleep, I was making a sculpture. I woke up twice and made drawings. I woke up this morning thinking it, you know, and I presume I was able to keep on working asleep. Sometimes I work with details and sometimes with broad statements. I don't have any conviction about one over the other.

HESS: Well, the silver you added to represent Purity, no one is going to see it unless you tell them.

SMITH: I don't think it's necessary to tell anybody.

HESS: Yes, but do you do it?

SMITH: The knowledge, the perception, of vision is so far greater than any statements using words, that nothing an artist can do passes beyond the vision of the beholder.

HESS: The silver would.

SMITH: Do you know [in James Joyce] the Little Red Hen that scratched up a letter? Well, I'm always scratching up letters and that's one of the nice things about Joyce. There's a part of Joyce in me all my life. I read 'Work in Progress' in *Transition*. It's a kind of opening, like when I first saw Cubism or Constructivism or De Stijl or any of the things I saw that I didn't know about. I love things I see and don't know about. I don't understand why other people don't like things they don't know about. It always astounds me that I can make something that somebody doesn't understand. I see everything in writing that other people write. I listen and I understand everything in music; I mean I like John Cage and Morty Feldman and Varèse and Stravinsky...

Did I tell you I just made 130 or 140 paintings this year from models, all nude models. I don't use drapery. When there's pussy, I put pussy in. And when there's a crack – on some of these girls who are so young you can't even see a definition – I put it in because I think it will be there, sooner or later.

HESS: You're just a stylist.

SMITH: I'm a sensualist... but I don't use a sketch when I make sculpture, ordinarily.

HESS: You make chalk drawings on the floor.

SMITH: Oh, that's when I'm in trouble.

HESS: What do you mean, 'no sketches'? You're always drawing.

SMITH: Well, I don't make drawings seldom. I do what I need to do, Tom, and sometimes I think I'm stronger and there are more possibilities open for invention if I don't use the sketch. I draw a lot to increase my mind or my vision, but when I work, I try to let the work make its own vision – while I keep a history of knowing behind it.

HESS: That's the most sophisticated kind of sketching... You also correct endlessly as you work.

SMITH: I often correct pieces, and throw bad pieces away.

HESS: So whatever spontaneity you use has been filtered through the most rigorous intellectual discipline. The working process is one of constant scrutiny.

SMITH: Scrutiny? I live it. I live it, and the pieces that are problems, I look at and think about three of four times a day while I'm working on other ones.

HESS: What about that spontaneity?

SMITH: I use every method or approach that I need. Sometimes it is spontaneous and sometimes studied, thought, and takes a long time. Some sculptures take a couple of years before they get realized.

HESS: The point being that you stay constantly aware, an intellectual artist. You bring everything to bear on the work and that's how the art comes out.

SMITH: It comes out different most of the time.

HESS: Because you can't oversee everything. The work evades scrutiny?

SMITH: There is a kind of vision, usually, which is a meditated vision – as against premeditated. But I would rather call it a continuation. And then sometimes I need the contradiction to the kind of work I'm doing. Sometimes I work in what people call lines or drawing. Sometimes I need big strong cubic shapes. Sometimes I need total disrespect for the material and paint it as if it were a building...

HESS: Should materials be respected? Do you think 'pure' is 'good'?

SMITH: Pretty good. It depends on the conviction of who is doing it. In relation to Ad Reinhardt's painting, pure is good.

HESS: You add color.

SMITH: I'm still working on that. I've made two sculptures in tune properly between color and shape. But I've been painting sculpture all my life. As a matter of fact, the reason I became a sculptor is that I was first a painter.

HESS: Why do you always choose bright colors?

SMITH: Because they are more difficult.

HESS: Wouldn't it be easier to start with grays?

SMITH: Yes, it would be easier to state color in a gentle monochrome manner, except it doesn't speak to me as strongly. I could work whites and blacks, but I think I'd have to work twenty years before I can paint circles in bright colors that succeed, and the minute I'd succeed, I would be done; that would be ended. When you get a unity, it's got to end something.

HESS: I don't see the point of whole bunches of artists today trying to do polychrome sculpture.

SMITH: Now that's a dirty word, 'polychrome'. What's the difference between sculpture using color and painting using color?

HESS: The painters seem able to and the sculptors don't.

SMITH: All right, then we haven't found it. When we find it, it's...

HESS: Twice...

SMITH: ... double. Painting and sculpture both; beats either one.

HESS: You think painting is the dominant mode?

SMITH: I think reaction and response of the public and the historians are built on painting.

HESS: That's been true since the seventeenth century.

SMITH: Tom, sculpture has been a whore for many ages. It had to be a commissioned thing. Sculpture was not sculpture until it was cast in bronze. Before it was cast, the man who paid for it had certain reservations and designations as to subject matter.

HESS: But modern sculpture comes out of paintings like a flower comes out of the ground.

SMITH: We come out of Cubism.

HESS: And Picasso and Matisse...

SMITH: ... are some of the people who made their greatest inventions through concepts of sculpture. And also they begin sculpture as an entity...

HESS: ... as an absolute?

SMITH: ... absolute from the artist. But the reproductive processes involve something else. Sculpture is lightly considered because you see the same goddamned sculptures. They become common and that reduces the interest. The world is full of reproductions of sculpture and that is one of the defiling things about it.

HESS: I don't think that's very important. If it's good, it's good. If not...

SMITH: It's only good when it comes from the hand and from the eye of the artist. Otherwise it's reproduction.

HESS: What about the beautiful bronze casts by Rosati?

SMITH: That's different. I'm talking about museums and dealers who make casts.

HESS: Have you ever felt in peril?

SMITH: Oh, I have so many ideas; I'm not dry. I'm living ten years beyond my time...

HESS: I mean physically.

SMITH: Physically. I'm scared something is going to happen, that I'm not going to have enough to eat. Once you've lived through a Depression, Thomas, I don't think you can outgrow it.

HESS: But your father had money and you were raised...

SMITH: My father was a working man...

HESS: ... raised with enough food.

SMITH: I was raised with enough food, but I came from pioneer people. Grandmothers and grandfathers, great-grandmother, my great-great-grandmother, all of those people I talked with were early settlers. They had been deprived of salt, flour, sugar, and staples like that for periods of time. I came directly from pioneer people who were scared for survival and this reinforced my consciousness of the Depression.

HESS: To you, waste is a sin?

SMITH: Right! I don't like to throw away bread...

HESS: You told me once that your Protestant background was a disadvantage.

SMITH: It's a hell of a background, but you've got to make it with what you've got. There are no rights and wrongs. The more you meet a challenge, the more your potential may become. The one rule is that there may be no rules!

HESS: In a sense, your sculpture as a whole is about 'no rules'?

SMITH: I think the minute I see a rule or a direction or a method or an introduction to success in some direction, I'm quick to leave it – or I want to leave it.

HESS: Is that an unsatisfactory state?

SMITH: The idea of satisfaction is like the idea of happiness – the great American illusion.

HESS: Is that the Protestant background speaking, backing away from satisfaction?

SMITH: I wish to be totally unacademic.

HESS: In a sense, you always want to fail.

SMITH: That's where the greatest challenge is... the American Protestant idea leads to revolt. A format is made to be changed...

I like outdoor sculpture and the most practical thing for outdoor sculpture is stainless steel, and I made them and I polished them in such a way that on a dull day, they take on the dull blue, or the color of the sky in the late afternoon sun, the glow, golden like the rays, the colors of nature. And in a particular sense, I have used atmosphere in a reflective way on the surfaces. They are colored by the sky and surroundings, the green or blue of water. Some are down by the water and some are by the mountain. They reflect the colors. They are designed for outdoors.

HESS: Like a pond...

SMITH: ...reflects the sky, changes color all day long. They are not designed for modern buildings.

HESS: What about the sculptures you've entitled *Primo Piano*?

SMITH: All the action takes place on the second floor.

HESS: There is the base, then a pause, then the action?

SMITH: Yes. The title was a secondary thought, but, actually, there it is. The ground floor is where the desk clerks are.

HESS: And the action goes on above eye level. What about the *Wagons*?

SMITH: I've got three on wheels. It's a kind of iron chariot, on four wheels, with open linear elements. Each section of drawing is totally unrelated, and they don't fall together. They just sit there, broken.

HESS: So the chariot becomes a kind of field where these things exist?

SMITH: A longitudinal field.

HESS: And you got the idea of...

SMITH: Actually I bought these wheels from a guy who was making two cannons for me, cannons that shoot.

HESS: What do you want cannons for, robins?

SMITH: No, I wasn't going to shoot any robins. The one cannon I have is a Revolutionary War model, and it shoots frozen orange juice cans, lemonade and that sort of stuff. I save all those cans and fill them with cement and then shoot them.

HESS: How far does it carry?

SMITH: Oh, you can shoot it a mile, but with three ounces of powder it will shoot 700 to 1,000 feet. I also have a bronze cannon.

HESS: One of those yacht-club signal guns?

SMITH: Only bigger. One was found in Lake George, originally cast in Scotland and brought over during the French and Indian War. When they pulled up a dock, they found seven old cannons shoved underneath and one was in pretty good shape. A friend of mine had his brother make a pattern of it; I had a few hundred pounds of pig bronze lying around, so they made me a bronze cannon with bronze cannon wheels. Well, on my last Wagon, I used three of the bronze wheels that were made for cannons. So it's iron sculpture and has bronze wheels.

HESS: In the longitudinal space are 'drawings'?

SMITH: Big forgings. I drew a number of forgings to order, about forty-five, and sent them to Pittsburgh to be made.

HESS: In steel?

SMITH: Steel, yes.

HESS: It becomes a kind of classic cart...

SMITH: ... so you can pull them around and set them out in the field. They are too heavy for people to handle so I put wheels on them. Of course, I've used wheels a lot. As far as I know, I got the wheel idea from Hindu temples.

HESS: Those wheels of life?

SMITH: They cut them out of stone on the temples to represent the processions where they carry copies of temples down the streets on wagons. Carved stone wheels. It's a fascinating idea. I went to the Museum of Science and Industry where they have square wheels.

HESS: Do you use magic? I remember a piece, fifteen years ago, with a pedestal, steel, then a plane divided into three sections and in each section there were series of shapes and, above that, some steel drawing.

SMITH: That was a letter... and that relates to the Little Red Hen that scratched in Joyce... The Little Red Hen that scratched the letter up.

HESS: A steel letter.

SMITH: Yes. And the letter says, "You sent for me." Something very simple. A short cryptic message. "You sent for me." All letters say, "You sent for me", as far as I'm concerned.

HESS: And there are sculptures with 'H's' and 'Y's'; in fact, you've been concerned with letters.

SMITH: Yes.

HESS: Greek letters.

SMITH: All kinds of ungreek Greek. They look like Greek and they are Greek because 'Greek' is something you don't understand. And there are no 'H's' or 'Y's' in the Greek alphabet.

HESS: There's a 'Y' except it's a trident sign...

SMITH: ... my 'Y's' are tridents. Jean Xceron wrote my Greek for me.

HESS: And you've done some big, linear sculptures which aren't 'letters' – *Australia*...

SMITH: Yes, and *Hudson River Landscape;* it was a matter of drawing.

HESS: You think of drawing in terms of writing?

SMITH: I don't differentiate between writing and drawing, not since I read that part of Joyce.

HESS: There is a kind of secret message?

SMITH: The little hen scratched up a secret message.

HESS: "I sent for you"?

SMITH: No. "You sent for me" – that's different. That's what I think the secret letter said. Nobody knows what the letter really said.

HESS: And in your sculpture of big towers...

SMITH: ... just rising from the earth...

HESS: ... are drawings pulled up.

SMITH: Yes, and it's also a challenge in engineering to make them one hundred feet high. But sometimes mine don't perform correctly; they don't look like they are standing up.

HESS: Sometimes they almost threaten to topple.

SMITH: They aren't any different from light towers, but they don't look like they'll make it. Because I make them aesthetically first. Once in a while I throw in a constructive line for strength. I try to incorporate strength into aesthetics.

HESS: The only problem left is – why color?

SMITH: It is a foreign introduction, but why not?

HESS: You have steel, that beautiful material...

SMITH: Oh balls!

HESS: Steel and bronze...

SMITH: I color them. They are steel, so they have to be protected, so if you have to protect them with a paint coat, make it color. Sometimes you deny the structure of steel. And sometimes you make it appear with all its force in whatever shape it is. No rules...

The above texts are reprinted from Garnett McCoy (ed.), *David Smith,* New York – Washington, 1973

Robert Motherwell

Recollections of David Smith

I enjoyed David's companionship more completely then any artist I have ever known; he was as a member of the family, with his own key to the house I have lived in on East Ninety-fourth Street for more than eighteen years (since the birth of my first daughter). I can still hear the key in the lock of the front door turn without warning, and his cheerful deep voice booming through the house with greetings, and under his arms wine, cognac, French cheeses, and once (memorably) a side of young bear that he had shot on his farm at Bolton Landing, Lake George. If it was late, he could be drunk, always cheerfully and perhaps abashedly – he was profoundly sensual, mad about very young women, but with a stern Midwestern puritan guilt (about working, too). Helen Frankenthaler and he and I would all embrace, and in the mornings she would have a beautiful breakfast on a hot tray and a flower for when he awoke, and he would be moved with tenderness after the roughness of his

David Smith in about 1964

bachelor's life in the mountains upstate. He was the only man I was willing to start drinking with at a late breakfast, because it was joy, not despair.

I have had many close friends among New York artists over the year, but David Smith's openness – he was never on guard, except that he would not say anything against a fellow artist, because by having that life commitment, he was beyond reproach – only David's openness was matched to my own instincts. Moreover, he loved Helen, who had been one of his first patrons when, a very young woman, she was going around with Clement Greenberg, and who never wavered in her belief in David, nor her open admiration for him ('open' is a very important word to me). With him alone among my close circle of colleagues would I talk about certain male things – Mercedes-Benz (to which he converted me), shotguns, the wonders of Dunhill's tobacco shop, where the best dark bread and sweet butter was (Locke-Ober's in Boston), baroque music, Scotch tweeds, the pleasures and mysteries of Europe, the Plaza over the Chelsea Hotel (I converted him), the reminiscences of a Western American youth between two world wars, in short, his whole 'Ernest Hemingway' side, so to speak, that was so adumbrated in New York City, and which, whether a fantasy or not, was a safety valve for both of us. Quite independently, we had come to roughly the same conclusions about aesthetic sources of our inspiration which, in ABC terms, might be put as any art before the fourth century B.C, cubism-*cum*-surrealism, James Joyce, Stravinsky, Picasso, the strength and sensuousness of materials themselves, and a certain 'primitive' directness. There were of course minor blind spots on both sides: he liked to go to the Five Spot to hear Charlie Mingus or whoever might be there, while I've never been attracted to popular music, no matter how great; or once, when Helen and I spent a sleepless night at Bolton Landing, her anger at discovering our mattress was not on bed springs, but on boards. (When we visited him the weekend before his last weekend, he asked Helen what make of bed to get for us; and then ten days later he was dead. Ken Noland called us to come to the hospital at Albany, and we drove north at ninety-five miles an hour through the night to get there, but Tony Caro came out with his kind face and said David had died from head injuries a few minutes before. For some months afterward, when I would occasionally come home with two items from a shopping tour – say, sea salt from England for boiled beef – I realized how deep my habit was to get one for him too. As always had he.)

David had many deep friendships, and I would guess with each that magic gift of making you feel you alone were the one. He'd been extremely handsome when young, and in his prime with his bearhugs and warm smile had the charisma of Clark Gable, or what a wonderful animal a man is, and how even more wonderful as a man.

On the occasion of his bringing the great hunk of bear meat, ghastly red (as much from the paprika marinade, I later realized, as from blood), it was the afternoon of a dinner party we were giving, and he would not have it that we did not serve the bear

after the smoked Scotch salmon. Helen left us at the kitchen table (with a bottle of cognac before us) for a mysterious errand, and he and I ransacked a shelf of cookbooks for a recipe for bear. There was none, so we adapted one for roast venison, with salt, fresh pepper, bay leaf, burgundy, meat glaze, and at the end, ruby port and a tablespoon of red currant jelly for the sauce. (It was superb.) There were perhaps twelve of us at the table, high on Scotch and wine and animated conversation, and Helen brought in the bear on a large platter after clearing the first course, and sat down in the middle of an absorbing story by someone. Suddenly she said, "David, look at me!" and he burst into raucous laughter as we looked at her in an apron on a bearsuit costume that she had rented at a theatrical supply house that afternoon and, as the little bear of the three bears, began to eat roast bear, like a cannibal, but a most ladylike one…

I first met David in 1950. Marion Willard, his dealer, had sounded me out as to whether I would write a preface for his forthcoming show, to which I agreed, and it was arranged that he and I, who had never met, though I had admired his work for at least ten years before, after seeing an abstract steel *Head* of his in an outdoor show in Greenwich Village (he loved it that I remembered that head so well), would meet in a bar in Times Square around noon. After we met he said, "I'm drinking Irish whiskey with Guinness stout as a chaser." "Fine," I said (after all, I am a Celt), and we proceeded to try to drink each other under the table. By midnight we had not succeeded, I don't remember where we ate (at Dorothy Dehner's?). I do remember driving my jeep station wagon back through the moonlight night to East Hampton, having a last beer to sustain me at Smithtown (or was it the name?), and wondering, before I fell into bed in a stupor, how I had made it, good a driver as I was in those days. But it was in 1958, when I married Helen Frankenthaler, that we became a trio, a special dimension in all our lives.

His two daughters were almost the same age as mine, we both delighted in them, adored them in our clumsy way, and when he had his daughters on leave from their mother, I helped him 'entertain' them. He loved during the summer to bring them down from Bolton Landing to visit us at the seashore in Provincetown, where I've mostly gone for the summers, and my daughters still remember their childish awe at him finding a wet, torn dollar bill in the outgoing tide. He and I both loved a

ménage, with women, children, and friends and a bountiful table and endless drink, and we could do it unselfconsciously with each other, which is perhaps the deepest relief one peer can give another.

And we both knew damned well the black abyss in each of us that the sun and the daughters' skin and the bounty and the drink could alleviate but not begin to fill, a certain kind, I suppose, of puritanical bravado, of holding off the demons of guilt and depression that largely destroyed in one way or another the abstract expressionist generation, whose suffering and labor was to make it easier, but not realer, for the next generation. And if they liked it cool, we liked it warm, a warmth that is yet to reappear in the art of the young generations who have, as they should, their own life styles, whether chic or hippie or what. In any case, during the last year before he killed himself in his truck – his beautiful head was crushed against the cargo guardrail when he dove into a ditch, chasing Ken Noland in his English Lotus sports car to an opening at Bennington – David subtly changed, as though, about to be sixty, the old bravado was no longer self-sustaining. That optimism that we had shared through everything fluctuated ever so slightly, he made a will for the first time (naming me, without my knowing it, as one of his three trustees and executors, doubtless because of his daughters, his sole heirs); sometimes when very drunk he would begin to talk with a touch of paranoia about other artists or his domestic life, and sometimes despair would darken a moment. Then we would wordlessly pat each other on the shoulder, and have a final drink before bed. Rothko, in the fifties, before he himself began to drink a lot, used to say to me angrily, "Your solution to everything is another drink." Now I do not drink at all, they both are violently dead, Helen Frankenthaler and I are splitting, and I have invited David's daughters to visit with my daughters again this summer (1971) in Provincetown. I have felt deeply for various men during my life – masculinity is as beautiful in its own way as femininity is in its– but there will never be another David Smith. I am fortunate that there was one. What freedom there is in being allowed to be open in every dimension, to feel complete empathy.

Reprinted from John Gruen, *The Party's Over Now,* New York: Viking Press, 1967

Appendix

List of Works in the Catalogue

including inscriptions by the artist, additional measurements and the numbers given to the sculptures by Rosalind E. Krauss, *The Sculpture of David Smith: A Catalogue Raisonné* (New York – London, 1977).

1 Construction, 1932; unsigned; painted wood, wire, nails, bronze, and corals; 94.5 x 41.5 x 18.5 cm; Krauss, no. 8; Collection of Candida and Rebecca Smith (by courtesy of M. Knoedler & Co., Inc., New York)

2 Saw Head, 1933; unsigned; iron, painted orange, and bronze; 47 x 30.5 x 21 cm; Krauss, no. 21; Collection of Candida and Rebecca Smith (by courtesy of M. Knoedler & Co., Inc., New York)

3 Agricola Head, 1933; signed (on head): *David Smith 1933,* and (on base): *DS* [in Greek] *1933;* iron and steel, painted red; 46.5 x 19.5 x 25.5 cm; Krauss, no. 17; Collection of Candida and Rebecca Smith (by courtesy of M. Knoedler & Co., Inc., New York)

4 Billiard Player Construction, 1937; unsigned; iron and encaustic painting; 44 x 52 x 16 cm; Krauss, no. 53; Collection of Dr. & Mrs. Arthur E. Kahn

5 Interior, 1937; signed (rear right): *David Smith '37,* and (on front of base): *1937 David Smith;* wrought steel with cast-iron spheres; 39.5 x 66 x 15 cm; base: 8.5 x 67.5 x 13.5 cm; Krauss, no. 58; The Weatherspoon Art Gallery, Greensboro, North Carolina

6 Swung Forms, 1937; signed (on vertical member): *David Smith/1937,* and (on diagonal member): *DS* [in Greek] *37;* steel; 58.5 x 28 x 58.5 cm; Krauss, no. 61; Collection of Candida and Rebecca Smith (by courtesy of M. Knoedler & Co., Inc., New York)

7 Untitled, 1937; unsigned; iron, painted in various colours; 30 x 42 x 14.5 cm; Krauss, no. 68; Collection of Frank Stella

8 Structure of Arches, 1939; unsigned; steel, plated with cadmium and copper; 100.5 x 124.5 x 77.5 cm; Krauss, no. 127; Addison Gallery of American Art, Phillips Academy, Andover, Mass. (Gift of Mr. and Mrs. Crosby Kemper)

9 Head as a Still Life, 1940; signed (on base): *David Smith;* steel, bronze; 39 x 44.5 x 20 cm; Krauss, no. 137; Collection of Candida and Rebecca Smith (by courtesy of M. Knoedler & Co., Inc., New York)

10 Home of the Welder, 1945; signed (on base): *1945 David Smith;* steel; 53 x 44 x 34.5 cm; Krauss, no. 180; Collection of Candida and Rebecca Smith (by courtesy of the Tate Gallery, London)

11 Pillar of Sunday, 1945; signed (on rear of base): *David Smith 1945;* steel, painted pink; 78 x 42 x 21.5 cm; Krauss, no. 184; Indiana Art Museum, Bloomington, Indiana

12 Steel Drawing I, 1945; signed (on right of base): *David Smith/1945,* and (on left of base): *David Smith 1945;* steel; 56.5 x 66 x 15 cm; Krauss, no. 190; Hirshhorn Museum and Sculpture Garden, Washington, D.C.

13 Helmholtzian Landscape, 1946; unsigned; steel, painted blue, red, yellow and green; 40 x 48.5 x 19.5 cm; Krauss, no. 203; Collection of Mr. and Mrs. David Lloyd Kreeger

14 Landscape with Strata, 1946; signed (on right of base): *David Smith 1948;* steel, bronze and stainless steel; 42.5 x 55 x 25 cm; Krauss, no. 204; Collection of Dr. and Mrs. Arthur E. Kahn

15 Aggressive Character, 1947; signed (on sculpture): *David Smith 1947;* stainless steel and wrought iron; 82.5 x 10 x 19 cm; base: 4.5 x 18 x 21 cm; Krauss, no. 212; Collection of Candida and Rebecca Smith (by courtesy of M. Knoedler & Co., Inc., New York)

16 Royal Bird, 1948; signed (on base): *David Smith 1948;* steel and bronze; 52.5 x 151 x 23 cm; Krauss, no. 219; Walker Art Center, Minneapolis, Minnesota (Gift of the T. B. Walker Foundation)

17 The Garden (Landscape), 1949; signed and stamped: *1949;* steel and bronze, painted green and brown; 39.5 x 60.5 x 19 cm; Krauss, no. 223; Collection of Stefan T. Edlis

18 Cathedral, 1950; signed (on base): *David Smith 1950;* steel, painted brown; 86.5 x 62 x 43.5 cm; Krauss, no. 229; private collection, New York (by courtesy of the David McKee Gallery, New York)

19 Royal Incubator, 1950; unsigned; steel, bronze and silver; 94 x 97.5 x 24 cm; Krauss, no. 234; Collection of Mr. and Mrs. Bagley Wright

20 Star Cage, 1950; signed (on base): *David Smith 1950;* various metals, welded and painted; 114 x 130 x 65.5 cm; Krauss, no. 238; The University Art Museum, University of Minnesota, Minneapolis (The John Rood Sculpture Collection)

21 Australia, 1951; unsigned; painted steel; 202 x 274 x 41 cm; base: 35.5 x 35.5 cm; Krauss, no. 245; The Museum of Modern Art, New York (Gift of William Rubin, 1968)

22 Hero, 1951–52; signed (on reverse): *David Smith/1951–52/G2;* steel, painted red; 187.5 x 65 x 30 cm; Krauss, no. 256; The Brooklyn Museum, New York (Dick S. Ramsay Fund)

23 Hudson River Landscape, 1951; unsigned; welded steel; 125.5 x 190.5 x 47 cm; Krauss, no. 257; Whitney Museum of American Art, New York

24 Agricola VIII, 1952; signed (on base): *David Smith 8 AGRICOLA VIII 1952;* steel; 80.5 x 54.5 x 47.5 cm; Krauss, no. 272; Collection of Candida and

Rebecca Smith (by courtesy of the National Gallery of Art, Washington, D.C.)

25 Agricola XIII, 1953; signed (on base): *David Smith 2/14/53 AGRICOLA XIII ARK;* steel and stainless steel; 85 x 106.5 x 26.5 cm; Krauss, no. 285; Collection of Dr. & Mrs. Arthur E. Kahn

26 Parallel 42, 1953; signed (on central section): *David Smith 2-26-53;* painted steel; 128.5 x 62 x 35.5 cm; Krauss, no. 300; Collection of Candida and Rebecca Smith (by courtesy of M. Knoedler & Co., Inc., New York)

27 Tanktotem III, 1953; signed (rear left): *David Smith 8/31/1953;* steel; 214.5 x 68.5 x 51 cm; Krauss, no. 303; Collection of Mr. and Mrs. David Mirvish, Toronto

28 The Five Spring, 1956; signed (on vertical member): *David Smith 11-24-1956;* steel, stainless steel and nickel; 91.5 x 37.5 x 197 cm; Krauss, no. 366; Collection of Candida and Rebecca Smith (by courtesy of the Tate Gallery, London)

29 Sentinel 1, 1956; signed (on the wing, upper right): *David Smith/ SENTINEL 1/1/10-20-56;* steel; 227.5 x 43 x 57.5 cm; Krauss, no. 382; National Gallery of Art, Washington, D.C. (Gift of the Collectors' Committee, 1979)

30 Fifteen Planes, 1958; signed (front left): *David Smith 1958;* stainless steel; 289 x 151 x 41.5 cm; Krauss, no. 446; Seattle Art Museum, Washington (Gift of the Virginia Wright Fund)

31 Tanktotem IX, 1960; signed (on the white sheet): *David Smith tnk IX KDS 8 20 1960;* steel, painted blue, black and white; 224 x 122 x 96.5 cm; Krauss, no. 496; Collection of Candida and Rebecca Smith (by courtesy of M. Knoedler & Co., Inc., New York)

32 Black White Forward, 1961; signed (on reverse); *David Smith 4-24-1961;* steel, painted black, white and brown; 224 x 122 x 90.5 cm; Krauss, no. 507; Collection of Candida and

Rebecca Smith (by courtesy of M. Knoedler & Co., Inc., New York)

33 Lectern Sentinel, 1961; signed (on base): *David Smith/Oct 23, 1961/ Lectern Sentinel;* stainless steel; 258.5 x 84 x 52 cm; Krauss, no. 518; Whitney Museum of American Art, New York (Gift of the Friends of the Whitney Museum, and purchase)

34 Zig III, 1961; signed (on base): *Hi Rebecca David Smith May 24, 1961 ZIG III;* steel, painted black; 235.5 x 282 x 152.5 cm; Krauss, no. 533; Collection of Candida and Rebecca Smith (by courtesy of M. Knoedler & Co., Inc., New York)

35 Zig II, 1961; signed (lower left): *David Smith 2-18-1961,* and (lower right): *Zig II;* steel, painted black, red and orange; 255.5 x 150.5 x 85 cm; Krauss, no. 532; Des Moines Art Center, Iowa (Gift of the Gardner Cowles Foundation in memory of Mrs. Florence Call Cowles, 1972)

36 Voltri IV, 1962; unsigned; steel; 174 x 152 x 37 cm; Krauss, no. 561; Rijksmuseum Kröller-Müller, Otterlo, Netherlands

37 Voltri VII, 1962; signed (on horizontal member): *David Smith 1962 Voltri VII;* iron; 216 x 312 x 110.5 cm; Krauss, no. 564; National Gallery of Art, Washington, D.C. (Ailsa Mellon Bruce Fund, 1977)

38 Voltri Bolton IX, 1962; signed (on base): *Voltri-Bolton IX David Smith 12.21.62;* steel, painted red; 216.5 x 85 x 68.5 cm; Krauss, no. 593; Collection of Lois and Georges de Menil, Paris

39 Volton XV, 1963; signed (on top of steel base): *David Smith Volton XV;* steel; 190.5 x 24 cm; Krauss, no. 599; Museum Ludwig, Cologne

40 Tower 1, 1963; signed (on base): *2-20/David Smith 1962–63;* stainless steel; 640 x 86.5 x 91.5 cm; Krauss, no. 625; Collection of Candida and Rebecca Smith (by courtesy of M. Knoedler & Co., Inc., New York)

41 Wagon II, 1964; signed (on large wheel): *Hi Candida David Smith*

April 16-1964; steel; 273 x 282.5 x 112 cm; Krauss, no. 639; Collection of Candida and Rebecca Smith (by courtesy of the National Gallery of Art, Washington, D.C.)

42 Untitled (Zig VI), 1964; signed (on the bottom horizontal bar): *David Smith/March 17, 1964;* steel girders, painted yellow ochre; 200 x 112.5 x 73.5 cm; Krauss, no. 642; Collection of Candida and Rebecca Smith (by courtesy of M. Knoedler & Co., Inc., New York)

43 Untitled, 1964; steel; 210 x 170 x 75 cm; Krauss, no. 643; Collection of Candida and Rebecca Smith (by courtesy of M. Knoedler & Co., Inc., New York)

44 Untitled (Candida), 1965; signed (on base): *David Smith February 26, 1965;* stainless steel; 256.5 x 304 x 78 cm; Krauss, no. 648; Collection of Candida and Rebecca Smith (by courtesy of M. Knoedler & Co., Inc., New York)

45 Cubi XIX, 1964; signed (on base): *David Smith 2-20-64 CUBI XIX;* stainless steel; 287.5 x 55 x 52.5 cm; Krauss, no. 667; The Trustees of the Tate Gallery, London

46 Cubi XXIV, 1964; unsigned; stainless steel; 291 x 214 x 72.5 cm; Krauss, no. 672; Museum of Art, Carnegie Institute, Pittsburgh, Pennsylvania (Howard Heinz Endowment Purchase Fund, 1967)

47 Cubi XXVI, 1965; signed (on horizontal cube): *David Smith/January 12 1965/CUBI XXVI;* stainless steel; 303.5 x 383.5 x 65.5 cm; Krauss, no. 674; National Gallery of Art, Washington, D.C. (Ailsa Mellon Bruce Fund, 1978)

48 Untitled, 1930; unsigned; oil on canvas; 30.5 x 40.6 cm; Estate no. 75-30.45; David Smith Estate (by courtesy of Washburn Gallery, New York)

49 Untitled, 1930–47; signed: *David Smith;* oil on canvas; 26.7 x 39.4 cm; Estate no. 75-30.56; Collection of Candida and Rebecca Smith (by courtesy of M. Knoedler & Co., Inc., New York)

50 Untitled (Relief Painting), 1932; signed: *David Smith,* and (on reverse): *David Smith 1932;* oil on wooden board and wooden relief elements, painted blue, green and black; 47 x 55.9 cm (wooden frame); Estate no. 75-30.136; David Smith Estate (by courtesy of Washburn Gallery, New York)

51 Untitled, 1936; signed: *David Smith E 1936;* oil on canvas; 35.6 x 48.3 cm; Estate no. 75-30.138; Collection of Candida and Rebecca Smith (by courtesy of M. Knoedler & Co., Inc., New York)

52 Untitled (Billiard Players), 1936; unsigned; oil on canvas; 119.4 x 132.1 cm; Estate no. 75-30.146; Collection of Mr. & Mrs. Barney A. Ebsworth

53 Untitled (St.Thomas Theme), 1932; signed: *D-Smith 1932;* pen and ink with wash on cardboard; 50.8 x 76.2 cm; Estate no. 73-32.2; Collection of Candida and Rebecca Smith (by courtesy of M. Knoedler & Co., Inc., New York)

54 Abstract Nautical Scene, 1933; signed: *David Smith 1933;* cut-outs in blue, ochre, white and green tempera, on lined paper mounted on canvas; 45.7 x 61 cm; Estate no. 73-33.4; Collection of Candida and Rebecca Smith (by courtesy of M. Knoedler & Co., Inc., New York)

55 Abstraction, 1933; signed: *David Smith '33;* red, grey and black forms in tempera, on blueprint; 43.2 x 35.6 cm; Estate no. 73-33.7; Collection of Candida and Rebecca Smith (by courtesy of M. Knoedler & Co., Inc., New York)

56 Untitled, 1936–37; unsigned; brush and ink with wash; 43.2 x 55.9 cm; Estate no. 73-37.5; Collection of Candida and Rebecca Smith (by courtesy of M. Knoedler & Co., Inc., New York)

57 Suspended Abstraction, 1937; signed: *DS* [in Greek] *1937 suspended between base uprights,* with measurements; pen and ink with tempera; 24.8 x 29.8 cm; Estate no. 73-37.11; Collection of Candida and Rebecca Smith (by courtesy of M. Knoedler & Co., Inc., New York)

58 Untitled, 1937–38; unsigned; pen and ink and pastel, with wash; 43.2 x 55.9 cm; Estate no. 73-38.2; Whitney Museum of American Art, New York (Gift of Joel and Anne Ehrenkranz)

59 Medals for Dishonor (War med), 1938–39; signed: *David Smith 1940;* pen and ink; 33.7 x 40.6 cm; Estate no. 73-38.15; Collection of Candida and Rebecca Smith (by courtesy of M. Knoedler & Co., Inc., New York)

60 Medals for Dishonor, 1938–39; unsigned; pen and ink; 33.7 x 41.9 cm; Estate no. 75-38.83; Collection of Candida and Rebecca Smith (by courtesy of M. Knoedler & Co., Inc., New York)

61 Medals for Dishonor, 1938–39; unsigned; pen and ink; 33.7 x 41.9 cm; Estate no. 75-38.88; Collection of Candida and Rebecca Smith (by courtesy of M. Knoedler & Co., Inc., New York)

62 Reclining Figure, 1939–40; signed: *DS* [in Greek]; tempera; 30.5 x 45.7 cm; Estate no. 73-40.4; Collection of Candida and Rebecca Smith (by courtesy of M. Knoedler & Co., Inc., New York)

63 Arian Fold Type 1, 1943; signed: *David Smith 43;* title inscribed on frame; pen and ink; 49.9 x 63.5 cm; Estate no. 73-43.1; David Smith Estate (by courtesy of M. Knoedler & Co., Inc., New York)

64 Fascist Royalty, 1943; signed: *David Smith 1943;* pen and ink; 49.5 x 63.5 cm; Estate no. 73-43.3; Collection of Candida and Rebecca Smith (by courtesy of M. Knoedler & Co., Inc., New York)

65 Untitled, 1942–43; signed: *David Smith;* pen and ink; 50.8 x 62.9 cm; Estate no. 73-43.6; David Smith Estate (by courtesy of M. Knoedler & Co., Inc., New York)

66 The Garden, 1950; signed: *DS* [in Greek] *1950;* pen and ink with green and yellow wash; 51.4 x 66.7 cm; Estate no. 73-50.3; Collection of Candida and Rebecca Smith (by courtesy of M. Knoedler & Co., Inc., New York)

67 Untitled, 1950; signed: *DS* [in Greek] *9 10/15,* and inscribed (right): *major plane* and (left): *L arc;* pen, brush and ink, and pastel; 46.4 x 57.8 cm; Estate no. 73-50.5; Collection of Candida and Rebecca Smith (by courtesy of M. Knoedler & Co., Inc., New York)

68 Untitled, 1951; signed: *DS* [in Greek] *1951 Jan;* brush and black, pink and brown ink with grey tempera and wash; 50.8 x 66 cm; Estate no. 73-51.18; Collection of Candida and Rebecca Smith (by courtesy of M. Knoedler & Co., Inc., New York)

69 Hudson River Landscape, 1951; signed: *River Landscape DS* [in Greek] *1951;* brush and black and purple-grey ink with umber tempera and wash; 50.8 x 66 cm; Estate no. 73-51.19; Collection of Candida and Rebecca Smith (by courtesy of M. Knoedler & Co., Inc., New York)

70 Untitled, 1951; signed: *DS* [in Greek] *Mar. 10;* pen and black and blue ink with tempera and orange wash; 46.4 x 57.8 cm; Estate no. 73-51.73; Collection of Candida and Rebecca Smith (by courtesy of M. Knoedler & Co., Inc., New York)

71 Untitled, 1952; unsigned; grey and white tempera; 73.5 x 107.3 cm; Estate no. 73-52.37; Collection of Candida and Rebecca Smith (by courtesy of M. Knoedler & Co., Inc., New York)

72 Untitled, 1952; signed: *DS* [in Greek] *11/20/52;* brush and grey and purple ink; 39.4 x 52.1 cm; Estate no. 73-52.52; Collection of Candida and Rebecca Smith (by courtesy of M. Knoedler & Co., Inc., New York)

73 Untitled, 1952; signed: *DS* [in Greek] *3/27/52;* brush and black and dark-green ink with tempera; 45.7 x 59.1 cm; Collection of Candida and Rebecca Smith (by courtesy of M. Knoedler & Co., Inc., New York)

74 Untitled, 1952; signed: *DS* [in Greek] *9-8-52;* brush and ink with tempera; 45.7 x 59.7 cm; Estate no. 73-52.134; Collection of Candida and Rebecca Smith (by courtesy of M. Knoedler & Co., Inc., New York)

75 Untitled, 1952; signed: *DS* [in Greek] *11-19-52;* brush and ink; 39.4 x 52.1 cm; Estate no. 73-52.177; Collection of Candida and Rebecca Smith (by courtesy of M. Knoedler & Co., Inc., New York)

76 Untitled, 1952; signed: *DS* [in Greek] *6-23-52;* brush and ink with white tempera; 45.7 x 59.1 cm; Estate no. 73-52.182; Collection of Candida and Rebecca Smith (by courtesy of M. Knoedler & Co., Inc., New York)

77 Untitled, 1953; signed: *DS* [in Greek] *2/29/53;* brush and ink; 75.6 x 108.6 cm; Estate no. 73-53.8; Collection of Candida and Rebecca Smith (by courtesy of M. Knoedler & Co., Inc., New York)

78 Untitled, 1953; signed: *David Smith 4/14/53 ark;* brush and violet ink; 76.2 x 107.5 cm; Estate no. 73-53.16; Wilhelm-Lehmbruck-Museum der Stadt Duisburg

79 Untitled, 1953; signed: *DS* [in Greek] *9/19/53;* brush and blue-black ink; 39.4 x 52.1 cm; Estate no. 73-53.26; Collection of Candida and Rebecca Smith (by courtesy of M. Knoedler & Co., Inc., New York)

80 Untitled, 1953; signed: *DS* [in Greek] *3/5/53;* brush and ink; 45.7 x 61 cm; Estate no. 73-53.70; Collection of Candida and Rebecca Smith (by courtesy of M. Knoedler & Co., Inc., New York)

81 Untitled, 1953; signed: *DS* [in Greek] *6/5/4/53;* brush and dark-red ink; 39.4 x 51.4 cm; Estate no. 73-53.97; Collection of Candida and Rebecca Smith (by courtesy of M. Knoedler & Co., Inc., New York)

82 Untitled, 1953; signed: *DS* [in Greek] *6/5/4/53;* brush and dark-red ink; 39.4 x 51.4 cm; Estate no. 73-53.100; Collection of Candida and Rebecca Smith (by courtesy of M. Knoedler & Co., Inc., New York)

83 Untitled, 1953; unsigned; brush and ink; 45.7 x 61 cm; Estate no. 73-53.131; Collection of Candida and Rebecca Smith (by courtesy of M. Knoedler & Co., Inc., New York)

84 Untitled, 1953; unsigned; pen and black and green ink; 45.7 x 61 cm; Estate no. 73-53.131; Collection of Candida and Rebecca Smith (by courtesy of M. Knoedler & Co., Inc., New York)

85 Untitled, 1954; signed: *DS* [in Greek] *11/8/54-7;* brush and salmon-coloured ink with red tempera; 40 x 51.4 cm; Estate no. 73-54.27; Private collection

86 Untitled, 1954; unsigned; brush and ink with white and red oil colour; 50.8 x 66 cm; Estate no. 73-54.83; Collection of Candida and Rebecca Smith (by courtesy of M. Knoedler & Co., Inc., New York)

87 Untitled, 1954; signed: *DS* [in Greek] *6/3/54;* mixed media in grey, white and black; 25.4 x 20.3 cm; Estate no. 73-54.103; Private collection

88 Untitled, 1955; unsigned; brush and ink; 43.2 x 53.3 cm; Estate no. 73-55.85; Collection of Candida and Rebecca Smith (by courtesy of M. Knoedler & Co., Inc., New York)

89 Untitled, 1955; signed (above): *DS* [in Greek] *2-11-55;* (below): *DS* [in Greek] *2-10-55 1;* and (in pencil): *DS* [in Greek] *2 10 55;* brush and ink; 42.6 x 53.3 cm; Estate no. 73-55.156; Collection of Candida and Rebecca Smith (by courtesy of M. Knoedler & Co., Inc., New York)

90 Untitled, 1956; unsigned; brush and black, white and salmon-coloured ink with tempera and grey oil colour; 51.4 x 39.7 cm; Estate no. 73-56.6 B; Collection of Candida and Rebecca Smith (by courtesy of M. Knoedler & Co., Inc., New York)

91 Untitled, 1957; signed: *DS* [in Greek] *10/30/57;* black, blue and red oil colour; 58.4 x 89.5 cm; Estate no. 73-57.3; Collection of Candida and Rebecca Smith (by courtesy of M. Knoedler & Co., Inc., New York)

92 Untitled, 1957; signed: *DS [in Greek] 5/10/30/57;* yellow, blue, red and white oil colour; 50.4 x 00.5 cm; Estate no. 73-57.5; Collection of Candida and Rebecca Smith (by courtesy of M. Knoedler & Co., Inc., New York)

93 Untitled, 1957; signed: *DS* [in Greek] *10/10/30/57;* yellow, blue, red and black oil colour; 58.4 x 89.5 cm; Estate no. 73-57.10; Collection of Candida and Rebecca Smith (by courtesy of M. Knoedler & Co., Inc., New York)

94 Untitled, 1957; signed: *DS* [in Greek] *Feb. 1957;* brush and ink; 68 x 101.6 cm; Estate no. 73-57.16; Collection of Candida and Rebecca Smith (by courtesy of M. Knoedler & Co., Inc., New York)

95 Untitled, 1957; signed: *DS* [in Greek] *Mar 1957;* pen and ink; 68 x 101.3 cm; Estate no. 73-57.25; Collection of Candida and Rebecca Smith (by courtesy of M. Knoedler & Co., Inc., New York)

96 Untitled, 1957; signed: *David Smith 11/26/57;* mixed media in black and white; 69 x 101.5 cm; Estate no. 73-57.36; Wilhelm-Lehmbruck-Museum der Stadt Duisburg

97 Untitled, 1957; unsigned; brush and ink, red and white oil colour and tempera; 40 x 51.8 cm; Estate no. 73-57.124; Collection of Candida and Rebecca Smith (by courtesy of M. Knoedler & Co., Inc., New York)

90 Untitled, 1957; signed: *DS* [in Greek] *63-12-57;* brush and ink on Japanese paper; 44.5 x 57.2 cm; Estate no. 73-57.204; Collection of Candida and Rebecca Smith (by courtesy of M. Knoedler & Co., Inc., New York)

99 Untitled, 1957; signed: *DS* [in Greek] *72-12-57;* brush and ink on Japanese paper; 44.5 x 57.2 cm; Estate no. 53-57.211; Collection of Candida and Rebecca Smith (by courtesy of M. Knoedler & Co., Inc., New York)

100 Untitled, 1957; signed: *DS* [in Greek] *92-12-57;* brush and purple ink on Japanese paper; 44.5 x 57.2 cm; Estate no. 73-57.228; Collection of Candida and Rebecca Smith (by courtesy of M. Knoedler & Co., Inc., New York)

101 Untitled, 1957; signed: *DS* [in Greek] *92-12-57;* brush and ink on

Japanese paper; 44.5 x 57.2 cm; Estate no. 73-57.233; Collection of Candida and Rebecca Smith (by courtesy of M. Knoedler & Co., Inc., New York)

102 Untitled, 1957; signed: *DS* [in Greek] *111-12-57;* brush and ink on Japanese paper; 44.5 x 57.2 cm; Estate no. 73-57.247; Collection of Candida and Rebecca Smith (by courtesy of M. Knoedler & Co., Inc., New York)

103 Timeless Clock, 1957; signed: *4-57;* brush and ink; 51.4 x 66.7 cm; Estate no. 73-57.271; Collection of Candida and Rebecca Smith (by courtesy of M. Knoedler & Co., Inc., New York)

104 Untitled, 1958; signed: *DS* [in Greek] *4 3/9/58;* brush and red and green ink with white tempera; 67.3 x 101 cm; Estate no. 73-58.22; Collection of Candida and Rebecca Smith (by courtesy of M. Knoedler & Co., Inc., New York)

105 Untitled, 1958; signed: *David Smith 8-8-58;* brush and ink; 68 x 101 cm; Estate no. 73-58.29; Collection of Candida and Rebecca Smith (by courtesy of M. Knoedler & Co., Inc., New York)

106 Untitled, 1958; signed: *DS* [in Greek] *1958;* spray drawing; 44.5 x 28.9 cm; Estate no. 73-58.223; Collection of Candida and Rebecca Smith (by courtesy of M. Knoedler & Co., Inc., New York)

107 Untitled, 1959; signed: *David Smith 10-3-1959;* brush and violet ink; 51.6 x 66 cm; Estate no. 73-59.3; Gabriele Henkel, Düsseldorf

108 Untitled, 1959; unsigned; brush and ink; 45.7 x 57.2 cm; Estate no. 73-59.31; Collection of Candida and Rebecca Smith (by courtesy of M. Knoedler & Co., Inc., New York)

109 Untitled, 1959; unsigned; brush and ink with grey tempera; 45.7 x 57.2 cm; Estate no. 73-59.40;

Collection of Candida and Rebecca Smith (by courtesy of M. Knoedler & Co., Inc., New York)

110 Untitled, 1959; signed: *David Smith 1959;* brush and ink; 67.3 x 101.6 cm; Estate no. 73-59.69; Collection of Candida and Rebecca Smith (by courtesy of M. Knoedler & Co., Inc., New York)

111 Untitled, 1959; signed: *David Smith 19-3-59;* brush and ink; 67.3 x 101.6 cm; Estate no. 73-59.81; Collection of Candida and Rebecca Smith (by courtesy of M. Knoedler & Co., Inc., New York)

112 Untitled, 1959; signed: *David Smith C-5-2-59;* brush and ink with tempera; 67.3 x 101.6 cm; Estate no. 73-59.88; Collection of Candida and Rebecca Smith (by courtesy of M. Knoedler & Co., Inc., New York)

113 Untitled, 1959; signed: *5/59;* spray drawing; 44.5 x 29.2 cm; Estate no. 73-59.119; Collection of Candida and Rebecca Smith (by courtesy of M. Knoedler & Co., Inc., New York)

114 Untitled, 1959; signed: *DS* [in Greek] *1959;* spray drawing; 44.5 x 29.2 cm; Estate no. 73-59.135; David Smith Estate (by courtesy of Anthony d'Offay, London)

115 Untitled, 1960; signed: *David Smith Oct. 1-1960;* brush and ink; 68 x 101 cm; Estate no. 73-60.3; Collection of Candida and Rebecca Smith (by courtesy of M. Knoedler & Co., Inc., New York)

116 Untitled, 1960; signed: *David Smith Oct 9-1960;* brush and ink; 68 x 101 cm; Estate no. 73-60.10; Collection of Candida and Rebecca Smith (by courtesy of M. Knoedler & Co., Inc., New York)

117 Untitled, 1960; signed: *David Smith 4-4-60 Ch;* mixed technique in brown, green, red and blue; 66.5 x 104.3 cm;

Estate no. 73-60.17; Collection of Henkel KGaA, Düsseldorf

118 Untitled, 1960; signed: *David Smith 3.20.60 Chelsea;* mixed technique in black and white; 76 x 102 cm; Estate no. 73-60.14; Collection of Henkel KGaA, Düsseldorf

119 Untitled, 1960; unsigned; brush and brown ink; 39.4 x 52.1 cm; Estate no. 73-60.91; Collection of Candida and Rebecca Smith (by courtesy of M. Knoedler & Co., Inc., New York)

120 Untitled, 1961; signed: *David Smith: 3-10-61;* brush and ink; 55.9 x 75.9 cm; Estate no. 73-61.29; Collection of Candida and Rebecca Smith (by courtesy of M. Knoedler & Co., Inc., New York)

121 Untitled, 1961; unsigned; spray drawing; 43.2 x 29.2cm; Estate no. 73-61.47; David Smith Estate (by courtesy of M. Knoedler & Co., Inc., New York)

122 Untitled, 1961; unsigned; spray drawing; 44.5 x 29.2 cm; Estate no. 73-61.57; David Smith Estate (by courtesy of the Anthony d'Offay Gallery, London)

123 Untitled, 1962; unsigned; spray drawing; 44.5 x 29.2 cm; Estate no. 73-62.93; Collection of Candida and Rebecca Smith (by courtesy of M. Knoedler & Co., Inc., New York)

124 Untitled, 1963; signed: *7 DS* [in Greek]; spray drawing; 41.3 x 29.2 cm; Estate no. 73-63.161; Collection of Candida and Rebecca Smith (by courtesy of M. Knoedler & Co., Inc., New York)

125 Untitled, 1963; signed (lower right): *David Smith 3-12-63;* black varnishing paint; 48.2 x 66.3 cm; Estate no. 73-63.14; private collection

126 Untitled, 1963; signed: *David S. DO 14-1963;* brush and brown ink on Japanese paper; 44.5 x 57.2 cm; Estate no. 73-63.41; Collection of Candida and Rebecca Smith (by courtesy of M. Knoedler & Co., Inc., New York)

Corinna Beyer

Exhibitions and Bibliography

Where possible, the exhibition lists indicate whether a catalogue accompanied the exhibition or not ("cat.", "no cat."). References to these catalogues appear in abbreviated form in the bibliography.

One-man Shows

1938

East River Gallery, New York, NY: *David Smith Steel Sculpture.* 19.1.–5.2.

1940

Neumann-Willard Gallery, New York, NY: *David Smith.* 25.3.–15.4.

Willard Gallery, New York, NY: *Medals for Dishonor by David Smith.* 5.11.–23.11. (cat.)

Saint Paul Gallery and School of Art, Saint Paul, MN: *David Smith.* Subsequently at the University Gallery, University of Minnesota, Minneapolis, MN

Walker Art Center, Minneapolis, MN: *David Smith*

1941

Kalamazoo Institute of Art, Kalamazoo, MI: *Medals for Dishonor.* Feb. (no cat.)

Walker Art Center, Minneapolis, MN: *Medals for Dishonor.* Nov.–Dec. (no cat.)

1942

Skidmore College, Saratoga Springs, NY: *David Smith.* 8.1.–28.1.

Willard Gallery, New York, NY: *Jewelry by David Smith.* Jan.

1943

Willard Gallery, New York, NY: *David Smith.* 6.4.–1.5.

1946

Buchholz Gallery and Willard Gallery, New York, NY: *The Sculpture of David Smith.* 2.1.–26.1. (cat.)

American Association of University Women, Biennial convention, Baker Hotel, Dallas, TX: *David Smith.* 13.4.–20.4. (cat.). Subsequently at: Gary Public Library, Gary, IN; Fort Wayne Civic Theater, Fort Wayne, IN; Worcester Pressed Steel Museum, Worcester, MA; Indiana State Teachers College, Terre Haute, IN; East Central State College and Public Library, Ada, OK; City Library, Logan, UT; Provo Public Library, Provo, UT; Butler Institute of Art, Youngstown, OH; Roosevelt College, Chicago, IL; Michigan State College, East Lansing, MI; Junior Gallery, Louisville, KY; Grinnell College, Grinnell, IA; Alabama Polytechnic Institute, Auburn, AL

1947

Skidmore College, Saratoga Springs, NY: *Sculpture & Drawings by David Smith.* 4.2.–25.2. (no cat.)

Willard Gallery, New York, NY: *David Smith Sculpture 1946–47.* 1.4.–26.4. (cat.)

Allen R. Hite Art Institute, University of Louisville Library, Louisville, KY: *David Smith – Medals for Dishonor.* 29.11.–18.12. (cat.)

1950

Willard Gallery, New York, NY: *David Smith.* 18.4.–13.5. (cat.)

1951

Willard Gallery, New York, NY: *David Smith.* 27.3.–21.4.

Bennington College, Bennington, VT: *David Smith.* 16.11.–25.11.

1952

Willard Kleemann Gallery, New York, NY: *David Smith Sculpture & Drawings (Four Soldiers – A Sculpture in Iron by David Smith).* 1.4.–26.4. (cat.)

Walker Art Center, Minneapolis, MN: *Sculpture and Drawings – David Smith.* 12.4.–11.5.

The Art Department, Catholic University of America, Washington, DC: *Drawings, Paintings, Sculptures by David Smith.* 22.10.–14.11. (no cat.)

Williams College Museum of Art, Williamstown, MA: *David Smith.*

1953

Kootz Gallery (in cooperation with the Willard Gallery), New York, NY: *David Smith – New Sculpture.* 26.1.–14.2. (cat.)

University of Arkansas, Fayetteville, AR: *David Smith.* Feb.

Portland Art Museum, Portland, OR: *David Smith.* 16.4.–19.5. (no cat.)

Philbrook Art Center, Tulsa, OK: *David Smith.* April

Contemporary Arts Center, Cincinnati Art Museum, Cincinnati, OH: *David Smith.* 19.5.–13.6. (cat.)

Willard Gallery, New York, NY: *David Smith – Drawings.* 15.12.–30.12.

1954

Willard Gallery, New York, NY: *David Smith.* 5.1.–30.1.

Contemporary Arts Center, Cincinnati Art Museum, Cincinnati, OH: *David Smith: Sculpture, Drawings, Graphics.* 19.5.–13.6. Subsequently in three other American cities.

1956

Willard Gallery, New York, NY: *David Smith – Sculpture – Drawings 1954–56.* 6.3.–31.3. (cat.)

1957

Museum of Modern Art, New York, NY: *David Smith.* 11.9.–29.10. (cat.)

Fine Arts Associates (Otto Gerson), New York, NY: *Sculpture by David Smith.* 17.9.–12.10. (cat.)

Widdifield Gallery, New York, NY: *David Smith: Sculptures in Silver.* 15.10.–2.11. (no cat.)

1959

The New Gallery, Bennington College, Bennington, VT: *David Smith (Drawings).* Opening: 26.3.

French & Company, Inc., New York, NY: *David Smith – Paintings & Drawings.* 16.9.–10.10. (cat.)

V. Bienal de São Paulo, Museu de Arte Moderna, São Paulo: *David Smith – 25 Sculptures, U.S. Representation.* Sept.–Nov.

1960

French & Company, Inc., New York, NY: *David Smith – Sculpture.* 15.2.–19.3.

Otto Gerson Gallery, New York, NY: *Selections: Paintings, Sculpture.* Summer

Everett Ellin Gallery, Los Angeles, CA: *David Smith – Sculpture & Drawings.* 7 11.–3.12. (cat.)

1961

Department of Fine Arts, Carnegie Institute, Pittsburgh, PA: *David Smith.* Oct.–Jan.

Otto Gerson Gallery, New York, NY: *David Smith – Recent Sculpture.* 10.10.–28.10. (cat.)

Memorial Art Gallery, Rochester, NY: *David Smith.* 3.11.–24.11. Travelling exhibition of the Museum of Modern Art, New York, NY. Subsequently at: Lamont Art Gallery, Phillips Exeter Academy, Exeter, NH, 15.1.1963–5.2.; Hayden Gallery, Massachusetts Institute of Technology, Cambridge, MA, 10.2.–27.2.; The Phillips Collection, Washington, DC, 11.3.–30.4.; Art Association of Indianapolis, John Herron Museum of Art, Indianapolis, IN, 2.9.–23.9.; Wadsworth Atheneum, Hartford, CT, 27.10.–24.11.; Mitchell Gallery, Southern Illinois University, Carbondale, IL, 2.1.1964–24.1.; Witte Memorial Museum, San Antonio, TX, 10.2.–3.3.

1963

Balin/Traube Gallery, New York, NY: *David Smith – A Decade of Drawings 1953 – 1963.* 14.5.–14.6. (no cat.)

State University College, Plattsburgh, NY: *Drawings by David Smith.* 1.12.–22.12. (no cat.). Travelling exhibition of the Museum of Modern Art, New York, NY. Subsequently at: Bowling Green State University, Bowling Green, OH, 6.1.1964–27.1.; University of Manitoba, Winnipeg, 10.2.–2.3.; Northern Michigan University, Marquette, MI, 16.3.–6.4.; Mankato State College, Mankato, MN, 4.11.–20.11.; State University of New York, Oswego, NY, 3.12.–24.12.; J.B. Speed Art Museum, Louisville, KY, 14.2.1965–7.3.; Paterson State College, Wayne, NJ, 22.3.–12.4.; Green Mountain College, Poultney, VT, 26.4.–17.5.; Madison Art Association, Madison, WI, 1.6.–22.6.; University of Detroit, Detroit, MI, 1.10.–24.10.; Skidmore College, Saratoga Springs, NY, 9.11.–30.11.; Wichita

State University Campus Activities Center, Wichita, KS, 26.10.1966–16.11.; Fresno State College, Fresno, CA, 1.12.–22.12.

1964

Institute of Contemporary Art, University of Pennsylvania, Philadelphia, PA: *David Smith – Sculpture & Drawings.* 1.2.–15.3. (cat.)

Hyde Collection, Glens Falls, NY: *David Smith.* 7.6.–1.7. (cat.)

Marlborough-Gerson Gallery, New York, NY: *David Smith.* Opening: 15.10. (cat.)

1965

Hyde Collection, Glens Falls, NY: *David Smith 1906–1965.* June.

Los Angeles County Museum of Art, Los Angeles, CA: *David Smith – A Memorial Exhibition.* 3.11.–30.1.1966

1966

Rijksmuseum Kröller-Müller, Otterlo: *David Smith 1906–1965.* 15.5.–17.6. (cat.). Travelling exhibition of the International Council of the Museum of Modern Art. Subsequently at: Tate Gallery, London, 18.7.–25.9.; Kunsthalle, Basle, 25.10. – 23.11.; Kunsthalle, Nuremberg, 17.1.1967 – 20.2.; Wilhelm-Lehmbruck-Museum, Duisburg, 15.4.–28.5.

Fogg Art Museum, Harvard University, Cambridge, MA: *David Smith – A Retrospective Exhibition 1906–1965.* 28.10 – 15.11. (cat.). Subsequently at the Washington Gallery of Modern Art, Washington, DC

1967

Marlborough-Gerson Gallery, New York, NY: *David Smith – Eight Early Works 1935–38.* April (cat.)

1968

Marlborough-Gerson Gallery, New York, NY: *David Smith 1906–1965 – Small Sculptures of the Mid-Forties.* 17.5.–17.6. (cat.)

1969

Solomon R. Guggenheim Museum, New York, NY: *David Smith.* March–May. (cat.). Subsequently at: Dallas Museum of Fine Arts, Dallas, TX; Corcoran Gallery of Art, Washington, DC

1971

Storm King Art Center, Mountainville, NY: *Sculpture by David Smith in the Storm King Art Center Collection.* (cat.)

1972

Fogg Art Museum, Harvard University Cambridge, Cambridge, MA: *David Smith:*

23 Related Sculptures, Drawings, Paintings. Jan.–Feb. (no cat.)

1973

Hyde Collection, Glens Falls, NY: *David Smith of Bolton Landing: Sculpture and Drawings.* 1.7.–30.9. (cat.)

Knoedler Contemporary Art, New York, NY: *David Smith: Drawings.* 13.10.–3.11.

1974

Knoedler Contemporary Art, New York, NY: *David Smith (1912–1965).* 5.10.–26.10. (cat.)

University Art Gallery, State University of New York, Albany, NY: *Terminal Iron Works: Photographs of David Smith and His Sculpture by Dan Budnik.* 13.10.–17.11. (cat.). Travelling exhibition of the American Federation of Arts. Subsequently at: University of Texas at Austin, Austin, TX; Rockland Community College, Suffern, NY; Center for Music, Drama and Art, Lake Placid, NY; Hopkins Center, Dartmouth College, Hanover, NH; Hudson River Museum, Yonkers, NY; Charles W. Bowers Memorial Museum, Santa Ana, CA

1976

Knoedler Contemporary Art, New York, NY: *David Smith: Small Sculptures.* 16.3.–7.4. *David Smith: Paintings.* 24.4.–13.5.

Storm King Art Center, Mountainville, NY: *David Smith.* 12.5.–31.10.

Staatsgalerie Stuttgart, Stuttgart: *David Smith: Zeichnungen.* 29.1.–29.2. (cat.). Subsequently at: Nationalgalerie, Berlin (West), 16.3.–2.5.; Wilhelm-Lehmbruck-Museum, Duisburg, Sept.–Oct.

1977

M. Knoedler and Company, New York, NY: *David Smith.* 22.11.–10.12.

1978

M. Knoedler and Company, New York, NY: *David Smith.* 21.11.–14.12.

1979

Galerie Wentzel, Hamburg: *David Smith.* 24.4.–2.5.

Hirshhorn Museum and Sculpture Garden, Washington, DC: *David Smith: The Hirshhorn Museum and Sculpture Garden Collection.* 25.7.–28.10. (cat.)

Lake George Art Project, Lake George, NY: *The Prospect Mountain Sculpture Show: An Hommage to David Smith.* 1.8.–15.10. (cat.)

Fogg Art Museum, Harvard University Cambridge, Cambridge, MA: *David Smith:*

Sculpture, Drawings and Paintings. 1.10.–25.11. (no cat.)

Whitney Museum of American Art, New York, NY: *David Smith: The Drawings.* 5.12.–10.2.1980 (cat.). With the addition of several sculptures, subsequently at the Serpentine Gallery (Arts Council of Great Britain), London: *David Smith: Sculpture and Drawings.* 8.5.–8.7. (catalogue extended to include sculptures).

1980

M. Knoedler and Company, New York, NY: *David Smith: Drawings with Color.* 14.5.–13.6.

1981

The Edmonton Art Gallery, Edmonton: *David Smith: The Formative Years – Sculpture and Drawings from the 1930s and 1940s.* 16.1.–1.3. (cat.). Subsequently at: Seattle Art Museum, Seattle; Winnipeg Art Gallery, Winnipeg; Art Gallery of Hamilton, Hamilton; Art Gallery of Windsor, Windsor; M. Knoedler and Company, New York, NY

Mekler Gallery, Los Angeles, CA: *David Smith: Drawings for Sculpture, 1954–1964.* 26.4.–30.5. (cat.)

Fogg Art Museum, Harvard University Cambridge, Cambridge, MA: *David Smith: Five Sculptures in the Courtyard.* Summer

Klonaridis, Toronto: *David Smith: Drawings.* 31.10.–21.11.

M. Knoedler and Company, New York, NY: *David Smith: Spray Paintings and Works on Paper.* 21.11.–12.12.

1982

Janie L. Lee Gallery, Houston, TX: *David Smith: Drawings.* 15.1.–6.2. (cat.)

Storm King Art Center, Mountainville, NY: *David Smith: Drawings for Sculpture, 1954–1964.* 19.5.–31.10. (cat.)

Hirshhorn Museum and Sculpture Garden, Washington, DC: *David Smith: Painter, Sculptor, Draftsman.* 4.11.–2.1.1983 (cat.)

Archives of American Art, Smithsonian Institution, Washington, DC: *From the Life of the Artist: A Documentary View of David Smith.* 4.11.1982–2.1.1983 (cat.). Subsequently at the San Antonio Museum of Art, San Antonio, TX, 27.3.–4.6.

National Gallery of Art, Washington, DC: *David Smith.* 7.11.–24.4.1983 (cat.)

1983

Knoedler Gallery, New York, NY: *David Smith: Sculpture, Painting, Drawing* 23.4.–12.5. (cat.)

Arts Club of Chicago, Chicago, IL: *David Smith: Spray Paintings, Drawings, Sculpture.* 1.6.–30.6. (cat.)

Washburn Gallery, New York, NY: *David Smith.* 20.9.–30.10. (cat.)

1985

Anthony d'Offay Gallery, London: *David Smith. Sprays From Bolton Landing.* 3.7.–24.8. (cat.)

The Oklahoma Museum of Art, Oklahoma City, OK: *The Drawings of David Smith.* Opening: Nov. (cat.). Travelling exhibition of the International Exhibition Foundation, Washington, DC. Subsequently at: St. Louis, MO; Little Rock, AR; Fort Worth, TX; Poughkeepsie, NY: Utica, NY; Beaumont, TX; Baton Rouge, LA; Seattle, WA; Santa Barbara, CA; Portland, OR; Claremont, CA; Kansas City, MO

Group Exhibitions

1930

Fourth Annual Exhibition of American Block Prints, The Print Club of Philadelphia, Philadelphia, PA, 17.3.–5.4.

1932

ACA Gallery, New York, NY (no. cat.)

1933

Feragil Galleries, New York, NY (no. cat.)

1934

Winter Exhibition of Paintings (with two sculptures by David Smith), Academy of Allied Arts, New York, NY, 18.1.–10.2.

Julian Levy Gallery, New York, NY, spring (no cat.)

1936

Julian Levy Gallery, New York, NY (no cat.)

1937

Boyer Galleries, New York, NY (no cat.)

1938

American Abstract Artists' Annual Exhibition of Non-Representational Art, Fine Arts Galleries, New York, NY, 14.2.–28.2.

American Artist's Congress – Second Annual Membership Exhibition, John Wanamaker, New York, NY, 5.5.–21.5.

Summer Group Showing of Painting & Sculpture, Onya La Tour Gallery, New York, NY, 7.7.–15.9. (no cat.)

Thirty-Seventh Exhibition, Municipal Art Galleries, New York, NY, 26.10.–13.11.

1939

Third Annual Exhibition of Paintings, Sculpture and Prints by American Abstract Artists, Riverside Museum, New York, NY, 7.3.–26.3.

Exhibition of Contemporary American Art, New York World's Fair, 30.4.–Oct. (no cat.)

United American Sculptors Exhibition, New School for Social Research, New York, NY, Feb. (no cat.)

ACA Gallery, New York, NY, 18.9.–30.9.

1940

Twelve Sculptors, Bonestell Gallery, New York, NY, 2.2.–17.2.

Exhibition of American Sculpture of Today, Buchholz Gallery, New York, NY, 30.12. – 18.1.1941

The Saint Paul Gallery and School of Art, Saint Paul, MN (no cat.). Subsequently at the University Gallery, University of Minnesota, Minneapolis, MN, until Jan.1941

Travelling Exhibition, Sculptor's Guild. Subsequently at, among other places, the Albany Institute of History & Art, Albany, NY, until Feb.1941

1941

Contemporary U. S. Sculpture, Buchholz Gallery, New York, NY, Jan. (cat.)

Annual Exhibition of Sculpture, Watercolors, Drawings & Prints, Whitney Museum of American Art, New York, NY, 15.1.–19.2.

Third Outdoor Sculpture Exhibition, Sculptor's Guild, Village Square, NY, 28.4.–May

Artists of the Upper Hudson – 6th Annual Exhibit, Albany Institute of History & Art, Albany, NY, May

Anti-War Show, Congress of American Artists, Hotel Commodore, New York, NY, June (no cat.)

15 American Sculptors, Rochester Memorial Gallery, Rochester, NY, 1.10.–29.10. (no cat.). Travelling exhibition of the Museum of Modern Art. Subsequently at: Pennsylvania State University, University Park, PA, 5.11.–26.11.; College of William and Mary, Williamsburg, VA, 6.12.–20.12.; Isaac Delgado Museum of Art, New Orleans, LA, 3.1.1942–24.1.; San Francisco Museum of Art, San Francisco, CA, 3.2.–24.2.; University of Chicago (Renaissance Society), Chicago, IL, 11.3.–1.4 · Mt Holyoke College, South Hadley, MA, 8.4.–29.4.; Swarthmore College, Swarthmore, PA, 4.10.–25.10.; University of

Minnesota, Minneapolis, MN, 3.11.–24.11.; Munson-Williams-Proctor Institute, Utica, NY, 3.2.1943–24.2.; Indiana University, Bloomington, IN, 11.3.–1.4.

20th Century Sculpture & Constructions, Montclair Art Museum, Montclair, NJ, 2.10.–26.10. (no cat.). Travelling exhibition of the Museum of Modern Art, New York, NY. Subsequently at: Honolulu Academy of Arts, Honolulu, HI, 2.12.–15.12.; Vassar College Art Gallery, Poughkeepsie, NY, 20.5.1942–15.6.; University of Minnesota, Minneapolis, MN, 3.11.–24.11.; Cincinnati Modern Art Society, Cincinnati, OH, 10.12.–31.12.; Skidmore College, Saratoga Springs, NY, 31.1.1943–21.2.

Seventy-Five Selected Prints/Small Sculptures, Buchholz Gallery, New York, NY, 8.12.–27.12.

1942

Art & Commerce, Willard Gallery, New York, NY, 2.1.–24.1. (no cat.)

Fourth Outdoor Sculpture Exhibition – Sculpture of Freedom, Sculptor's Guild, International Building, Rockefeller Center, New York, NY, 15.9.–15.10.

Annual Exhibition of Contemporary American Art – Sculpture, Paintings, Watercolors, Drawings and Prints, Whitney Museum of American Art, New York, NY, 24.11.–6.1.1943

Artists for Victory, Metropolitan Museum of Art, New York, NY, 7.12.–22.2.1943

Seventy-Five Selected Prints – Small Sculpture by Maillol – Casts in Stone by John B. Flannagan, Buchholz Gallery, New York, NY, 8.12.–26.12.

7th Annual Exhibit – Artists of the Upper Hudson, Albany Institute of History & Art, Albany, NY

1943

American Sculpture of Our Time, Buchholz-Willard Gallery, New York, NY, 5.1.–23.1.

American Drawing – Annual III (with sculptures by David Smith), Albany Institute of History & Art, Albany, NY, 3.2.–28.2.

Art Begins at Home – 1943 – The Addison Gallery Gift Plan, Addison Gallery of American Art, Phillips Academy, Andover, MA, 17.9.–11.10.

Annual Exhibition, Whitney Museum of American Art, New York, NY, 23.11.–4.1.1944

7 Years, Willard Gallery, New York, NY, 6.12.–31.12.

1944

9th Annual Exhibit – Artists of the Upper Hudson, Albany Institute of History & Art, Albany, NY, 26.4.–3.6.

Art in Progress, Museum of Modern Art, New York, NY

1945

Annual Exhibition of Contemporary American Sculpture, Watercolors and Drawings, Whitney Museum of American Art, New York, NY, 3.1.–8.2.

Recent Works by American Sculptors, Buchholz Gallery, New York, NY, 6.2.–24.2.

10th Annual Exhibit – Artists of the Upper Hudson, Albany Institute of History & Art, Albany, NY, 26.4.–3.6.

1946

Annual Exhibition of Contemporary American Sculpture, Watercolors and Drawings, Whitney Museum of American Art, New York, NY, 5.2.–13.3.

St. Paul Gallery & School of Art, St. Paul, MN, March

Origins of Modern Sculpture, City Art Museum of St. Louis, St. Louis, MO, 30.3.–1.5.

11th Upper Hudson Annual Exhibition, Albany Institute of History & Art, Albany, NY, 1.5.–2.6.

Sixth Annual Exhibition of Paintings and Sculpture by Members of the Federation of Modern Painters and Sculptors, Wildenstein Gallery, New York, NY, 18.9.–5.10.

Skidmore College, Saratoga Springs, NY, (no cat.)

Yale University Art Gallery, New Haven, CT

1947

Exhibition of Modern Sculpture, Howard University Gallery of Art, Founders Library, Washington, DC, Jan.–Feb.

Munson-Williams-Proctor Institute, Utica, NY, 17.1. (no cat.)

142nd Annual Exhibition of Painting & Sculpture, The Pennsylvania Academy of the Fine Arts, Philadelphia, PA, 26.1.–2.3.

57th Annual Exhibition of Contemporary Art, University of Nebraska, Morrill Hall, Nebraska Art Association, Lincoln, NB, 2.3.–30.3.

47th Annual Exhibition of Contemporary American Sculpture, Watercolors & Drawings, Whitney Museum of American Art, New York, NY, 11.3.–17.3.

Abstract and Non-Objective Sculpture, Sculptors Gallery, Clay Club Sculpture Center, New York, NY, 27.10.–29.11.

Abstract and Surrealist American Art, Fifty-eighth Annual Exhibition of American Painting and Sculpture, Art Institute of Chicago, Chicago, IL, 6.11.–11.1.1948

1948

Annual Exhibition of Contemporary Sculpture, Watercolors & Drawings, Whitney Museum of American Art, New York, NY, 31.1.–21.3.

Sculpture at the Crossroads, Worcester Art Museum, Worcester, MA, 15.2.–21.3.

10th Anniversary Outdoor Sculpture Exhibition, Sculptor's Guild. 18 Washington Square North, New York, NY, April

Kleeman Gallery, New York, NY, summer (no cat.)

Abstract-Surrealist, Art Institute of Chicago, IL

1949

Sculpture Group, Willard Gallery, New York, NY, 4.1.–29.1.

Annual Exhibition of Contemporary American Sculpture, Watercolors & Drawings, Whitney Museum of American Art, New York, NY, 2.4.–8.5.

Third Sculpture International Exhibition, Philadelphia Museum of Art, Philadelphia, PA, 15.5.–11.9.

1950

Annual Exhibition of Contemporary American Sculpture, Watercolors & Drawings, Whitney Museum of American Art, New York, NY, 1.4.–28.5.

International Exhibition of Sculpture in the Open Air, Middelheim Park, Antwerp, summer

Post-Abstract Painting 1950 – France & America, Provincetown Art Association, Provincetown, MA, 6.8.–4.9.

Midwestern College Art Conference, Sculpture by Panel Members, J. B. Speed Art Museum, University of Louisville, Louisville, KY, Oct.

Carvers, Modelers, Welders: A Selection of Recent American Sculpture, Museum of Modern Art, New York, NY, August (no cat.). Subsequently at: University of Delaware, Newark, DE, 5.10.1952–26.10.; Columbia Museum of Art, Columbia, SC, 9.11.–30.11.; University of Georgia, Athens, GA, 14.12.–4.1.1953; Nashville – The Parthenon, Nashville, TN, 18.1.–8.2.; Iowa State Teachers College, Cedar Falls, IA, 15.3.–5.4.; Evansville Public Museum, Evansville, IN, 19.4.–9.5.

1951

Tradition & Experiment – An Exhibition of Modern Sculpture, Watkins Memorial Gallery, The American University, Washington, DC, 21.1.–15.2. Travelling exhibition supported by the American Federation of

Arts, subsequently at: Department of Fine Arts, University of Pittsburgh, Pittsburgh, PA, 1.3.–22.3.; Grand Rapids Art Gallery, Grand Rapids, MI, 4.4.–25.4.; Henry Gallery, University of Washington, Seattle, WA, 10.5.–31.5.; School of Architecture & Allied Arts, University of Oregon, Eugene, OR, 15.6.–15.7.; San Francisco Museum of Art, Civic Center, San Francisco, CA, 1.8.–16.9.; The Kansas City Art Institute, Kansas City, MO, 1.10.–22.10.; Philbrook Art Center, Tulsa, OK, 4.11.–25.11.; Norton Gallery & School of Art, West Palm Beach, FL, 2.12.–9.1.1952; J.B. Speed Art Museum, Louisville, KY, 1.2.–29.2.

Abstract Painting & Sculpture in America, Museum of Modern Art, New York, NY, 23.1.–25.3.

Artists of Upstate New York, Munson-Williams-Proctor Institute, Utica, NY, 4.2.–25.2.

Annual Exhibition of Contemporary American Sculpture, Watercolors and Drawings, Whitney Museum of American Art, New York, NY, 17.3.–6.5.

Contemporary Painting and Sculpture, Indiana University, Bloomington Contemporary Art Festival, Bloomington, IN, May

Margaret Brown Gallery, Boston, MA, autumn (no cat.)

60th Annual American Exhibition – Paintings and Sculpture, Art Institute of Chicago, Chicago, IL, 25.10.–16.12.

I. Bienal de São Paulo, São Paulo, October

Bennington College, Bennington, VT, 16.11.–25.11. (no cat.)

American Sculpture 1951, Metropolitan Museum of Art, New York, NY, 7.12.–24.2.1952

1952

147th Annual Exhibition of Painting and Sculpture, The Pennsylvania Academy of the Fine Arts, Philadelphia, PA, 20.1.–24.2.

The Artists' Vision, Des Moines Art Center, Des Moines, IA, 27.2.–23.3.

Annual Exhibition of Contemporary American Sculpture, Watercolors and Drawings, Whitney Museum of American Art, New York, NY, 13.3.–4.5.

12th Annual Exhibition, Art Institute of Chicago, Chicago, IL, 7.5.–8.6. (no cat.)

Margaret Brown Gallery, Boston, MA, June (no cat.)

Exhibition: Welded Sculpture, Sculpture Center, New York, NY, 6.10.–31.10.

Sculpture of the Twentieth Century, Philadelphia Museum of Art, Fairmont Park Art Association, Philadelphia, PA, 11.10.–7.12.

Subsequently at: Art Institute of Chicago, Chicago, IL, 22.1.1953–8.3.; Museum of Modern Art, New York, NY, 29.4.–7.9.

Williams College Museum of Art, Williamstown, MA (no cat.)

1953

University of Arkansas, Fayetteville, AR, Feb. (no cat.). Subsequently at the Philbrook Art Center, Tulsa, OK, 10.3.–April

Contemporary Painting & Sculpture, Portland Art Museum, Portland, OR, March–April (no cat.)

Nebraska Art Association – Sixty-Third Annual Exhibition, University Galleries, University of Nebraska, Lincoln, NB, March

Contemporary American Painting and Sculpture, University of Illinois, Urbana, IL, 1.3.–12.4.

Annual Exhibition of Contemporary American Sculpture, Watercolors and Drawings, Whitney Museum of American Art, New York, NY, 9.4.–29.5.

The Classic Tradition in Contemporary Art, Walker Art Center, Minneapolis, MN, 24.4.–28.6.

Twelve Modern American Painters and Sculptors, Musée National d'Art Moderne, Paris, 24.4.–7.6. (cat.). Travelling exhibition of the Museum of Modern Art, New York, NY. Subsequently at: Kunsthaus Zürich, Zurich, 25.7.–30.8.; Kunstsammlungen der Stadt Düsseldorf, Düsseldorf, 20.9.–25.10.; Liljevalchs Konsthall, Stockholm, 24.11.–20.12.; Taidehalli-Konsthallen, Helsinki, 8.1.1954–24.1.; Kunstnernes Hus, Oslo, 18.2.–7.3.

Initial Exhibition Summer 1953, The Museum of Art of Ogunquit, Ogunquit, ME, summer

Margaret Brown Gallery, Boston, MA, 21.9.–10.10. (no cat.)

First Biennial Exhibition – American Painting and Sculpture, Museum of Cranbrook Academy of Art, Bloomfield Hills, MI, 2.10.–1.11.

1954

One Hundred and Forty-Ninth Annual Exhibition of Painting and Sculpture, Pennsylvania Academy of Fine Arts, Philadelphia, PA, 24.1.–28.2.

Annual Exhibition of Contemporary American Sculpture, Watercolors and Drawings, Whitney Museum of American Art, New York, NY, 17.3.–18.4.

? Painters/? Sculptors, XXVII. Biennale Venezia, American pavilion, June – Oct. (cat.)

Le Dessin Contemporaine aux Etats-Unis, Musée National d'Art Moderne, Paris, Oct.–Nov. 1954 (cat.)

61st American Exhibition – Paintings & Sculpture, Art Institute of Chicago, Chicago, IL, 21.10.–5.12.

1955

Annual Exhibition – Paintings, Sculpture, Watercolors, Drawings, Whitney Museum of American Art, New York, NY, 12.1.–20.2.

Skidmore College, Saratoga Springs, NY, March–April (no cat.)

Three Contemporary Sculptors, San Francisco Museum of Art, San Francisco, CA, 19.5.–12.6. (no cat.)

Art in the 20th Century, San Francisco Museum of Art, San Francisco, CA, 17.6.–10.7.

Third Annual Exhibition, The Museum of Art of Ogunquit, Ogunquit, ME, 1.7.–11.9.

A Selection of Contemporary American Sculpture, The University Gallery, University of Minnesota, Minneapolis, MN, 30.9.–4.11.

1956

The Figure in Contemporary Sculpture, Munson-Williams-Proctor Institute, Utica, NY, 8.1.–29.1. Subsequently at the Rochester Memorial Art Gallery, Rochester, NY, 3.2.–24.2.

Annual Exhibition of Contemporary American Sculpture, Watercolors and Drawings, Whitney Museum of American Art, New York, NY, 18.4.–10.6.

Sculpture – Stone, Clay and Metal – by Eight Contemporaries, The Gallery, Katonah Village Library, Katonah, NY, 30.4.–31.5.

Exposition internationale de sculpture contemporaine, Musée Rodin, Paris, summer (cat.)

American Sculpture Today, Virginia Museum of Fine Arts, Richmond, VA. Opening: 28.9.

Monumentality in Modern Sculpture, Contemporary Arts Museum, Houston, TX, 13.12.–13.1.1957

1957

LXII American Exhibition: Painting & Sculpture, Art Institute of Chicago, Chicago, IL, 17.1.–3.3.

Irons in the Fire – An Exhibition of Metal Sculpture, Contemporary Arts Museum, Houston, TX, 17.10.–1.12.

Sculpture 1880–1957, Fine Arts Associates, New York, NY, 10.12.–11.1.1958 (cat.)

1958

Nature in Abstraction, Whitney Museum of American Art, New York, NY, 14.1.–16.3. Subsequently at: The Phillips Gallery, Washington, DC, 2.4.–4.5.; Fort Worth Art Center, Fort Worth, TX, 2.6.–29.6.; Los Angeles County Museum, Los Angeles, CA, 16.7.–24.8.; San Francisco Museum of Art, San Francisco, CA, 10.9.–12.10.; Walker Art Center, Minneapolis, MN, 29.10.–14.12.; City Art Museum of St. Louis, St. Louis, MO, 7.1.1959–8.2.

Contemporary American Sculpture, USA pavilion, World Fair, Brussels, 3.4.–30.10.

American Federation of Arts Exhibition, World House, Brussels

Painting – Sculpture: A Decade in Review: England – France – Italy – United States, De Cordova Museum, Lincoln, MA, 27.4.–1.6.

Lipton, Rothko, Smith and Tobey, USA representation at the XXIXth Biennale Venezia, Venice, June–Oct. (cat.)

Paintings – Watercolors – Sculpture, Fine Art Associates, New York, NY, summer – autumn

The Human Image, Museum of Fine Arts, Houston, TX, 10.10.–23.11.

Annual Exhibition Sculpture, Paintings, Watercolors, Drawings, Whitney Museum of American Art, New York, NY, 19.11.–4.1.1959

1958 Pittsburgh International Exhibition of Contemporary Painting and Sculpture, Department of Fine Arts, Carnegie Institute, Pittsburgh, PA, 5.12.–8.2.1959

Some Contemporary Works of Art, The Cleveland Museum of Art, Cleveland, OH

1959

The Museum and Its Friends: Eighteen Living American Artists Selected by the Friends of the Whitney Museum, Whitney Museum of American Art, New York, NY, 5.3.–12.4.

Sculpture in Our Time – Collected by Joseph H. Hirshhorn, Detroit Institute of Arts, Detroit, MI, 5.5.–13.8.

Recent Sculpture USA, Museum of Modern Art, Junior Council, New York, NY, 13.5.–16.8. Subsequently at: The Denver Art Museum, Denver, CO, 12.10.–22.11.; The Art Center, Tucson, AZ, 5.12.–10.1.1960; Los Angeles County Museum, Los Angeles, CA, 22.2.–3.4.; City Art Museum of St. Louis, St. Louis, MO, 3.5.–12.6.; Museum of Fine Arts, Boston, MA, 14.9.–16.10.

Paintings Sculpture, Fine Arts Associates, New York, NY, 20.5.–14.6.

Documenta II, Kassel, 11.7.–11.10. (cat.)

Living American Artists, American Federation of Arts, Project Elai, Jerusalem, Tel Aviv, Haifa, Aug.–Dec.

Summer Gallery Exhibition – Paintings and Sculpture, French & Company, New York, NY, summer

Fine Arts Associates, New York, NY, summer – autumn

V. Bienal de São Paulo, representation of the USA, São Paulo, 21.9.–31.12. (cat.)

Sculpture & Sculptors Drawings, Fine Arts Associates, New York, NY, 21.9.–10.10.

Winter Gallery Exhibition – Paintings and Sculpture, French & Company, New York, NY, winter

Minnesota Collects Modern Sculpture, Minneapolis Institute of Arts, Minneapolis, MN

1960

John and Dorothy Rood Collection – John Rood Sculpture Collection, Walker Art Center, Minneapolis, MN, 10.1.–7.2. Subsequently at the University Gallery, University of Minnesota, Minneapolis, MN, 11.2.–21.3.

New Sculpture Now, Smith College Museum of Art, Northhampton, MA, 6.4.–9.5.

Aspects de la sculpture américaine, Galerie Claude Bernard, Paris, Oct.

Annual Exhibition 1960 – Sculpture & Drawings, Whitney Museum of American Art, New York, NY, 7.12.–22.1.1961

1961

Union Carbide Corporation, New York, NY, March (no cat.)

Treasures of Chicago Collectors, Art Institute of Chicago, Chicago, IL, 15.4.–17.5.

Twentieth Century American Art, Art Center, Kalamazoo Institute of Arts, Kalamazoo, MI, autumn

The Art of Assemblage, Museum of Modern Art, New York, NY, 2.10.–12.11.

Mechanism and Organism – An International Sculpture Exhibition, The New School for Social Research, Art Center, New York, NY, 5.10.–27.10.

Pittsburgh International Exhibition of Contemporary Painting & Sculpture, Department of Fine Arts, Carnegie Institute, Pittsburgh, PA, 27.10.–7.1.1962

Spotlight on Sculpture 1880–1961, Otto Gerson Gallery, New York, NY, Dec.–Jan. 1962

1962

Geometric Abstraction in America, Whitney Museum of American Art, New York, NY, 20.3.–13.5.

Continuity and Change – 45 American Abstract Artists, Wadsworth Atheneum, Hartford, CT, 12.4.–27.5.

Art Since 1950, Pavilion of the Arts, World Fair, Seattle, WA, 21.4.–21.10. Subsequently at: Rose Art Museum, Brandeis University, Waltham, MA; Institute of Contemporary Art, Boston, MA

Monumental Sculpture, Otto Gerson Gallery, New York, NY, June–July

Fourth Festival of Two Worlds, Roman amphitheatre, Spoleto, June – July (no cat.)

Sculpture in the City, Festival of Two Worlds, Spoleto, June–July

Modern Sculpture from the Joseph H. Hirshhorn Collection, Solomon R. Guggenheim Museum, New York, NY, 3.10.–6.1.1963

Annual Exhibition – Contemporary Sculpture & Drawings, Whitney Museum of American Art, New York, NY, 12.12.–3.2.1963

1963

66th Annual American Exhibition – Directions in Contemporary Painting and Sculpture, Art Institute of Chicago, Chicago, IL, 11.1.–10.2.

US Government Art Projects: Some Distinguished Alumni, Allen Memorial Art Museum, Oberlin College, Oberlin, OH, 11.2.–4.3. (no cat.). Travelling exhibition of the Museum of Modern Art, New York, NY. Subsequently at: Mercer University, Macon, GA, 19.3.–9.4.; University of Nevada, Reno, NV, 24.4.–19.5.; Tacoma Art League, Tacoma, WA, 30.5.–20.6.; Washington Gallery of Modern Art, Washington, DC, 8.7.–1.9.; State University of New York, Oswego, NY, 18.9.–9.10.; Cranbrook Academy of Art Galleries, Bloomfield Hills, MI, 21.10.–11.11.; Carleton College, Northfield, MN, 22.11.–13.12.; Coe College, Cedar Rapids, IA, 2.1.1964–23.1.; Pamona College, Claremont, CA, 7.2.–28.2.

Sculpture in the Open Air, Battersea Park, USA representation at the County Council Exhibition, London, May–Sept. (cat.)

Sculptors of Our Time, Washington Gallery of Modern Art, Washington, DC, 17.9.–31.10.

Artist and Maecenas – A Tribute to Curt Valentin, Marlborough – Gerson Gallery, New York, NY, Nov.–Dec.

Lettering by Hand, Museum of Modern Art, New York, NY, 6.11.–6.1.1964.

Subsequently at: Marshall University, Huntington, WV, Jan.; Laguna Gloria Art Museum, Austin, TX, March; Wisconsin Union, University of Wisconsin, Madison, WI, 12.6.–13.7.; Cornell University, College of Home Economics, Ithaca, NY, 28.9.–18.10.; East Tennessee State University, Johnson, TN, Nov.; Western Illinois University, Macomb, IL, 2.12.–23.12.
In extended form toured as part of the international programme of the Museum of Modern Art to: University of Puerto Rico, Rio Piedras, 12.5.1965–30.5.; Instituto Torcuato di Tella, Buenos Aires, 14.7.–3.8.; Museo de Arte Plastica, La Plata, 7.8.–25.8.; Instituto Brazil Estados Unidos, Rio de Janeiro, 8.12.–28.12.; Museo de Arte Moderno, Lima, 27.4.1966–29.5.; Museo de Arte Contemporaneo, University of Chile, Santiago, 2.12.–20.1.1967; Museo de Bellas Artes, Caracas, 14.5.–4.6.

1964

Munson-Williams-Proctor Exhibits at World Fair, World Fair, Pavilion of the Federal State of New York, Mezzanine Area, New York, NY, April–Oct. (no cat.)

'54–'64, Painting and Sculpture of a Decade, Tate Gallery, Gulbenkian Foundation, London, 22.4.–28.6.

Four Centuries of American Masterpieces, World Fair New York, New York, NY, April–Oct. (cat.)

Between the Fairs: Twenty-five Years of American Art 1939–1964, Whitney Museum of Art, New York, NY, 24.6.–23.9.

Documenta III, Alte Galerie, Museum Fridericianum, Orangery, Kassel, 27.6.–5.10. (cat.)

Ceramics by Twelve Artists, American Federation of Arts, New York, NY, 30.11.–11.12., travelling exhibition

Annual Exhibition of Contemporary American Sculpture, Whitney Museum of American Art, New York, NY, 9.12.–31.1.1965

Art since 1889, University of New Mexico, Albuquerque, NM (cat.); Wellesley College, Wellesley, MA (no cat.)

1965

1965 Kane Memorial Exhibition Critics' Choice: Art since World War II, Providence Art Club, Providence, RI, 31.3.–24.4.

Artists for Core – 4th Annual Art Exhibition and Sale, Graham Gallery, New York, NY, 28.4.–8.5.

Sculpture of the Twentieth Century, Museum of Fine Arts, Dallas, TX, 12.5.–13.6.

Festival of the Arts, White House, Washington, DC, 14.6.

United States: Sculpture of the Twentieth Century, Musée Rodin, Paris, 22.6.–10.10. Travelling exhibition of the International Council of the Museum of Modern Art, New York, NY. Subsequently at: Deutsche Gesellschaft für bildende Kunst, Kunstverlag, Berlin (West), 20.11.–9.1.1966; Staatliche Kunsthalle, Baden-Baden, March–April

Art in Embassies, Embassy of the USA, Mexico City. Travelling exhibition of the Museum of Modern Art, New York, NY

One Hundred Contemporary American Drawings, University of Michigan, Kalamazoo, MI (cat.)

7 Sculptors, Institute of Contemporary Art, Philadelphia, PA (cat.)

1966

Twentieth-Century Sculpture, University Art Museum, The University of New Mexico, Albuquerque, NM, 25.3.–1.5. (cat.)

Seven Decades – 1895–1965 – Cross-currents in Modern Art, Joint exhibition of the Public Education Association, New York, NY, 26.4.–21.5. At: Paul Rosenberg & Co. (1895–1904); M. Knoedler & Co., Inc. (1905–1914); Perls Galleries, E.V. Thaw & Co. (1915–1924); Saidenberg Gallery (1925–1934); Pierre Matisse Gallery (1935–1944); Andre Emmerich Gallery, Galleria Odyssia (1945–1954); Cordier & Ekstrom, Inc. (1955–1965)

Fifty Years of Modern Art 1916–1966, The Cleveland Museum of Art, Cleveland, OH, 15.6.–31.7. (cat.)

Art of the United States 1670–1966, Whitney Museum of American Art, New York, NY, 28.9.–27.11.

1967

International Exhibition of Contemporary Sculpture, Expo 67, Montreal, April–Oct.

American Sculpture of the Sixties, Los Angeles County Museum of Art, Los Angeles, CA, 28.4.–25.6. (cat.). Subsequently at the Philadelphia Museum of Art, Philadelphia, PA, 15.9.–29.10.

Dix ans d'art vivant 55–65. Fondation Maeght, Saint Paul de Vence, 3.5.–23.7. (cat.)

Sculpture: A Generation of Innovation, Art Institute of Chicago, IL, 23.6.–27.8. (cat.)

Guggenheim International Exhibition 1967, Solomon R. Guggenheim Museum, New York, NY, 20.10.–4.2.1968 (cat.). Subsequently at: Art Gallery of Ontario, Toronto, 23.2.–24.3.; The National Gallery of Canada, Ottawa, 26.4.–9.6.; Montreal Museum of Fine Arts, Montreal, 27.6.–18.8.

Art America, Bamberger's Department Store, Newark, NJ, Dec.

1968

Dada, Surrealism, and Their Heritage, Museum of Modern Art, New York, NY, 27.3.–9.6. (cat.). Subsequently at: Los Angeles County Museum, Los Angeles, CA, 16.7.–8.9.; Art Institute of Chicago, Chicago, IL, 19.10.–8.12.

Scultura-Internazionale, Marlborough Galleria d'Arte, Rome, April–May

Art & Artists at Sarah Lawrence through 40 Years, Riverside Museum, New York, NY, 9.4.–2.6.

Opening Exhibition, National Collection of Fine Arts, Washington, DC, 1.5.–Aug. (no cat.)

Documenta IV, Galerie Schöne Aussicht, Museum Fridericianum, Orangery, Kassel, 27.6.–6.10. (cat.)

The Art of the Real – USA 1948–1968, Museum of Modern Art, New York, NY, 3.7.–8.9. (cat.). Subsequently at: Grand Palais, Paris, 14.11.–23.12.; Kunsthaus, Zurich, 19.1.1969–23.2.; Tate Gallery, London, 22.4.–1.5.

The 1930's: Painting and Sculpture in America, Whitney Museum of American Art, New York, NY, 15.10.–1.12. (cat.)

Twentieth Century Sculpture: Walker Art Center, Walker Art Center, Minneapolis, MN (cat.)

1970

Noguchi, Rickey, Smith, Indiana University Art Museum, Bloomington, IN, 8.11.–13.12. (cat.)

1971

Six Sculptors and Their Drawings, Fogg Art Museum, Harvard University, Cambridge, MA, 7.5.–7.6. (cat.)

11e Biennale Antwerpen, Openluchtmuseum, Middelheim, Antwerp, 6.6.–3.10. (cat.)

1973

19 Sculptors of the 40th, Art Galleries, University of California, Santa Barbara, CA, 3.4.–6.5. (cat.)

1974

The Great Decade of American Abstraction: Modernist Art 1960 to 1970, Museum of Fine Arts, Houston, TX, 15.1.–11.3. (cat.)

Monumenta: A Biennial Exhibition of Outdoor Sculpture, Newport, RI, 17.8.–13.10. (cat.)

Sculpture in Steel, Edmonton Art Gallery, Edmonton, 6.9.–31.10. Travelling exhibition (cat.)

Sculptors and Their Drawings: Selections from the Hirshhorn Museum and Sculpture Garden, Lyndon Baynes Johnson Library, Austin, TX (cat.)

Twentieth Century Monumental Sculpture, Marlborough Gallery, New York, NY (cat.)

From Reliable Sources: An Exhibition of Letters, Photographs, and other Documents from the Collection of the Archives of American Art, Smithsonian Institution, Commemorating the Twentieth Anniversary of Founding the Archives. Archives of American Art, Smithsonian Institution, Washington, DC (cat.)

1976

7+5: Sculptors in the 1950's, The Art Galleries, University of California, Santa Barbara, CA, 6.1.–15.2. (cat.). Subsequently at the Phoenix Art Museum, Phoenix, AZ, 5.3.–11.4.

New Works in Clay by Contemporary Painters and Sculptors, Everson Museum of Art, Syracuse, NY, 23.1.–4.4.

200 Years of American Sculpture, Whitney Museum of American Art, New York, NY, 16.3.–26.9. (cat.)

Artists of Lake George, 1776–1976, Hyde Collection, Glens Falls, NY (cat.)

A Selection of American Art: The Skowhegan School 1946–1976, Institute of Contemporary Art, Boston, MA (cat.)

Second Williams College Loan Exhibition: In Celebration of the 50th Anniversary of the Williams College Museum of Art and in Honor of President W. Chandler and Professor S. Lane Faison, Jr., Williams College, Williamstown, NY (cat.)

Three Hundred Years of American Art in the Chrysler Museum, Chrysler Museum at Norfolk, Norfolk, VA (cat.)

1977

Graham, Gorky, Smith and Davis in the Thirties, Bell Gallery, Brown University, Providence, RI, 30.4.–22.5. (cat.)

American Drawing 1927–1977, Minnesota Museum of Art, Saint Paul, MN (cat.)

Works on Paper 1900–1960: From Southern California Collections, Pomona College, Claremont, CA (cat.)

1978

American Art at Mid-Century: The Subjects of the Artists, National Gallery of Art, Washington, DC, 1.6.–14.1.1979 (cat.)

Masters of Modern Sculpture, Marlborough Gallery, Inc., New York, NY (cat.)

1979

David Smith/Robert Motherwell, El Museo de Arte Contemporaneo de Caracas, Caracas, May (cat.)

1980

Julio González, David Smith, Anthony Caro, Tim Scott, Michael Steiner: Sculpture, Galerie de France, Paris, 5.2.–29.3. (cat.). Subsequently at: Kunsthalle Bielefeld, Bielefeld; Haus am Waldsee, Berlin (West)

Skulptur im 20. Jahrhundert, Wenkenpark, Riehen/Basle, 10.5.–14.9. (cat.)

Memories of Jan Matulka, 1890–1972, Smithsonian Institution Press, Washington, DC (cat.)

Sculptor's Studies: Prospect Mountain Sculpture Show, Hyde Collection, Glens Falls, NY (cat.)

1981

Westkunst – Zeitgenössische Kunst seit 1939, Cologne Fair, 30.5.–16.8. (cat.)

Sculpture du XX^e siècle: 1900–1945, Fondation Maeght, Saint-Paul de Vence, 4.7.–4.10. (cat.)

Drawing Acquisitions 1978–1981, Whitney Museum of American Art, New York, NY, 17.9.–15.11.

Sculptors Drawings over Six Centuries 1400–1950, Agrinde Publications, New York, NY (cat.)

1982

Zeichnungen von Bildhauern nach 1945, Kunstverein, Brunswick, 8.10.–28.11. (cat.)

1983

Abstract Painting and Sculpture in America 1927–1944, Museum of Art, Carnegie Institute, Pittsburgh, PA, 5.11.–31.12. (cat.). Subsequently at: San Francisco Museum of Modern Art, San Francisco, CA, 26.1.1984–25.3.; The Minneapolis Institute of Art, Minneapolis, MN, 15.4.–3.6.; Whitney Museum of American Art, New York, NY, 28.6.–9.9.

1984

Skulptur im 20. Jahrhundert, Merian Park, Basle, 3.6.–30.9. (cat.)

1985

Transformations in Sculpture: Four Decades of American and European Art, The Solomon R. Guggenheim Museum, New York, NY, Nov.–Dec. (cat.)

Monographs

Krauss, Rosalind E., *Terminal Iron Works. The Sculpture of David Smith,* Cambridge, MA: The MIT Press, 1971
Krauss, Rosalind E., *The Sculpture of David Smith, a catalogue raisonné,* New York, NY–London: Garland Pb., 1977
Marcus, S. E., *The Working Methods of David Smith* (doctoral thesis), New York, NY: Columbia University, 1972
Marcus, S. E., *David Smith. The Sculptor and His Work,* Ithaca, NY–London: Cornell University Press, 1983
McCoy (ed.), *David Smith,* New York, NY–Washington, DC: Praeger, 1973 (collection of the most important texts by David Smith, including interviews and letters)
Rikhoff, Jean, *David Smith, I remember,* Glens Falls, NY: Loft Press, 1984

Articles in Catalogues of One-man Shows

Blake, William/Stead, Christina, Cat. Willard Gallery, 1940
Budnik, Dan, Cat. State University of New York, 1974
Carandente, Giovanni, Cat. University of Pennsylvania, 1964
Carmean, F. A., Jr., Cat. Washington, 1982
Clark, Trinkett, Cat. The Oklahoma Museum of Art, 1985
Cone Harrison, Jane, Cat. Fogg Art Museum, 1966
Cummings, Paul, "David Smith, the Drawings", Cat. Whitney, 1979
Dehner, Dorothy, "Reminiscences", Cat. Art Project, 1979
Dehner, Dorothy / Kettlewell, James K., Cat. The Hyde Collection, 1973
Ellin, Everett, Cat. Everett Ellin Gallery, 1960
Fry, Edward F., Cat. Guggenheim, 1969
Fry, Edward F., "David Smith: An Appreciation Essay", Cat. The Hirshhorn Museum, 1982
Greenberg, Clement, Cat. University of Pennsylvania, 1964
Hazlitt, Gordon, Cat. Storm King Art Center, 1982
Hunter, Sam, "David Smith's New Sculpture", Cat. Otto Gerson Gallery, 1961
Johnson, Una, Cat. Storm King Art Center, 1971
Kramer, Hilton, "David Smith (1906–1965)", Cat. Los Angeles County Museum of Art, 1965
Krauss, Rosalind E., Cat. Marlborough-Gerson Gallery, 1967
Krauss, Rosalind E., Cat. Marlborough-Gerson Gallery, 1968

Lampert, Catherine, Cat. Serpentine Gallery, 1980
Luck, Robert H., Cat. Contemporary Arts Center, 1954
McClintic, Miranda, Cat. Washington, 1979
McClintic, Miranda, "David Smith. Painter, Sculptor, Draftsman", Cat. The Hirshhorn Museum, 1982
McCoy, Garnett, Cat. Washington, Archives, 1982
Mekler, Adam / Nordland, Gerald, Cat. Mekler Gallery, 1981
Motherwell, Robert, "For David Smith", Cat. Willard Gallery, 1950
Nemerov, Howard, Cat. Willard and Kleemann Galleries, 1952
O'Hara, Frank, Cat. The Museum of Modern Art, 1966
Rubin, Lawrence, Cat. M. Knoedler and Co., 1978
Sandler, Irving, Cat. Art Project, 1979
Valentiner, Wilhelm R., Cat. Buchholz Gallery and Willard Gallery, 1946
Valentiner, Wilhelm R., Cat. Willard Gallery and Kleemann Gallery, 1952
Wiese, Stephan von, Cat. Stuttgart, 1976
Wilkin, Karen, Cat. The Edmonton Art Gallery, 1981

Articles in Catalogues of Group Exhibitions

Agee, William C., Cat. Whitney, 1968
Anderson, Dennis, Cat. Chrysler Museum at Norfolk, 1976
Armstrong, Tom, Cat. Whitney, 1976
Ashton, Dore, Cat. Caracas, 1979
Carmean, E. A., Jr. (ed.), Cat. Houston, 1974
Carmean, E. A., Jr., Cat. National Gallery of Art, 1978
Craeybeck, L., Cat. Antwerp, 1971
Cummings, Paul, Cat. Minnesota Museum of Art, 1977
Eisler, Colin, Cat. New York, NY: Agrinde Publications, 1981
Ellenzweig, Allen, Cat. Boston, 1976
Faison, S. Lane, Cat. Williams College, 1976
Friedman, Martin, Cat. Walker Art Center, 1968
"From Reliable Sources...", Cat. Washington, 1974
Gardner, Albert Ten Eyck, Cat. Metropolitan Museum, 1965
Glozer, Laszlo, Cat. Cologne, 1981
Glozer, Laszlo, "Neuansätze der 50er Jahre. Die neue Freiheit der Skulptur", Cat. Basle, 1984
Hunter, Sam, "David Smith", Cat. Biennale Venezia, 1958
Hunter, Sam, Cat. Bienal São Paulo, 1959
Hunter, Sam (ed.), Cat. Newport, 1974

Kuchta, Ronald, Cat. Everson Museum of Art, 1976
Lane, John R. / Larsen, Susan C. (eds.), Cat. Carnegie Institute, 1983
Mato, Daniel, Cat. Indiana University Art Museum, 1970
McCabe, Cynthia Jaffee, Cat. Austin, 1974
Prat, Jean-Louis, Cat. Saint-Paul de Vence, 1981
Ritchie, Andrew Carnduff, Cat. The Museum of Modern Art, 1951
Rubin, William S., Cat. The Museum of Modern Art, 1968
Rueppel, Merril C., Cat. Dallas, 1965
"Skulptur im 20.Jahrhundert", Cat. Basle, 1980
Trier, Eduard, Cat. Kassel, 1959
Tuchmann, Maurice (ed.), Cat. Los Angeles, 1967
Van Deren, Coke, Cat. Albuquerque, 1966
Wasserman, Jeanne L., Cat. Fogg Art Museum, 1971
Wight, Frederick S., Cat. Pomona College, 1977
Wilkin, Karen, Cat. Carnegie Institute, 1983

General Literature

Andersen, Wayne, *American Sculpture in Process 1930/1970,*Boston, MA: New York Graphic Society, 1975
Arnason, H. Harvard, *History of Modern Art,* New York, NY: Harry N. Abrams, Inc., 1975
Art for the Millions: Essays from the 1930s by Artists and Administrators of the WPA Federal Art Project, Francis V. O'Connor (ed.), Greenwich, CT: New York Graphic Society, 1973
Ashton, Dore, *Modern American Sculpture,* New York, NY: Harry N. Abrams, 1968
Bazin, Germain, *The History of World Sculpture,* Greenwich, CN: New York Graphic Society, 1968
Burnham, Jack, *Beyond Modern Sculpture: The Effects of Science and Technology on the Sculpture of This Century,* New York, NY: George Braziller, 1968
Burnham, Jack / Harper, Charles / Burnham, Judith Benjamin, *The Structure of Art,* revised ed., New York, NY: George Braziller, 1973
Cummings, Paul, *American Drawings: The 20th Century,* New York, NY: The Viking Press, 1976
Dehner, Dorothy: see Grahams, John / Epstein Allentuck, Marcia
Elderfield, John, *The Modern Drawing,* New York, NY: The Museum of Modern Art, 1983
Geselbracht, R. H., *The Two New Worlds: The Arts and the Inspiration of Nature in the Twentieth Century* (doctoral thesis),

Santa Barbara, CA: University of California, 1973

Goldwater, Robert, *What Is Modern Sculpture?* New York, NY: Museum of Modern Art/Greenwich, CT: New York Graphic Society, 1969

Goodrich, Lloyd / Baur, John I. H., *American Art of Our Century,* New York, NY: Praeger, 1965

Grahams, John / Epstein Allentuck, Marcia, *Systems and Dialectics of Art,* Baltimore, MD/London: The John Hopkins Press, 1971 (includes Dehner, Dorothy)

Greenberg, Clement, *Art and Culture,* Boston, MA/Beacon, 1961

Hammacher, Abraham M., *The Evolution of Modern Sculpture: Tradition and Innovation,* New York, NY: Harry N. Abrams, 1969

Henning, Edward B., *Paths of Abstract Art,* Cleveland, OH: Cleveland Museum of Art, 1960

Hunter, Sam, "Sculpture for an Iron Age", in *Modern American Painting and Sculpture,* New York, NY: Dell, 1959

Johnson, Una E., *20th-Century Drawings, Part II: 1940 to the Present,* New York, NY: Shorewood Publishers, 1964

Kelly, James J., *The Sculptural Idea,* 2nd ed., Minneapolis, MN, Burgess Publishing Co., 1970

Kozloff, Max, "David Smith", in *Renderings: Critical Essays on a Century of Modern Art,* New York, NY: Simon and Schuster, 1968

Krauss, Rosalind E., *Passages in Modern Sculpture,* New York, NY: The Viking Press, 1977

Levy, Mervyn, *Drawing and Sculpture,* New York, NY: Walker and Co., 1970

Licht, Fred, *Sculpture, 19th and 20th Centuries* (A History of Western Culture), London: Michael Joseph, 1967

McKinzie, Richard, *The New Deal for Artists,* Princeton, NJ: Princeton University Press, 1973

Merillat, Herbert Christian, *Modern Sculpture: The New Old Masters,* New York, NY: Dodd, Mead and Co., 1974

Modern Artists in America, Robert Motherwell (ed.) and Ad Reinhardt, New York, NY: Wittenborn, Schultz, 1949–50

Motherwell, Robert, "David Smith – Erinnerungen", in Cat. *Bilder und Collagen 1967–1970,* Galerie im Erker, St. Gallen, 1971

O'Hara, Frank, *Art Chronicles 1954–1966,* New York, NY: George Braziller, 1975

Primitivismus in der Kunst des 20. Jahrhunderts, William Rubin (ed.), Munich: Prestel Verlag, 1984

Read, Herbert, *A Concise History of Modern Sculpture,* New York, NY: Frederick A. Praeger, 1964

Rickey, George, *Constructivism: Origins and Evolution,* New York, NY: George Braziller, 1967

Ritchie, Andrew Carnduff, *Sculpture of the Twentieth Century,* New York, NY: The Museum of Modern Art, 1952

Rodman, Selden, *Conversations with Artists,* New York, NY: Devin-Adair, 1957

Rosenberg, Harold, *Art and other serious matters,* Chicago, IL: University of Chicago Press, 1985

Seuphor, Michel, *Plastik unseres Jahrhunderts. Wörterbuch der modernen Plastik,* Cologne: DuMont, 1959

Stebbins, Theodore E., Jr., *American Master Drawings and Watercolors: A History of Works on Paper from Colonial Times to the Present,* New York, NY: Harper & Row Publishers, 1976

Strachan, Walter J., *Towards Sculpture: Maquettes and Sketches from Rodin to Oldenburg,* London: Thames and Hudson, 1976

Thomas, Karin / Vries, Gerd de, *DuMont's Künstlerlexikon von 1945 bis zur Gegenwart,* 3rd ed., Cologne: DuMont, 1981

Trier, Eduard, *Figur und Raum. Die Skulptur des XX. Jahrhunderts,* Berlin: Gebr. Mann Verlag, 1960

Tucker, William, *Early Modern Sculpture,* New York, NY: Oxford University Press, 1974

Wittkower, Rudolf, *Sculpture: Processes and Principles,* New York, NY: Harper & Row Publishers Inc., 1977

Articles in Newspapers and Periodicals

"Zeichnungen von David Smith", *Aachener Volkszeitung,* 2. 9. 1976

"David Smith Retrospective at Guggenheim March 29", *Albany Knickerbocker News,* 5. 3. 1969

Alloway, Lawrence, "3-D: David Smith and Modern Sculpture", *Arts Magazine,* Feb. 1969

Alloway, Lawrence, "Art" (Exhibition at The Solomon R. Guggenheim Museum, New York), *The Nation,* 21. 4. 1969

Alloway, Lawrence, "Monumental Art at Cincinnati", *Arts Magazine,* Nov. 1970

Andreae, Christopher, "Smith: Sculpture as Identity", *Christian Science Monitor,* April 1969

"Archives Exhibition in Washington and San Antonio", *Archives of American Art Newsletter,* II/2 (Winter 1983)

"Art Across the USA: Outstanding Exhibitions" (Dallas Museum of Fine Arts), *Apollo,* LXXXIX/88 (June 1969)

Arnes, Richard, "In 7 plus 5, UCSB has put on a stunning sculpture show", *News Press,* Santa Barbara, CA., 10. 1. 1976

"Big ocean, small splash" (What's on in London), *Art,* 16. 5. 1980

On drawings by David Smith, *Art & Artists,* July 1980

David Smith, "A Personal Portfolio. Photographs by Dan Budnik and Ugo Mulas", *Art in America,* L/1 (Jan.–Feb. 1966)

Artner, Alan G., "Show finds another aspect of David Smith's artistry", *Chicago Tribune,* 24. 6. 1983

"Reviews and previews", *Art News,* LI (April 1952)

"Breaking down the monolith", *Art News,* March 1972

The ARTnewsletter. The international biweekly report on the art market, VII/1 (1. 9. 1981)

Ashberry, John, "Reviews and Previews" (exhibition at the Marlborough-Gerson Gallery, New York, NY), *Art News,* LXVII/4 (1968)

Ashberry, John, "Back to the Drawing Board", *Newsweek,* 6. 4. 1981

Ashton, Dore (on the exhibition at the Willard Gallery, New York), *Arts and Architecture,* LXXIII/6 (June 1956)

Ashton, Dore (on the retrospective at the Museum of Modern Art, New York), *Arts and Architecture,* LXXIV/12 (Dec. 1957)

Ashton, Dore (on the exhibition at French and Company, New York, NY, *Arts and Architecture,* LXXVII/4 (April 1960)

Ashton, Dore, "New American Sculpture", *XXe siècle,* XXII/12 (Dec. 1960)

Ashton, Dore (on the Pittsburgh International Exhibition of Contemporary Painting and Sculpture, 1961), *Arts and Architecture,* LXXIX/2 (Feb. 1962)

Ashton, Dore, "New York Commentary: On the Way to the Fair", *Studio International,* CLXVIII/857 (Sept. 1964)

Ashton, Dore, "David Smith", *Arts and Architecture,* Feb. 1965

Ashton, Dore, "American Sculpture in Paris", *Studio International,* Nov. 1965

Bannard, Walter Darby, "Cubism, Abstract Expressionism, David Smith", *Artforum,* VI/8 (April 1968)

Bannard, Walter Darby, "Caro's New Sculpture", *Artforum,* June 1972

Barker, Walter, "The Vices and Virtues of The Whitney's Bicentennial Blockbuster", *St. Louis Post-Dispatch,* 4. 4. 1976

Baro, Gene, "International Reports, London: Bond Street and Battersea", *Arts Magazine,* Nov. 1963

Baro, Gene, "David Smith (1906–1965), *Arts, Yearbook,* 1965, no. 8

Baro, Gene, "David Smith: The Art of Wholeness", *Studio International,* CLXXII (Aug. 1966)

Beals, Kathie, "Sculpture in the rough", *Gannett Papers / Weekend Section,* VIII/36 (15. 2. 1982)

Beam, Lura, "David Smith", *Journal of the American Association of University Women,* XLIII (Spring 1950)

Berenson, Ruth, "Undefinitive", *National Review*, 11.6.1976

Bickel, Peter, "DMFA Sculpture Show Takes Time", *Times Herald*, Dallas, TX: 25.6.1969

Bourdon, David, "The Whitney Overflows With Sculpture", *the village VOICE*, 29.3.1976

Bourdon, David, "Sculptors Drawings Over Six Centuries, The Drawings Center, New York City; through June 20", *Vogue*, April 1981

Brenson, Michael, "Art: 20 Years of David Smith Painting", *The New York Times*, 7.10.1983

Brenson, Michael, "Art: 100 Modern Sculptures at Storm King Art Center", *The New York Times*, 3.8.1984

Brown, Elizabeth Ann, "Sculptors' Drawings", *Arts Magazine*, June 1981

Brown, Joe, "Showing off Smith", *The Washington Post*, 4.11.1982

Budnik, Dan, "Issues and Commentary: David Smith: A Documentation", *Art in America*, LXII/5 (Oct.–Nov. 1974)

Burkamp, Gisela, "Revolte gegen gründlich abgetragene Schönheiten", *Neue West-fälische Zeitung*, Bielefeld, 29.9.1976

"Recent Museum Acquisitions: David Smith's Wagon I (National Gallery of Canada)", *Burlington Magazine*, July 1969

Burr, James, "London Galleries: Man of Iron and Steel at the Tate Gallery", *Apollo*, LXXXIV/55 (Sept. 1966)

Busch, Julia, "A Decade of Sculpture", *Art Alliance Press*, Cranbury, NY: 1974

Butler, Joseph T., "The American Way with Art: David Smith Retrospective Exhibition", *Connoisseur*, July 1969

Campell, Lawrence, "Four Sculptors, Four Systems", *Art News*, LXII/4 (1963)

Carrier, David, "American Apprentices: Thirties Abstraction", *Art in America*, Feb. 1984

Causey, A., "Sculpture's Debt to the Machine", *Illustrated London News*, 3.9.1966

Claus, Jürgen, "Dürer macht's möglich", *Die Zeit*, 3.2.1967

Coates, Robert M., "The Art Galleries: A Sculptor and Two Painters" (exhibition at French & Co., New York, NY), *New Yorker*, 5.3.1960

Coates, Robert M., "Six" (exhibition at the Marlborough-Gerson Gallery, New York, NY), *New Yorker*, 7.11.1964

Coates, Robert M., "Monument", (exhibition at the Fogg Art Museum, Cambridge, MA), *New Yorker*, 22.11.1966

Cochrane, Diane, "The Artist and His Estate Taxes", *American Artist*, Jan. 1974

Cone Harrison, Jane, "David Smith", *Art-forum*, June 1967

Cooke, H. Lester, "David Smith", *I 4 Sull. Rassegna d'Arte Attuale*, Turin: Jan.–Feb. 1955

Corbin, Patricia, "Sculpture Out in the Open", *House and Garden*, Dec. 1974

Courthion, Pierre, "Situation de la Nouvelle Peinture Americaine", *XXᵉ Siècle*, 1970

"Smith Retrospective To Open at Museum", *The Dallas Morning News*, Dallas, TX: 22.6.1969

David, Douglas/Rourke, Mary, "American Art 200 Years On", *Newsweek*, 9.2.1976

Davis, Hugh M./Yard, Sally E., "Some Observations on Public Scale and Sculpture", *Arts Magazine*, Jan. 1976

Dehner, Dorothy, "Medals for Dishonor: The Fifteen Medallions of David Smith", *Art Journal*, Winter 1977–78

Dellamora, Richard, "The Sculpture and Drawings of David Smith: 1933–1950", *Arts Magazine*, Nov./Dec./Jan. 1981–82

Demisch, Eva Maria, "Kraft und Klarheit", *Frankfurter Allgemeine Zeitung*, 10.2.1967

Demisch, Eva Maria, "Die jüngste documenta, die es je gab", *Frankfurter Allgemeine Zeitung*, 6.12.1967

Derfner, Phyllis, "New York Letter" (exhibition at the Knoedler Gallery, New York, NY), *Art International*, XVIII/10 (Dec. 1974)

Donadio, Emmie, "David Smith's Legacy: The View from Prospect Mountain", *Arts Magazine*, LIV/4 (Dec. 1979)

Dorfles, Gillo, "David Smith: A Lesson in Modernity", *Metro*, 1961, No. 4–5

Echter, Martin S., "The David Smith Case. The Tax Court Takes a First Step", *Trust & Estates*, June 1975

"7 Brothers Fine Arts Division Moves Huge Sculpture Show From New York to Texas … Guggenheim Museum Scene of Departure For Over 114 Pieces of World Famous David Smith Works", *The 8th (eighth) Brother*, 11.8.1969

Elsen, Patricia, "College Museum Notes: Sculpture at Princeton", *Art Journal*, Autumn 1970

Enright, Richard, "Premonitions of Menace", *MacLeans Magazine*, Sept.1981

"Sculptors' drawings at Pace Gallery", *Evening Star*, 6.1.1982

Fabri, Ralph, "David Smith Retrospective. Finger Painting in Transparent Oils", *Today's Art*, May 1969

"David Smith in der Kunsthalle Baden-Baden", *Frankfurter Allgemeine Zeitung*, 15.3.1966

Feaver, William, "William Turnbull", *Art International*, XVIII/7 (Sept. 1974)

Feaver, William, "Painters on Paper", *Observer*, 25.5.1980

Fenton, Terry, "Smith and Surrealism", *Update*, VI/1 (Jan./Feb. 1985)

Forgey, Benjamin, "Two centuries of US sculpture all in one place", *Smithsonian*, Sept. 1976

Forgey, Benjamin, "Hirshhorn Provides a New Opportunity to Appreciate David Smith", *The Washington Star*, 5.8.1979

Frackman, Noel, "Arts Reviews" (exhibition at the Knoedler Gallery, New York, NY), *Arts Magazine*, June 1976

Frackman, Noel, "Arts Reviews" (exhibition at the Knoedler Gallery, New York, NY), *Arts Magazine*, Sept. 1976

Frackman, Noel, "Arts Reviews" (exhibition at the Knoedler Gallery, New York, NY), *Arts Magazine*, Feb.1978

Frank, Peter, "American Abstract Artists Make A Concrete Impression", *Diversion Vacation Planner*, July/Aug. 1984

Franzke, Andreas, "Zur Ausstellung in der Kunsthalle Tübingen: Skulpturen der Moderne. Julio González, David Smith, Anthony Caro, Tim Scott, Michael Steiner", *Pantheon*, I (1981)

Friedrichs, Yvonne, "Grazile Eisenstele und tektonische Perspektiven", *Rheinische Post*, 28.4.1979

Fuller, Peter, "Smith's Original Greenbergs", *Arts Review*, 18.10.1974

Geelhaar, C., "Zeichnungen: Staatsgalerie, Graphische Sammlung, Stuttgart", *Pantheon*, XXXIV/3 (Aug./Sept. 1976)

Geist, Sidney, "A Smith as Draftsman", *Art Digest*, XXVIII (1.1.1954)

Geist, Sidney, "Color It Sculpture", *Arts Yearbook 8*, New York, NY: The Art Digest, 1965

Genauer, Emily, "Art: Sculpture in silver", *House and Garden*, May 1965

Genauer, Emily, "Art and the Artist", *New York Post*, 5.4.1969

Genauer, Emily, "Art and the Artist", *New York Post*, 19.4.1969

Genauer, Emily, "David Smith's Turn in the Road", *Houston Post*, 20.4.1969

Genauer, Emily, "New York's Exercise in Egotism", *Los Angeles Times*, 4.5.1969

Genauer, Emily, "Questions About a Sculpture Show", *International Herald Tribune*, 20.–21.3.1976

Getlein, Frank, "The Visibility of the Intellect", *New Republic*, 14.3.1960

Getlein, Frank, "Gallery of Modern Art Opens Finest Exhibition", *The Sunday Star*, 22.9.1963

Gibson, Eric, "David Smith", *Art International*, XXII/9 (Feb.1979)

Giedion-Welcker, Carola, "Contemporary Sculpture", *Documents of Modern Art*, no. 12. New York, NY: Wittenborn Schulz, 1955

Glozer, Laszlo, "Zum Beispiel Minimal-art", *Frankfurter Allgemeine Zeitung*, 2.4.1969

Glueck, Grace, "David Smith's Art On Way To Europe", *The New York Times*, 16.4.1966

Glueck, Grace, "David Smith Seen in His Full Range and Scope", *The New York Times*, 28.11.1982

Glueck, Grace, "Sculptors on Paper and A Gallery On the Move", *The New York Times*, 25.9.1983

Krauss, Rosalind E., "Changing the Work of David Smith", *Art in America*, Sept.–Oct. 1974

Kreisberg, Louisa, "Shopping Culture With the Kids During The Easter Vacation", *Peekskill Star*, 9.4.1969

Kuh, Katherine, "Talks with seventeen artists", *The artist's voice*, New York, NY: 1962

Laddey, Virginia, "Impact of sculpture in David Smith show", *Press Telegram*, Los Angeles, CA: 5.12.1965

Lafean, Richard, "Ceramics by Twelve Artists", *Craft Horizons*, Jan. 1965

Langsner, Jules, "David Smith – exhibition at Everett Ellin Gallery", *Art News*, LIX/8 (Dec. 1960)

Larson, Kay/Rickey, Carrie, "Space Walk. Uptown", *Voice*, 21.1.1980

Larson, Kay, "The Other David Smith", *New York Magazine*, 31.10.1983

Laws, Frederick, "Drawings in the air", *The Guardian*, 23.8.1966

Lee, David, "David Smith alla Guggenheim", *Le Arti*, Sept. 1969

Lewis, Jo Ann, "The Breakthrough Sculpture of David Smith", *The Washington Post*, 26.7.1979

Lewis, Jo Ann, "The Two Sides of David Smith", *The Washington Post Magazine*, 31.10.1982

Licameli, Paul G., "Artists of America celebrated in museum on Madison Avenue", *The News Tribune*, 22.2.1980

"An Artistic Smith at Work", *Life*, XXXIII/12 (Sept. 1952)

"David's Steel Goliaths", *Life*, LIV/14 (5.12.1963)

"Farewell to the Vulcan of American Life", *Life*, LVIII/23 (11.6.1965)

Lima Greene, Alison de, "Looking at David Smith's Two Circle Sentinel", *The Bulletin of the Museum of Fine Arts*, Houston, TX. VIII/4 (Winter/Spring 1985)

Loercher, Diana, "The Anatomy of Ideas", *The Christian Science Monitor*, 2.5.1977

"Smith Exhibit: A Step Beyond", *Los Angeles Times*, 11.1.1968

Lubar, Robert S., "Metaphor and Meaning in David Smith's Jurassic Bird", *Arts Magazine*, New York, NY: Sept. 1984

Marcus, S. E., "Revolution in Sculpture. A Look at David Smith", *Intellect*, Feb. 1977

Marcus, S. E., "Brief", *Art in America*, May–June 1978

Marmer, Nancy, "A Memorial Exhibition: David Smith", *Artforum*, Jan. 1966

McCausland, Elizabeth, "David Smith's Abstract Sculpture in Metals", *Springfield Republican*, 31.3.1940

McCoy, Garnett, "The David Smith Papers", *Archives of American Art Journal*, VIII/2 (April 1968)

McEwen, John, "Another Dimension", *Spectator*, 24.5.1980

Mellow, James R., "Sculpture Swings to an Industrial Look", *Industrial Design*, March 1967

Mellow, James R., "New York Letter" (exhibition at the Solomon R. Guggenheim Museum), *Art International*, XIII/5 (May 1969)

Meltzoff, Stanley, "David Smith and Social Surrealism", *Magazine of art*, XXXIX (March 1946)

Melville, Robert, "David Smith", *New Statesman*, 26.8.1966

Menck, Clara, "Eisen hat viele Gesichter", *Frankfurter Allgemeine Zeitung*, 4.9.1970

Menck, Clara, "David Smith: Stahlarbeiter und sozialer Surrealist", *Frankfurter Allgemeine Zeitung*, 12.2.1976

Merryman, John H., "Bernard Buffet's Refrigerator and the Integrity of the Work of Art", *Art News*, Feb. 1977

"Twentieth Century Art: Becca", *The Metropolitan Museum of Art Bulletin*, Summer 1973

"A Man Named Smith. Guggenheim Show All Set", *Michigan Ann Arbor News*, 9.3.1969

Michel, Jacques, "L' école de New-York chez elle", *Le Monde*, 5.2.1980

Millard, Charles W., "David Smith", *The Hudson Review*, XXII/2 (Summer 1969)

Miller, Arthur, "Ferric Sculpture Suffers in Human Environment", *Herald Examiner*, Los Angeles, CA: 5.12.1965

Morris, George L. K., "La Sculpture abstraite aux USA", *Art d'Aujourd'hui*, IV/1 (Jan. 1953)

Morschel, Jürgen, "Plastik auf Rädern. David Smith-Ausstellung im holländischen Park von Otterlo", *Süddeutsche Zeitung*, no. 165 (12.7.1966)

Motherwell, Robert, "David Smith: A Major American Sculptor", *Vogue*, CXLV/3 (1.2.1965)

Muchnic, Suzanne, "Abstract Expressionism: Humanoid Sculpture From The 3rd Dimension", *Los Angeles Times*, 13.1.1985

Mullins, Edwin, "All Look and No Think?", *Sunday Telegraph*, 26.4.1964

Mullins, Edwin, "Explorer in Steel", *Sunday Telegraph*, 28.8.1966

Munro, Eleanor, "Exploration in Form: a view of some recent American Sculpture", *Perspectives USA*, no. 16 (Summer 1956)

Munro, Eleanor, "David Smith Drawings Centrality of the Image", *Art/World*, IV/4 (20.12./15.1.1980)

Murry, Jesse, "On David Smith Drawings", *Arts Magazine*, New York, NY: June 1980

Myers, Fred A., "David Smith Sculpture Acquired", *Carnegie Magazine*, no. 41 (1967)

Navaretta, E. A., "New Sculpture of David Smith", *Art in America*, XLVII/4 (Winter 1959)

"Bilder zum Nachdenken", *Neue Ruhr Zeitung*, no. 191 (28.8.1976)

"Iron Works Closed", *Newsweek*, LXV/23 (7.6.1965)

"Art: Alter Ego", *Newsweek*, 30.9.1974

"Art on a grand scale", *New York Sunday News*, 13.4.1969

"Sculptor Rejects Award of $ 1000", *The New York Times*, 1.11.1961

"Lincoln Center Given a David Smith", *The New York Times*, 6.11.1967

Nochlin, Linda, "People are talking about … Art: Standing sculpture on its head", *Vogue*, Dec. 1982

Nodelman, Sheldon, "David Smith", *Art News*, LXVII/10 (Feb. 1969)

Nordland, Gerald, "Los Angeles Newsletter", *Art International*, XX (March–April 1976)

O'Doherty, Brian, "Highway to Las Vegas", *Art in America*, LX/1 (Jan.–Feb. 1972)

O'Hara, Frank, "David Smith: The Color of Steel", *Art News*, LX/8 (Dec. 1961)

Overy, Paul, "Gleaming cantos", *The Listener*, 1.9.1966

Pachner, Joan, "David Smith: The Formative Years", *Arts Magazine*, LVI/10 (1982)

Pachner, Joan, "Theodore Roszak and David Smith: A Question of Balance", *Arts Magazine*, Feb. 1984

David Smith, "The Drawings", *Pantheon*, II (1980)

Phillips, Deborah, "The Third Dimension – Whitney Museum of American Art", *Art News*, April 1985

Piene, Nan R., "New York Exhibition Notes, Museums and Galleries", *Art in America*, LVII 1 (Jan.–Feb. 1969)

Pomeroy, Ralph, "David Smith in Depth", *Art and Artists*, IV/6 (Sept. 1969)

Porter, Fairfield, "David Smith: Steel into Sculpture", *Art News*, LVI (Sept. 1957)

Preston, Malcolm, "Drawings by David Smith", *Newsday*, Long Island, NY: 21.1.1980

Preston, Malcolm, "A show of sculptors drawings", *Newsday*, Long Island, NY: 11.10.1983

"News Report: Architectural Sculpture", *Progressive Architecture*, Dec. 1964

Railing, Patricia, "La Sculpture Americaine de 1940 à 1959", *XXe Siècle*, June 1973

Ratcliff, Carter, "The Whitney Makes History", *Saturday Review*, Oct. 1981

Ratcliff, Carter, "Domesticated Nightmares", *Art in America*, May 1985

Raynor, Vivien, "Art: Drawing with Metal", *The New York Times*, 2.12.1977

Raynor, Vivien, "Drawn to Drawings", *The New York Times*, 14.12.1979

Reinke, Klaus U., "Ein Hemmingway der Bildhauerei", *Handelsblatt*, 25.4.1967

"American Sculptor's Work On Exhibition In Dallas", *Reporter Telegram*, Midland, TX: 4.8.1969

"David Smith. Painter, Sculptor, Draftsman", *The Revue*, I/8 (April 1983)

Richard, Paul, "A Taxing Problem", *Post-Times Herald*, Washington, D.C: 17.2.1972

Richard, Paul, "Legacy of the Mighty Man of Metal", *The Washington Post*, 5.11.1982

Riley, Maude, "David Smith, Courtesy American Locomotive", *Art Digest*, XVII (15.4.1943)

Robbins, Daniel, "Collector: Roy Neuberger", *Art in America*, LVI/6 (Nov.–Dec. 1968)

Robbins, Eugenia S., "The Storm King Art Center", *Art in America*, LVII/3 (May–June 1969)

Roberts, Colette, "Les Expositions à l'Etranger: Lettre de New York", *Aujourd'hui*, VII/40 (Jan. 1963)

Roberts, Keith, "Current and Forthcoming Exhibitions, London", *Burlington Magazine*, Oct. 1966

Robertson, Bryan, "Force of Circumstance", *Spectator*, 26.8.1966

Robertson, Bryan, "David Smith", *Harpers & Queen*, May 1980

Roper, L., "Pepsico Gardens, Purchase, New York", *Country Life*, 21.4.1977

Rosati, James, "David Smith (1906–1965)", *Art News*, LXIV/5 (Sept. 1965)

Rose, Barbara, "Looking at American Sculpture", *Artforum*, III/5 (Feb. 1965)

Rosenthal, Nan, "American Artists Photographed by Arnold Newman", *Art in America*, LIII/3 (June–July 1965)

Rubin, William, "David Smith", *Art International*, VII/9 (Dec. 1963)

Rubin, William, "Brief", *Art in America*, May–June 1978

Rubinfein, Leo, "Reviews" (exhibition at the Knoedler Gallery, New York, NY), *Artforum*, June 1976

Russell, John, "A great head of steam", *Sunday Times*, 28.8.1966

Russell, John, "Spray Paintings and Works on Paper by David Smith", *The New York Times*, 4.12.1981

Russell, John, "Sculpture: David Smith", *The New York Times*, 30.4.1982

Russell, John, "Finding Pleasure in Early Work", *Bulletin M. Knoedler & Co.*, 9.5.1982

on "David Smith: Painter, Sculptor, Draftsman", *News from SAMA (Bulletin of the San Antonio Museum Association)*, 10.1.1983

Schjeldahl, Peter, "Anxieties of Eminence", *Art in America*, Sept. 1980

Schmidt, Dietmar N., "Kunst, im Müll geboren", *Die Welt*, 2.2.1967

Schmidt, Doris, "Auftakt mit David Smith", *Süddeutsche Zeitung*, 20.1.1967

Schmidt-Grohe, Johanna, "Eindrücke von einer Ausstellung in der Kunsthalle Nürnberg", *Kunst und das schöne Heim*, LXV (1966–67)

Schneede, Uwe M., "USA-Plastik in Europa", *Artis*, XVIII/10 (1966)

Schneede, Uwe M., "David Smith: Anläßlich Seiner Ersten Retrospektive in Europa", *Das Kunstwerk*, Oct. 1966

Schulze-Vellinghausen, Albert, "Am Scheideweg. Holländische 'Documenta' der Skulptur/Sonsbeek in Arnheim", *Frankfurter Allgemeine Zeitung*, 16.6.1966

Schurr, Gerald, "Continental Dispatch: Duisburg: David Smith", *Connoisseur*, May 1967

Schurr, Gerald, "Europe, Berlin", *Connoisseur*, May 1976

Seldis, Henry J., "Forging Ahead – Sculptors of the 50s in Retrospect", *Los Angeles Times*, 8.2.1976

Sewell, Carol, "Sculpture exhibit inventive, diverse", *Morning Star-Telegram*, Fort Worth, TX: 19.5.1985

Shepherd, Michael, "The big draw", *Sunday Telegraph*, 11.5.1980

Shepherd, Michael, "Art: Big Ocean, Small Splash", *In London*, 16.5.1980

Shirey, David L., "Art: Man of Iron", *Newsweek*, 31.3.1969

Shirey, David L., "Horror Show", *Newsweek*, 3.11.1969

Shirey, David L., "Sculptures as Grand as all Outdoors", *The New York Times*, 12.11.1978

Silver, Jonathan, "Remaking the History of American Sculpture", *Art News*, Summer 1976

Silver, Jonathan, "The Classical Cubism of David Smith", *Art News*, Feb. 1983

Silverthorne, Jeanne, "The Third Dimension: Sculpture of the New York School", *Artforum*, May 1985

Sloane, Leonard, "Valuing Artist's Estates: What Is Fair?", *Art News*, April 1976

Smith, Miles A., "Smith's Sculpture Linked to Painting", *Gleaner & Journal*, Henderson, KY: 13.4.1969; *American*, Austin, TX: 16.4.1969

Smith, Miles A., "Sculptor Smith's Entire Career Encompassed in Show", *The Journal*, Flint, MI: 20.4.1969

Smith, Miles A., "Current Guggenheim Exhibition Shows David Smith's Stages", *Asbury Park Evening/Sunday Press*, Asbury, NY: 20.4.1969

Smith, Miles A., "Exhibit traces development of painter-sculptor", *Battle Creek Enquirer & News*, Battle Creek, MI: 20.4.1969

Smith, Miles A., "Painting – Sculpture Linkage Seen In Guggenheim Show", *The Sun*, Baltimore, MD: 7.5.1969

Smith, Roberta, "Old Timers as New Comers", *The Village Voice*, 4.10.1983

Smith, Roberta, "Abstraction Then, for Now", *Voice*, 31.7.1984

Sozanski, Edward J., "A mythic master's works in 2 shows", *Philadelphia Inquirer*, 8.11.1982

Sozanski, Edward J., "A show that provides a chance to scan sculpture's evolution", *Art/Architecture*, 6.1.1985

Spiess, Werner, "Zwei Plastiker – Zwei Schmiede", *Frankfurter Allgemeine Zeitung*, 9.7.1980

Stevens, Elisabeth, "The monumental imagination of David Smith", *Baltimore Sun*, 14.11.1982

Stevens, Mark, "Shifting Shapes of Sculpture", *Newsweek*, 22.11.1982

Stevens, Mark, "A Fresh Look at the '50s", *Newsweek*, 21.1.1985

Storr, Robert, "David Smith – Heroic or Protean?", *Art in America*, Oct. 1983

Sylvester, David, "New York Takeover", *The Sunday Times*, 26.4.1964

Sylvester, David, "A Man to Join the Ranks of Gorky and Pollock", *The Sunday Times*, 30.5.1965

Tamms, Werner, "Pinsel und Spritzpistole", *Westdeutsche Allgemeine Zeitung*, 30.8.1976

Taylor, John Russell, "Controlled frenzy on the brink of abstraction", *The Times*, 6.5.1980

Tighe, Mary Anne, "Journal: The Evolving Mastery of David Smith", *House and Garden Magazine*, Jan.1983

Tillim, Sidney (exhibition at French and Company, New York, NY), *Arts*, XXXIV/1 (Oct. 1959)

"Sculpture in the Raw", *Time Magazine*, 23.9.1957

"Art: The Giant Smithy", *Time Magazine*, 26.8.1966

"The Belligerent Balladry of a Master Welder", *Time Magazine*, 8.11.1968

"Totems of a Titan", *Time Magazine*, 2.4.1969

"Arrogant Intrusion", *Time Magazine*, 30.9.1974

"Proof Enough Of The Vitality Of Recent Painting And Sculpture", *The Times*, 21.4.1964

"The sculpture of David Smith", *The Times*, 19.8.1966

"Hopkins Will Lecture On Smith Show", *Times Herald*, Dallas, TX: 28.6.1969

Tomkins, Calvin, "The Art World", *The New Yorker*, 18.7.1983

Treanor, Aline Jean, "Giant of Modern Sculpture", *Blade*, Toledo, OH: 16.8.1953

Trescott, Jacqueline, "At the National Gallery, a Toast to the Master", *The Washington Post*, 5.11.1982

Tuchmann, Phyllis, "In Detail: David Smith and Cubi XXVII", *Portfolio Magazine*, Jan.–Feb. 1983

Tucker, William, "Four Sculptors, Part 4: David Smith", *Studio International*, CLXXXI, no. 929 (Jan. 1971)

Tully, Judd, "Dorothy Dehner and Her Life on the Farm With David Smith", *American Artist*, Oct. 1983

Usborne, K., "David Smith", *Arts Review*, 10.3.1973

Vaizey, Marina, "A burst of emotion from the great out-doors", *The Sunday Times*, 4.5.1980

"David Smith", *Village Voice*, 21.1.1980
Wallach, Amei, "The drawings of David Smith", *Newsday*, 2.12.1979
Wallach, Amei, "A personal approach", *Newsday*, 27.4.1980
"David Smith", *Notes and Comment from the Walker Art Center*, Minneapolis, MN: VI (May 1952)
Wechsler, Judith, "Why Scale? The Los Angeles County Museum's Ambitious Survey of US Sculpture", *Art News*, LXVI/4 (Summer 1967)
Welish, Marjorie, "Art", *Manhattan East*, New York, NY: 18.4.1969
"Chronik Ausstellungen, Basel: David Smith, Skulpturen", *Werk*, Dec. 1966
"Drawings By Sculptors On View At Pace", *Westmore News*, Pt. Chester, NY: 7.1.1982; *Surburban Street*, White Plains. NY: 13.1.1982
Whelan, Richard, "David Smith" (Knoedler) *Art News*, Feb. 1969
Willard, Charlotte, "Drawing Today", *Art in America*, LII/5 (Oct.–Nov. 1964)
Wilson, Wayne P., "An Interview with Peter Selz", *Art Journal*, Autumn 1970
Winter, Peter, "Zeitgenössische Skulptur in Bielefeld. Kernenergie aus der Schweißerwerkstatt", *Frankfurter Allgemeine Zeitung*, 17.5.1980
Winter, Peter, "Stahltotem", *Frankfurter Allgemeine Zeitung*, 3.4.1986
Winter, Peter, "David Smith", *Kunstforum International*, LXXXIV (June–Aug.1986)
Withers, Josephine, "The Artistic Collaboration of Pablo Picasso and Julio González", *Art Journal*, XXXV/2 (Winter 1975–76)
Whittet, G. S., "Some London Shows", *The Artist*, London: Nov. 1966
Wolff, Theodore F., "American sculpture today: Is it art? Why not!", *Christian Science Monitor*, Boston, MA: 14.5.1980
Wolff, Theodore F., "A hard look at American avant-garde sculptors", *Christian Science Monitor*, Boston, MA: 3.1.1985
Wolfram, Eddie, "David Smith Retrospective" (Tate Gallery, London), *Arts Review*, 3.9.1966
Wortz, Melinda, "Sculpture Of The Fifties", *Art West Coast*, VII/6 (7.2.1976)

Writings by the Artist, Interviews

Watson, Ernest, "From Studio to Forge: An interview", *American Artist*, IV/3 (1940)
Smith, David, "Abstract Art", *The New York Artist*, I/5–6 (1940)
Smith, David, "Sculpture: Art Forms in Architecture – New Techniques Affect Both", *Architectural Record*, LXXXVIII (Oct. 1940)

Smith, David, "Medals for Dishonor", in cat. Willard Gallery, 1940
Smith, David, "The Landscape; Spectres Are; Sculpture Is", in cat. Willard Gallery, 1947
Smith, David, "I Have Never Looked at a Landscape; Sculpture Is", *Possibilities*, I/25 (1947–48)
Smith, David, "The Golden Eagle… A Recital; Robinhood's Barn", *Tiger's Eye*, I/4 (1948)
Smith, David, "Open letter to Roland I. Redmond, President of the Metropolitan Museum of Art, New York", 20.5.1950
Smith, David, Notes on his work, in cat. Willard Gallery, 1951
Smith, David, Speech in New Orleans, LA: Newcomb College, 21.3.1951. Estate
Smith, David, "The New Sculpture". Paper read during the symposium at the Museum of Modern Art, New York. Printed in McCoy, Garnett, *David Smith*, New York, NY: Praeger, 1973
Smith, David, "The Language is Image", *Arts and Architecture*, LXIX (Feb. 1952)
Smith, David, Speech in Portland, OR: Portland Museum of Art, 23.3.1952. Estate
Smith, David, "The Sculptor and His Problems". Paper read at the Woodstock Conference in Woodstock, NY, 23.8.1952. Printed in McCoy, Garnett, *David Smith*, New York, NY: Praeger, 1973
Smith, David, Speech for the WYNC Radio Station, New York, NY: 30.10.1952. Estate
Smith, David, "Who Is the Artist? How Does He Act?", *Everyday Art Quarterly*, Minneapolis, MN: Walker Art Center, no. 23 (Winter 1952). Reprinted in *Numero*, no. 3 (May–June 1953)
Smith, David, Statement, in *Peintres et sculpteurs Americains contemporains*, cat. Paris, 1953
Smith, David, Statement in "Symposium: Art and Religion", *Art Digest*, XXVIII/6 (Dec. 1953)
Smith, David, "Thoughts on Sculpture", *College Art Journal*, XIII/2 (1954). Reprinted in cat. Fogg Art Museum, 1966
Smith, David, "Second Thoughts on Sculpture", *College Art Journal*, XIII/3 (1954)
Smith, David, "González: First Master of the Torch", *Art News*, LIV/10 (Feb. 1956)
Smith, David, "Sculpture and Architecture", *Arts*, XXXI/8 (May 1957)
Rodman, Selden, *Conversations with Artists*, New York, NY: Devin-Adair, 1957
Smith, David, Letter to the editor disputing the authenticity of statements ascribed to him by Rodman Selden, *Arts*, XXXI/9 (June 1957)
Smith, David, Statement in "Is Today's Artist With or Against the Past?", *Art News*, LVII/5 (Sept. 1958)

Smith, David, "Notes on My Work", *Arts*, XXXIV/5 (Feb. 1960). Reprinted in cat. Fogg Art Museum, 1966
Smith, David, "Memories to Myself" (speech on the occasion of the 18th conference of the National Committee on Art Education), New York, NY: Museum of Modern Art, 5.5.1960. Printed in *Archives of American Art Journal*, VIII (April 1968)
Smith, David, Letter protesting against vandalism, *Arts*, XXXIV/9 (June 1960); *Art News*, LIX/4 (1960)
Smith, David, Statement in "Sculpture Today", *The Whitney Review*, 1961–1962
Kuh, Katherine, "David Smith" (interview), in *The Artist's Voice: Talks With Seventeen Artists*, New York, NY: New York & Evanston, 1962
Smith, David, Facsimile of a letter to David Sylvester, in Carandente, Giovanni, *Voltron*, Philadelphia, PA: Institute of Contemporary Art, University of Pennsylvania, 1964
Sylvester, David, "David Smith" (interview), *Living Arts*, I/3 (April 1964)
Hess, Thomas B., "The Secret Letter", (interview), cat. Marlborough-Gerson Gallery, 1964
Baro, Gene, "Some Late Words of David Smith", *Art International*, IX/7 (Oct. 1965)
Sylvester, David, "David Smith" (interview), *Museumsjournaal*, II (1965–1966)
David Smith by David Smith, Cleve Gray (ed.), New York, NY: Holt, Rinehart and Winston, 1968
Smith, David, "Memories to Myself", *Archives of American Art Journal*, VIII (April 1968)
Smith, David, "Notes for David Smith Makes a Sculpture", *Art News*, LXVIII (Jan. 1969)
McCoy (ed.), *David Smith*, New York, NY – Washington, DC: Praeger, 1973 (collection of the most important texts by David Smith, including interviews and letters)
"Words by David Smith", *Arts Forum*, Dec. 1979

Material in Archives

Archives of American Art, Smithsonian Institution, Washington, D.C.: *The David Smith Papers.*

The archive contains an exceptionally large number of letters, business papers, photographs, sketchbooks, working notes, lecture notes, exhibition catalogues, newspaper cuttings and much other material.

The correspondence consists of letters from art dealers, collectors, curators, critics, suppliers, teachers and friends, augmented by letters from David Smith to for example, the artists Josef Albers,

Alexander Calder, Helen Frankenthaler, John Graham, Morris Louis, Robert Motherwell, Kenneth Noland, Mark Rothko and Mark Tobey.

The most extensive and, in some respects, most informative correspondence is that between Smith and Marian Willard, a friend of the artist who showed his works for many years in her gallery. This exchange of letters covers the period from 1940 to 1956.

The more than forty notebooks and sketchbooks range from the early Thirties to the mid-Fifties. Included in the archive are approximately 3,000 photographs of Smith's works, two thirds taken by the artist himself, and extensive photographic material of a biographical nature.

In addition, the archive preserves numerous newspaper articles and about forty articles from periodicals of the Forties and Fifties.

Museum of Art, Carnegie Institute of Technology, Pittsburgh, PA. American Federation of Arts, New York, Sara Roby Foundation File: *unpublished correspondence with David Smith*, 21.10.1960 – 5.3.1961.

Kunstsammlung Nordrhein-Westfalen, Düsseldorf: extensive international documentation, especially of newspaper and magazine articles.

Photographic Acknowledgments

For kindly putting photographic material at our disposal we thank the museums and collections mentioned in the captions as well as the following photographers and archives:

Jörg P. Anders, Berlin 123 (below)
Dan Budnik, New York (by courtesy of Woodfin Camp & Associates, New York) 8/9, 14, 16, 23–27, 30, 31, 148–150, 156, 158, 169, 171
Geoffrey Clements, New York 114 (below), 126 (below)
Ken Cohen, New York 109 (below), 110 (below), 117 (below), 143 (above)
Jacqueline Hyde, Paris 88
Bruce C. Jones, New York 18, 59

Walter Klein, Düsseldorf 112, 113, 114 (above), 115, 116, 117 (above), 118–122, 123 (above), 124–126 (above), 127 (above), 128–131, 132 (below), 133–135, 136 (above), 137, 138, 139 (above, below left), 140, 141 (above), 142, 144, 145 (below)
Bernd Kritz, Duisburg 132 (above)
Tate Gallery, London 21
Ugo Mulas, Milan 2, 15, 52/53, 56 (right), 106/107, 146/147, 153, 155 (above), 160
The Brooklyn Museum, New York 73
Washburn Gallery, New York 110 (above)
Rijksmuseum Kröller-Müller, Otterlo 86
Eric Pollitzer, New York 57 (above), 65 (below), 76

Prudence Cuming Association Ltd., London 139 (below right), 143 (below)
Galerie de France, Paris 38
Alfred Puhn, San Francisco 155 (below)
Ken Strothmann, Bloomington 63
Staatsgalerie, Stuttgart 127 (below), 136 (below), 141 (below)
Archives of American Art, Smithsonian Institution, Washington, D.C 11, 12, 34, 44, 55, 56 (left), 58, 60–62, 64, 65 (above), 66–72, 74, 75, 78–85, 87, 89–91, 94–96, 159
National Gallery of Art, Washington, D.C. 97
Weatherspoon Art Gallery, Greensboro 57 (below)